NATIONAL GALLERY OF SCOTLAND

CATALOGUE OF ITALIAN DRAWINGS

VOLUME I
TEXT

NATIONAL GALLERY OF SCOTLAND

CATALOGUE OF ITALIAN DRAWINGS

KEITH ANDREWS

VOLUME I
TEXT

CAMBRIDGE
PUBLISHED FOR THE TRUSTEES
OF THE NATIONAL GALLERIES OF SCOTLAND
AT THE UNIVERSITY PRESS
1968

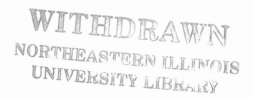

Published by the Syndics of the Cambridge University Press
Bentley House, 200 Euston Road, London, N.W.1
American Branch: 32 East 57th Street, New York, N.Y.10022

Library of Congress Catalogue Card Number: 68-22661

Standard Book Number: 521 07121 6 (set of two vols.)

Printed in Great Britain
at the University Printing House, Cambridge
(Brooke Crutchley, University Printer)

CONTENTS

v

FOREWORD

Although the National Gallery of Scotland's first considerable acquisition of drawings dates from 1860, it was only in 1946 that a separate Department of Prints and Drawings was formed. By this time the collection of drawings was both rich and extensive, but virtually uncatalogued and hence little known outside the Gallery. Work on the large collection of drawings by Scottish artists was started by the first Keeper of the Department, the late James R. Brotchie, and continued by the present Keeper, Keith Andrews. A concise catalogue, or handlist, of the Scottish drawings was published in 1960, together with a booklet of selected illustrations.

In that year Mr Andrews began the eight years' work that has resulted in the present catalogue of the Italian drawings. This is the first of a new series of fuller catalogues designed to make the collection of drawings more generally useful and accessible.

DAVID BAXANDALL
Director
National Gallery of Scotland, Edinburgh

INTRODUCTION

The backbone of the collection of drawings in the National Gallery of Scotland consists of three large gifts and bequests: by Lady Murray (1860), W. F. Watson (1881) and David Laing (1910).

The first was a gift of over 300 drawings by Allan Ramsay, together with a fair number of continental, mainly Italian, drawings which Lady Murray of Henderland presented in 1860, the year after the opening of the National Gallery. Lady Murray's husband was the nephew of Allan Ramsay, and the drawings had been bequeathed to him by the artist's son. It is therefore more than likely that the majority had belonged to Allan Ramsay himself, though there is no extant record of what his collection in fact contained. However, the artists that are represented in the Murray gift reflect admirably the taste an 18th century artist might supposedly have shown. Of particular interest is the long series of drawings by Francesco Allegrini, apart from the collections at Leipzig and the Metropolitan Museum in New York the largest of this very spirited draughtsman, and distinguished by the fact that it contains an unusually large number of red chalk drawings, rather than the more common pen and ink sketches. Equally noteworthy is the series of Pompeo Batoni drawings, which were probably acquired by Ramsay during his first stay in Italy (1736–38) direct from Batoni's studio, which would give a useful *terminus ante quem* for their dating.

The second bequest was a large number of drawings (and prints) left to the Gallery, after his death in 1881, by William F. Watson, an Edinburgh bookseller. Little or nothing seems to be known about him, but his interests were chiefly antiquarian and topographical (see the *Catalogue of Scottish Drawings in the National Gallery of Scotland*), though he had a large number of masterpieces among his collection, for example the Gentile da Fabriano and the *Head of St Francis* by Barocci.

The third and most substantial portion of the collection of the National Gallery Print Room are the drawings which David Laing (1793–1878) bequeathed to the Royal Scottish Academy (see Gilbert Goudie, *David Laing: a memoir of his life and literary work*. Edinburgh, 1913, pp. 132 and 136). These were bound into nineteen large folio volumes, as stipulated in his will, 'excluding such as may be reckoned not worth preservation' (Goudie, p. 132). The nineteen folios were transferred to the National Gallery of Scotland in 1910, and the residue which the Academy had failed to mount, probably because they were thought to fall under the last clause

just quoted, were generously handed over on extended loan by the Royal Scottish Academy in 1966. The Italian drawings among these have been incorporated into the present catalogue, and have been indexed in a separate inventory sequence, prefixed by the letters RSA. Thus the Laing collection can probably now be considered complete once again.

Laing was a historian, antiquarian and librarian of the Writers to the Signet, and played a major role in the cultural life of Edinburgh. He was a member of the Society of Antiquaries of Scotland, and staunchly advocated the formation of a Scottish National Portrait Gallery, a project which he did not live to see fulfilled.

He was an inveterate collector of anything on paper, whether books, manuscripts, prints or drawings. His large collection of papers and manuscripts is now preserved in the Edinburgh University Library, but it is disconcerting to find that there is not a scrap of a letter or a single bill connected with his activities as a collector of works of art. He may well have picked up a great deal in his father's bookshop in the Canongate, or later on the South Bridge, where he had joined his father as a partner in 1821. He was known to have made 'raids on Paris, returning laden with spoils—books and prints—from the great libraries confiscated during the Revolution, which he picked up in bookshops and in the bookstalls on the Quais...And there were other journeys to France and Holland, and to Germany, Flanders, Sweden and Denmark' (Goudie, pp. xxvii and 39). As might have been expected, he had contact with Andrew Wilson, who resided for long periods in Italy and who was instrumental in acquiring many valuable paintings for Scottish collectors, in particular for the Royal Institution for the Encouragement of the Fine Arts, the predecessor of the National Gallery of Scotland. (For Andrew Wilson, see William Buchanan, *Anecdotes of Paintings*. 1824, II, 195 ff.) One clue to this relationship is an inscription on a drawing from the Laing collection, attributed to Breenbergh (D 986), which reads: *Bt. in Ferrara. A.W.* And among Laing's correspondents, listed by Goudie, was also the eccentric Irish antiquary and collector of drawings Bindon Blood (L 3001) who resided, and made many of his purchases, in Edinburgh.

Although Laing, like Watson, had the magpie instinct of all collectors, and accumulated much (especially in the purely antiquarian field) that is of second- or third-rate quality, his eye for an interesting drawing, if not an outright masterpiece, will be obvious to anyone who peruses these pages.

Apart from these three cornerstones, there have been many generous gifts and bequests from private individuals, while the policy of the Trustees is to keep the collection alive by buying such drawings as their limited funds will permit.

Most of the drawings were only known to specialists who had made their way to Edinburgh. Campbell Dodgson undoubtedly knew some of them and Sidney Colvin selected a few for publication in the First Series of the *Vasari Society* portfolios. A number were shown in the exhibition of *Old Master Drawings* at the Royal Academy, London, in 1953, and odd ones have made their appearance

from time to time in British and overseas exhibitions. However, until Messrs Colnaghi's very generously showed a larger selection in their gallery in the summer of 1966, the general public was largely unaware of the riches and variety of the National Gallery's collection.

Although it will be found that, especially in the anonymous section, many drawings of slighter interest have been listed, it was felt that it would be essential to include every drawing that was thought to be of Italian origin, rather than adopt the doubtful expediency of a *Zweite Garnitur*, that bane of every student and visitor of Print Rooms. An inversion of the proverb, 'One man's poison is another man's meat', is more than ever applicable here.

It was further thought that the catalogue would be of more value to scholars if the volume of plates illustrated every Italian drawing in the collection, with the exception of direct copies or very slight or fragmentary drawings. This was therefore decided upon, even though the illustrations are on a comparatively small scale, rather than have larger plates of only the more important drawings.

Anybody who has been engaged in compiling a catalogue such as the present one will be aware how great a reliance needs to be placed on the help of kindly friends and colleagues. It is a far more communal undertaking than the name listed on the title page would suggest. This compiler is deeply conscious of his debt to the many people who, over the years, have given him help and provided him with information of one sort or another, and while it is impossible to name everyone individually here, it is hoped that proper acknowledgement has been made in the relevant places. But a few names must be mentioned specially, among them first and foremost Philip Pouncey, who has never stinted his peerless knowledge of the vast field of Italian drawings. He has not only discussed with the compiler virtually every drawing here listed, but the reader will note that a great many of the new or changed attributions come from him, and in other cases he has suggested avenues for enquiry and research. The compiler has also frequently sought advice not only from his patient colleagues at the National Galleries of Scotland, but also from Anthony M. Clark, J. A. Gere and Walter Vitzthum. He is further indebted to the facilities given to him at the Warburg Institute, in particular by Mrs Enriqueta Frankfort and Dr Jennifer Montagu of the photographic collection. For a great deal of practical help, he is much indebted to Miss D. M. Fulton and John Dick. It is for once not a cliché to say that without the unfailing generosity of these and many others, the work on this catalogue could not have been completed. It is in any case in the nature of such a work that it is in fact never really finished, and there is hardly a week when new information does not make necessary the emendation of one or the other entry. For any shortcomings the compiler must take sole responsibility, for any corrections he will be truly grateful.

K. A.

July 1967

NOTES ON THE CATALOGUE

In the Main Catalogue the drawings are in alphabetical order of artists' names.

The following subdivisions have been adopted:

Attributed implies that, in the opinion of the compiler, the artist's name proposed has a good chance of being the correct one. If no source for an attribution is given, it may be taken to be the traditional one.

Ascribed is applied when the traditional or more recent attribution seems to the compiler to be doubtful, although he is not able to suggest a better alternative.

Studio: when the drawing seems very close to the artist himself.

Circle: when a remoter, though still close, influence seems to be apparent.

Copy: a repetition of a known composition.

Follower: when stylistic characteristics of the artist are evident, though the drawing may have been made at a later date.

Imitator: when a deliberate, though not very successful, resemblance to the artist's style has been attempted.

This alphabetical section is followed by the Catalogue of Anonymous Drawings, divided into SCHOOLS and CENTURIES. In each of the latter sections the drawings are listed in numerical order according to the inventories.

Inventory Numbers: The drawings are to be referred to by their inventory numbers (printed in bold type), prefixed by the letters *D* or *RSA*.

Sizes are given in millimetres, height before width, measured along the left-hand margin and across the bottom margin. In the case of irregularly shaped, cut or torn sheets the largest dimensions are given.

Medium: Certain ambiguous terms such as *bistre* or *sepia* have been avoided. *Black chalk* includes crayon as well as pencil, as it is often impossible to distinguish clearly between them.

Defects are stated in brackets after the description of the medium.

Inscriptions found on the actual drawings are printed in italics, those on the mounts or old backings in roman.

Paper: Unless otherwise stated the colour of the paper can be presumed to be white.

Watermarks are only cited in cases when they help to date a particular drawing. In very many cases it was impossible to ascertain if a watermark is present, as it has been thought too dangerous to lift the sheets from the old mounts or backings.

Provenance: Only in the case of the more important drawings has it been thought worth while to pursue their path through the various sale catalogues. If a provenance has been inferred from evidence other than a collector's mark or an inscribed name (for example, a characteristic mount or handwriting) it has been put between brackets.

Collectors' Marks: Lugt numbers (L.) are only quoted in cases of comparatively unfamiliar collectors, or when a collector has more than one mark.

LIST OF WORKS REFERRED TO
IN ABBREVIATED FORM

Albertina I	Beschreibender Katalog der Handzeichnungen in der Graphischen Sammlung Albertina. I: A. Stix and L. Fröhlich-Bum, *Die Zeichnungen der Venezianischen Schule* (Vienna, 1926).
Albertina III	*Idem.* III: A. Stix and L. Fröhlich-Bum, *Die Zeichnungen der Toskanischen, Umbrischen und Römischen Schulen* (Vienna, 1932).
Albertina VI	*Idem.* VI: A. Stix and A. Spitzmüller, *Die Schulen von Ferrara, Bologna,* etc. (Vienna, 1941).
Ashmolean Cat.	K. T. Parker, *Catalogue of the Collection of Drawings in the Ashmolean Museum.* Vol. II: *The Italian Schools* (Oxford, 1956).
B.	A. Bartsch, *Le Peintre-Graveur.* 21 vols. (Vienna, 1803–21).
Berenson	B. Berenson, *The Drawings of the Florentine Painters.* Vol. II (Catalogue) (Chicago, 1938). [The 1961 Italian edition preserves the same numbering.]
BM XIV–XV	A. E. Popham and Philip Pouncey, *Italian Drawings in the Department of Prints and Drawings in the British Museum: The Fourteenth and Fifteenth Centuries.* 2 vols. (London, 1950).
BM Raphael	Philip Pouncey and J. A. Gere, *Italian Drawings...in the British Museum: Raphael and his Circle.* 2 vols. (London, 1962).
Briquet	C. M. Briquet, *Les Filigranes.* 4 vols. (Paris, 1907).
Churchill	W. A. Churchill, *Watermarks in Paper* (Amsterdam, 1935).
Colnaghi	*Old Master Drawings: a Loan Exhibition from the National Gallery of Scotland.* London, Colnaghi's, 1966.
Hollstein	F. W. H. Hollstein, *Dutch and Flemish Etchings, Engravings and Woodcuts, 1450–1700* (Amsterdam, 1949ff.).
Italian Drawings at Windsor	A. E. Popham and J. Wilde, *The Italian Drawings of the XV and XVI Centuries...at Windsor Castle* (London, 1949).
L.	Frits Lugt, *Les marques de collections de dessins et d'estampes,* etc. (Amsterdam, 1921). Supplément (The Hague, 1956).
Master Drawings	*Master Drawings* (New York). Vol. I, 1963– .
Metz	C. M. Metz, *Imitations of Ancient and Modern Drawings from the Restoration of the Arts in Italy to the Present Time* (London, 1798).
OMD	*Old Master Drawings.* Vols. I–XIV. (London, 1926–40.)

ABBREVIATIONS

Pigler, Barockthemen	A. Pigler, *Barockthemen: Eine Auswahl von Verzeichnissen zur Ikono-graphie des 17. und 18. Jahrhunderts*. 2 vols. (Budapest, 1956).
Thieme–Becker	U. Thieme and F. Becker, *Allgemeines Lexikon der bildenden Künstler*, etc. 37 vols. (Leipzig, 1907–50).
Tietze	H. Tietze and E. Tietze-Conrat, *The Drawings of the Venetian Painters in the Fifteenth and Sixteenth Centuries* (New York, 1944).
Van Marle	R. van Marle, *The Development of the Italian Schools of Painting*. 19 vols. (The Hague, 1923–38).
Vasari Society	*The Vasari Society for the Reproduction of Drawings by Old Masters*. Parts I–X (London, 1905–15); 2nd Series, parts I–XVI (London, 1920–35).
Venturi	A. Venturi, *Storia dell'arte italiana*. XI vols. [From vol. VI onwards divided into parts.]
Voss, Spätrenaissance	Hermann Voss, *Die Malerei der Spätrenaissance in Rom und Florenz* (Berlin, 1920).
Voss, Barock	Hermann Voss, *Die Malerei des Barock in Rom* (Berlin, 1924).
Weigel	R. Weigel, *Die Werke der Maler in ihren Handzeichnungen. Beschreibendes Verzeichnis der in Kupfer gestochenen, lithographierten, und photographierten Facsimiles von Originalzeichnungen Grosser Meister* (Leipzig, 1865).

MAIN CATALOGUE

NICCOLÒ DELL'ABBATE
Modena c. 1512–1571 Paris

RSA 123 Fig. 1

Study of a seated female figure and two male figures.

238 × 292. Pen and brown ink. (Sheet cut and joined. Laid down.) Inscribed: *M. Ang. Buonarotti.* Also nos. *1792* and *1517*.

PROV: Sir Thomas Lawrence; David Laing; Royal Scottish Academy. On loan 1966.

The fairly late ascription to Michelangelo in the bottom right corner is, of course, untenable, although the figure on the right-hand side of the sheet is clearly derived from some of the *ignudi* of the Sistine ceiling or the sculptured *Slaves* for the Julius tomb. It was Philip Pouncey who first suggested the present attribution, while Mme Sylvie Béguin pointed to the drawing at the Louvre (5895) from the Crozat Collection, with an old inscription *Messer Nicolo*, which shows the same two figures as on the left of RSA 123. A comparison between the two sheets, however, shows clearly that the Louvre drawing is far more spontaneous, with several pentimenti, which may suggest that the Edinburgh drawing, although without doubt contemporary, is possibly a studio copy. The seated female figure is a type which occurs frequently in dell'Abbate's paintings, although none has been identified which corresponds exactly with the one depicted in the two drawings.

D 3073 Fig. 2

Venus and Cupid.

257 × 412. Pen, brown ink and wash over black chalk, heightened with white. Squared in red chalk.

PROV: Count J. von Ross (L. 2693); W. F. Watson. Bequeathed 1881.

A fine original late chalk drawing, but gone over in ink, perhaps by a studio hand.

D 1648 Fig. 3

Two nudes placing an ornamental jar on an altar. (Part of a larger ceremonial composition.)

470 × 283. Pen, brown ink and wash, heightened with white. (Damaged in several places, and left-hand bottom corner torn away completely; oxidized in parts.) Inscribed in a 19th century hand with the artist's name.

PROV: David Laing; Royal Scottish Academy. Transferred 1910.

Sidney Colvin accepted the attribution tentatively, according to a note on the mount. The heightening is indeed applied in Abbate's manner, although rather crudely. This may perhaps suggest the interference of a studio hand. The drawing shows a Florentine influence, possibly that of Francesco Salviati.

FRANCESCO ALBANI
Bologna 1578–1660 Bologna

Copy after FRANCESCO ALBANI

D 696 A and B Figs. 4 and 5

(A) Pan and Syrinx; (B) The death of Eurydice. (Two designs for fans.)

275 × 533 and 280 × 535. Water-colours on silk. Inscribed on (A): *Satiro e Siringe* (in pencil). The following inscriptions are on the respective mounts: (A) 'Nymphs and Satyrs—Part of ceiling in the Medici Palace—Albano.' (B) 'Part of the window of the Confessional in the Medici Palace. By Albano.'

PROV: David Laing; Royal Scottish Academy. Transferred 1910.

No two such compositions by Albani have been traced, nor is it clear which Medici Palace is referred to. The two inscriptions may, in any case, be misleading, as it is hardly likely that a subject such as the one depicted in design B was used for a window in a Confessional. Both designs bear an illegible inscription, probably approving the designs for engraving.

Imitator of FRANCESCO ALBANI

D 1290 Fig. 6

The rape of Europa.

249 × 333. Black ink over black chalk; partly touched with water-colour. Some colour-notes in pencil. (Small tear in

upper left margin.) Inscription on the back *Orig. in der Leuchtenb. Gallerie* crossed out.

PROV: David Laing; Royal Scottish Academy. Transferred 1910.

The drawing appears to be of the early 19th century, and was probably inspired by a Bolognese artist like Albani (see for example his picture of the same subject in the Palazzo Pitti). No painting resembling this composition could be traced as being formerly in the Leuchtenberg Gallery, according to the inscription on the back. Neither J. D. Passavant's Catalogue (1851) nor the article by A. Néonstroieff 'I Quadri Italiani nella Collezione del Duca G. N. von Leuchtenberg...' in *L'Arte*, VI (1903), pp. 323 ff. make any mention of such a painting. A drawing representing essentially the same composition in reverse, and attributed to Albani, is at Christ Church, Oxford (Inv. 0570).

CHERUBINO ALBERTI
(Borcheggiano)
Borgo S. Sepolcro 1553–1615 Rome

D 905 Fig. 7

Two putti sitting on a plinth in front of a balustrade, supporting coronets above the Borghese griffin and eagle.

212 × 413. Pen, black ink and brown wash over red chalk.

PROV: W. Sharp (L. 2650) on the reverse; David Laing; Royal Scottish Academy. Transferred 1910.

LIT: Reginald Blomfield, *Architectural Drawings and Draughtsmen* (1912), p. 58, as Perino del Vaga.

The attribution to Alberti was first made by A. E. Popham. The arms are those of Pope Paul V (Borghese), 1605–1621, and no doubt the 'P' on the entablature stands for 'Paulus'. Philip Pouncey was the first to connect the composition with one of the lunettes in the Casino Rospigliosi, painted for the Cardinal Borghese. Although the drawing does not correspond exactly with the fresco except for the general subject, it seems reasonable to suppose that it is a preliminary idea for it. According to Passeri, *Vite* (ed. Hess), p. 88, payments for the lunette were made to Cherubino Alberti in 1613–14. A very similar composition, with the arms of Cardinal Visconti, was engraved by Alberti in 1607 (B. XVII, p. 101, 142).

D 1514 Fig. 8

Study of putti flying upwards (for a ceiling decoration).

119 × 117. Black and red chalk.

PROV: David Laing; Royal Scottish Academy. Transferred 1910.

The attribution to Cherubino Alberti of this drawing, which entered the collection as 'Van Dyck', is due to A. E. Popham. Compositions with similar putti occur frequently in Alberti's works: see for instance the engraving (B. XVII, p. 106, 153) dedicated to Cosimo II, where the central figure of D 1514 is seen in reverse; in the ceiling of the Sagrestia dei Canonici, S. Giovanni Laterano (Venturi, IX/5, fig. 540); or on the ceiling of the Presbytery in S. Silvestro al Quirinale, Rome. Maria Brugnoli suggested that the drawing should rather be given to *Giovanni* Alberti.

ALESSANDRO ALGARDI
Bologna 1602–1654 Rome

D 900 Fig. 9

Design for a fountain.

214 × 163. Pen, brown ink and wash over black and red chalk. Inscribed: *Bernino*.

PROV: (W. Y. Ottley, from style of mount); Sir Thomas Lawrence; David Laing; Royal Scottish Academy. Transferred 1910.

This drawing, as well as the following (D 901), seems obviously by Algardi, in his looser and more anaemic manner. Good comparisons are such drawings as the one in the collection of Lord Leicester at Holkham Hall of *Putti with the arms of Cardinal Pamphili*, which is a preparatory study for the stucco medallion in the Stanze di Ercole in the Villa Doria-Pamphili, Rome; or the *Design for a Cardinal's Tomb* in the Louvre (6850, from the Mariette Collection)—illustrated by W. Vitzthum in 'Disegni di Alessandro Algardi', *Bolletino d'Arte* (Jan.–June 1963), figs. 2 and 27. Jennifer Montagu and Walter Vitzthum have drawn attention to a chalk drawing in the Louvre (6856), showing the composition of D 900 in reverse, presumably a counterproof from a copy. This sheet, together with a drawing of a *Baptism* (Vitzthum, *op. cit.* note 50), is mounted on the same paper; in between is the inscription 'dell'Algardi', in Baldinucci's hand, according to Walter Vitzthum.

D 901 Fig. 10

Design for a fountain, with a nymph (Galatea?) seated on a dolphin, attended by three putti. (On the verso of the backing: a very faint pencil sketch of a classical landscape with a crouching figure.)

255 × 175. Pen, brown ink and wash, heightened with white.

PROV: Sir Thomas Lawrence; David Laing; Royal Scottish Academy. Transferred 1910.

LIT: Reginald Blomfield, *Architectural Drawings and Draughtsmen* (1912), p. 57 (as Bernini).

If not by Algardi himself, the drawing must stem from his immediate circle.

Copy *after* ALESSANDRO ALGARDI

D 909 Fig. 11

Study for the tomb of Pope Leo XI.

384 × 247. Pen, brown ink and wash over black chalk. Inscribed on the bottom left: *A. Algardi ft.*

PROV: J. Richardson, Senr (L. 2183) gone over with ink; ?Samuel Woodburn, according to a sale catalogue cutting affixed to the top of the drawing; David Laing; Royal Scottish Academy. Transferred 1910.

LIT: Reginald Blomfield, *Architectural Drawings and Draughtsmen* (1912), p. 60; Walter Vitzthum, 'Disegni di Alessandro Algardi', *Bolletino d'Arte* (Jan.–June 1963), pp. 75, 85–6; fig. 26.

This weak drawing cannot be regarded as an original. However, as it shows differences from the finished tomb, it may well be a copy, perhaps not even contemporary, after a preliminary drawing by Algardi.

FRANCESCO ALLEGRINI

Gubbio c. 1624–c. 1663 Rome

D 915 Fig. 12

St Sebastian converting the prefect Cromatio and his son (On the left: St Tranquillirio Martyr. On the right: St Zoe)—in an architectural setting.

242 × 259. Pen, brown ink and wash. (Laid down on heavy cardboard.) Inscription in pencil (probably 19th century) on the back of the cardboard backing: 'Giusepe d'Arpino'.

Inscriptions on the drawing: left, *S. Tranquillirio Martire*; middle, *S. Sebastiano conuerti Cromatio, Prefetto con il suo figlo*; right, *Sta Zoe Martire, moglie di Nicostrato*.

PROV: David Laing; Royal Scottish Academy. Transferred 1910.

The present attribution is due to Philip Pouncey. Interesting is the inscription to the Cav. d'Arpino on the back, in whose studio Allegrini was supposed to have been apprenticed. There can be no doubt, however, of Allegrini's authorship of this drawing; both technique and the manner of the inscriptions are entirely characteristic of him.

D 4842 Fig. 13

The meeting of Anthony and Cleopatra.

133 × 193. Pen, brown ink and wash. Inscription in the artist's hand at the top.

PROV: John Manning. Purchased 1961.

A similar composition exists in two further drawings, one at Munich (34866) in the same pen and wash technique and another at Leipzig (N.J. 7461, p. 67) in pen only, which is nearer to the Edinburgh drawing than the other (rep. Voss in *Berliner Museen* XLV (1924), fig. 3). A further drawing, illustrating the history of *Anthony and Cleopatra*, which seems to have been a favourite subject with Allegrini, is contained in the Leipzig 'Klebebände' (N.J. 7450, p. 13 and N.J. 7460, pp. 33 and 39).

D 4884 Figs. 14 and 15

(*recto*) A child being presented to seven 'Virtues'; (*verso*) Two female figures, one with upraised arms.

179 × 146. Recto: pen and ink. Verso: red chalk. (Torn and repaired along top margin.)

PROV: Mrs A. G. Macqueen Ferguson. Purchased 1963.

The previously unattributed drawing is clearly by Allegrini. The subject presumably represents an allegory on the birth of a noble child, similar to Rubens's *Birth of Maria de Medici* (Louvre). The attending 'Virtues', in clockwise order, beginning with the kneeling figure, are: *Justitia*; *Sapienzia*, holding the child; *Consiglio*, with the 'signum triceps'; *Pietà*; *Intelletto*: *Scienza*, holding a mirror; and the uninscribed figure *Fortitudine*, with the lion.

D 1871 Fig. 16

The Birth of the Virgin.

256 × 203. Pen and black ink, over red chalk.

PROV: Lady Murray. Presented 1860.

Similar composition at Leipzig (N.J. 7460, p. 1).

D 1876 Fig. 17

The martyrdom of a cardinal or bishop.

174 × 160. Black chalk.

PROV: Lady Murray. Presented 1860.

A similar incident, but part of a more elaborate composition, with female figures holding a child is contained in the Leipzig 'Klebeband' (N.J. 7461, p. 55).

D 1892 Fig. 18

Sheet of studies of a group of figures as well as two kneeling figures.

113 × 163. Pen, brown ink and wash. Red chalk scribbles in the top right corner. Inscribed: *minor dabasso?*

PROV: Lady Murray. Presented 1860.

Although not at first sight a characteristic Allegrini drawing, it corresponds in style and technique with D 915 above (especially the tapering feet) and in technique with a *Flagellation* at Leipzig (N.J. 7461, p. 32).

D 1882 A Fig. 19

Two male figures (one kneeling) and one female figure.

174 × 164. Black chalk.

PROV: Lady Murray. Presented 1860.

D 1897 A Fig. 20

A monk healing.

128 × 195. Black chalk, with parts of the central figure gone over in ink.

PROV: Lady Murray. Presented 1860.

D 1885 B Fig. 21

The Holy Family. (On the verso: a standing angel, in black chalk.)

118 × 146. Red chalk.

PROV: Lady Murray. Presented 1860.

EXH: Colnaghi, 1966 (38b).

D 1865 Fig. 22

Seated woman turned to the right, with putto seen from the back.

248 × 192. Red chalk.

PROV: Lady Murray. Presented 1860.

Possibly a study for a *Rest on the Flight to Egypt*, which shows Allegrini in a rather Correggesque mood and style. An almost identical composition, in reverse, and in pen and ink, is at Leipzig (N.J. 7460, p. 25).

D 1887 A Fig. 23

The Madonna and Child with St Anne.

182 × 163. Red chalk.

PROV: Lady Murray. Presented 1860.

D 1863 Fig. 24

Madonna and Child, supported by two angels ('Madonna di Loreto').

322 × 204. Red chalk.

PROV: Lady Murray. Presented 1860.

A more carefully worked-out study, in pen and ink, of the same composition, but with significant variations is at Leipzig (N.J. 7459, p. 20).

D 1948 Fig. 25

The seated Madonna and Child. ('Madonna di Loreto'.)

170 × 128. Black chalk. (Laid down.)

PROV: Lady Murray. Presented 1860.

Various studies of this particular group exist in the Leipzig albums, all apparently leading up to the composition of D 1863.

D 1869 Fig. 26

Madonna and Child.

210 × 173. Red chalk.

PROV: Lady Murray. Presented 1860.

A rather softer and more carefully finished drawing than is usual with this artist. An almost identical study, in wash, is at Leipzig (N.J. 7459, p. 30).

D 1947 Fig. 27

Madonna and Child holding the orb.

135 × 120. Pen, black ink, brown wash over red chalk. (Laid down.)

PROV: Lady Murray. Presented 1860.

A drawing of the same composition is included on a sheet of studies at Leipzig (N.J. 7459, p. 96 bottom).

D 1899 H Fig. 28

Madonna and Child.

68 × 54. Red chalk.

PROV: Lady Murray. Presented 1860.

D 1899 C Fig. 29

Madonna and Child.

73 × 52. Pen and black ink, over red chalk.

PROV: Lady Murray. Presented 1860.

D 4883 Fig. 30

The Madonna of the Annunciation.

229 × 160. Red chalk.

PROV: Mrs Macqueen Ferguson. Purchased 1963.

This previously unattributed drawing is typical of Allegrini's chalk style.

D 1919 Fig. 31

The Madonna of the Annunciation.

122 × 103. Red chalk, with red wash.

PROV: Lady Murray. Presented 1860.

D 1907 Fig. 32

The Madonna of the Annunciation.

220 × 182. Red chalk.

PROV: Lady Murray. Presented 1860.

D 1882 B Fig. 33

Studies for a *Madonna Adoring*.

142 × 195. Pen and black ink (traces of red chalk).
PROV: Lady Murray. Presented 1860.

D 1901 B Fig. 34

A head of the Madonna with downcast eyes.

160 × 170. Black chalk on grey paper, heightened with white.
PROV: Lady Murray. Presented 1860.

D 1915 Fig. 35

Figure of Christ.

261 × 185. Red chalk.
PROV: Lady Murray. Presented 1860.
Copied from the *Agony in the Garden* by M. Venusti (Doria Gallery, Rome), based on Michelangelo.

D 1881 A Fig. 36

Seated figure of Christ, looking to the right.

153 × 143. Red chalk.
PROV: Lady Murray. Presented 1860.

D 1908 Fig. 37

Christ and St Peter (?)

237 × 189. Red chalk.
PROV: Lady Murray. Presented 1860.

D 1867 Fig. 38

The penitent Magdalen.

178 × 179. Red chalk (some black ink spots).
PROV: Lady Murray. Presented 1860.

D 1868 Fig. 39

The Magdalen at the foot of the Cross.

172 × 151. Black chalk, with traces of red chalk.
PROV: Lady Murray. Presented 1860.

D 1898 A Fig. 40

A monk with left hand pointing upwards.

231 × 96. Red chalk.
PROV: Lady Murray. Presented 1860.

D 1880 B Fig. 41

Standing draped female figure.

214 × 91. Black chalk (raised right hand gone over with red chalk).
PROV: Lady Murray. Presented 1860.

D 1881 B Fig. 42

Half-length of a woman, resting her head on her right hand.

148 × 119. Red chalk.
PROV: Lady Murray. Presented 1860.

D 1875 A Fig. 43

A kneeling woman, embracing another lying figure lightly sketched in.

98 × 125. Red chalk.
PROV: Lady Murray. Presented 1860.

D 1879 C Fig. 44

Two studies of a nude, seen from the back.

203 × 154. Red chalk (paper crinkled).
PROV: Lady Murray. Presented 1860.

D 1899 B Fig. 45

Seated female figure, seen from the back. Two other figures indicated in the background.

90 × 52. Red chalk.
PROV: Lady Murray. Presented 1860.

D 1879 B Fig. 46

Sketch of a putto crowning a female figure with a wreath.

87 × 69. Pen and black ink.
PROV: Lady Murray. Presented 1860.
An identical composition including another female figure on the left (here probably cut off) is at Leipzig (N.J. 7459, p. 29 and N.J. 7460, p. 23).

D 1899 F Fig. 47

A bearded male and a winged figure.

56 × 50. Pen and black ink.
PROV: Lady Murray. Presented 1860.

RSA 150 Fig. 48

Jupiter and two female goddesses.

76 × 110. Pen and ink. (Laid down, damaged and lower right corner cut off.)

PROV: David Laing; Royal Scottish Academy. On loan 1966.

A typical example of Allegrini's pen drawing.

D 1899 E Fig. 49

Three children, one riding on a goat.

69 × 101. Pen and brown ink.

PROV: Lady Murray. Presented 1860.

A similar group occurs in the extreme right corner of a drawing depicting *The Youth of Bacchus* at Leipzig (N.J. 7461, p. 68).

D 1893 B Fig. 50

Four putti, one seated astride.

80 × 82. Black chalk, pen and wash.

PROV: Lady Murray. Presented 1860.

A drawing of similar subject and technique is at Leipzig (N.J. 7450, p. 21).

D 1898 C Fig. 51

A draped putto.

96 × 54. Red chalk.

PROV: Lady Murray. Presented 1860.

D 1870 Fig. 52

A seated female figure, with outstretched left hand.

270 × 211. Red chalk.

PROV: Lady Murray. Presented 1860.

A study for the figure of Juno in the fresco of *Juno, Venus and Cupid*, part of the ceiling decoration in the Palazzo Doria-Pamphili, Piazza Navona, Rome (cf. Voss, Barock, p. 273). The drawing shows Allegrini in rather a Guercinesque manner.

D 1901 A Fig. 53

A seated crowned female figure. Another version of the head, lightly indicated to the right.

199 × 165. (Lower margin cut to an irregular shape.) Red and black chalk.

PROV: Lady Murray. Presented 1860.

Very Guercinesque in style.

D 1862 Fig. 54

A seated woman supporting her head on her hand.

297 × 177. Red chalk.

PROV: Lady Murray. Presented 1860.

A fairly modern ascription to 'Boscoli' has been noted on the mount, probably owing to a faint similarity of his characteristic parallel shading lines. The drawing is, however, certainly by Allegrini. For a similar, standing, figure in the same technique see Leipzig (N.J. 7460, p. 5).

D 1861 Fig. 55

A seated woman.

307 × 189. Red chalk. (Laid down.) Inscribed in pencil on the mount: 'Montelupo'.

PROV: Lady Murray. Presented 1860.

The inscription on the mount refers probably to Raffaello da Montelupo, who was left-handed, and the shading in the drawing runs from the top left to the bottom right, in the way a left-handed artist would draw them. However, the drawing is in fact a 'counterproof'. The style is characteristic of Allegrini's chalk manner.

D 1872 Fig. 56

A seated female figure in armour; in the right background: study of an angel.

204 × 137. Red chalk.

PROV: Lady Murray. Presented 1860.

Two more finished versions of the figure, also with an angel in the background, as well as a slight sketch of perhaps a *Madonna and Child* in the lower right-hand corner, are contained in drawings at Leipzig (N.J. 7461, pp. 39 and 103). There too the figure is clad in a helmet and is holding a staff. The figure may possibly be connected with the decoration of the ceiling in the Palazzo Doria-Pamphili, Rome, where closely related figures occur in the four corners. A similar figure personifying 'Law' occurs in Romanelli's ceiling decorations in the Palazzo Lante, Rome (see E. K. Waterhouse, *Baroque Painting in Rome*, 1937, fig. 14).

D 1902 B Fig. 57

A crouching female figure with uplifted right arm.

157 × 143. Red chalk.

PROV: Lady Murray. Presented 1860.

D 1900 B Fig. 58

A standing male figure with outstretched right arm and averted head.

121 × 63. Black chalk.

PROV: Lady Murray. Presented 1860.

D 1898 B Fig. 59

Half-length of a female figure, three-quarter view.

97 × 97. Red chalk.

PROV: Lady Murray. Presented 1860.

D 1900 C Fig. 60

Female figure with uplifted head. ('Hope'?)

112 × 73. Pen and brown ink, shading in black chalk.

PROV: Lady Murray. Presented 1860.

D 1900 A Fig. 61

A kneeling female figure.

144 × 108. Red chalk.

PROV: Lady Murray. Presented 1860.

D 1879 A Fig. 62

Back view of a draped female figure.

86 × 81. Red chalk.

PROV: Lady Murray. Presented 1860.

D 1880 A Fig. 63

Study for a flying figure.

93 × 142. Pen and black ink.

PROV: Lady Murray. Presented 1860.

For comparison of style see drawing of a *St Michael* at Leipzig (N.J. 7460, p. 87).

D 1866 Fig. 64

Seated female nude turned to the left and looking down.

251 × 178. Red chalk.

PROV: Lady Murray. Presented 1860.

D 1903 Fig. 65

Two views of a nude man with hands at his back.

268 × 184. Black chalk.

PROV: Lady Murray. Presented 1860.

D 1905 Fig. 66

A Roman emperor with flowing cloak.

296 × 172. Red chalk.

PROV: Lady Murray. Presented 1860.

Very Guercinesque, and pointing towards Maratta, yet also exceedingly close to the Cavaliere d'Arpino, cf. for example the red chalk drawing at Berlin (20870). The same figure, kneeling and surrounded by other figures, occurs in a drawing at Leipzig (N.J. 7460, p. 96).

D 1904 Fig. 67

A striding Roman soldier.

250 × 141. Black chalk.

PROV: Lady Murray. Presented 1860.

D 1885 A Fig. 68

A soldier dismounting from a fallen horse (part of another horse on the top right). (On the verso: two seated figures.)

214 × 146. Red chalk.

PROV: Lady Murray. Presented 1860.

EXH: Colnaghi, 1966 (38a).

A similar drawing is at Leipzig (N.J. 7461, p. 25).

D 1883 A Fig. 69

A soldier kneeling beside his horse.

166 × 151. Red chalk.

PROV: Lady Murray. Presented 1860.

Possibly for a *Conversion of St Paul*.

D 1884 A Fig. 70

A soldier on a galloping horse.

160 × 161. (Top left-hand corner cut off.) Black chalk (the contours of the right leg gone over in ink).

PROV: Lady Murray. Presented 1860.

This and the following eight drawings may be connected with the compositions for the lunettes in the Palazzo Colonna, Rome.

D 1883 B Fig. 71

Two soldiers on horseback in full gallop, another lying on the ground, lightly sketched in.

152 × 164. Red chalk.

PROV: Lady Murray. Presented 1860.

A similar study is at Leipzig (N.J. 7461, p. 113).

D 1884 B Fig. 72

A soldier with shield and sword on a galloping horse.

154 × 181. Red chalk.

PROV: Lady Murray. Presented 1860.

D 1887 B Fig. 73

Two soldiers on horseback in full gallop.

145 × 168. Black chalk, with traces of red chalk.

PROV: Lady Murray. Presented 1860.

D 1902 A Fig. 74

A helmeted soldier with shield and sword on a prancing horse, seen from the rear.

196 × 181 (top left-hand corner cut). Black chalk.

PROV: Lady Murray. Presented 1860.

D 1888 A Fig. 75

Two soldiers fighting beside a fallen horse.

155 × 190 (bottom left-hand corner missing). Black chalk, with traces of red chalk.

PROV: Lady Murray. Presented 1860.

D 1888 B Fig. 76

Three soldiers, one falling backwards from his horse.

142 × 190. Black chalk.

PROV: Lady Murray. Presented 1860.

D 1899 I Fig. 77

A soldier holding the reins of a prancing horse.

93 × 62. Red chalk.

PROV: Lady Murray. Presented 1860.

RSA 352 Figs. 78 and 79

(*recto* and *verso*) Soldier on horseback.

102 × 114. Red chalk. (Top corners torn.)

PROV: David Laing; Royal Scottish Academy. On loan 1966.

Almost identical with a drawing in one of the Leipzig 'Klebebände' (N.J. 7461, p. 20).

D 1875 B Fig. 80

A horseman with attendant figures.

124 × 150. Red chalk.

PROV: Lady Murray. Presented 1860.

D 1899 G Fig. 81

A monk holding up the Cross, and a soldier on horseback swinging a sword.

88 × 82. Red chalk.

PROV: Lady Murray. Presented 1860.

D 1897 B Fig. 82

Rough sketch of a soldier in a quadriga.

104 × 152. (Part of the top right corner cut away.) Red chalk.

PROV: Lady Murray. Presented 1860.

D 1899 A Fig. 83

Head of a horse.

77 × 50. Pen and ink.

PROV: Lady Murray. Presented 1860.

A similar drawing is at Leipzig (N.J. 7450, p. 5).

D 1899 D Fig. 84

Back view of a laden donkey.

55 × 44. Pen and black ink.

PROV: Lady Murray. Presented 1860.

Similar animal studies are at Leipzig (N.J. 7461, p. 112).

Ascribed to FRANCESCO ALLEGRINI

D 1877

Sketch of a left hand.

190 × 135. Red chalk. (Laid down.)

PROV: Lady Murray. Presented 1860.

This sketch at one time formed part of the sequence of drawings now attributed to Francesco Allegrini; it is, however, impossible to confirm that it is in fact by him.

ALESSANDRO ALLORI

Florence 1535–1607 Florence

D 1635 Fig. 85

Anatomical drawing of a figure with raised left leg, seen from the back.

420 × 282. Black chalk. (Laid down.) Faint pencilled inscription: *Michael Angelo*.

PROV: W. Y. Ottley; Alexander Munro, Jnr; David Laing; Royal Scottish Academy. Transferred 1910.

This is apparently one of the group of drawings mentioned in Ottley's letter of 23 February 1813 in the Gallery's archives (see entry under Rosso, D(NG) 601). The present attribution was made in comparison with the similar drawings by Allori in the Uffizi, and those in the Louvre (especially 13 and 14) which have old and convincing attributions to this artist.

Attributed to
MICHELANGELO ANSELMI
Lucca 1491–1554 Parma

D 1766 Fig. 86

Study of a child.

262 × 135. Red chalk on faded blue paper. (Irregularly cut and laid down.)

PROV: Sir Joshua Reynolds; David Laing; Royal Scottish Academy. Transferred 1910.

LIT: *Catalogue: National Gallery of Scotland* (1946), p. 391 (as Parmigianino).

The drawing was formerly ascribed to Parmigianino, and there are in fact certain resemblances to such Parmigianino figures as, for example, the Christ Child in the *Vision of St Jerome* (National Gallery, London), or one of the putti in the Fontanellato frescoes. However, the style differs from that of Parmigianino. It would seem to point rather to Anselmi, another of the more important followers of Correggio (see A. E. Popham, 'I Disegni di Michelangelo Anselmi' in *Parma per l'Arte*, III (1953) and A. E. Popham, *Correggio's Drawings* (1957), pp. 107 ff.), although, as Popham has kindly pointed out, Anselmi generally used a more purplish chalk. The type of putto should be compared with that at the foot of Anselmi's *The Holy Family and St Barbara* in the National Gallery at Parma, whilst the pose is reminiscent of the putti flanking the central panels in the Cappella del Bono in S. Giovanni Evangelista, Parma.

ANTONIO VICENTINO
See Antonio VICENTINO.

CAV. d'ARPINO
See Giuseppe CESARI.

GIOVANNI BAGLIONE
Rome 1571–1644 Rome

D 939 Fig. 87

A putto sitting on the edge of an ornamental fountain, supporting some architecture above.

114 × 143 (left margin torn). Pen, brown ink and wash. Traces of red chalk. Inscribed in an old hand: *Di Simone Cantarini*, but on a strip of paper to which the drawing is attached, at the top: 'Caval^r Gio: Baglioni 47'. On the back illegible notes with regard to 'sensaria' (i.e. ? senseria = brokerage).

PROV: David Laing; Royal Scottish Academy. Transferred 1910.

The inscription at the top should be heeded, rather than that on the drawing itself, as the style is clearly that of Baglione.

D 1889 Fig. 88

Study of three putti, seated on pedestals.

112 × 95. Pen, brown ink and wash, over black chalk. (Laid down.)

PROV: Lady Murray. Presented 1860.

D 1889 A Fig. 89

A putto holding the base of a broken pillar.

112 × 78. Pen, brown ink and wash over black chalk. (Laid down.)

PROV: Lady Murray. Presented 1860.

D 1893 A Fig. 90

A small putto.

78 × 53. Pen, brown ink and wash on blue paper.

PROV: Lady Murray. Presented 1860.

D 1859 Fig. 91

The Madonna and Child with St Francis.

189 × 146. Pen, brown ink and wash over red chalk.

PROV: Lady Murray. Presented 1860.

The attribution is due to Philip Pouncey.

D 1918 Fig. 92

St Francis contemplating the crucifix.

92 × 65. Pen, brown ink and wash over black chalk. (Laid down.)

PROV: Lady Murray. Presented 1860.

D 1894 Fig. 93

Madonna and Child adored by a bishop, a cardinal and a kneeling Franciscan.

178 × 127. Pen, brown ink and wash, with traces of black chalk.

PROV: Lady Murray. Presented 1860.

Very close in composition to the following drawing D 1860 and obviously for the same altarpiece.

D 1860 Fig. 94

Madonna and Child adored by a bishop, a cardinal and a kneeling Franciscan.

185 × 129. Pen, brown ink and wash, over black chalk. (Laid down.)

PROV: Lady Murray. Presented 1860.

Very close in composition to D 1894, and obviously a design for the same altarpiece.

D 4820 B Fig. 95

A horseman surrounded by several figures.

116 × 198. Red chalk and brown wash. Inscribed at the top of an old mount: 'Caval^r· Giovanni Baglioni 90'.

PROV: Richard Cooper; Miss Eyre, Lydney (Glos.). Presented 1959.

BARTOLOMEO BAGNACAVALLO
(Ramenghi)
Bagnacavallo 1484–1542 Bologna

RSA 197 Fig. 96

Diana and Actaeon.

202 × 283. Pen, brown ink and wash, heightened with white, on blue paper. Inscribed on the old mount: 'Bartolomeo Ramenghi da Bagnacavallo'.

PROV: Richard Cosway; J. Richardson, Jnr (L. 2170); David Laing; Royal Scottish Academy. On loan 1966.

It is not certain whether the attribution to Bartolomeo Bagnacavallo himself is correct, or whether the drawing is not perhaps by one of his sons or nephews.

Attributed to
MARIO BALASSI
Florence 1604–1667 Florence

D 3098 Fig. 97

A seated male figure holding a book (St Matthew), separate sketches of the foot in the right margin.

406 × 277. Red chalk. (The main part of the drawing has been cut out and laid down again, and parts have been added to it.)

PROV: W. F. Watson. Bequeathed 1881.

There is a fairly late ascription to 'Andrea del Sarto' on the mount. However, the drawing, although Florentine, is clearly of the late 16th or early 17th century. The style is characteristic of Matteo Rosselli (see drawing of *Seated Male figure*, Uffizi 9722), but even more so of his pupils and immediate followers. The style of D 3098 appears to come closest to drawings (especially those in the Uffizi) with old attributions to Balassi. Uffizi 1167 F may even show the same model as in the present drawing. The broad and soft shading, and the characteristic modelling of the fingers, can also be observed in the figure of a *Nun, with pointing hand* (Uffizi 1182 F), which is obviously by the same artist, but is kept at present with drawings by Lorenzo Lippi.

LAZZARO BALDI
Pistoia c. 1624–1703 Rome

D 1585 Fig. 98

S. Giovanni di Dio succouring the sick.

290 × 210. Black chalk and brown wash, heightened with white. Squared. (Damaged and rubbed.) Inscribed on the old mount: 'P. da Cortona'.

PROV: Thomas Hudson; Sir Joshua Reynolds; Jonathan Richardson, Senr (L. 2183); David Laing; Royal Scottish Academy. Transferred 1910.

LIT: *Itinerari dei Musei e Monumenti d'Italia* (Rome, 1952), p. 10, no. 22; F. Zeri, *La Galleria Spada in Roma* (Florence, 1954), p. 27, no. 37.

Attributed independently to Baldi by Philip Pouncey and J. A. Gere. It is a preliminary study for an altarpiece of which only the *modello*, in the Galleria Spada, Rome, is now known.

D 752 Fig. 99

The Madonna and Child handing the rosary to St Dominic.

137 × 96. Pen, brush and brown wash, heightened with white, over black chalk.

PROV: David Laing; Royal Scottish Academy. Transferred 1910.

A former, untenable, ascription was to P. F. Mola. The style is, however, clearly that of Baldi.

RSA 277 Fig. 100

St Irene removing the arrows from St Sebastian.

234 × 302. Brush and brown wash, heightened with white, over black chalk. (Damaged and laid down.) Inscribed on the old backing: 'Ludovico Caracci'.

PROV: David Laing; Royal Scottish Academy. On loan 1966.

The attribution to Baldi was suggested by Philip Pouncey, and a comparison can be made, for example, with a drawing of the *Annunciation* at Düsseldorf (1018) in which the figure of the Madonna is exceedingly close to the St Irene in the present drawing.

Attributed to
GIOVANNI BALDUCCI
Florence, mid-16th c.–1603 Naples

RSA 139 Fig. 101
Mourners around the crucified Christ.

348 × 266 (arched top). Pen, brown ink, heightened with body colour, on prepared paper. Squared in black chalk. Inscription: 'Veronese' on the old mount.

PROV: David Laing; Royal Scottish Academy. On loan 1966.

The tentative attribution to Balducci, the chief pupil of Naldini, is due to Philip Pouncey.

Attributed to
ANTONIO BALESTRA
Verona 1666–1740 Verona

D 1934 Fig. 102
Music-making angels on clouds.

170 × 159. Pen, brown ink and wash, with splashes of red ink. (Laid down.)

PROV: (? Allan Ramsay); Lady Murray. Bequeathed 1860.

The attribution has been suggested by T. Pignatti and seems convincing when compared, for instance, with the drawing of *Jupiter and Semele* in Verona, Museo di Castelvecchio (13008; Exh. *La pittura del Seicento a Venezia*, 1959, no. 98 (Disegni)).

Ascribed to ANTONIO BALESTRA

D 2911 Fig. 103
Design for a title page.

197 × 129. Pen, brown ink. Inscription:

L'Amore della Virtù c'insegna a veder (?)
L'imagine del sole in uno specchio poiche
non lo potiamo veder ad occhio nudo, e questa imagine
la chiamiamo ritratto
Lascio che Vs. pensi se deve essere Apollo con la cetra,
 o vero il Sole col'arco
et se l'Amore deve star in atto che addita, overo
 con un compasso.

and *vol. 1, p. 71* on the back.

PROV: W. F. Watson. Bequeathed 1881.

The traditional ascription to Balestra seems unconvincing, and the volume for which it was intended has not been traced.

BARTOLOMEO BACCIO BANDINELLI
Florence 1493–1560 Florence

D 1536 Fig. 104
Back view of a man, resting the left hand and right knee on a bench or parapet. Sketch of a left hand holding a staff (?) in the upper right hand corner.

290 × 195 (upper and lower margins torn). Black chalk, slightly heightened with white on prepared grey paper. Inscription on back: *Bandinelli*.

PROV: ?Paul Sandby, according to a note on the mount, but his mark cannot be traced; David Laing; Royal Scottish Academy. Transferred 1910.

Formerly called Bronzino, in spite of the traditional attribution. J. A. Gere pointed to a very similar sheet by Bandinelli in the Uffizi (6954 F), also in black chalk on grey paper, and almost certainly drawn from the same model.

D 710 Figs. 105 and 106
(*recto*) A seated bearded man (Michelangelo?); (*verso*) Two male torsos.

381 × 229. Pen and brown ink. Inscribed on both sides: *Donatello, Sculptor B. 1383. D. 1466.*

PROV: Francis Abbott (L. 970); David Laing; Royal Scottish Academy. Transferred 1910.

The suggestion that this is an original, rather than a studio work, was first made by J. A. Gere. It is possible that this drawing was formerly in the collection of W. Y. Ottley, who owned a number of Bandinelli drawings, some of which he believed were by Donatello (see F. Antal, *Fuseli Studies* (1956), p. 158).

Studio of BANDINELLI

D 1789 Fig. 107
A nude man, seen from the back, turned to the left.

372 × 240. Pen and brown ink. Inscribed: *Cav^{re} Bat^{eo} Baccio Bandinella.*

PROV: Nicholas Lanier; P. H. Lankrink; David Laing; Royal Scottish Academy. Transferred 1910.

This drawing has all the superficial exaggeration of a studio work.

GIOV. FRANCO BARBIERI
See Il GUERCINO.

FEDERICO BAROCCI
Urbino 1526–1612 Urbino

RSA 216 Fig. 108

The Visitation.

463 × 316. Pen, brown ink and wash, over black chalk, heightened with white on blue paper. Squared in pen, black and red chalk. All outlines incised.

PROV: (Collector's mark cut out); Sir Thomas Lawrence; David Laing; Royal Scottish Academy. On loan 1966.

Preliminary study for the altarpiece of 1583–86 in the Chiesa Nuova, Rome (H. Olsen, *Federico Barocci* (1962), Cat. 38, pl. 59). Of all surviving compositional studies this is closest in all essentials to the finished altarpiece, and may have been the final design from which the painting was made.

D 821 Fig. 109

Sketches for a sitting Madonna.

210 × 151. Pen and brown ink, traces of black chalk. (Left side of the paper stained.) Inscribed (left corner): *Barocci*.

PROV: Count Gelozzi or Gelosi (L. 545); Sir Thomas Lawrence; David Laing; Royal Scottish Academy. Transferred 1910.

Studies for the figure of the Madonna in *The Rest on the Flight to Egypt*, known in several versions, of which the principal one is in the Vatican. As the painting is known to have been executed in 1573 for Sr. Simonetto Anastagi of Perugia, this provides a convenient date for this drawing.

D 725 Fig. 110

The Deposition from the Cross.

280 × 209. Pen, brown ink with wash. (A strip of about 110 mm along the left hand margin has been added.) Inscribed on both sides: *Barocci*.

PROV: Sir Joshua Reynolds; (W. Young Ottley, according to his characteristic mount); Sir Thomas Lawrence; David Laing; Royal Scottish Academy. Transferred 1910.

Preliminary study, with variations, for the altarpiece in the Cathedral at Perugia (1566–69).

D 2250 Fig. 111

Head of St Francis.

345 × 268. Coloured chalks on buff paper. (Partly cut and laid down.)

PROV: P. J. Mariette (L. 1852), also his mount; F. Basan, *Catalogue Raisonné des différents objets…de feu M. Mariette*, Paris 1775/6, lot 165; Marquis de Lagoy (L. 1710); Sir Thomas Lawrence; W. F. Watson. Bequeathed 1881.

LIT: *Catalogue: National Gallery of Scotland* (1946), p. 385; *Fifty Master Drawings in the National Gallery of Scotland* (Edinburgh, 1961), no. 19; Harald Olsen, *Federico Barocci* (1962), p. 160.

EXH: Royal Academy, *Old Master Drawings*, 1953 (118); Colnaghi, 1966 (20); *Le Cabinet…P. J. Mariette*, Paris, 1967 (11).

This is the cartoon fragment for the head of St Francis in the altarpiece *The Absolution of St Francis* in S. Francesco, Urbino (c. 1574–76). The careful restoration of the paper may have been due to Mariette.

D 1589 Fig. 112

Three-quarter back view of a male head. Superimposed outline study of male figure seen from the back.

266 × 232. Coloured chalks on blue paper. Squared in red chalk. Outlines incised.

PROV: Jonathan Richardson, Jnr (L. 2170); Sir Joshua Reynolds; David Laing; Royal Scottish Academy. Transferred 1910.

LIT: Harald Olsen, *Federico Barocci* (1962), p. 174.

The head is for the figure on the extreme left (middle distance) in the *Martyrdom of S. Vitale* (Brera, Milan), clutching the arm of his companion; the outline drawing is for the man throwing a stone in the same painting.

Studio of FEDERICO BAROCCI

RSA 260 Fig. 113

Study of a right hand.

139 × 250. Black chalk, heightened with white on brown paper. (Much rubbed and laid down.)

PROV: David Laing; Royal Scottish Academy. On loan 1966.

Although probably not by Barocci himself, the drawing may have originated in his studio. The pose of the hand is similar to that of St Cecilia in *St Cecilia with Mary Magdalen, SS. John Evangelist, Paul and Catherine* in the Duomo at Urbino (Olsen, *Federico Barocci*, 1962, pl. 1) and the seated woman at left bottom in the *Martyrdom of S. Vitale*, Brera, (Olsen, pl. 47).

Follower of FEDERICO BAROCCI

D 779 Fig. 114

St Christopher.

280 × 198. Pen, brown ink, heightened with white, on toned paper. (Laid down.) Pencilled inscription in a modern hand on the back: ?*Domenichino*.

PROV: David Laing; Royal Scottish Academy. Transferred 1910.

The style of the drawing appears to be derived from Barocci, and may be by an artist who worked around Urbino or in the Marches. A. E. Popham, in a note, has put forward the suggestion that the artist of this drawing might possibly be the Sienese Francesco Vanni, who studied with Barocci and at times imitated his style closely.

D 1651 Fig. 115

Head of a bearded man.

235 × 184. Coloured chalks on blue paper. Inscribed *3* at top right corner, and *Baroccio* on back.

PROV: David Laing; Royal Scottish Academy. Transferred 1910.

Copy after FEDERICO BAROCCI

D 4890/48 Fig. 116

The Madonna holding the Christ Child in one hand, and a book in the other.

201 × 153. Red chalk. Inscribed: *Barocci*.

PROV: Marchese del Carpio; Paul and Edwardo Bosch, Madrid; H. M. Calmann. Purchased 1964.

The two figures correspond closely with the central group in Barocci's *Madonna di S. Simone* (Galleria Nazionale, Urbino). As the pose of the Christ Child differs from the painted version, the present drawing may be a copy from a preliminary study rather than from the painting itself.

PIETRO SANTO BARTOLI
Perugia c. 1635–1700 Rome

D 3202 Fig. 117

Amoretti at play with Bacchic cult emblems.

80 × 414. Pen, brown ink and wash. Inscribed in pencil: *Bartoli*.

PROV: W. F. Watson. Bequeathed 1881.

After a sarcophagus relief in the Palazzo Mattei, Rome (Reinach, III, 295, 3). The traditional attribution to Bartoli seems perfectly convincing, when comparison is made with his numerous engravings.

D 3203 Fig. 118

Roman marriage ceremony.

130 × 400. Pen, brown ink and wash. Inscribed: *Bartoli*.

PROV: W. F. Watson. Bequeathed 1881.

After a Roman sarcophagus relief in S. Lorenzo fuori le Mura (Reinach, III, 320, 2–4).

FRA BARTOLOMEO
(Baccio della Porta)
Florence 1472–1517 Florence

D 681 Figs. 119 and 120

(*recto*) Two studies of a Madonna and Child; (*verso*) Part of a head of a youth.

176 × 172. Silverpoint, heightened with white on prepared paper. (Some tears repaired, and all four corners damaged.) Inscription on verso: *Leonardo da Vinci. E. nº...*

PROV: 'P. Crozat'? (L. 474); David Laing; Royal Scottish Academy. Transferred 1910.

LIT: Berenson, 2510[1] (as Sogliani); *Catalogue: National Gallery of Scotland* (1946), p. 389 (as Italian School 15th century, possibly Fra Bartolomeo).

The drawing, whose verso has only recently been laid bare, entered the collection under the designation 'School of S. Marco' (i.e. School of Fra Bartolomeo). Other suggestions made were 'more like Granacci' (Sir Kenneth Clark, note on the mount), and Sogliani, under whose name it was catalogued by Berenson. He compared it (1) with a drawing in the Uffizi (1198E) which had been attributed to Credi, and (2) with one in the Albertina (25295, Albertina III, 157) with an attribution to Fra Bartolomeo. For both these drawings Berenson also suggested the name of Sogliani. Furthermore, he put forward the view that D 681 was a sketch for Sogliani's *Madonna* in the Cathedral at Pisa (repr. Venturi IX/1, fig. 291). This relationship is, however, of the slightest: the figure of the Madonna in the drawing is standing, whilst she is seated in the altarpiece and the position of the Child is completely different, and only a vague *contrapposto* pose is similar to both. The Uffizi drawing (repr. *Burlington Magazine*, LV (July 1929), p. 5[B], together with a related drawing in the Albertina, convincingly attributed by E. Sandberg-Vavalà to Fra Bartolomeo (*Burlington Magazine, op. cit.*), and also given to Sogliani by Berenson, have more resemblance in general pose with the seated Madonna and Child on the recto of D 681, although the Edinburgh drawing shows the figure in three-quarter view, whilst on the other two she is depicted in severe profile. Also stylistically D 681 seems similar to these two examples.

If one wants to compare the recto of D 681 with a painting at all, a much more convincing example would be the tondo of *The Holy Family* in the Borghese Gallery (439), which used to be attributed to Lorenzo di Credi, but which Longhi has convincingly assigned to Fra Bartolomeo; yet a rather Credi-like air in the pose and expression of the

figures and in the Leonardesque background remains. The particular features whose absence made Longhi attribute the Borghese painting to Fra Bartolomeo rather than to Credi—the slightness of the forms, the lighter shadows—show up in the Edinburgh drawing very strikingly. Thus the traditional attribution seemed fully justified.

Mesmerized by the head on the verso, with its strong Credi-like features, the compiler had at one time felt inclined to attribute the whole sheet to Lorenzo di Credi. However, there can be little doubt that both sides are by the same hand, and it was due to the persuasive arguments of Everett Fahy Jnr that it has now been restored to its original attribution.

Copy after FRA BARTOLOMEO

D 1642

St Peter.

357 × 192. Pen, brown ink and wash, slight heightening with white, on blue paper. (Laid down.) Inscribed on mount: 'J. Romano'.

PROV: David Laing; Royal Scottish Academy. Transferred 1910.

Copy of the painting by Fra Bartolomeo in the Vatican Pinacoteca.

Attributed to
JACOPO BASSANO
(Da Ponte)
Bassano c. 1512–1592 Bassano

D 2990 Figs. 121 and 122

(*recto*) Half-length portrait of a seated man with folded hands;
(*verso*) Study of a right arm and hand.

305 × 225 (irregularly torn margins). Black chalk (traces of white heightening) on faded blue paper. (Damaged.)

PROV: Sir Joshua Reynolds; W. F. Watson. Bequeathed 1881.

Although previously tentatively ascribed to Tintoretto, the style of the drawing, as far as one can see from its rubbed and faded state, accords more naturally with Jacopo Bassano. A similar drawing, in the same medium, is at Munich (2963).

LEANDRO BASSANO
(Da Ponte)
Bassano 1557–1622 Venice

D 2232 Fig. 123

Adoration of the Shepherds.

235 × 327 (vertical strips of 25 and 7 mm have been added at the left and right hand margins respectively). Black and red chalk on faded blue paper.

PROV: Jonathan Richardson, Senr (L. 2184); E. Bouverie (L. 325); W. F. Watson. Bequeathed 1881.

LIT: D. v. Hadeln, *Venezianische Zeichnungen der Spätrenaissance*, p. 16 (as Jacopo Bassano). W. Arslan, *I Bassano* (1931), pl. 36 (as Jacopo Bassano); Tietze, no. 133, pl. CXLIV (as Jacopo Bassano). *Catalogue: National Gallery of Scotland* (1946), p. 385 (as Jacopo Bassano); M. Muraro, *Venetian Drawings from the Collection Janos Scholz* (1957), no. 45, p. 36; W. R. Rearick, 'Jacopo Bassano: 1568–9' in *Burlington Magazine* (December 1962), p. 526, note 8.

This sketch corresponds with the painting by Jacopo Bassano, dated 1568, in the Museo Civico, Bassano and formerly in the church of S. Giuseppe, Bassano (*Mostra di Jacopo Bassano*, Venice, 1957, no. 55). Muraro was the first to suggest an attribution to Leandro, connecting it with a group of other drawings, including a *Noli me tangere* (Uffizi). Rearick, without mentioning Muraro, also puts forward an attribution to Leandro, suggesting that it is an adaptation of his father's composition (hence the added strips) which he intended to repeat, probably in a horizontal format. A precedent for this is Leandro's drawing in the British Museum (1895–9–15–858) which is a copy of Jacopo's *Adoration* (Bode Museum, East Berlin) and which was executed in several versions (Padua, Siena and National Gallery of Scotland, no. 1511).

POMPEO BATONI
Lucca 1708–1787 Rome

D 1804 Fig. 124

Pleading woman with attendants before an emperor.

206 × 309 (whole sheet); actual composition: 165 × 247. Red chalk. Squared.

PROV: David Laing; Royal Scottish Academy. Transferred 1910.

Identified by Anthony Clark as a very early drawing by Pompeo Batoni.

D 1940 Fig. 125

The Visitation.

259 × 348 (whole sheet); actual composition: 183 × 262. Red chalk. Squared. Inscribed very faintly at the top in pencil: *Pompero*.

PROV: (? Allan Ramsay); Lady Murray. Presented 1860.

LIT: Frederico Zeri, *La Galleria Pallavicini* (Florence, 1959), no. 20.

EXH: *Allan Ramsay, his Masters and Rivals*, Edinburgh, 1963 (21).

Identified by Anthony Clark as by Pompeo Batoni for the early painting in the Pallavicini Collection, Rome (F. Zeri, *op. cit.*). Zeri dates the painting 'not much later than 1740'. As, however, the drawing almost certainly belonged to Allan Ramsay, who no doubt obtained it direct from Batoni's studio, and as Ramsay left Rome first for Naples in 1737 and then for home in the spring of 1738, the drawing, and therefore presumably also the painting, may be dated a year or two earlier than Zeri suggested.

The following three drawings were probably also acquired by Ramsay before he left Italy in 1738, which would provide a general date for these drawings and the compositions related to them. This applies also to Ramsay's copies after Batoni: D 1941 and D 2144 (*National Gallery of Scotland: Catalogue of Scottish Drawings* (1960), p. 169).

D 2145 Fig. 126

Sheet of studies of a child's head, left arm and right hand.

249 × 197. Red chalk, heightened with white on faded blue paper.

PROV: (? Allan Ramsay); Lady Murray. Presented 1860.

LIT: *National Gallery of Scotland: Catalogue of Scottish Drawings*, p. 168 (as *Ramsay*).

Formerly thought to be an Allan Ramsay copy after Carlo Maratta, the drawing was identified by Anthony Clark as being by Pompeo Batoni for an unknown early picture.

D 2146 Fig. 127

Sheet of studies of a child's legs, drapery and a profile head of Christ.

292 × 220. Red chalk, heightened with white on buff prepared paper.

PROV: (? Allan Ramsay); Lady Murray. Presented 1860.

LIT: *National Gallery of Scotland: Catalogue of Scottish Drawings*, p. 165 (as *Ramsay*).

Formerly ascribed to Allan Ramsay, but identified as by Pompeo Batoni by Anthony Clark. Probably studies for an unknown early painting; the legs may be for the same figure of the Christ Child for which a study of the head is on D 2145.

D 2148 Fig. 128

Sheet of studies with a woman's upturned head, two poses of a nude boy, and his legs.

307 × 214. Red chalk, heightened with white on buff prepared paper.

PROV: (? Allan Ramsay); Lady Murray. Presented 1860.

LIT: *National Gallery of Scotland: Catalogue of Scottish Drawings*, p. 164 (as *Ramsay*).

EXH: *Allan Ramsay, his Masters and Rivals*, Edinburgh, 1963 (20).

Formerly ascribed to Allan Ramsay, but identified as by Pompeo Batoni by Anthony Clark. The woman's head is a study for one of the *Virtues* in the Palazzo Colonna, Rome, and the other drawings are nude studies of an angel for the altarpiece of *The Holy Family* (Brera) formerly in SS. Cosma e Damiano, Milan.

D 781 Fig. 129

Study of an angel playing a pipe (with a further study of the two feet below). Another angel, lightly sketched in at the right back, playing a gamba.

306 × 214. Red chalk on prepared paper. (Laid down.) Squared. Inscribed in lower right corner: *Bʳ* (?) *Pompeo Battoni*.

PROV: David Laing; Royal Scottish Academy. Transferred 1910.

Anthony Clark has pointed out that this drawing, together with a companion sheet (owned by him) are studies for the *modello* of *The Madonna and Child in Glory* painted *c.* 1745 for the Merenda family of Forlì, and now in the Toledo Museum of Art, Toledo, Ohio (Acc. 63.5, reproduced in *Toledo Museum Notes*, Winter 1964). The altarpiece, according to Clark, was probably one of two commissioned for the church at Chiari, near Brescia, but it seems doubtful whether it was in fact ever executed.

D 1701 Figs. 130 and 131

(*recto*) Sheet of studies of a female head, a hand and drapery;
(*verso*) Study of a child's arm.

268 × 200. Red chalk heightened with white, on faded blue paper.

PROV: David Laing; Royal Scottish Academy. Transferred 1910.

According to Anthony Clark, the recto shows studies for the Madonna, the arm of Joseph (draped) and the hand of the High Priest in the *Presentation of Christ* over the High Altar in S. Maria della Pace, Brescia, which can be dated 1735/7. The verso is apparently for the arm of the Child in the *Madonna and Child with St Philip Neri* in the Collection of the Marchese Mario Incisa della Rochetta. This is earlier than the Brescia picture by three or four years.

D 1345 Fig. 132

A seated female figure holding an oil-lamp ('Truth'?). (On the verso: a slight sketch of a reclining female figure holding a pair of scales?)

154 × 186. Red chalk. Squared.

PROV: David Laing; Royal Scottish Academy. Transferred 1910.

According to Anthony Clark, a compositional study for one of the four canvas-inserts of *Virtues* in the Sala dell'Apoteosi di Martino V, Palazzo Colonna, Rome.

Attributed to
POMPEO BATONI

D 1615 Figs. 133 and 134

(*recto*) Seated female figure with head turned left;
(*verso*) Woman holding a basket, flying eagle above.

187 × 251. Recto: Red chalk. Verso: Pen and black ink over red chalk.

PROV: David Laing; Royal Scottish Academy. Transferred 1910.

Ascribed according to an inscription on the mount to Carlo Maratta, but the figures, in subject and pose, seem to relate to *The Virtues* by Batoni, part of the decorations in the Palazzo Colonna, Rome. Anthony Clark comments that both sides of D 1615 are in a Marattesque style, very unusual for Batoni. The watermark (a six-pointed star in a circle, surmounted by a cross: Briquet 6089), found on a Lucchese paper, is the same as in the previous drawing.

D 2122 Fig. 135

An upturned left hand grasping a flat object.

119 × 144. Red chalk on blue paper, heightened with white.

PROV: (?Allan Ramsay); Lady Murray. Presented 1860.

LIT: *National Gallery of Scotland: Catalogue of Scottish Drawings*, p. 168 (as *Ramsay*).

The technique and the paper are the same as D 2145 (also formerly ascribed to Ramsay), as well as D 1701. The drawing has not been identified with any of Batoni's known compositions.

DOMENICO BECCAFUMI
Siena 1486–1551 Siena

D 4812 Fig. 136

Portrait head of a lady seen in profile.

231 × 174. Red chalk. Inscribed: *Mecar*[*ino*], i.e. the artist's nickname, on the right margin.

PROV: Lord Burlington; Sir Peter Lely; Richard Cavendish; Christie sale, 15 July 1957 (35); H. M. Calmann. Purchased 1959.

EXH: Colnaghi, 1966 (17).

The extreme right hand figure in the *Descent into Limbo* (Siena, Pinacoteca) is most probably the same model. On the verso is a sketch of coats of arms.

Attributed to
DOMENICO BECCAFUMI

D 3026 Fig. 137

Head of a putto.

129 × 104. Black and coloured chalks. Inscribed on the mount: 'Barocci'.

PROV: J. Richardson, Senr (L. 2183); W. F. Watson. Bequeathed 1881.

If not by Beccafumi himself, as Philip Pouncey suggested, the drawing probably originated in his studio, and corresponds to the type of putti which occur for instance among the ceiling decorations in the Sala del Concistoro, in the Palazzo della Repubblica in Siena.

Attributed to
GIROLAMO MAZZOLA BEDOLI
Parma c. 1500–1569 Parma

D 4890/12 Fig. 138

Seated female figure.

201 × 150. Red chalk. (Laid down.)

PROV: Marchese del Carpio; Paul and Edwardo Bosch, Madrid; H. M. Calmann. Purchased 1964.

The attribution to Bedoli was first suggested by Philip Pouncey, and supported as very likely by A. E. Popham, who saw a photograph of the drawing. Especially the handling of the drapery, and the modelling of the arm and hand, are entirely characteristic of Bedoli (see the same features, although in ink and wash, in the drawing of the *Madonna and Child with St John* at the Royal Institution of Cornwall, Truro, repr. A. E. Popham, 'The Drawings of Girolamo Bedoli', *Master Drawings*, II, 3 (1964), pl. 13).

D 4890/45 Fig. 139

Christ walking on clouds, surrounded by angels.

214 × 132. Pen, brown ink and wash, heightened with white, on pink prepared paper. (Cut out and laid down.)

PROV: Marchese del Carpio; Paul and Edwardo Bosch, Madrid; H. M. Calmann. Purchased 1964.

The present attribution, of the previously anonymous drawing, is due to Philip Pouncey, with whom A. E. Popham concurs after seeing a photograph. No group corresponding exactly has been traced in Bedoli's work, although the subject matter is not unrelated to his fresco in the apse in the Cappella Maggiore in the Duomo at Parma, depicting *Christ Triumphant*. The pose of some of the attendant angels there is indeed strikingly close to that of Christ in the drawing.

BEINASCHI
See Giov. Batt. BENASCHI.

STEFANO DELLA BELLA
See Stefano DELLA BELLA.

FILIPPO BELLINI
Urbino c. 1550/55–1604 Macerata

D 707 Figs. 140 and 141

(*recto*) St Roch preaching;
(*verso*) The main figure traced through from the front in ink, with some of the attendant figures outlined in black chalk.

334×239. Pen, brown ink and wash over black chalk. Squared in black chalk. Inscribed, and partly erased: *Fran. Barotius*.

PROV: David Laing; Royal Scottish Academy. Transferred 1910.

A more elaborate drawing, bearing an old inscription of the artist's name and showing important variations, is at Munich (2603). While the poses of the saint and those of the attendant figures are essentially the same, the Munich drawing shows a more detailed landscape background and is furthermore designed within an elaborately conceived ornamental framework, including the Borghese arms. It is probable that the whole design was intended for a painted banner (*gonfalone*) for the Confraternity of St Roch. If the evidence to the contrary was not there, the facial types might have led one to believe that the drawing was by a Northern Mannerist.

D 1595 Fig. 142
The Circumcision.

411×268. Pen, brown ink and wash over black chalk. Inscription in lower right corner: ?*Zucc°*.

PROV: David Laing; Royal Scottish Academy. Transferred 1910.

The drawing was previously classified as 'Bolognese'. Philip Pouncey suggested an artist like Filippo Bellini, an attribution which was confirmed when the drawing turned out to be a study, with considerable and significant differences, for Bellini's painting in the Pinacoteca at Loreto (Venturi IX/7, fig. 555) which was executed for the Santa Casa at Loreto. A further drawing of this composition, again varying considerably in details, is at Munich (1951: 106ᶻ, as Taddeo Zuccaro).

RSA 121 Fig. 143
Madonna and Child adored by SS. Michael and Francis.

427×281. Pen, ink and wash, heightened with white on prepared paper. Inscribed on the back in contemporary hand: *philipo belino da urbino*.

PROV: (? W. Y. Ottley, according to the mount); Sir Thomas Lawrence; J. MacGowan (L. 1496); David Laing; Royal Scottish Academy. On loan 1966.

VINCENZIO BELLONI
fl. 18th century

RSA 116 Fig. 144
A farmhouse. (On the verso: a design for an ornament.)

95×133 (whole sheet). Pen and ink on buff paper. Signed: *Vincenzio Belloni fecit*.

PROV: David Laing; Royal Scottish Academy. On loan 1966.

Nothing seems to be known about this artist.

GIOVANNI BATTISTA BENASCHI (or BEINASCHI)
Fossano (Turin) 1636–1688 Naples

D 1791 Fig. 145
Studies of a male figure.

503×375. Black chalk, heightened with white, on blue paper.

PROV: Bindon Blood; David Laing; Royal Scottish Academy. Transferred 1910.

LIT: *Catalogue: National Gallery of Scotland* (1946), p. 390 (as Lanfranco); *Fifty Master Drawings in the National Gallery of Scotland* (1961), no. 25 (as Lanfranco); J. Bean and W. Vitzthum 'Disegni del Lanfranco e del Benaschi' in *Bolletino d'Arte* (1961), I and II, pp. 106ff., fig. 25.

EXH: *17th Century Art in Europe*, Royal Academy, 1938 (428, as Lanfranco); *Neapolitan Baroque and Rococo Painting*, Bowes Museum, Barnard Castle, 1962 (29).

Formerly ascribed to Lanfranco, this drawing has recently been recognized by several students as being from the hand of Lanfranco's imitator, Benaschi. The top figure corresponds closely to one in the vaulting of a chapel in S. Carlo al Corso, Rome, depicting *La Forza* (repr. Bean & Vitzthum, *op. cit.* fig. 26). The lower figure is almost exactly like the *St John the Baptist* in a composition study for an *Assumption of the Virgin* at Düsseldorf (10836).

RSA 146 Fig. 146

A seated evangelist (St John ?) with additional study of his left arm.

467 × 388. Black chalk heightened with white on blue paper. Inscribed: *Lanfranco*.

PROV: Bindon Blood (L. 3011); David Laing; Royal Scottish Academy. On loan 1966.

A comparison with D 1791 confirms the attribution to Benaschi.

FRANCESCO BERNARDI

(fl. Verona, first half of 17th century)

D 3038 Fig. 147

Christ on the Mount of Olives.

230 × 380. Pen, brown ink over black chalk. Inscribed on the back in pencil: *Christ with his disciples in the garden of Gethsemane / Original pen sketch by Francesco Bernardi / Born at Verona / From the collection of Mr. Hone.*

PROV: N. Hone; W. F. Watson. Bequeathed 1881.

The old attribution may be correct. The drawing has all the appearance of a Veronese work of about 1630. In the Cappella del Rosario in S. Anastasia, Verona, is, on the left, a painting by Francesco Bernardi of the same subject as D 3038. Although the composition of the painting (as far as one can see from the completely darkened canvas) varies considerably (the figure of Christ is in reverse, with hands across the breast), it is conceivable that the drawing is a preliminary study for this painting. The facial types are also somewhat reminiscent of Marcantonio Bassetti, who worked in Verona and died there in 1630.

GIAN LORENZO BERNINI

Naples 1598–1680 Rome

Studio of GIAN LORENZO BERNINI

D 3208 Fig. 148

Side view of the equestrian statue of Louis XIV.

490 × 373. Pen, brown ink and wash, heightened with white, over black chalk. Signs of deep tracing in parts along the outlines. (Laid down, very damaged.) With scale of measurement in *Palmi Romani* and *Piedi di Francia* at the top.

PROV: W. F. Watson. Bequeathed 1881.

LIT: R. Wittkower, *Bernini* (revised ed.) (London, 1966), p. 255, fig. 112.

Professor Wittkower suggested that this and the following drawing probably originated in Bernini's studio, and were executed on the basis of Bernini's original study, now in the Museum at Bassano (Wittkower, *Bernini*, London, 1966, fig. 111), or one similar to it. The two Edinburgh drawings may have been intended for despatch to Paris, in order to give an idea of the character of the prospective monument—hence perhaps also the two 'scales' at the top of D 3208. However, Wittkower thinks it doubtful whether this despatch could have happened during Bernini's life-time, since—judging from the trend of the correspondence—Bernini never yielded to pressure from Paris. On the other hand, such drawings may well have been sent after Bernini's death.

The importance, especially of D 3208, lies in the rendering of the king's head and face as Bernini had conceived them, so that one can now determine Girardon's alterations with greater accuracy. (See also R. Wittkower in *De Artibus opuscula XL: Essays in Honor of Erwin Panofsky* (New York, 1961).)

D 3207 Fig. 149

Back view of the equestrian statue of Louis XIV.

488 × 375. Pen, brown ink and wash, heightened with white. (Laid down and very damaged.)

PROV: See previous entry.

LIT: See previous entry.

See note to previous drawing.

GIOVANNI BATTISTA BERTANI

Mantua 1516–1576 Mantua

D 1634 Fig. 150

The baptism of Constantine in the Lateran Baptistry.

452 × 276. Pen, brown ink and wash. (Laid down.)

PROV: David Laing; Royal Scottish Academy. Transferred 1910.

LIT: BM Raphael, p. 85.

The drawing entered the collection under the name of G. F. Penni. This was later amended to 'School of Giulio

Romano'. Philip Pouncey recognized the connection with the altarpiece in the church of S. Barbara in Mantua, which is considered to have been painted by Lorenzo Costa the Younger from a design by Bertani, because of its similarity to *The Martyrdom of St Adrian*, in the opposite chapel, which is fully inscribed with the names of Costa (as the painter) and Bertani (as the designer). As the drawing shows some significant alterations from the finished painting it is probably Bertani's original, although not of very high quality. A squared drawing by Bertani depicting the lower group of figures is in the Louvre (10544).

Ascribed to GIOVANNI BATTISTA BERTANI

D 1566 Fig. 151

Aglauros preventing Mercury from approaching Herse.

305 × 204. Pen and brown ink. (Laid down.) Inscribed: *Bertano.*

PROV: Sir Thomas Lawrence; David Laing; Royal Scottish Academy. Transferred 1910.

The subject, identified by Jennifer Montagu, is taken from Ovid's *Metamorphoses* (II, 724–830), and shows Aglauros trying to stop Mercury who is seen running towards Herse, who is seated with a third sister. In the background Minerva, holding the spear mentioned by Ovid, confronts 'Envy' who is eating snake flesh. It appears to be unusual for this scene to be set in the open air.

The old attribution to Bertani is probably incorrect, judging by the only really authenticated drawing by him, the sheet of studies with *Hercules and the Hydra*, formerly in the Michael Jaffé collection (Sotheby sale, 11 November 1965, lot 52, repr.), and the drawings tentatively attributed to him in the British Museum (BM Raphael, 151 and 152) and in fact D 1634 above. However, there is a faint Mantuan air about the drawing, and in the facial types remote echoes of Giulio Romano (whose pupil Bertani was). The drawing seems certainly North Italian, John Gere thinks probably Cremonese, while Philip Pouncey places it between Giulio Campi and Bertoia, with influences of Primaticcio.

JACOPO BERTOIA
(Zanguidi)
Parma 1544–1574 Parma

D 674 Figs. 152 and 153

(*recto*) Studies of two female nudes, seen from the back;
(*verso*) Studies of three female nudes, in *contrapposto*, seen from the front.

268 × 197. Red chalk. Inscribed on upper margin of recto: *GJacomo Bertoi parmesan scolaro del Parmigianino mori nel 1558.*

PROV: Sir Thomas Lawrence? (according to inscription on old mount, but lacking his mark); David Laing: Royal Scottish Academy. Transferred 1910.

LIT: *Catalogue: National Gallery of Scotland* (1946), p. 386; A. E. Popham, *Drawings of Parmigianino* (1953), p. 18, n. 5; *Fifty Master Drawings in the National Gallery of Scotland* (1961), no. 6; A. G. Quintavalle, *Il Bertoja* (1963), pp. 38, 47, 52, figs. 66 and 67; A. E. Popham, review of A. G. Quintavalle's book in *Master Drawings*, II, no. 2 (1964), p. 172, pl. 38; A. E. Popham, *Italian Drawings in the British Museum: School of Parma, XVI Century* (1967), p. 113.

EXH: Recto, Colnaghi, 1966 (18, pl. 6).

As A. E. Popham has shown, in his review of Mrs Quintavalle's book (*op. cit.*), the larger of the two nudes on the recto must be a study for the figure of Minerva in the painting of *The Judgement of Paris* at Tours (illustr. as fig. 2 on p. 171 in A. E. Popham's *Master Drawings* article). Mme Sylvie Béguin had previously tentatively attributed this painting to Mazzola Bedoli (*Aurea Parma*, XL (1956), facing p. 5), but Popham convincingly identified it as the painting described in the inventory of the Palazzo del Giardino at Parma, compiled around 1680.

D 4892 Fig. 154

The judgement of Moses.

216 × 355. Pen, brown ink and wash, heightened with white on blue paper.

PROV: Sir Thomas Lawrence; The Rt Hon. The Earl of Crawford and Balcarres. Presented 1964.

This drawing corresponds exactly with the fresco in the Sala dei Giudizi at Caprarola. Another, more extravagant and freer drawing of this subject, at Turin (A. Bertini, *I Disegni Italiani della Biblioteca Reale di Torino* (1958), no. 57), records an earlier stage of the composition.

BIAGIO BETTI
Cutigliano c. 1545–1615 Rome

D 4890/46 A

A reclining figure.

52 × 100. Black chalk. Inscriptions in ink on both sides, as well as: *de Padre Biagio.*

PROV: Marchese del Carpio; Paul and Edwardo Bosch, Madrid; H. M. Calmann. Purchased 1964.

The inscription is presumably intended to refer to Biagio Betti, a pupil of Daniele da Volterra, but it is impossible to confirm the attribution from so tiny a sketch.

GIOVANNI FRANCESCO BEZZI
(Nosadella)
Bologna 1500–1571 Bologna

D 1530 Fig. 155

A kneeling sibyl, touching a book held up by a kneeling figure (putto?).

237 × 175. Pen, black ink with grey wash. Squared in black chalk. Inscribed: *Nosadella*, in lower margin.

PROV: (? Paul Sandby); David Laing; Royal Scottish Academy. Transferred 1910.

The old attribution is entirely convincing. For comparison see the illustrations to the article by Hermann Voss in *Mitteilungen des Kunsthistorischen Institutes in Florenz* (III/8, 1932, pp. 449 ff.).

RSA 186 Fig. 156

Girl with jug and two standing putti.

109 × 101. Pen and brown ink. (Cut, repaired and laid down.) Inscribed: *Nosadella*.

PROV: (Collector's mark cut out); David Laing; Royal Scottish Academy. On loan 1966.

VITTORIO MARIA BIGARI
Bologna 1692–1776 Bologna

D 731 Fig. 157

The Assumption of the Virgin.

267 × 417. Pen, brown ink and wash over black chalk. Inscribed: *Vittorio Maria Bigari Fect.*

PROV: Robert Udny (L. 2248); Sir Thomas Lawrence; David Laing; Royal Scottish Academy. Transferred 1910.

As stated in pencil on the mount, this drawing is after Carlo Cignani's cupola in the Duomo at Forlì. There are, however, slight variations, as for instance the head of the putto on the left, partly covered by the Virgin's cloak, and in the group around the organ at the left top of the composition. It is therefore possible that this is a copy from a preparatory drawing rather than from the finished ceiling. It is interesting to note that Bigari's two ceiling frescoes of the *Assumption*, in S. Petronio (second chapel left) and in the choir of the Sanctuary of the Madonna di San Luca, Bologna, repeat in a general way the same composition.

D 763 Fig. 158

An angel (Archangel Michael?) in flight, surrounded by putti on clouds.

267 × 209. Pen, black ink with grey wash over black chalk. Contemporary inscription on the back: *Vitorio bigari f^t·*, repeated by a later hand on the front.

PROV: David Laing; Royal Scottish Academy. Transferred 1910.

This drawing has similarities of style with one by Bigari in the British Museum, *A Witches' Sabbath* (1946-7-13-93), formerly in the Fenwick Collection (A. E. Popham, *The Philip Fenwick Collection of Drawings* (1935), p. 127).

D 4888 Fig. 159

The Creation of Adam.

213 × 171. Pen, black ink and grey wash over black chalk. Inscribed on back: *Bigheri*.

PROV: Mrs A. G. Macqueen Ferguson. Presented 1963.

Attributed to
GIOVANNI BILIVERTI
Maastricht 1576–1644 Florence

D 2955 Figs. 160 and 161

(*recto*) Kneeling draped woman with attendant figures;
(*verso*) Balaam and the ass.

131 × 192. Pen, black ink over red chalk, with touches of black chalk. (Verso: red chalk.)

PROV: W. F. Watson. Bequeathed 1881.

The rather convincing attribution was first put forward by Philip Pouncey.

Copy after GIOVANNI BILIVERTI

D 1639

The toilet of Venus.

309 × 215. Pen and brown ink.

PROV: David Laing; Royal Scottish Academy. Transferred 1910.

A coarse copy of the painting at Dresden (386).

BARTOLOMEO BISCAINO
Genoa 1632–1657 Genoa

D 1621 Fig. 162

The Holy Family with St John.

125 × 223 (arched top). Red chalk.

PROV: Robert Udney; Sir Thomas Lawrence; David Laing; Royal Scottish Academy. Transferred 1910.

A study for the etching (B. XXI, p. 195, 26).

D 1620 Fig. 163

The Presentation in the Temple.

180 × 183. Red chalk, outlines incised. Inscribed in pencil: *Biscaino.*
PROV: Sir Thomas Lawrence; David Laing; Royal Scottish Academy. Transferred 1910.

The traditional attribution has been accepted, although the drawing might possibly be of a slightly earlier date.

<div align="center">Attributed to
BARTOLOMEO BISCAINO</div>

D 2890 Fig. 164

The finding of Moses.

149 × 176. Pen and black ink. Squared in chalk. (Laid down.) Inscription on the back: *Parmigianino.*
PROV: W. F. Watson. Bequeathed 1881.

The ascription to Parmigianino is certainly incorrect, though his influence can be discerned in this drawing. Another suggested ascription to Lelio Orsi has also little to commend it. The compiler feels that the drawing is not Emilian, but Genoese, and very close to Biscaino, if not in fact by his own hand.

GIUSEPPE BERNARDINO BISON
<div align="center">*Palmanora 1762–1844 Milan*</div>

D 875 Fig. 165

Classical landscape with animals and two herdsmen.

309 × 304. Pen, black ink with grey and greenish-blue washes over black chalk.
PROV: David Laing; Royal Scottish Academy. Transferred 1910.

Formerly ascribed to Zuccarelli. The present convincing attribution is due to M. R. Rearick. The freer style of drawing—particularly that of the figures—and the application of the washes point unmistakably to Bison.

D 1245 Figs. 166 and 167

(*recto*) Peasant on a donkey, followed by a *contadina* carrying two small children, passing a peasant resting on a hillside, opposite a town on a hill;
(*verso*) St Jerome.

278 × 211 (the size of the actual design on the reverse is 231 × 171). Pen, black ink and grey wash over black chalk.
PROV: David Laing; Royal Scottish Academy. Transferred 1910.

This drawing had been given ascriptions as various as 'School of Rembrandt' and 'Castiglione'. It has, however, all the characteristics of Bison's style. For comparison the drawing at Vienna (Albertina 1, 460) might be cited, and for style, composition and even the types, the drawing at Leningrad (152). The figure of St Jerome on the reverse is almost identical with that on a drawing in the Castello Sforzesco, Milan (A. Rizzi, *Cento Disegni del Bison* (1962–63), no. 14).

<div align="center">Attributed to
GIUSEPPE BERNARDINO BISON</div>

D 860 Fig. 168

Landscape with figures by a covered bridge.

195 × 262. Pen, brown ink and brown and grey wash.
PROV: David Laing; Royal Scottish Academy. Transferred 1910.

The convincing attribution was first suggested by Anthony Clark. Judging by the style of the costumes, the drawing should probably be dated around 1790.

CARLO BONELLI
<div align="center">*fl. 18th century*</div>

RSA 172 Fig. 169

Assumption of the Virgin.

392 × 241. Black chalk. Inscribed in ink: *Carlo Bonelli.*
PROV: David Laing; Royal Scottish Academy. On loan 1966.

There is no record of an *artist* of this name. It is, however, possible that it is the collector of the same name whom Pascoli mentions in his life of Claude Lorraine (*Vite dei Pittori* etc. (1730), p. 29).

GIOVANNI PAOLO DAL BORGO
<div align="center">(*fl. Rome c. 1545*)</div>

D 4890/3 Fig. 170

God the Father on clouds, surrounded by putti.

131 × 185. Pen and ink, over black chalk. (Laid down.) Inscribed: *Gio. Paolo dal Borgo.*
PROV: Marchese del Carpio; Paul and Edwardo Bosch, Madrid; H. M. Calmann. Purchased 1964.

Little or nothing is known about Giovanni Paolo dal Borgo (i.e. Borgo San Sepolcro), apart from the fact that he worked with Vasari on the decorations of the Cancelleria in Rome, about 1545/6 (see L. Lanzi, *The History of Painting in Italy*, transl. Roscoe (1828), I, 273).

MATTIA BORTOLONI

S. Bollino (Rovigo) 1696–1750 Bergamo

D 953 Fig. 171

A monstrance, surrounded by angels' heads.

228 × 192. Brush and red wash. Inscribed, also on the back: *Bortoloni*.

PROV: David Laing; Royal Scottish Academy. Transferred 1910.

FABRIZIO BOSCHI

Florence 1570–1642 Florence

D 688 Fig. 172

Tobias and the angel.

304 × 189. Black chalk on buff paper. (Both lower corners torn away and the whole sheet laid down.) Inscribed on mount: 'Correggio'.

PROV: David Laing; Royal Scottish Academy. Transferred 1910.

The drawing entered the collection under the designation 'Florentine School', later to be elaborated into '?Matteo Rosselli'. It is obvious that the drawing is in fact Florentine, and not far from Rosselli. C. and G. Thiem have recognized the connection between the two figures and those of Cosimo II and 'Fame' in Fabrizio Boschi's fresco-lunette in the Casino Mediceo entitled *Cosimo II, led by 'Fame', awakens 'Painting'*, c. 1620. (See A. R. Masetti, 'Il Casino Mediceo e la pittura fiorentina del Seicento, I', *Critica d'Arte*, IX, no. 50 (March–April 1962), pp. 17–18, figs. 26, 27, 29.) Although there can be no doubt that the figures depicted on D 688 are Tobias and the angel, Boschi obviously adapted them for the protagonists of his lunette-fresco. Another study for the figure of 'Fame' is in the Uffizi (9464F), and comes stylistically very close to the angel in D 688.

ANDREA BOSCOLI

Florence 1550–1606 Florence

D 776 Fig. 173

An old bearded man, in a wide cloak and high cap, seated, clasping his left knee.

254 × 164. Red chalk.

PROV: Richard Cosway (L. 628); Sir Thomas Lawrence; David Laing; Royal Scottish Academy. Transferred 1910.

LIT: Berenson 2393C (as Rosso); Anna Forlani, 'Andrea Boscoli' in *Proporzioni*, IV (1963), Cat. 3, fig. 33.

Berenson had catalogued the drawing as Rosso, observing that the sitter looks vaguely like Michelangelo. The style is, however, not merely entirely characteristic of Boscoli, but

the drawing is in fact a study for the seated figure on the extreme right in the painting *The Triumph of Mordecai* in the County Museum, Los Angeles (repr. Forlani, *op. cit.* fig. 34), there formerly ascribed to Zucchi.

D 1344 Fig. 174

A seated man with large hat and cloak, turned left.

90 × 61. Pen, brown ink and wash. (Laid down.)

PROV: David Laing; Royal Scottish Academy. Transferred 1910.

LIT: Anna Forlani, 'Andrea Boscoli' in *Proporzioni*, IV (1963), Cat. 6.

A. Forlani suggests that this might be a preliminary idea for the seated figure in *The Triumph of Mordecai*, see D 776.

D 1515 Figs. 175 and 176

(*recto*) A seated woman, resting her head on her right arm; (*verso*) Studies of drapery, and two studies of a reclining monk holding a crucifix (St Francis).

281 × 207. Red chalk. Inscribed in 18th century hand: *Andrea Boscoli*. Verso (top) in ink by a contemporary hand: *boscoli*.

PROV: Sir Peter Lely; Jonathan Richardson, Senr (L. 2184); Paul Sandby; David Laing; Royal Scottish Academy. Transferred 1910.

LIT: Anna Forlani, 'Andrea Boscoli' in *Proporzioni*, IV (1963), Cat. 7, fig. 45.

Ascriptions to Siciolante da Sermoneta, or merely, and unhelpfully, 'Florentine School' have been suggested according to notes on the mount. The traditional attribution is, however, entirely convincing, and the verso appears to be, as A. Forlani has pointed out, a study for the painting of *St Francis* in the Museum at Pisa (repr. Forlani, fig. 46). The recto is a counterproof.

D 1583 Fig. 177

Esther before Ahasuerus.

367 × 261. Pen, brown ink and wash, heightened with white, over black chalk. Squared in black chalk. Inscribed 'Tadeo Zuccaro' on the old mount.

PROV: 'P. Crozat'? (L. 474); David Laing; Royal Scottish Academy. Transferred 1910.

LIT: Anna Forlani, 'Andrea Boscoli' in *Proporzioni*, IV (1963), Cat. 8.

The present convincing attribution is due to Philip Pouncey. A. Forlani suggests that this may be the study for the paint-

ing, now lost, which Baldinucci described as having been executed for Baccio Valori in 1599. (F. Baldinucci, *Notizie dei professori del Disegno*, ed. Ranalli, III (1846), p. 74; Forlani, *op. cit.* p. 136, no. 15.)

D 1629 Fig. 178

Abraham and Melchisedech.

86 × 103. Pen, brown ink and wash. (Laid down.)

PROV: David Laing; Royal Scottish Academy. Transferred 1910.

LIT: Anna Forlani, 'Andrea Boscoli' in *Proporzioni*, IV (1963), Cat. 9.

The attribution was first made by J. A. Gere. It is a copy after Raphael's composition in the *Loggie*, and probably executed during Boscoli's stay in Rome during the 1580's.

D 1342 Fig. 179

Two studies of an elderly man reclining on the ground with his head resting on his right hand (top); and a kneeling man, turned left, seen from the side. (On the verso: illegible writing (part of a letter?).)

110 × 68. Top figure: black chalk. Bottom figure: red chalk.

PROV: David Laing; Royal Scottish Academy. Transferred 1910.

LIT: Anna Forlani, 'Andrea Boscoli' in *Proporzioni*, IV (1963), Cat. 4.

D 1343 Fig. 180

Una and the lion.

70 × 92. Black chalk and grey wash.

PROV: David Laing; Royal Scottish Academy. Transferred 1910.

LIT: Anna Forlani, 'Andrea Boscoli' in *Proporzioni*, IV (1963), Cat. 5.

The attribution was first suggested by A. E. Popham.

D 3157 Fig. 181

The martyrdom of St Lawrence.

326 × 195. Pen, brown ink and wash, white heightening oxidized.

PROV: W. F. Watson. Bequeathed 1881.

LIT: Anna Forlani, 'Andrea Boscoli' in *Proporzioni*, IV (1963), Cat. 10.

Formerly called variously 'Veronese' and 'Francesco Maffei'. The present attribution is due to Philip Pouncey

who also identified the source. It is interesting to observe that Boscoli, who spent a considerable time in the Marches, here copied Federico Zuccaro's altarpiece in the Church of the Cappuccini at Fermo, probably based on a design by his brother Taddeo. (See *Inventario degli oggetti d'arte d'Italia*, VIII: Provincia di Ancona e Ascoli Piceno (1936), p. 264). A preliminary drawing for the altarpiece exists in the Uffizi (11042F) which shows several differences from the finally executed painting, especially in the background. A comparison makes it clear, however, that D 3157 was copied from the painting, not from the drawing.

GIUSEPPE BOSSI

Busto Arsizio (Milan) 1777–1815 Milan

D 689 Fig. 182

Diogenes. (On the verso: sketches of a seated man, partly cut off.)

162 × 128. Pen and black ink, shading in black chalk. Signed: *Giuseppe Bossi. Rome 1797.*

PROV: Sir Thomas Lawrence; David Laing; Royal Scottish Academy. Transferred 1910.

D 690 Figs. 183 and 184

(*recto*) Two sketches of a prophet;
(*verso*) Pen and ink sketches for figures of a *Holy Family*.

221 × 304. Pen and black ink, shading in black chalk. Signed: *Giuseppe Bossi, Rome 1797.*

PROV: Sir Thomas Lawrence; David Laing; Royal Scottish Academy. Transferred 1910.

CECCO BRAVO

See Francesco MONTELATICI.

FRANCESCO BRIZIO

Bologna c. 1575–1623 Bologna

RSA 133 Fig. 185

Philip baptizing the eunuch.

388 × 505. Pen and ink. (Laid down.)

PROV: (W. Y. Ottley, from the style of the mount); Sir Thomas Lawrence; David Laing; Royal Scottish Academy. On loan 1966.

Very likely one of the two drawings mentioned by Malvasia in his account of Brizio's drawings: 'ed io ne possiedo nel mio studio, fra gli altri uno in gran foglio, entro il quale con immenso equipaggio ed apparato finse la storia dell'Eunuco; e l'istesso pensiero della stessa grandezza,

fattura e bellezza ancorchè diverso, ammirasi nello studio de' famosi disegni del Negri.' C. G. Malvasia, *Felsina Pittrice*, ed. Zanotti, I (1841), p. 383.

D 811 Fig. 186

A putto holding a branch with grapes.

186 × 123. Pen and brown ink. (Laid down.) Inscribed: '25' and 'di Brizio' on the mount.

PROV: Sir Thomas Lawrence; David Laing; Royal Scottish Academy. Transferred 1910.

The old attribution may possibly be correct.

FELICE BRUSASORCI
Verona c. 1542–1605 Verona

D 3084 Fig. 187

Angels lamenting the dead Christ.

402 × 341. Pen, brown ink and wash over black chalk on blue paper. (Laid down.)

PROV: W. F. Watson. Bequeathed 1881.

A study for the signed painting (on slate) in the Gallery at Eger, Hungary (repr. in *Pantheon*, xx, no. 5 (Sept.–Oct. 1962), p. 322; see also A. Czobor and E. Bodnar, *Guide et catalogue de la Galerie des tableaux à Eger* (Budapest, 1960), no. 4). The painting does not include the group of putti visible at the top of the drawing, nor the putto in the extreme left corner. There are also variations in the two small kneeling putti in the foreground.

GIOVANNI ANTONIO BURRINI
Bologna 1656–1727 Bologna

RSA 171 Fig. 188

The Madonna of the Immaculate Conception, surrounded by the Trinity and adored by six male saints.

412 × 264. Pen, brown ink and wash, heightened with white. Inscribed with brush: *Borini*.

PROV: Sir Thomas Lawrence; (cut-out collector's mark from mount); David Laing; Royal Scottish Academy. On loan 1966.

GIOVANNI BATTISTA BUSIRI
Rome c. 1698–c. 1757 Rome

RSA 3 Fig. 189

Landscape with a ruined arch and farm buildings.

285 × 428. Pen, brown ink and wash over black chalk. (Laid down.) Inscribed on the backing: *Bosiri*.

PROV: Paul Sandby; sale, 18 March 1812, lot 63 (one of 14); David Laing; Royal Scottish Academy. On loan 1966.

Although the name is spelt wrongly in the inscription, there can be little doubt that the drawing is by Busiri.

GUGLIELMO CACCIA
See MONCALVO.

GIACINTO CALANDRUCCI
Palermo 1646–1707 Palermo

D 3150 Fig. 190

The Baptism of Christ.

332 × 220 (arched top). Pen and brown ink, over red chalk.

PROV: Jonathan Richardson, Jnr (L. 2170); Richard Cosway (L. 628); W. F. Watson. Bequeathed 1881.

The previously anonymous drawing seems entirely characteristic of Carlo Maratta's favourite pupil.

D 3135 Fig. 191

The expulsion of Adam and Eve.

232 × 315. Pen, black ink over red chalk.

PROV: W. F. Watson. Bequeathed 1881.

The convincing attribution is due to Walter Vitzthum. The rough style and coarse pen-work are characteristic of the artist. The iconography with the carrying of the Cross and the figure of a winged Death is unusual, although there is a strikingly similar composition by Hendrik van den Broeck in the vault of the Cappella del Salvatore in S. Maria degli Angeli, Rome, datable after 1570 (*Dipinti Fiamminghi di Collezioni Romane* (Rome, 1966), p. 16, fig. 17).

RSA 311 Fig. 192

The Christ Child adored by his parents.

344 × 273. Pen and black ink over black chalk. Inscribed on the back: *dell'Albani*.

PROV: David Laing; Royal Scottish Academy. On loan 1966.

The perfectly convincing attribution is due to Philip Pouncey. The most pertinent comparison would be with a lunette-drawing in the Victoria and Albert Museum (Dyce 215) of a *Holy Family and St John*, bearing a contemporary inscription of the artist's name.

BENEDETTO CALIARI
Verona 1538–1598 Verona

D 2225 Fig. 193

St Jerome.

391 × 215. Black and red chalk and brown wash on blue paper. (An old fold across the paper, about 85 mm from the bottom, has been repaired.) Old inscription: *Benedetto Calliari.*

PROV: Count J. von Ross? (L. 2693) very faint; W. F. Watson. Bequeathed 1881.

LIT: Tietze, 2193.

The Tietzes accepted the old attribution as convincing.

PAOLO CALIARI

See Paolo VERONESE.

LUCA CAMBIASO
Moneglia 1527–1585 Madrid

D 630 Fig. 194

The rape of the Sabines.

191 × 403. Pen, brown ink and wash. Squared with red chalk. (Laid down.) Old inscription on the mount: 'cangiassi'.

PROV: Jonathan Richardson, Senr (L. 2183); George Knapton (1807) according to an inscription on the back; William Esdaile; David Laing; Royal Scottish Academy. Transferred 1910. (An inscription, in Richardson's hand, on the back states that the reverse of the drawing has the inscription *Giusepp. M^a· Granara.*)

LIT: B. Suida Manning and William Suida, *Luca Cambiaso* (1958), fig. 142 (incorrectly as being in the Royal Scottish Academy).

EXH: *Old Master Drawings*, Leicester, 1952 (5); Colnaghi, 1966 (26).

This is the final study, squared for transfer, for the ceiling fresco in the Villa Imperiale a Terralba, near Genoa. A drawing showing a slightly earlier stage of the composition, but probably a copy, is in the Victoria and Albert Museum (Dyce Collection, D 344, repr. *Gazette des Beaux Arts* (October 1952), p. 163), and a study for the right hand portion of the central group is at Düsseldorf (31/69). Yet another version, formerly in the possession of Charles Rogers and N. Hone, was in the collection of Admiral Sir G. King-Hall, K.C.B., London.

D 718 Fig. 195

The death of Cleopatra.

257 × 342. Pen, brown ink and wash over black chalk.

No. '1774' in an old hand in the bottom left hand corner of the mount.

PROV: Sir Joshua Reynolds; David Laing; Royal Scottish Academy. Transferred 1910.

LIT: B. Suida Manning and William Suida, *Luca Cambiaso* (1958), p. 88.

EXH: *Old Master Drawings*, Leicester, 1952 (6).

This drawing, which was probably cut at the left hand margin, represents, as Mrs Suida Manning pointed out, a little more than half of the composition for the fresco in the Palazzo Vincenzo Imperiale sul Campetio, Genoa, destroyed during the Second World War. Another preliminary drawing was formerly in the Tomàs Harris Collection (Suida Manning, fig. 47).

D 755 Fig. 196

The judgement of Midas.

460 × 322. Pen and black ink (on two sheets stuck together). Inscribed in an old hand: *Cangieggio.*

PROV: Bindon Blood (L. 3011); David Laing; Royal Scottish Academy. Transferred 1910.

D 696 Fig. 197

The shame of Calisto.

238 × 356. Pen, brown ink and wash. Squared in black chalk. No. '93' in an old hand at the top of the mount.

PROV: David Laing; Royal Scottish Academy. Transferred 1910.

LIT: B. Suida Manning and William Suida, *Luca Cambiaso* (1958), p. 150, fig. 348 (incorrectly as being in the Royal Scottish Academy).

Mrs Suida Manning has pointed out that this may be the preparatory drawing for a painting mentioned in the Collection of Rudolf II (Inventory of the Prague 'Schatz- und Kunstkammer'), *Ein Bad mit Calisto mit nackenden Weibern von Lucas de Janua*. This painting has not been traced. There are related paintings at Cassel and Turin (ex. Coll. Spinola, Genoa).

D 2976 Fig. 198

Venus and Cupid.

202 × 248. Pen and brown ink over black chalk. (The rather damaged sheet has been laid down on part of a page from a 16th century book.) Inscribed: *Luca Cangiasio.*

PROV: W. F. Watson. Bequeathed 1881.

The inscription is possibly by the Venetian collector whose usually reliable attributions are found on a number of drawings. (See Cat. *Disegni di una collezione veneziana del Settecento*, Fondazione Cini (Venice, 1966).)

D 1570 Fig. 199

Psyche carried by Mercury to Olympus.

323 × 222. Pen and brown ink over black chalk. (Laid down.) Inscribed on the reverse: *Di Luca Cangiaso.*

PROV: David Laing; Royal Scottish Academy. Transferred 1910.

LIT: B. Suida Manning and William Suida, *Luca Cambiaso* (1958), fig. 179.

There are two comparable drawings in the Louvre (9308 and 9309). This composition, but with the shading in wash, was engraved in reverse by J. T. Prestel, *Cinquante estampes* 48 (Weigel 685).

RSA 162 Fig. 200

Prometheus.

277 × 399. Pen, brown ink and wash. (Laid down.) Inscribed: *Luca Cangiasi fec.*

PROV: David Laing; Royal Scottish Academy. On loan 1966.

RSA 166 Fig. 201

Hercules and the bull.

294 × 208. Pen and ink. (Damaged and laid down.) Inscribed: *Luca Cangiasi 30.*

PROV: Sir Joshua Reynolds; David Laing; Royal Scottish Academy. On loan 1966.

Presumably a study for the series of frescoes depicting the *Labours of Hercules* for the Palazzo Sinibaldo Doria at Genoa (B. Suida Manning, *Luca Cambiaso* (1958), p. 81, pl. VII/10).

RSA 167 Fig. 202

Trumpeting angel and putto.

228 × 208. Pen and ink over red chalk. (Laid down.)

PROV: David Laing; Royal Scottish Academy. On loan 1966.

D 2933 Fig. 203

A seated woman holding a pennant.

236 × 339. Pen and brown ink. Inscribed in a late hand: *By Cangiasio.*

PROV: Sir Thomas Lawrence; W. F. Watson. Bequeathed 1881.

Comparison should be made with the drawing in the Uffizi (13835) repr. in Suida Manning, *op. cit.* (fig. 313).

D 661 Fig. 204

The first steps of the infant Christ.

332 × 244. Pen and brown ink. Inscribed: *Lod. Caracci.* Verso: *Luca Cangiaso, Gen.*

PROV: David Laing; Royal Scottish Academy. Transferred 1910.

LIT: B. Suida Manning and William Suida, *Luca Cambiaso* (1958), fig. 110 (incorrectly as being in the Royal Scottish Academy).

A similar drawing is at Munich (2725).

D 740 Fig. 205

The Baptism of Christ.

284 × 205. Pen and brown ink.

PROV: Sir Thomas Lawrence; Woodburn sale, 1860, lot 191; William Esdaile; David Laing; Royal Scottish Academy. Transferred 1910.

LIT: B. Suida Manning and William Suida, *Luca Cambiaso* (1958), p. 44, fig. 331 (incorrectly as being in the Royal Scottish Academy).

Mrs Suida Manning has pointed out that there are related paintings to this composition in S. Bartolomeo degli Armeni, Genoa (listed by Venturi, IX/7, p. 853, but now missing), S. Chiara sopra Bisogno, Genoa and S. Giacomo Cornigliano, Genoa. The drawing seems curious for an autograph work, and may possibly be by a studio assistant. In some respects (particularly the facial types) the style gets close to G. B. Paggi.

D 3141 Fig. 206

Christ being nailed to the Cross.

213 × 343. Pen, brown ink and wash. (Paper damaged in parts, especially along the left margin.) Inscribed: *Luca Cangiasi/63.*

PROV: W. F. Watson. Bequeathed 1881.

RSA 157 Fig. 207

St Matthew and the angel.

392 × 265. Pen, brown ink and wash. (Laid down.) Inscribed: *Luca Cangiasi fece* in ink, and *Cangiasi* in pencil.

PROV: David Laing; Royal Scottish Academy. On loan 1966.

D 814 Fig. 208

The Conversion of St Paul.

224 × 349. Pen, brown ink and wash. (Left hand margin and lower left hand portion damaged.)

PROV: Manuscript initials *GB* (connected, one below the other) on the verso (not in Lugt); David Laing; Royal Scottish Academy. Transferred 1910.

This drawing may possibly be connected with the composition of the same subject, for which there is another drawing at Princeton (Suida Manning, fig. 181). On the other hand, it is also close to *The Extermination of the Niobides* in the Palazzo Lercavi-Parodi, Genoa (Suida Manning, fig. 293).

D 810 Fig. 209

A combat of nude men.

120 × 351. Pen, brown ink and wash. Inscribed in lower margin: *Cangiago*.

PROV: J. Pz. Zoomer (L. 1511); Richard Cosway (L. 628); W. Y. Ottley (L. 2663); David Laing; Royal Scottish Academy. Transferred 1910.

This is possibly a studio work.

Studio of LUCA CAMBIASO
D 664 Fig. 210

A commander receiving jars as tribute.

200 × 312. Pen, brown ink and wash (within an oval). Squared in red chalk. Inscribed: *Luca Cangiasi n° 59*.

PROV: David Laing; Royal Scottish Academy. Transferred 1910.

Probably a design for a central ceiling decoration.

Circle of LUCA CAMBIASO
D 3072 Fig. 211

Men lifting a carved chest or sarcophagus from a boat on to a landing stage.

239 × 323. Pen, brown ink and wash over black chalk. Squared partly in black, partly in red chalk. Outlines incised.

PROV: W. F. Watson. Bequeathed 1881.

The confines of the composition would suggest the middle part of a ceiling decoration. The style of the drawing indicates that it stems from someone who had studied directly under Cambiaso, but had developed his own individuality by the time this drawing was made. Some of the facial types come close to Domenico Piola.

D 745 Fig. 212

A king and queen surrounded by courtiers and soldiers greet an officer and his two companions.

255 × 388 (top left hand corner torn off). Brush and brown wash, heightened with white, on prepared paper.

PROV: David Laing; Royal Scottish Academy. Transferred 1910.

EXH: *Old Master Drawings*, Leicester, 1952 (7), as Cambiaso.

Although some of Cambiaso's characteristics, especially the cube-like shape of the heads, can be discerned in this drawing, it cannot be by the artist himself. The style is, however, very close to his and seems certainly to be Genoese.

DOMENICO CAMPAGNOLA
Venice 1500–1564 Venice
D 4911 Fig. 213

Landscape with Juno and Calisto.

353 × 484. Pen and brown ink. Inscribed: *Tiziano*.

PROV: Prince W. Argoutinsky-Dolgoroukoff (L. 2602 d); sale Sotheby, 4 July 1923, lot 3; P. & D. Colnaghi. Purchased 1966.

This fine and characteristic drawing is probably of a late date, closely allied to the two landscape drawings with figures in the Albertina (V, 57 and 58) of which the former is dated 1558. The subject of D 4911 illustrates a passage from Ovid (*Metamorphoses* II, Fable 7) which relates how Calisto, who had given birth to Arcas after her amour with Jupiter, is being changed into a bear by the jealous Juno. A drawing by Campagnola in the same medium, and approximately the same size, depicting the next stage in the story, Calisto's full transformation into a bear, with the baby boy Arcas lying beside her, is at Detroit (Tietze 455, pl. LXXXI, 3), which the Tietzes also consider as 'typical late period'.

Attributed to
DOMENICO CAMPAGNOLA
RSA 313 Fig. 214

The gathering of the quails.

251 × 395. Red chalk. (Laid down.) Inscribed on the mount: 'Polidoro Veneziano' and 'Bonifazio'.

PROV: (W. Y. Ottley, with his mount); Sir Thomas Lawrence; David Laing; Royal Scottish Academy. On loan 1966.

Philip Pouncey suggested the attribution to Domenico Campagnola, pointing to the strongly decorative line work, the crowded composition and the characteristically bunched-up manner of the draperies.

The scene depicted appears to be that described in Exod. xvi. 13 and Num. xi. 31 in which the Israelites gather the quails sent in wrath. The bearded figure on the left is Moses.

Circle of DOMENICO CAMPAGNOLA

D 873 Fig. 215

Rocky river landscape with figures.

237 × 380. Pen and brown ink. Old inscription on the back: *Domenico Campagnola.*

PROV: Sir Peter Lely; David Laing; Royal Scottish Academy. Transferred 1910.

LIT: Tietze, 460 (as 'Shop').

The old attribution to Campagnola cannot be correct, as the draughtsmanship looks somewhat thin and mechanical. The hand appears to be the same as that of a landscape drawing, also with an inscription of Campagnola's name, erroneously said to be in the Lugt Collection (Tietze 783). The Tietzes, however, have suggested for this an attribution to Costantino Malombra in view of stylistic resemblances to his signed etchings. An attribution for D 873 of Battista del Moro has also been considered though not found very convincing, as those drawings which bear traditional attributions to him—in particular the landscape drawing with figures at Stockholm (1375/1863) to which Terence Mullaly has drawn attention—reveal a much looser and broader handling of the pen.

ANTONIO CAMPI

Cremona c. 1536–1591 Cremona

D 4905 Fig. 216

St Sebastian.

425 × 285. Pen, brown ink and wash over black chalk. (Laid down.) Old inscription: 'Campi' on old mount.

PROV: Count Gelozzi (L. 545); Miss G. Donati, London. Purchased 1966.

This is a preliminary study for the painting in the Castello Sforzesco, Milan (No. 77; repr. in *Paragone*, 87 (March 1957), fig. 40) which is signed and dated 1575. The pose of the saint varies slightly from the painted version, where the left arm partly covers the face. The composition of the painting shows the portrait of the donor holding arrows in the left corner, and a horseman in the right background.

D 924 Fig. 217

Design for a *sotto in su* ceiling decoration.

300 × 437 (cut to irregular shape). Pen, brown ink and wash, heightened with white, gold and red. Incised. (Laid down and very damaged.) Old inscription on the back: *antonio campi s. pietro cremona.*

PROV: David Laing; Royal Scottish Academy. Transferred 1910.

The old attribution may be right, although this particular fragment does not seem to appear in the church of S. Pietro at Cremona, as stated in the inscription. Similar designs

were executed by Antonio's brother Vincenzo Campi (1536–1591), for example the ceiling in S. Paolo, Milan (repr. Venturi IX/6, fig. 545).

BERNARDINO CAMPI

Cremona c. 1522–1590/95 Reggio Emilia

Studio of BERNARDINO CAMPI

D 2948 Fig. 218

The Temptation of Christ.

116 × 88. Pen, brown ink and pinkish wash. Inscribed on back: *Schiavone.*

PROV: W. F. Watson. Bequeathed 1881.

Although probably not by Bernardino Campi himself, the pen-work of this drawing reveals his close influence.

Circle of BERNARDINO CAMPI

D 1684 Figs. 219 and 220

(*recto*) The entry of the wooden horse into Troy; (*verso*) Study for *The Deluge*?

307 × 219. Pen, brown ink and wash over black chalk.

PROV: Monogram in ink, containing a small G within a larger L, in the left corner (not in Lugt); David Laing; Royal Scottish Academy. Transferred 1910.

The recto of the drawing seems to show the influence of Bernardino Campi. The composition is rather close to that for the Sala di Enea in the Palazzo del Giardino at Sabbioneta (illustrated in *Dedalo*, September 1928). The verso, however, must be of a later date.

Attributed to
GIULIO CAMPI

Cremona 1500–1572 Cremona

D 3152 Fig. 221

Landscape with three riders on the left and a group of standing figures on the right.

85 × 191. Reed pen and brown ink. (Laid down.) Inscribed on mount (in Richardson's hand): 'Domenicho Campagnola'.

PROV: Sir Peter Lely (L. 2092); Jonathan Richardson, Senr (L. 2183); W. F. Watson. Bequeathed 1881.

The attribution by Richardson to Campagnola is patently wrong. The style hovers uneasily between Romanino and Giulio Campi, the latter suggested by Philip Pouncey. As far as Romanino is concerned, one might be inclined to use as comparison for example the drawing of putti in the Uffizi (1465 E). Yet the series of scenes from Roman History by Giulio Campi (Uffizi 13438–9 F) is much closer

to the style of D 3152, while another drawing also in the Uffizi (13437F), of figures round a cradle, even appears to be by the same hand as the Edinburgh sheet.

REMIGIO CANTAGALLINA

Florence 1582–after 1630 Florence

D 671 Fig. 222

Landscape with three old trees near a small church and monastic buildings. (On the backing: scribbles of armorial bearings.)

186 × 268. Pen, black ink and wash. Inscribed: 'Di Remigio Cantagallina' on the old mount.

PROV: David Laing; Royal Scottish Academy. Transferred 1910.

RSA 129 Fig. 223

Ruins and trees.

214 × 179. Pen and ink. Inscribed: *Canta Gallina*.

PROV: 'P. Crozat' ? (L. 474); Count de Caylus, according to inscription on back; Thomas Williamson (L. 2468); David Laing; Royal Scottish Academy. On loan 1966.

D 874 Fig. 224

Landscape with ruined farm buildings near Florence.

209 × 309. Pen, brown ink and wash over black chalk. Inscribed on the back in pencil: *Gaetano Cittadino* and also *R. Cantagallina*.

PROV: David Laing; Royal Scottish Academy. Transferred 1910.

LIT: *Catalogue: National Gallery of Scotland* (1946), p. 392 (as Pittardina).

EXH: Colnaghi, 1966 (37).

The attribution to Cantagallina, probably dating from the 19th century, is entirely convincing. Cittadino, well known for his views in and around Rome, was an 18th century artist.

Attributed to
REMIGIO CANTAGALLINA

RSA 138 Fig. 225

Rocky landscape with figures.

242 × 332. Pen and ink with brown wash, over black chalk.

PROV: David Laing; Royal Scottish Academy. On loan 1966.

The previously unattributed drawing appears to be by Cantagallina.

SIMONE CANTARINI

Oropezza (Pesaro) 1612–1648 Verona

Copy after SIMONE CANTARINI

D 1599

Mercury and Argus.

264 × 300. Pen, brown ink and wash, heightened with white. (Laid down.) Inscribed: *Del guido dal pesarese*.

PROV: David Laing; Royal Scottish Academy. Transferred 1910.

Copy after the etching (B. XIX, p. 142, 31).

DOMENICO MARIA CANUTI

Bologna 1620–1684 Rome

D 3007 Fig. 226

The Virgin appearing to St Roch.

267 × 197. Pen, brown ink and grey wash over red chalk.

PROV: W. F. Watson. Bequeathed in 1881.

The attribution is due to Philip Pouncey.

FRANCESCO ANTONIO DE CAPO

Born in Lecce; worked in Rome in the late 18th century

RSA 404 Fig. 226a

River landscape with ruined tower.

125 × 280. Brush and brown wash. (Laid down.) Inscribed on mount: 'Franc° Antonio de Capo. Roma 1784'.

PROV: David Laing; Royal Scottish Academy. On loan 1966.

Little is known of this Apulian artist. He is recorded in Rome from around 1775 onwards. Cunego engraved several of his works, and some drawings and a large number of his oils were in private collections in Perugia (see Orsini, *Guida...di Perugia* (1784), p. 89).

GIOVANNI DOMENICO CAPPELLINO

Genoa 1580–1651 Genoa

D 3092 Fig. 227

The Last Supper.

260 × 477. Pen, brown ink and grey wash. Some of the contours gone over with the brush. (Badly damaged and laid down.) Part of an old inscription: Di Dom°° Capellini' pasted on to the back of the mount.

PROV: W. F. Watson. Bequeathed 1881.

CARLO CAPPELLO

(fl. 17th century)

D 2953 Fig. 228

Two putti, one with bow and arrow, the other with sword and shield.

111 × 183. Pen, brown ink and wash. (Laid down.) Inscribed: *di Carlo Cappello*.

PROV: John MacGowan; W. F. Watson. Bequeathed 1881.

No artist of this name seems to be recorded.

CARLO CARLONE

Scaria (Como) 1686–1775 Como

D 4689 Fig. 229

Study for a *St John and Virgin at the Cross*.

320 × 325. Oil on paper.

PROV: Herbert Horne; Sir Edward Marsh. Presented through the National Art-Collections Fund, 1953.

EXH: Burlington Fine Arts Club, 1916 (8), as Sebastiano Ricci.

D 4690 Fig. 230

Floating putti.

242 × 330 (arched top). Oil on paper.

PROV: Herbert Horne; Sir Edward Marsh. Presented through the National Art-Collections Fund, 1953.

EXH: Burlington Fine Arts Club, 1916 (9), as Sebastiano Ricci; Colnaghi, 1966 (74).

Probably a design for part of a ceiling decoration.

GIROLAMO DA CARPI

Ferrara 1501–1556 Ferrara

D 824 Figs. 231 and 232

(recto) The young Bacchus (with two other studies of the torso);
(verso) Two studies for a *Leda*.

164 × 110. Pen, brown ink and wash.

PROV: David Laing; Royal Scottish Academy. Transferred 1910.

The recto of this fine and typical drawing is copied from the Roman sculpture *Bacchus and Amor* in the National Museum at Naples (kind information of Michael Baxandall). The verso shows the influence of Parmigianino, whose work Carpi studied and copied avidly in Parma.

D 3146 Fig. 233

Standing draped male figure, holding a shield. (?From the antique.)

181 × 95. Pen and brown ink. (Laid down.) Inscribed: 'Rafaello' on the mount.

PROV: Sir Peter Lely; Jonathan Richardson, Senr; William Roscoe; sale Liverpool, 24 September 1816, lot 174, as Raphael; W. F. Watson. Bequeathed 1881.

The attribution to Raphael on the mount appears to be in Richardson's hand. The drawing, although somewhat hard, seems, however, characteristic of Girolamo da Carpi's style. A drawing at Munich (1919/20:44) of a female figure (attributed to Carpi), and another one in the Uffizi (402 s, as Marcantonio) appear to reveal the same hand; for the latter, John Gere has also proposed an attribution to Carpi.

Attributed to

GIROLAMO DA CARPI

D 2985 Fig. 234

An antique ceremony.

140 × 363. Pen and brown ink on blue paper. (Laid down.) Inscribed on the front of the mount: 'P. da Caravaggio' and on the back, possibly in Gabburri's hand: 'Polidoro da Caravaggio/ 30/nel studio'.

PROV: Unidentified crest on the back of the mount; ? F. M. N. Gabburri (L. 2992 B); Sir Peter Lely (the 'L' of the mark has not caught the ink); W. F. Watson. Bequeathed 1881.

Several attributions have been put forward for this drawing: one accepting the old attribution to Polidoro, others suggesting Perino del Vaga or Battista Franco. An attribution to Girolamo da Carpi, whose drawings are frequently confused with those by Battista Franco, would appear to be more reasonable, although whether D 2985 is in fact by his hand, and not that of a studio assistant, must remain doubtful. It may possibly be a record of a Polidoro composition.

AGOSTINO CARRACCI

Bologna 1557–1602 Parma

D 624 Fig. 235

Adam and Eve.

278 × 212. Pen and black ink.

PROV: David Laing; Royal Scottish Academy. Transferred 1910.

The various pentimenti suggest that this may have been an early idea. It does not seem unreasonable to connect the drawing with Agostino's own etching (B. XVIII, p. 35, 1) of 1581, although the composition varies considerably. The

figure of Adam is reminiscent of that in Raphael's drawing in the Ashmolean (539 verso) depicting the *Temptation*, which was later engraved by Marcantonio (B. XIV, p. 3, 1).

D 651 Fig. 236

River landscape with a *Rest on the Flight to Egypt*.

200 × 284. Reed pen and brown ink. The figures *XV* in the upper, and *19* in the lower right margin.

PROV: P. Mariette with his mount and inscription, also a number *644* in the lower left margin; F. Basan, *Catalogue Raisonné des différents objets de curiosités...de feu M. Mariette*, Paris 1775/6, lot 316?; Count Moritz von Fries (L. 2093); David Laing; Royal Scottish Academy. Transferred 1910.

LIT: *Catalogue: National Gallery of Scotland* (1946), p. 386.

D 1729 Fig. 237

Wide landscape with distant town and figures engaged in fowling and gaming.

250 × 405. Pen, brown ink. (Laid down, damaged and very faded.) Inscribed: *Titian* on the back.

PROV: Robert Udney (in 1803 according to inscription on the back); David Laing; Royal Scottish Academy. Transferred 1910.

This ghost of a drawing must have been exposed to strong daylight at one time, with the exception of a strip along the two side margins and the lower margin, which were probably protected by a mount. From what there is left to see, the style, especially the manner of cross-hatching and the type of figures, suggests the hand of Agostino.

D 764 Figs. 238 and 239

(*recto*) Mars and Venus;
(*verso*) Sketches of a horse's head, a right foot, a trumpeting angel, etc.

214 × 164. Pen, brown ink and wash over red chalk. Verso: Pen and brown ink; the cartouche at the bottom in coloured wash. Inscribed on the verso in an old hand: *Augustino Carraccio*.

PROV: Sir Peter Lely (L. 2092); William Esdaile (1815); David Laing; Royal Scottish Academy. Transferred 1910.

D 4890/47 Fig. 240

Head of a helmeted soldier.

100 × 128. Pen and brown ink, with scribbles in black chalk. Inscribed: *Agost. Caracci*.

PROV: Marchese del Carpio; Paul and Edwardo Bosch, Madrid; H. M. Calmann. Purchased 1964.

The old attribution seems plausible. The manner of hatching and the ornaments on the helmet are very close to similar studies of heads of which the majority is at Windsor (see Wittkower, *Carracci Drawings at Windsor Castle* (1952), nos. 143 ff.). Miss Scott-Elliot has pointed out that D 4890/47 compares particularly well with a similar helmeted head at Windsor (Wittkower, 159).

<div align="center">Attributed to
AGOSTINO CARRACCI</div>

D 4890/18 Fig. 241

A seated satyr.

125 × 133. Pen, brown ink. (Laid down.) Inscribed: *Scola Caraccese*.

PROV: Marchese del Carpio; Paul and Edwardo Bosch, Madrid; H. M. Calmann. Purchased 1964.

This looks as if it might be by Agostino, drawn in the rather shaggy style of some of his other sheets of studies, for example that in the collection of the Duke of Sutherland (repr. Denis Mahon, *Mostra dei Carracci-Disegni* (1956), no. 77, fig. 23).

RSA 152 Fig. 242

Head of a bearded man, looking up.

136 × 109. Pen and brown ink. Inscribed on the back: *Baroccio* and in pencil on the old mount: 'Ludovico Carracci'.

PROV: David Laing; Royal Scottish Academy. On loan 1966.

The drawing was etched in facsimile by a hitherto unidentified, probably 18th century, artist. The style seems to speak for Agostino rather than Ludovico.

D 1291 Fig. 243

Skittle players outside an inn.

182 × 235. Pen and brown ink. (Laid down.)

PROV: L. D. Lempereur (L. 1740); David Laing; Royal Scottish Academy. Transferred 1910.

EXH: Colnaghi, 1966 (44, pl. 27).

A. E. Popham had tentatively suggested P. F. Mola as the author of this drawing. Sir Karl Parker wrote 'Carracci' on the mount, and Denis Mahon elaborated that this must be Agostino in his last period, during his short stay in Rome (*c.* 1598). It shows him strongly under the influence of Annibale, greatly simplifying the landscape details. The preoccupation of Agostino with the game of *boccia* is reflected also, for example, in the figure on the sheet of studies in Windsor (R. Wittkower, *Carracci Drawings at Windsor Castle* (1952), no. 157, pl. 38). J. Byam Shaw, however, favours an attribution to Annibale, pointing to resemblances of the figures to those in the Windsor drawing of an *Execution* (Wittkower, 414, pl. 52).

<div align="center">31</div>

RSA 322 Fig. 244

Studies of figures and caricature heads.

355 × 269. Pen and brown ink over black chalk. (Laid down.) Inscribed: *24*.

PROV: David Laing; Royal Scottish Academy. On loan 1966.

The previously unattributed sheet seems to be from the hand of Agostino Carracci.

Copy after AGOSTINO CARRACCI

D 3159

St Jerome.

319 × 252. Red chalk. (Damaged.)

PROV: W. F. Watson. Bequeathed 1881.

Copy of the engraving (B. XVIII, p. 75, 75).

ANNIBALE CARRACCI

Bologna 1560–1609 Rome

D 1658 Fig. 245

Landscape with tree and a castle on a hill in the background.

191 × 172. Pen and brown ink (probably cut along the two side margins and laid down). Inscription in Richardson's hand on the mount: 'Annibale Carracci'.

PROV: Jonathan Richardson, Senr (L. 2183); David Laing; Royal Scottish Academy. Transferred 1910.

The traditional attribution may be correct, although the draughtsmanship appears rather mechanical.

D 1714 Fig. 246

River landscape with two boats, one capsized, with a tower-like building in the background.

199 × 300. Pen and brown ink. (Laid down.)

PROV: David Laing; Royal Scottish Academy. Transferred 1910.

LIT: *Catalogue: National Gallery of Scotland* (1946), p. 387.

EXH: Colnaghi, 1966 (34, pl. 25).

The attribution is the traditional one. A similar drawing is in the collection of Michael Jaffé, Cambridge.

D 1917 Fig. 247

Madonna and Child, with secondary studies of the Child's head.

172 × 125. Pen and brown ink. (Laid down.) Inscribed on the mount in an old hand: 'di Anibale Caracci originale 12'.

PROV: Lady Murray. Presented 1860.

The old attribution seems convincing. Particularly the angular, broad drawing of the Child's features and that of

the nose of the Madonna, as well as the manner of shading are entirely characteristic, not only of Annibale, but incidentally also of Agostino.

D 4896 Fig. 248

Almsgiving. (On the verso: red-chalk scribbles of a flying putto.)

209 × 275. Pen, brown ink and wash, over black chalk.

PROV: W. R. Jeudwine; H. M. Calmann. Purchased 1965.

In style and spirit, the drawing resembles some of the other *genre* subjects by Annibale as well as the designs for the *Arti di Bologna* series of engravings of Bolognese street-cries (engr. by Simon Guillain in 1646). Several of these are in the collection of the Duke of Sutherland (exh. *Mostra dei Carracci*, Bologna, 1956, for instance the *Domestic Scene*, no. 225, and *The Chimney Sweep*, no. 231). These drawings have generally been dated roughly between 1585 and the early 1590's, a period in which D 4896 is also likely to have originated.

D 4813 Fig. 249

Caricature profile of a man wearing a turban.

113 × 116. Pen and brown ink. (Three corners cut, tiny piece torn from the upper margin.) Inscription: 'Caracci' on the mount in Skippe's hand.

PROV: John Skippe (sale Christie, 20 November 1958, 69 c); P. and D. Colnaghi. Purchased 1959.

Attributed to

ANNIBALE CARRACCI

D 1587 Fig. 250

A youth, three-quarter length, with inclined head. Rough outlines of a horse's leg and hoof.

241 × 186. Black chalk (the figure), the horse's leg and hoof with brush gone over partly with black chalk. (Laid down.) Inscribed: *Correggio*.

PROV: Nathaniel Hone; Sir Joshua Reynolds; John Barnard; David Laing; Royal Scottish Academy. Transferred 1910.

The ascription to Correggio cannot be correct. The compiler would hazard a guess that the drawing is Bolognese and shows, in its simplified forms, the hand of the young Annibale.

Circle of ANNIBALE CARRACCI

D 677 Fig. 251

The mystic marriage of St Catherine.

226 × 182. Pen, brown ink and wash over black chalk. (Laid down.)

PROV: David Laing; Royal Scottish Academy. Transferred 1910.

A former ascription to Perino del Vaga, probably dating from the 19th century, is untenable. The drawing seems to be by the same hand as the one in the Albertina of the *Holy Family with St John and St Francis* (VI, 113), which was engraved by Prestel, from the Praun Collection, with an attribution to Annibale (Weigel 872). It appears fairly certain that both the Edinburgh and the Vienna drawings originated from the circle of Annibale, but it is equally certain that neither of them is from his own hand, although the compositions are reminiscent of some of his. Weigel thinks the Albertina drawing 'ähnlich der Radirung von Guido Reni' by which he is probably referring to Reni's various etchings of the *Holy Family* generally, rather than to any particular one. D 677 at any rate seems to be later than Annibale, and in a style not unlike that of Bartolomeo Schidone.

D 1782 Fig. 252

The Madonna and Child.

162 × 167. Pen and brown ink. Outlines gone over by a later hand. (Laid down.)

PROV: Jonathan Richardson, Senr (L. 2183); David Laing; Royal Scottish Academy. Transferred 1910.

There is a pencilled ascription to 'Annibale Caracci' in Laing's hand on the mount. It cannot be by Annibale himself, but betrays his influence and may date from the beginning of the 17th century.

D 2922 Fig. 253

The Holy Family.

110 × 81. Pen and brown ink, traces of red chalk. (Laid down.) 19th century inscription on the mount: 'Dom° Campagnola'.

PROV: W. F. Watson. Bequeathed 1881.

The broad pen-work and the sharp, angular features of the faces place this drawing in the circle around Annibale Carracci.

D 4890/21 Fig. 254

Madonna and Child with St John.

148 × 108. Pen and black ink, over black chalk. (Laid down.) Inscribed: *nella scola de Caracci*.

PROV: Marchese del Carpio; Paul and Edwardo Bosch, Madrid; H. M. Calmann. Purchased 1964.

The drawing is probably based on a Carracci composition.

D 886 Fig. 255

Landscape with ruined architecture and a man sitting on the bank of a river.

209 × 312. Pen, brown ink. Pencilled inscription on back: *A. Carracci No. 469.*

PROV: Thomas Dimsdale (L. 2426); David Laing; Royal Scottish Academy. Transferred 1910.

Another version of this composition, from the Mariette Collection, is among the uncatalogued drawings in the Albertina (S.B. 143) as Ludovico Carracci. The style of D 886 looks rather like that of Grimaldi.

Follower of ANNIBALE CARRACCI

D 1659A Fig. 256

A tree-lined riverbank with three boats.

190 × 260. Pen and brown ink over black chalk. (Laid down.) The initials *A C* in pencil by a later hand in the lower left corner. The number *207* in the opposite one.

PROV: David Laing; Royal Scottish Academy. Transferred 1910.

LIT: *Catalogue: National Gallery of Scotland* (1946), p. 387 (as Annibale Carracci).

This drawing is possibly a copy of an Annibale drawing, or perhaps an original by an artist imitating him. The style is not inconsistent with that of Grimaldi.

Copies after ANNIBALE CARRACCI

D 631

Ulysses and Mercury in Circe's palace.

282 × 498 (arched top). Pen, brown ink and wash, heightened with white. Inscribed on mount in Richardson's hand?: 'Fatto da Annibale Carracci per il Cardinale Farnese'.

PROV: P. H. Lankrink; Jonathan Richardson? from evidence of the characteristic mount and inscription; David Laing; Royal Scottish Academy. Transferred 1910.

This is a close and probably fairly contemporary copy of Annibale's composition in the 'Camerino' of the Palazzo Farnese, Rome.

D 852

View of a river with sailing boats and smaller craft, with a house in the right background.

150 × 216. Pen, brown ink. (Laid down.)

PROV: David Laing; Royal Scottish Academy. Transferred 1910.

Copy of a drawing in the collection of John Nicholas Brown, Providence, R.I., U.S.A. Other versions are at Christ Church, Oxford (Inv. 1017) and Chatsworth (461; Courtauld List 193).

D 1594

The Adoration of the Shepherds.

492 × 320. Pen, brown ink and wash, heightened with white. (Laid down.) Inscribed on mount: 'Lodovico Caracce'.

PROV: David Laing; Royal Scottish Academy. Transferred 1910.

Copy of the painting in S. Maria della Pioggia, Bologna (repr. Venturi IX/7, fig. 658).

D 2908

A standing male nude holding a pole, with left arm raised.

245 × 172. Red chalk on pink prepared paper.

PROV: W. F. Watson. Bequeathed 1881.

A poor copy of one of the atlas-herms from the Farnese Gallery.

D 3062

Seated Apollo.

379 × 255. Red chalk. (Laid down.)

PROV: W. F. Watson. Bequeathed 1881.

D 3112

Head of a faun.

320 × 242. Red chalk. Inscribed on back: *Annibale Carracci*.

PROV: Indecipherable collector's mark; W. F. Watson. Bequeathed 1881.

D 3132 Fig. 257

Sheet of studies.

230 × 320. Pen and ink, with traces of black chalk. (Laid down.)

PROV: Paul Sandby; W. F. Watson. Bequeathed 1881.

Includes copies of the *Pietà* (Pinacoteca, Naples), an *Infancy of Jupiter*, *Hercules freeing Prometheus*, and various satyrs.

D 3186

Polyphemus and Galatea.

429 × 312. Red and black chalk. (Laid down.) Inscribed on mount: 'A. Carracci'.

PROV: Paul Sandby; W. F. Watson. Bequeathed 1881.

Weak copy after the fresco in the Farnese Gallery, Rome.

LUDOVICO CARRACCI
Bologna 1555–1619 Bologna

D 4873 Fig. 258

Two standing angels.

205 × 113. Pen, brown ink and grey wash.

PROV: W. R. Jeudwine. Purchased 1962.

A study for the two angels at the foot of the 'ladder' in the background of *Jacob's Dream* (c. 1605), painted for Bartolomeo Dulcini and now in the Pinacoteca, Bologna. The pose of the two figures varies from the final version, for which there is a drawing of the full composition at Windsor (R. Wittkower, *Carracci Drawings at Windsor Castle* (1952), no. 19, pl. 15).

Circle of LUDOVICO CARRACCI
D 1197 Fig. 259

St Paul being carried to the third heaven.

260 × 220. Red chalk, heightened with white. (Laid down.) Inscribed on the mount: 'Lanfranco'.

PROV: Jonathan Richardson, Senr (L. 2184); Lord Eldin; sale Edinburgh, 19 March 1833, lot 302; David Laing; Royal Scottish Academy. Transferred 1910.

The attribution to Lanfranco in Richardson's hand on the mount does not seem convincing, even if it were assumed that it was an early work by him. The hand reveals an artist near to Ludovico Carracci, several of whose characteristics—the short forehead, the staring eyes—are here evident. One could imagine that the young Francesco Albani or Camillo Procaccini could have been the authors of a drawing with such exciting texture, perhaps at a time when both worked with Ludovico at Piacenza, c. 1605. From this period dates in fact a composition of this rather rare subject by Ludovico himself (see Wittkower, *Carracci Drawings at Windsor Castle* (1952), no. 47).

Follower of LUDOVICO CARRACCI
D 1928 Fig. 260

The rape of Europa.

154 × 218. Pen, brown ink. Old inscription: *Domenichino* on the back.

PROV: David Laing; Royal Scottish Academy. Transferred 1910.

The influence of Ludovico Carracci is strongly evident, especially in the treatment of the landscape. Dwight Miller suggested the drawing might possibly be by Pasinelli.

Circle of THE CARRACCI
D 812 Fig. 261

St Bernardino of Siena adoring the name of Jesus.

225 × 132. Pen, brown ink and grey wash over black chalk. (Laid down.) Inscribed: *m 1014*.

PROV: (Lord Somers) according to inscription on mount; David Laing; Royal Scottish Academy. Transferred 1910.

The style shows the influence of the Carracci, but there are also Venetian elements discernible. The inscribed number is in imitation of Padre Resta's mark, but does not in fact occur in his inventory.

D 1626 Fig. 262

Susannah and the elders.

122 × 82. Pen, brown ink. (Laid down.) Inscribed on the old backing: 'della Scola di Carazi'.

PROV: David Laing; Royal Scottish Academy. Transferred 1910.

The drawing seems to be Bolognese, and it is possible that it originated in the Carracci Circle.

Attributed to
ALESSANDRO CASOLANI
Siena 1552–1606 ? Siena

D 783 Fig. 263

Sheet of studies with figures of 'Justice' and 'Charity'.

291 × 223. Pen, brown ink over black chalk. (Laid down.) Inscribed on the mount: 'Barocci'.

PROV: Thomas Thane (L. 2461); John Webb; sale Phillips, London, 2 May 1822, lot 28; William Esdaile; David Laing; Royal Scottish Academy. Transferred 1910.

The inscription 'Barocci' is in Esdaile's hand. The free handling of the pen seems characteristic of Casolani's style.

Attributed to
BERNARDO CASTELLO
Albaro (Genoa) 1557–1629 Genoa

D 769 Fig. 264

The judgement of Solomon.

437 × 325. Pen and black ink. Outlines incised. Squared in red chalk. (Very damaged.) Inscription on the old mount: 'Vict° Carpaccio Veneziano'.

PROV: Sir Peter Lely (L. 2093); David Laing; Royal Scottish Academy. Transferred 1910.

A. E. Popham was the first to suggest a 16th century Genoese attribution. The style of Bernardo Castello is evident as far as can be discerned from a drawing which is not only a wreck, but has been completely gone over.

D 955 Fig. 265

A sea battle near a fortified harbour.

107 × 177 (cut out and laid down). Pen, black ink and grey wash on blue paper; white heightening oxidized.

PROV: David Laing; Royal Scottish Academy. Transferred 1910.

The attribution of this previously anonymous drawing is due to Philip Pouncey. The subject is treated in imitation of bas-relief.

D 1579 Fig. 266

The triumph of temperance.

205 × 303. Pen, black ink and grey wash on faded blue paper, over black chalk, heightened with white. (Damages through wormholes.) Inscribed on the back in an old hand: *Di Cecchino Salviati*.

PROV: David Laing; Royal Scottish Academy. Transferred 1910.

The drawing entered the collection with an ascription to Taddeo Zuccaro; the present tentative attribution is due to Philip Pouncey.

VALERIO CASTELLO
Genoa 1625–1659 Genoa

D 1573 Fig. 267

Pentecost.

330 × 445. Black chalk. (Paper stained and damaged in parts; heavy fold down the middle of the paper, which is laid down.) Inscribed in bottom left and top right margin: *Valerio Castello*.

PROV: David Laing; Royal Scottish Academy. Transferred 1910.

Probably a design for the decoration of an apse.

Attributed to
VALERIO CASTELLO

D 3171 Fig. 268

Two women supporting a recumbent figure.

133 × 175. Pen, brown ink and wash over black chalk. (Laid down.)

PROV: G. Vallardi (L. 1223); W. F. Watson. Bequeathed 1881.

The former ascription was to Palma Giovane. However, the drawing seems certainly to be Genoese, and if not by, then very close to Valerio Castello.

FRANCESCO CASTIGLIONE
(died Genoa 1716)

RSA 290 Fig. 269

Diogenes (?) with the lamp, surrounded by various animals. (On the verso: slight chalk sketches of faces and animals.)

197 × 271. Pen, brown ink and wash over black chalk.

PROV: David Laing; Royal Scottish Academy. On loan 1966.

The attribution to Giov. Benedetto, Castiglione's son, is based on the close stylistic resemblance of this drawing to two in the Metropolitan Museum, inscribed with the artist's name in the 'Reliable Venetian Hand' (see *Disegni di una collezione veneziano del Settecento* (Venice, 1966), nos. 49 and 50; and also *Drawings from New York Collections: The 17th Century in Italy* (1967), no. 118). The heightening with water-colour, apparently a characteristic of Francesco's drawings, is here missing. On the other hand, J. Byam Shaw has suggested that the drawing may possibly be a copy after G. B. Castiglione, perhaps by A. M. Zanetti the Elder who was a great admirer of Castiglione.

GIOVANNI BENEDETTO CASTIGLIONE
Genoa c. 1600–1665 Mantua

D 700 Fig. 270

Eliezer and Rebecca at the well.

271 × 406. Oil colour. The date *1646* appears on the reverse in a contemporary hand. Inscribed on the old mount: 'Gio. Benedetto Castiglione'.

PROV: David Laing; Royal Scottish Academy. Transferred 1910.

LIT: *Catalogue: National Gallery of Scotland* (1946), p. 387.
EXH: Colnaghi, 1966 (43, pl. 29).

Attributed to
GIOVANNI BENEDETTO CASTIGLIONE

RSA 184 Fig. 271

Flora and Venus with attendant figures.

176 × 257. Black chalk. The names of the characters inscribed in pen. (Laid down.) Inscribed on the mount: 'Albano'.

PROV: David Laing; Royal Scottish Academy. On loan 1966.

The attribution to Castiglione is proposed because of such features as the blowing angel at the top, the animals on the right, and the faintly Flemish look of the figure of Venus— an influence which Castiglione absorbed in Genoa mainly through Van Dyck.

RSA 289 Fig. 272

Adoration of the Shepherds.

225 × 292. Pen, brown ink and wash. (Laid down.) Inscribed: *Castiglione*.

PROV: David Laing; Royal Scottish Academy. On loan 1966.

D 673 Fig. 273

Landscape with two goatherds and goats near a rock.

216 × 299. Pen, brown ink and wash. (Laid down.) Inscribed: *4* in the lower margin.

PROV: David Laing; Royal Scottish Academy. Transferred 1910.

As Miss A. Percy pointed out, this (and the three sheets D 889, D 893 and RSA 198, to which the name of Salvator Rosa got attached) is in fact by G. B. Castiglione. They form a group (perhaps part of a dismembered drawing book) of which others are at Windsor (A. Blunt, *The Drawings of G. B. Castiglione & Stefano della Bella at Windsor* (1954), nos. 10–14) and in the Metropolitan Museum and Pierpont Morgan Library, New York (*Drawings from New York Collections: The 17th Century in Italy* (1967), nos. 78 and 79, where others are also mentioned). All of these drawings are numbered in the lower margin in a similar manner.

D 889 Fig. 274

Landscape with a herd of oxen.

254 × 394. Pen and brown ink. (Laid down.) Inscribed: *18* in the lower margin, (in pencil): *Salvator Rosa*.

PROV: David Laing; Royal Scottish Academy. Transferred 1910.

LIT: *Catalogue: National Gallery of Scotland* (1946), p. 393 (as Rosa).

See note to D 673.

D 893 Fig. 275

Rocky landscape with houses, and two shepherds with flock.

277 × 416. Pen, brown ink and wash. (Stained and laid down.) Inscribed: *28* in the lower margin, and *84* on the back. Pencil inscriptions: *Salvator Rosa*.

PROV: David Laing; Royal Scottish Academy. Transferred 1910.

See note to D 673.

RSA 198 Fig. 276

Study of trees, with two figures on the right.

274 × 417. Pen and brown ink. (Laid down.) Inscribed: *57* in the lower margin, (in pencil): *Salvator Rosa*.

PROV: David Laing; Royal Scottish Academy. On loan 1966.

See note to D 673.

Studio of GIOVANNI BENEDETTO
CASTIGLIONE

D 1665 Fig. 277

Music-making goatherds.

259 × 329. Oil colour over black chalk. (Vertical tear along paper, a triangular piece in the bottom margin added.)

PROV: Charles Rogers (L. 624); David Laing; Royal Scottish Academy. Transferred 1910.

This rather flimsy drawing looks as if it might have originated in Castiglione's studio. It bears some resemblance, in handling and composition (especially the boy on the laden mule), to the drawing in the Albertina (VI, 532) which is given there, together with other sub-Castiglione drawings, to the still rather enigmatic figure of the artist's son Francesco. A rather more general designation to Castiglione's studio has been preferred here.

?Copies after GIOVANNI BENEDETTO
CASTIGLIONE

D 1765 Fig. 278

The Annunciation to the Shepherds.

322 × 256. Red chalk.

PROV: David Laing; Royal Scottish Academy. Transferred 1910.

This is obviously a counterproof of a drawing, which could possibly have been derived from a composition by Castiglione, although none of his surviving works corresponds. The watermark of the paper (Strasburg Lily, Churchill no. 425) is apparently Dutch and dates from c. 1683.

D 736

Diogenes looking for a man.

202 × 147. Pen, brown ink and grey wash. (Laid down.)

PROV: David Laing; Royal Scottish Academy. Transferred 1910.

A copy after Castiglione's etching (B. XXI, p. 20, 21).

ANTONIO CAVALLUCCI
Sermoneta 1752–1795 Rome

D 516 Fig. 279

Two male heads.

184 × 274. Black chalk, heightened with white on buff paper. Late inscription: 'Cavalucci' on the mount.

PROV: Count J. von Ross (L. 2693); David Laing; Royal Scottish Academy. Transferred 1910.

These are studies of two heads (the kneeling man on the left, and the youth looking over the shoulder of the priest with the open book) in the painting of *St Bona taking the Veil* (1792) in the Cathedral at Pisa. (Illustrated in Voss, Barock, p. 431.)

GIACOMO CAVEDONE
Sassuolo (Modena) 1577–1660 Bologna

Circle of GIACOMO CAVEDONE

D(NG) 637 Fig. 280

Christ at the pool of Bethesda.

384 × 291. Oil colour on paper. (Laid down.)

PROV: S. Woodburn (according to an inscription on the back); Francis Abbott. Presented 1878.

LIT: *Catalogue: National Gallery of Scotland* (1946), p. 395 (as Veronese).

Neither the former ascription to Veronese, nor a later suggestion that the artist is Domenico Tintoretto, can be maintained. The drawing seems certainly to be Bolognese, 17th century, and, although rather rough and crude, several of the figures have stylistic resemblances to those of Cavedone.

Follower of GIACOMO CAVEDONE

D 1891 B Fig. 281

The Holy Family with St Anne.

100 × 165 (arched top). Pen, black ink and red wash. (Laid down. There is some writing on the verso.)

PROV: Lady Murray. Presented 1860.

IL CERANO
See Giov. Batt. CRESPI.

MICHELANGELO CERQUOZZI
(delle Battaglie a delle Bambocciate)
Rome 1602–1660 Rome

D 1951 Fig. 282

A seated woman with outstretched left hand.

196 × 153. Red chalk heightened with white on buff paper. Old inscription on the mount: 'Michelangelo Cerquozzi detto delle Battaglie 2'.

PROV: (? Allan Ramsay); Lady Murray. Presented 1860.

The old attribution on the mount seems convincing.

GIUSEPPE CESARI
(Il Cavaliere d'Arpino)
Rome 1568–1640 Rome

D 727 Fig. 283

The Virgin of the Immaculate Conception.

303 × 171. Black and red chalk, heightened with white.

PROV: W. Y. Ottley; sale Philipe, London, 6 June 1814, lot 55; Sir Thomas Lawrence; David Laing; Royal Scottish Academy. Transferred 1910.

Probably connected with the painting in the Academia, Madrid (repr. Voss, *Spätrenaissance*, fig. 241), of which two other versions exist (at Seville and at Sanlúcar de Barrameda, all of them repr. in A. E. Perez Sanchez, *Pintura Italiana del Siglo XVII en España* (Madrid, 1965), p. 220, pl. 55). Other related drawings of the *Immaculata* are at Berlin (15271 and 20859).

D 728 Fig. 284

Christ bearing the Cross between St Jerome and St Blaise.

239 × 175. Red and black chalk.

PROV: Jonathan Richardson, Senr (L. 2184); Thomas Hudson; W. Y. Ottley; sale Philipe, London, 6 June 1814, lot 54; Sir Thomas Lawrence; David Laing; Royal Scottish Academy. Transferred 1910.

This impressive drawing is rightly described in the Philipe sale catalogue as having been 'executed with great delicacy'.

D 1950 Fig. 285

An angel.

255 × 137. Black and red chalk.

PROV: (? Allan Ramsay); Lady Murray. Presented 1860.

EXH: Colnaghi, 1966 (23, pl. 11).

D 3027 Fig. 286

A group of eight heads.

168 × 175. Black and red chalk. (Laid down and much rubbed.) Old inscription stuck on mount: 'Caval^r· Giuseppe d'Arpino'.

PROV: W. F. Watson. Bequeathed 1881.

This is a study for the right hand group, including the figure of Christ, in *The Raising of Lazarus* in the Palazzo Barberini, Rome (see R. E. Spear, 'The "Raising of Lazarus"': Caravaggio and the sixteenth century tradition', *Gazette des Beaux-Arts*, February 1965, pp. 65 ff., fig. 2), usually dated *c.* 1590 (see Italo Faldi, 'Gli affreschi della Cappella Contarelli e l'opera giovanile del Cavaliere

d'Arpino', *Bolletino d'Arte* (1953), p. 54). A drawing at Berlin (15273) for a *Raising of Lazarus* may be for the same composition.

Attributed to
GIUSEPPE CESARI

D 1610 Fig. 287

Female head.

192 × 164. Red chalk. (Laid down.)

PROV: There is an unidentified 'paraphe' on the old backing, somewhat similar to the Jabach mark, L. 2959); David Laing; Royal Scottish Academy. Transferred 1910.

LIT: *Catalogue: National Gallery of Scotland* (1946), p. 385 (as Fra Bartolomeo).

Previous ascriptions have ranged from Fra Bartolomeo and Bacchiacca to Raffaelino del Garbo, which shows that it has been considered to be an early 16th century drawing. It seems, however, certain that the draughtsman was an artist of the second half of the century, and Philip Pouncey has suggested the attribution to the Cavaliere d'Arpino. The characteristic outlining and shadowing of the face— probably taken from life—would support this attribution. They recur, for example, in such chalk drawings as the *St John in the Wilderness* at Berlin (15274) and the seated male nude at Basle (382.24).

Ascribed to GIUSEPPE CESARI

D 3087 Fig. 288

A warrior martyr.

233 × 158. Red and black chalk. Squared in red chalk. (Laid down.) Inscribed in lower margin and on the back, in a fairly contemporary hand: *Giuseppe Arpino*.

PROV: Ch. Jourdeuil (L. 527); W. F. Watson. Bequeathed 1881.

It must remain doubtful whether this is in fact an original by Cesari.

D 4890/32 Fig. 289

A child's head.

125 × 107. Pen and brown ink. Traces of black chalk. (Laid down.) Inscribed: *delle p^e cose del Cav^e Giuseppe sotto al P. Dante.*

PROV: Marchese del Carpio; Paul and Edwardo Bosch, Madrid; H. M. Calmann. Purchased 1964.

The P. Dante referred to in the inscription is probably Padre Ignazio Dante, the cartographer, whom Baglione mentions as Cesari's first teacher (*Le vite de' Pittori*, etc. (1733), p. 252). If the drawing is really by Cesari, it must be a very early work.

D 637 Fig. 290

Female figure striding forward with flowing drapery.

227 × 115 (irregularly cut along right margin). Black chalk. Fairly early ascription to Cesari, in faint pencil on the back of the mount.

PROV: David Laing; Royal Scottish Academy. Transferred 1910.

In spite of the inscription, the correctness of the attribution is doubtful. The drawing may possibly be Milanese, by an artist close to Lomazzo.

Circle of GIUSEPPE CESARI

D 1494 Fig. 291

The judgement of Zaleucus.

156 × 229. Pen, brown ink over black chalk. (Laid down, rubbed and damaged in parts.) Inscription 'Beccafumi' on the mount, probably 19th century.

PROV: Paul Sandby; David Laing; Royal Scottish Academy. Transferred 1910.

The ascription to Beccafumi is untenable. As Philip Pouncey has pointed out, the influence of the Cavaliere d'Arpino is apparent, although the figures in the background seem to have been derived from someone like Francesco Salviati.

BARTOLOMEO CESI

Bologna 1556–1629 Bologna

Ascribed to BARTOLOMEO CESI

D 2945 Fig. 292

A centaur.

135 × 78. Pen, brown ink and wash. Old inscriptions on the mount (in same hand as the Palma Giovane drawing D 1627): 'di Bartolomeo Cesi'.

PROV: W. F. Watson. Bequeathed 1881.

The 17th century ascription to Cesi seems extremely doubtful. The drawing appears to be by a Lombard artist, though A. E. Popham has tentatively suggested the name of Palma Giovane.

CARLO CIGNANI

Bologna 1628–1719 Forlì

D 1763 Fig. 293

The Flight into Egypt.

405 × 278. Black chalk. (Laid down.) Inscribed on the mount (?in Richardson's hand): 'Carlo Cinniane'. Lower down, a faint pencilled inscription, probably in a 19th

century hand: 'A study for the large picture painted for the Compt Bighini at Rome by Carlo Cignani'.

PROV: From the Dijonval Collection, according to an inscription on the back; David Laing; Royal Scottish Academy. Transferred 1910.

No painting which corresponds to this drawing has been traced; the altarpiece by Cignani of the same subject in the church of S. Filippo Neri at Forlì is not very close. Neither has a Count Bighini, the patron, been identified. A drawing depicting *The Rest on the Flight to Egypt*, in the same medium, and apparently by the same hand, is in the Albertina, as G. C. Procaccini (S. Div. 210, Suppl., Inv. 15455), whilst another, depicting *Charity*, in the same technique, and with an old attribution to Cignani, is in the Pinacoteca at Brescia.

GIANBETTINO CIGNAROLI

Verona 1706–1770 Verona

D 2891 Fig. 294

Two female figures by a rocky lakeshore.

198 × 287. Pen and brown ink. Traces of black chalk. (Laid down.) Inscribed on the old mount: 'Cignaroli, G. B.'

PROV: Conte di Bardi (L. 336); Sir Charles Bagot; W. F. Watson. Bequeathed 1881.

LUDOVICO DA CIGOLI
(Cardi)

Cigoli 1559–1613 Rome

D 3138 Figs. 295 and 296

(*recto*) The Holy Family with the sleeping St John;
(*verso*) The Holy Family (a figure of St John lightly sketched in).

227 × 171. Recto: Pen, brown ink and wash, over black and red chalk. Verso: Pen and brown ink over red chalk.

PROV: Thomas Dimsdale (L. 2426); W. F. Watson. Bequeathed 1881.

The convincing attribution of this interesting and previously anonymous drawing is due to Philip Pouncey.

Circle of LUDOVICO CIGOLI

D 1596 Fig. 297

The sacrifice of Isaac.

266 × 205. Pen, brown ink and wash. (Damaged in parts and laid down.) 19th century inscription on the back: *Cav. d'Arpino*.

PROV: Lord Francis Granville Leveson Gower, according to inscription on back; David Laing; Royal Scottish Academy. Transferred 1910.

The ascription to the Cavaliere d'Arpino is incorrect. Herwarth Roettgen has drawn attention to the connection of this drawing with one of the frescoes in the Villa Muti at Frascati. He favours an attribution of both drawing and fresco (which shows slight differences) to Cigoli, which however does not seem to be wholly convincing.

It is known that Cigoli was employed on some of the fresco-decorations at the Villa Muti, but the only one that can at present certainly be attributed to him is *Hagar in the Desert* (see G. Chelazzi-Dini, 'Aggiunte e precisazioni al Cigoli e alla sua cerchia', *Paragone*, 167 (1963), p. 59). The remainder seem to have been executed (probably after Cigoli's death in 1613) by a variety of artists, among them the young Pietro da Cortona (see G. Briganti, *Pietro da Cortona* (1962), pp. 153 ff., and E. Schleier, *Paragone*, 171 (1964), pp. 59 f.). Some, at least, were done by Florentine artists who were at that time working in and around Rome.

The *Sacrifice of Isaac*, and its companion the *Creation of Eve*, have been claimed by Longhi (quoted in the catalogue *Mostra del Cigoli* (1959), p. 207) and Briganti (*op. cit.* p. 154) to be from the hand of Passignano. As far as the drawing is concerned this does not seem to be a convincing attribution either. Philip Pouncey has recently made the interesting suggestion that both drawing and fresco are by Agostino Ciampelli (1577–1640), the Florentine artist who was certainly in Rome at that time, and alongside whom, eight or ten years later, Pietro da Cortona worked in S. Bibiana, Rome. This artist had not hitherto been mentioned as working at the Villa Muti.

A comparison of the *Sacrifice of Isaac* fresco with those by Ciampelli in S. Bibiana would seem to make the suggested attribution a plausible one. As for the drawing, features such as the broad silhouette, the coarse pen-work and the types and hair-styles also speak for Ciampelli (Philip Pouncey pointed to a drawing in the Louvre of the *Martyrdom of St John the Evangelist*, Inv. 10232).

Ascribed to LUDOVICO CIGOLI

D 784 Fig. 298

The stoning of St Stephen.

398 × 268. Pen, brown ink and wash, over black chalk. Outlines of figures incised. (Tear across drawing and in corner of upper left margin.)

PROV: David Laing; Royal Scottish Academy. Transferred 1910.

Although A. E. Popham accepted this drawing as an autograph work, according to a note on the mount, it is difficult to see Cigoli's own hand here, a view which is supported by Philip Pouncey and Jacob Bean. The calligraphy, especially of the contours, seems too flimsy and the drawing as a whole rather disorganized. The subject was, of course, a favourite of Cigoli.

ANTONIO CIMATORI
(Visacci)
Urbino c. 1550–1623 Rimini

D 1786 Fig. 299

Draped female head with downcast eyes.

271 × 206. Black chalk, heightened with white on light-yellow toned paper. Inscribed *A.C.V.* (the characteristic Antaldi mark). On the verso: *Raphaele d'Urbino* in a 19th century hand.

PROV: Antaldi (L. 2245); W. Y. Ottley; David Laing; Royal Scottish Academy. Transferred 1910.

The 'Antaldi' initials A.C.V. have been convincingly interpreted by Philip Pouncey as standing for Antonio Cimatori Urbinati. The style certainly suggests a follower of Barocci, and the pose of the head invites direct comparison with similar Madonnas by Barocci himself, e.g. *La Concessione*, Urbino Pinacoteca; *Madonna del Rosario*, S. Rocco, Sinigaglia; and in particular the monochrome sketch in the Ashmolean Museum, Oxford (Cat. no. 94, pl. XXVII). Attention might also be drawn to Annibale Carracci's etching (B. XVIII, p. 187, 10) which is based in turn on one by Barocci (B. XVII, p. 3, 2). Among Cimatori's own works the head of the Madonna in his altarpiece in S. Agostino, Urbino, comes very close to the drawing.

GIOVANNI BATTISTA CIPRIANI
Florence 1727–1785 London

D 653 Fig. 300

Dancing and music-making putti.

149 × 250. Pen, black ink and wash. Traces of black chalk. (Laid down.) Inscribed: 'Cipriani' in a 19th century hand on the mount.

PROV: J. Auldjo; David Laing; Royal Scottish Academy. Transferred 1910.

The traditional attribution to Cipriani may well be correct, although the pen-work seems rather loose compared to his usual style.

D 2901 Fig. 301

Athletes and women watching from rocks.

165 × 190. Pen, black ink and water-colour. Inscribed: 'Cipriani' on the mount. A faint inscription on the back reads: *Persons viewing Foot Racing and other games for prizes.*

PROV: William Esdaile (inscribed: 1802); W. F. Watson. Bequeathed 1881.

D 3018 Fig. 302

Workmen excavating a grave, with a monk deciphering an old tombstone.

180 × 180. Pen and black ink with water-colour.

PROV: W. F. Watson. Bequeathed 1881.

D 3258 Fig. 303

The four seasons.

225 × 305 (cut to an oval). Pen and brown ink. Inscribed on the back in pencil: *Chapron*.

PROV: W. F. Watson. Bequeathed 1881.

This is a characteristic drawing by Cipriani. It was formerly classified as French, owing to the inscription on the back —no doubt a misreading of an older reference to Cipriani.

D 3420 Fig. 304

Sheet of studies, probably for figures at the foot of the Cross. (Drawn on a sheet of letter paper.)

183 × 225. Pen and black ink over black chalk.

PROV: W. F. Watson. Bequeathed 1881.

The studies were drawn on the empty space of a letter of acknowledgement sent to the artist. The inscription reads: 'Mr Hollis presents his compliments to Signor Cipriani, requests his acceptance of this book, and returns him thanks for the loan of the print of the divine Milton. bedford street. Sat. even. dec. 9.' The 'Mr Hollis' was probably Thomas Hollis (1720–74), the antiquary, for whose *Memoirs* Cipriani and Bartolozzi engraved the plates. A previous owner of the drawing worked out that December 9th only fell on a Saturday in 1758 and 1769 and remarked that 'in both years Mr Hollis was in town'!

D 944 Fig. 305

Decorative design of a term.

448 × 295 (paper size). Pen and ink, over black chalk, with water-colour.

PROV: David Laing; Royal Scottish Academy. Transferred 1910.

John Harris identified this and the following drawing as the work of Cipriani. D 944 was published by Sir William Chambers in his *Treatise on the Decorative part of Civil Architecture*, 3rd edition (1791), pl. 51, who says in the text that it illustrates one of 'various ornamental utensils designed for the Earl of Charlemont, for Lord Melbourne, and for decorations in my own house'. Sir John Soane used both designs as a lecture diagram and they are reproduced as plate 46 in his *Lectures on Architecture*, ed. A. T. Bolton (1929).

D 945 Fig. 306

Decorative design of a term.

453 × 304 (paper size). Pen and ink, over black chalk, with water-colour.

PROV: David Laing; Royal Scottish Academy. Transferred 1910.

See note to D 944.

Attributed to

GIOVANNI BATTISTA CIPRIANI

D 693 Fig. 307

Arcadian scene with figures dancing and making music.

194 × 153. Pen, black ink and grey wash, over black chalk.

PROV: David Laing; Royal Scottish Academy. Transferred 1910.

An anonymous suggestion that this is a drawing by Mola cannot be maintained. The style, as well as the subject matter, suggests rather the much later hand of Cipriani.

SEBASTIANO CONCA

Gaeta 1680–1764 Naples

Studio of SEBASTIANO CONCA

RSA 303 Figs. 308 and 309

**(*recto*) Christ healing the lame man;
(*verso*) The Immaculate Conception.**

274 × 199. Recto: black chalk and brown wash; verso: pen, brown ink and wash over black chalk. Inscribed on the mount: 'Sebastiano Conca'.

PROV: J. Auldjo (L. 48); David Laing; Royal Scottish Academy. On loan 1966.

Anthony Clark thinks the two drawings, although revealing similarities to early Conca, look more like feebler efforts of his pupil Corrado Giaquinto or another studio assistant.

JACOPO CONFORTINI

fl. Florence, first half of the 17th century

D 3336 Fig. 310

A youth holding a bowl with a carafe and a glass. (In the lower right corner another study for the hands and the bowl.)

241 × 186. Black and red chalk.

PROV: W. F. Watson. Bequeathed 1881.

LIT: C. and G. Thiem, 'Der Zeichner Jacopo Confortini', *Mitteilungen des Kunsthistorischen Institutes in Florenz*, XI, Heft 2 and 3 (November 1964), pp. 160, 164, fig. 12.

Owing to an inscription 'Joseph pin' on the old mount, the drawing was thought to be by the English painter George Francis Joseph (1764–1846) and had therefore been placed in the boxes among the English drawings. The compiler extracted it from there and transferred it to the Italians, under the provisional ascription 'Circle of Cristofano Allori'. Later, the general stylistic resemblance between the drawing and a black-chalk composition of the *Marriage at Cana* at Hamburg (21255, rep. Thiem, *op. cit.* fig. 2) was noted, and an even closer connection observed with a slightly larger drawing, obviously by the same hand, at Christ Church, Oxford, of *Christ in the house of Simon the Pharisee* (Inv. 1157, Thiem, *op. cit.* fig. 8), where both the servants, on the extreme right and the one behind the figure of Christ, seemed directly related to the figure in D 3336. Both these drawings are in the same medium and in lunette form, as well as bearing an ascription to Giovanni da San Giovanni, which however did not seem very convincing, judging by the authenticated drawings which are known from his hand.

It was Philip Pouncey who, recognizing the stylistic similarity with a chalk drawing of a *Man in oriental dress* n the Pierpont Morgan Library (1955. 4, also as Giovanni da San Giovanni) which bears an old inscription in pen of the name *Confortini* on the back, suggested an attribution of this then hypothetical artist also for D 3336. Thieme-Becker (VII, p. 296) mentions four members of a Tuscan family of painters of that name, but the only one who could be considered here is Jacopo, the younger son of the Pisan painter Matteo Confortini. His only known date was 1617, the year when he was granted citizenship in Florence.

These considerations, as well as the attribution, were confirmed by the discovery by C. and G. Thiem of two lunette frescoes in the refectory of S. Trinita, Florence, which agreed in all respects with the designs on the Hamburg and Christ Church drawings. Furthermore, for us the more relevant fresco of *Christ in the house of Simon* (Thiem, *op. cit.* fig. 7) is inscribed and dated: *JACOBI CONFORTINI OPUS 1631*, in addition to the monogram *J C 1631* at the top.

That Giovanni da San Giovanni did indeed work in the refectory of S. Trinita is known (see O. H. Giglioli, *Giovanni da San Giovanni* (1949), pl. LXX and LXXI), but the document, also published by Giglioli (*op. cit.* p. 192) and cited by the Thiems (*op. cit.* p. 159) states quite explicitly Confortini's commission and authorship of the two frescoes.

Although there are slight differences, it is clear that D 3336 is a study for either, or both, of the servants in the fresco.

D 1619 Fig. 311

Study for a figure of Christ.

288 × 181. Black chalk, heightened with white on brown paper. Two holes near the upper margin. Inscribed on the verso: *Cornelius Schut fe.*

PROV: J. D. Böhm (L. 1442); David Laing; Royal Scottish Academy. Transferred 1910.

The drawing, obviously for an *Ecce Homo*, was indexed among the Flemish drawings, owing to the inscription on the reverse. There can, however, be little doubt that it is Italian, and from the hand of Confortini, an attribution which a comparison with the material published by G. and C. Thiem (*Mitteilungen des Kunsthistorischen Institutes in Florenz*, XI, Heft 2 and 3 (Nov. 1964), pp. 153 ff.) confirms.

Circle of JACOPO CONFORTINI

D 1156 Fig. 312

Musicians playing to a dining couple at an inn.

208 × 285. Pen, brown ink, grey wash, heightened with white. (Laid down.)

PROV: R. Udny; David Laing; Royal Scottish Academy. Transferred 1910.

The drawing was classified as French, but it is quite clearly Florentine, close to Jacopo Confortini, though the drawing is presumably too eccentric and provincial to be from his own hand.

Attributed to
BELASARIO CORENZIO
Greece, c. 1560–after 1640 Naples

D 3095 Fig. 313

The Virgin adoring the Christ Child, surrounded by angels and saints.

450 × 257. Pen, black ink and wash, on blue paper, over black chalk. White heightening oxidized.

PROV: W. F. Watson. Bequeathed 1881.

The tentative attribution of the hitherto anonymous drawing is due to Philip Pouncey. The technique, however, differs from the drawings usually attributed to Corenzio, and the compiler has been wondering whether D 3095 may not turn out to be Genoese. Philip Pouncey has pointed out the derivation of the central group from Lelio Orsi's elaborate drawing of the *Madonna della Ghiara* in the church of the same name at Reggio Emilia (repr. cat. *Mostra del Correggio* (Parma, 1935), p. 168, no. 62; *Mostra di Lelio Orsi* (1950), Disegni 29).

ANTONIO CORREGGIO
(Allegri)
Correggio 1494–1534 Correggio

Copy after ANTONIO CORREGGIO

D 3002

The Agony in the Garden.

301 × 198. Red and black chalk.

PROV: W. F. Watson. Bequeathed 1881.

A weak copy after the painting in Apsley House, London.

PIETRO DA CORTONA

See PIETRO da Cortona.

GIOVANNI FRANCESCO COSTA
?–1773 Venice

RSA 324 Fig. 314

Landscape with an old man with distaff and dressed in woman's clothes (?Vertumnus) and a man leading a mule carrying a dead child.

490 × 350. Pen, brown ink and wash, figures in grey ink and wash. Signed: *COSTA F.* on stone in centre foreground and *Costa* in lower right margin.

PROV: David Laing; Royal Scottish Academy. On loan 1966.

Obviously by the same hand as the two landscapes in the Albertina (I, 392 and 393), the latter also signed in the same manner as RSA 324. It might appear that the figures and the landscape in RSA 324 are from different hands, and not only because of the different medium. J. Byam Shaw has suggested that possibly P. A. Novelli could have drawn the figures.

LORENZO DI CREDI
Florence 1459–1537 Florence

D 642 Figs. 315 and 316

(*recto*) A standing bishop and other figures; (*verso*) Study of a head, and sketches of angels, figures in armour, etc.

285 × 201. Silverpoint, pen and brown ink and wash, on a pink prepared paper. Verso: Pen and wash on the unprepared paper. (Brittle and damaged in parts.)

PROV: David Laing; Royal Scottish Academy. Transferred 1910.

LIT: Vasari Society, 1st Series, VII, 3; *Catalogue: National Gallery of Scotland* (1946), p. 387; Van Marle, *Development of the Italian Schools of Painting*, XI, p. 581; A. Scharf in *Burlington Magazine* (November 1953), p. 352; G. Dalli Regoli, *Lorenzo di Credi* (1966), cat. 14, fig. 52.

EXH: *Drawings of Old Masters*, Royal Academy, 1953 (33, as 'School of Verrocchio'); Colnaghi, 1966 (5, pl. 2).

The two drawings—two sides of one sheet—entered the collection under the name of Lorenzo di Credi. They received the less committal designation 'School of Verrocchio' when they were published in 1912 in one of the Vasari Society's portfolios, the anonymous writer of the text (probably Sidney Colvin) thinking that 'it would be rash to give them a name'. Parker and Byam Shaw adhered to this form of ascription in their catalogue of the 1953 Royal Academy exhibition. Earlier on Van Marle had talked of them as 'two sheets' inspired by Verrocchio's Pistoia altarpiece, or possibly original rough drafts for this painting, while Scharf looked upon the recto not as a preliminary study by Credi but as a copy.

Recto: The full-length figure corresponds closely to the Bishop standing to the right in the altarpiece in the Cathedral at Pistoia (Van Marle, XI, p. 537; G. Passavant, *Andrea del Verrocchio als Maler* (Düsseldorf, 1959), pl. 1). That the Bishop is S. Donato of Arezzo and not S. Zenobio, as had previously been thought, was established when W. R. Valentiner succeeded in identifying the three predella panels of the altarpiece, comprising the small *Annunciation* (Louvre); the *Birth of St John* (Liverpool) and *St Donato and the Publican* (Worcester, Mass.). Furthermore, the altarpiece was put up in honour of the patron Saint of Donato de' Medici, Bishop of Pistoia.

Agreement as to the actual artist (or artists) who painted the panels is still incomplete (for the most convenient summary see Passavant, *op. cit.* pp. 29ff.). What is established by the documents is that the altarpiece was commissioned from Verrocchio, probably in 1475, by the executors of Donato de' Medici's will, and that in 1478/79 the work was almost ready in the workshop; that in 1485 the community of Pistoia complained that the altarpiece had still not been delivered; and that Lorenzo di Credi delivered it—probably before the end of 1486 (Passavant, pp. 32, 38f.).

Vasari attributes the whole altarpiece to Credi (Vasari–Milanesi, IV, 566), probably owing to the fact that when Verrocchio left for Venice in 1485, Lorenzo di Credi apparently took charge of the Florentine workshop and is said to have completed and delivered the work.

This is not the place to reopen once again the question of how much, if anything, of the painting is from Verrocchio's own hand and how much by Credi or other members of Verrocchio's studio. The recto of D 642 is ignored by Passavant, although he discusses all other surviving drawings related to the Pistoia altarpiece (pp. 50 ff. and 238). Like the drawing in the Louvre for the *St John* (455; Berenson 725, fig. 138; Passavant, fig. 8), the Edinburgh *Bishop* is a silverpoint drawing, gone over with pen and

wash, though this was done more heavily and crudely on the recto of D 642 than on the Louvre drawing. The latter has always been given unequivocally to Credi and it can be supposed that the silverpoint drawing on the Edinburgh sheet is also his and has subsequently been gone over and its subtleties largely disfigured. Credi again made use of the figure in the predella now at Worcester.

Verso: The prominent male head among the sketches on the reverse seems to show the same features as that of the Bishop on the front and may possibly have been connected with the composition of this figure. Verrocchio's influence is clearly visible here and even a faint though distinct Leonardesque flavour is discernible, so that an origin from Verrocchio's workshop is without doubt. As the entry in the catalogue of the 1953 Royal Academy exhibition pointed out, the sketches on this side of the sheet, as well as the handwriting, are reminiscent of the so-called 'Verrocchio Sketchbook', whose contents are now scattered among various collections and which Georg Gronau established as the work of Francesco di Simone, another of Verrocchio's pupils (*Jahrbuch der Preussischen Kunstsammlungen* (1896), p. 65). The occurrence of the name 'Simone' among the otherwise largely indecipherable scribbles may have led to suggesting this connection. However, as was also pointed out in the catalogue, the draughtsmanship on the Edinburgh sheet is superior in quality to that found in the Sketchbook, and the preparation of the paper is not the same. Thus although one ought not to associate the name of Credi directly with the verso of D 642, it must have come, like him, from Verrocchio's immediate circle.

GIOVANNI-BATTISTA CRESPI,
called Il Cerano
Cerano (Novara) c. 1557–1633 Milan

D 4898 Fig. 317

Equestrian figure in parade costume.

254 × 200. Black chalk. Inscribed: *di Gio: Battista Crespi detto il Cerano dal luogo in cui nacque.*

PROV: Prof. Gertrud Bing. Bequeathed 1965.

The drawing looks, at first sight, surprising, when compared with the few authenticated drawings by this artist, yet the facial type is very characteristic of his style and makes the old inscription at the bottom of the sheet seem perfectly convincing. This is rather like the hand of Francesco Gaburri, the 18th century Florentine art historian and collector. The figure must have been intended as part of a triumphal procession, for the body-armour, the head-dress and particularly the caparison of the horse, with its dragon-shaped ornaments, could only have been used in a festive parade. No work by Cerano in which this figure actually occurs has yet been traced.

DONATO CRETI
Cremona 1671–1749 Bologna

D 1647 Fig. 318

Studies for a *Holy Family*.

145 × 130. Pen and brown ink. Drawn on the back of the only recorded etching by Bartolomeo Schidone (1560–1616), B. XVIII, p. 206, I, also depicting *The Holy Family*. On the recto, a pencilled inscription: *S : 430.*

PROV: David Laing; Royal Scottish Academy. Transferred 1910.

The ingenious and convincing attribution was put forward by Denis Mahon. It shows the artist, of usually slick and carefully worked drawings, in a very free moment. A drawing in the Uffizi (14178F) of a *Martyrdom of a Female Saint* shows a comparable style (repr. in *Bolletino d'Arte* (April–September 1962), p. 243, fig. 5).

D 2930 Fig. 319

A seated female figure with outstretched left arm, with a plant. (On the verso: very slight pen sketch of a boy's head.)

152 × 128. Pen and ink.

PROV: Earl Spencer (L. 1530); W. F. Watson. Bequeathed 1881.

The hitherto anonymous drawing is entirely characteristic of Creti. Whether the figure has any special significance is not clear. Both the Libyan and Erythrean sibyls are sometimes represented with plants, but these are usually held in the hand.

VINCENZO DANDINI
Florence 1607–1675 Florence

D 1644 Fig. 320

Seated male nude seen from the back. (On the verso: another slight sketch of a seated nude.)

401 × 250. Red chalk. Inscription on back: *Vincenzio Dandini.*

PROV: David Laing; Royal Scottish Academy. Transferred 1910.

The old attribution may well be correct. Dandini was a pupil of Pietro da Cortona, and for a time head of the Academy at Rome.

Attributed to
DANIELE (RICCIARELLI) DA VOLTERRA
Volterra 1509–1566 Rome

D 1771 Fig. 321

Nude male figure with hands over his head as if supporting a load.

385 × 120. Black chalk. The shading has been gone over by a later hand. (Laid down.) Inscribed: *1538* in lower margin. An old inscription in ink, almost competely cut off in the lower left corner, might once have read *Michelangelo*.

PROV: Nicholas Lanier (L. 2885); David Laing; Royal Scottish Academy. Transferred 1910.

A. E. Popham, according to a note on the mount, accepted the attribution to Daniele, which appears to be of fairly recent date, for the drawing entered the collection anonymously. Philip Pouncey, however, suggested that the drawing is nearer to Primaticcio. The Michelangelesque features of the drawing appear to the compiler to speak rather for Daniele.

Copy after DANIELE DA VOLTERRA

D 3148 Fig. 322

Standing Madonna.

308 × 146. Pen, brown ink and wash, heightened with white. (Damaged and laid down.) Inscribed: *Danielle da Volterra*.

PROV: W. F. Watson. Bequeathed 1881.

(Inscribed on back: *Study for the celebrated picture of 'Descent from the Cross' by Daniele da Volterra, destroyed by the French.* This obviously refers to the altarpiece still in Trinità dei Monti, which, however, contains no such figure.)

STEFANO DELLA BELLA
Florence 1610–1664 Florence

D 617 Fig. 323

A fleet outside a fortified harbour.

211 × 456. Pen, brown ink and grey wash over black chalk. Inscribed with the artist's name in left corner (partly cut off); *135* in the centre of lower margin.

PROV: David Laing; Royal Scottish Academy. Transferred 1910.

A rather similar drawing, but showing fewer ships, is in the Louvre (436).

D 778 Fig. 324

A Moorish warrior on horseback.

240 diameter. Pen and brown ink over black chalk. *48* inscribed in lower margin.

PROV: David Laing; Royal Scottish Academy. Transferred 1910.

A drawing for the etching *Cavaliere Negro diretto verso sinistra* (De Vesme 270), one of eleven comprising the *Serie di Cavalieri Negri, Polacchi e Ungheresi* which is thought to have been executed in 1651. The drawing differs from the etching in the landscape background, and the middle and far distances of the etching show a large number of figures, not represented in the drawing.

D 857 Fig. 325

Fortified harbour with shipping.

130 × 201. Pen and brown ink.

PROV: David Laing; Royal Scottish Academy. Transferred 1910.

D 989 Fig. 326

View of the Colosseum and the Arch of Constantine.

198 × 265. Pen and brown ink over black chalk. Pencilled inscription on the back: *di Stefano della Bella*. Inscription, probably *Costantino*, in the lower margin, cut off.

PROV: David Laing; Royal Scottish Academy. Transferred 1910.

The old attribution to della Bella may well be correct. The style seems to be close to the della Bella drawing at Windsor of *The Obsequies of the Emperor Ferdinand* (A. Blunt, *The Drawings of Castiglione and Stefano della Bella at Windsor* (1954), Cat. 7, pl. 1).

D 2258 Fig. 327

Battle scene between soldiers on foot and on horseback.

54 × 137. Pen and brown ink. Inscription on old mount: 'S. Labelle. bien original'.

PROV: W. F. Watson. Bequeathed 1881.

LIT: *Catalogue: National Gallery of Scotland* (1946), p. 385.

RSA 130 Fig. 328

Cavalry skirmish.

101 × 212. Fine brush and wash, with traces of black chalk. Partly erased inscription: *Stepha…Della Bella*, and *m. 38* (in Padre Resta's hand).

PROV: Padre Resta; David Laing; Royal Scottish Academy. On loan 1966.

RSA 2 Fig. 329

Standing female figure with elaborate head-dress.

264 × 177. Pen, ink and grey wash, over black chalk. Partly cut inscription in lower margins. Inscribed on the back in contemporary hand: *Poesia Giocosa/Poesia seria/disegno di Stef...per il ballo.*

PROV: David Laing; Royal Scottish Academy. On loan 1966.

Similar in style and even in facial type to a head at Windsor, also part of a series of figures in fantastic costumes (A. F. Blunt, *Drawings of Castiglione and Stefano della Bella at Windsor* (1954), nos. 24 and 25, plates 11 and 12).

GASPARE DIZIANI
Belluno 1689–1767 Venice

D 754 Fig. 330

The celebration of the Eucharist.

212 × 339. Pen, ink and wash, heightened with white, on brown paper. (Damaged in lower right corner.)

PROV: David Laing; Royal Scottish Academy. Transferred 1910.

The attribution of this formerly anonymous drawing is based on two drawings, one in the Hermitage (38147), which shows the same composition in a freer, and therefore probably earlier state (*Catalogue of Italian Drawings of the 17th and 18th centuries in the Hermitage* (Leningrad, 1961), no. 826, pl. XLV; also L. Salmina, *Disegni veneti del Museo di Leningrado*, Venice, 1964, no. 63); the other, in a private German collection (*Zeichnungen alter Meister aus deutschem Privatbesitz*, Hamburg, October–November 1965, no. 41, pl. 102). It is not surprising to learn that the Leningrad drawing was at one time ascribed to Sebastiano Ricci, for particularly the group of angels at the top is strongly reminiscent of Sebastiano, Diziani's master.

D 1774 Fig. 331

The Virgin and Child appearing to St Anthony Abbot.

215 × 145. Pen, black ink and grey wash over black chalk. A piece of the former mount with an 18th century inscription 'Gaspari Diziani Bellanese' has been preserved.

PROV: David Laing; Royal Scottish Academy. Transferred 1910.

A drawing rather in the style of Sebastiano Ricci.

D 2847 Fig. 332

Battle scene with warrior on horseback.

273 × 370. Pen, black ink and grey wash over red chalk.

PROV: W. F. Watson. Bequeathed 1881.

The convincing attribution of this formerly anonymous drawing is due to Walter Vitzthum.

CARLO DOLCI
Florence 1616–1686 Florence

D 4820 C Fig. 333

A woman reading a book.

293 × 215. Black and red chalk. (Very brittle and damaged paper, laid down.) Old, damaged inscription: *Carolus Dolcius* removed from back.

PROV: Taken from an album, once in the possession of Richard Cooper Senr and Jnr—the engravers and landscape painters. Presented by Miss M. Eyre, 1959.

EXH: Colnaghi, 1966 (35).

A study for the painting of the *Mary Magdalen* in the Galleria Corsini, Florence.

Ascribed to CARLO DOLCI

D 1699 Fig. 334

Head of a young woman.

158 × 133. Red and black chalk. Inscribed: *Carlino Dulce.*

PROV: David Laing; Royal Scottish Academy. Transferred 1910.

The poor quality of the drawing precludes this from being an autograph work.

DOMENICHINO
(Domenico Zampieri)
Bologna 1581–1641 Naples

D 2234 Fig. 335

Portrait head of a young boy.

232 × 197. Black chalk on blue paper, heightened with white. (Laid down.) An old inscription: *Domenichino* in the lower left corner.

PROV: Uvedale Price, according to inscription on back; sale Sotheby, 3 May 1854, no. 72. Bought Spence; W. F. Watson. Bequeathed 1881.

Possibly dating from the period of the S. Cecilia frescoes (c. 1615) in S. Luigi dei Franchesi, Rome.

RSA 8 Fig. 336

River landscape with bridge, buildings and church on opposite bank.

190 × 253. Pen and brown ink; black chalk in one detail. (Laid down.)

PROV: J. Richardson (without his mark, but with characteristic mount and inscription); David Laing; Royal Scottish Academy. On loan 1966.

The attribution to Domenichino, in Richardson's hand, seems fairly convincing.

RSA 341 Fig. 337

Head of a youth.

182 × 150 (irregular). Red and black chalk. (Cut out.) Inscribed on the back: *Domeniquin.*

PROV: David Laing; Royal Scottish Academy. On loan 1966.

It is possible that this rubbed and cut drawing is indeed from Domenichino's hand.

D 1601 Fig. 338

Two winged figures (after Raphael).

174 × 299. Red chalk, with traces of white heightening. Inscribed on recto and verso in pencil: *Domenichino da Raffaelle.*

PROV: Sir Joshua Reynolds; David Laing; Royal Scottish Academy. Transferred 1910.

The two figures occur at the top of Raphael's fresco in the Farnesina, *The Nuptials of Cupid and Psyche.* It is quite likely that the copy is in fact by Domenichino, a drawing he might have made early on during his stay in Rome. Especially the faint sketch of the arm in the right margin lends support to the traditional attribution.

Copies after DOMENICHINO

D 1719 Fig. 339

Hilly river landscape with bathers, and a seated female figure in the foreground.

368 × 504. Pen, brown ink and wash. (Laid down.)

PROV: David Laing; Royal Scottish Academy. Transferred 1910.

A painting of this composition is in the Museum of Fine Arts, Boston, as Annibale Carracci. The composition, and particularly the seated female figure are, however, very characteristic of Domenichino.

D 3040

Madonna and Child with SS. John Evangelist and Petronius.

213 × 137. Pen, brown ink and wash. (Laid down.)

PROV: W. F. Watson. Bequeathed 1881.

Weak copy from the altarpiece for S. Petronio, Bologna, now in the Brera, Milan.

DOMENICO VENEZIANO
See Domenico VENEZIANO.

BATTISTA DOSSI
Ferrara c. 1493–1548 Ferrara

RSA 140 Fig. 340

Mythological scene.

283 × 438. Pen and ink with oxidized white heightening. (Badly damaged and laid down.) The outlines of the three animals on the right are pricked for transfer. Illegible inscription (partly erased) in Padre Resta's hand, with his number *k.30.* Inscribed on the mount: 'Battista Dosso Ferrarese'.

PROV: Padre Resta; Richard Cosway (L. 628); J. Richardson, Senr, according to style of mount and inscription; David Laing; Royal Scottish Academy. On loan 1966.

The subject of this drawing has not been satisfactorily explained. Incidents from the stories of Ganymede or Tityus, which come most readily to mind, do not fit the central action depicted, or the peopled landscape background, or the outsize eagle-like birds on the right. A suggestion which might be put forward is that the scene depicts the Stymphalian lake in Arcadia where Hercules killed the carnivorous birds, as described by Ovid (*Metamorphoses* IX, 187).

DOSSO DOSSI
(Giovanni de Lutero)
Mantua c. 1489–1542 Modena

Studio of DOSSO DOSSI

D 3093 Fig. 341

The Christ Child learning to walk.

208 × 353. Pen, brown ink and wash. Inscribed: *Del Dosso.*

PROV: N. Hone; W. F. Watson. Bequeathed 1881.

The old attribution to Dosso Dossi is unlikely to be correct. Yet one can see how such a drawing links up with Dossi, for its Ferrarese features are fairly prominent. The drawing could conceivably have originated in Dossi's studio.

POMPEO DA FANO
(Morganti)
Fano, fl. 1535–69

D 719 Fig. 342

Scenes of two bound prisoners kneeling before a potentate, and a man being captured by soldiers. (On the verso: a slight sketch of soldiers and a captive.)

97×200. Pen and brown ink, with traces of red and black chalk. Inscribed on the mount: 'Perino del Vaga' and no. '837'.

PROV: Jonathan Richardson, Senr (L. 2183); David Laing; Royal Scottish Academy. Transferred 1910.

The drawing entered the collection under the title 'Sienese School, Sodoma?' with later suggestions such as Perino del Vaga, Cesare da Sesto and 'near to Lorenzo Costa'. The present attribution rests on a comparison with a double sided sheet, depicting four nude warriors in combat, and on the verso horsemen in combat (no. 93 in the exhibition of Old Master Drawings in 1966 at Hal O'Nians, London, where Philip Pouncey recognized the stylistic connection with D 719). The O'Nians drawing has on the recto the inscription (according to John Gere in Federico Zuccaro's hand) *schizzo de mane de pompeo da fano* who was the first teacher of Taddeo Zuccaro.

Another drawing recognized as a da Fano by Philip Pouncey, is at Stockholm (781/1863), representing a couple of soldiers dragging off a prisoner to the left, and on the right a nude man striking out. As A. E. Popham has observed, the group on the left occurs also on the left of an early drawing by Taddeo Zuccaro, probably copying a Polidoro frieze, in the British Museum (BM Raphael, 287).

PAOLO FARINATI
Verona 1524–1606 Verona

RSA 153 Fig. 343

Two equestrian warriors and other fighting figures.

236×434. Pen, brown ink and wash, heightened with white, on blue paper. Inscriptions: *na Tintoret* and *P. Farinato* on the back.

PROV: E. Peart (L. 892); David Laing; Royal Scottish Academy. On loan 1966.

Terence Mullaly points out that the drawing is *en suite* with a sheet at Ottawa (Popham and Fenwick, *Catalogue of European Drawings in the National Gallery of Canada* (1965), no. 32) forming in fact one continuous composition with it, RSA 153 following on the right of the Ottawa drawing. The whole corresponds very closely with part of the fresco-cycle, illustrating the story of Esther and Ahasuerus, executed in 1587 in the palace which is now the Biblioteca Popolare at Verona.

RSA 154 Fig. 344

Phaethon in his chariot.

417×263 (arched top). Pen, ink and wash over black chalk, heightened with white. (Laid down.)

PROV: Sir Peter Lely; David Laing; Royal Scottish Academy. On loan 1966.

The hitherto unattributed drawing is undoubtedly by Paolo Farinati. Terence Mullaly has pointed out that it is a preliminary study for the fresco on the right wall of the Cappella Marogna in S. Paolo, Verona, dated 1565. He further points to another drawing of this composition, more carefully finished, in the Louvre (4851).

RSA 155 Fig. 345

Jupiter and two men with spears (Perseus and Neptune?).

420×295. Pen, ink and brown wash, heightened with white, on ochre prepared paper. Inscribed: *paulo Farinato*.

PROV: Count von Ross (L. 2693); David Laing; Royal Scottish Academy. On loan 1965.

Terence Mullaly has pointed out that this is probably a preliminary study for the fresco in the Villa ex Nichesola at Ponton di S. Ambrogio di Valpolicello, whose theme has not been explained. Two other drawings, of the same subject, are in the Louvre (4902, 4903), both more highly finished.

D 1258 Figs. 346 and 347

(*recto*) Figure of 'Chastity' holding a sieve; (*verso*) Sketches of men with swords chasing dogs; figure of an angel with spear, another figure with a dragon. Various inscriptions (see below).

275×403. Recto: pen and brown ink over black chalk, brown wash, heightened with white on blue paper. Partly gone over and retouched. Verso: black chalk, pen and brown ink and wash. Inscribed: *P. Farinato, 5.2* (in W. Gibson's hand).

PROV: 'P. Crozat'? (L. 474); Sir Peter Lely; Jonathan Richardson, Senr (L. 2184); W. Gibson; David Laing; Royal Scottish Academy. Transferred 1910.

LIT: *Catalogue: National Gallery of Scotland* (1946), p. 388.

Recto: Probably a design for part of a decoration of the interior of a villa, or for a façade.

Verso: It seems doubtful whether these slight sketches have anything to do with Farinati direct, or whether they are from his studio, or from the hand of his son Orazio, as Terence Mullaly suspects.

The transcription of the texts probably reads:

Left: ...este aliquid quam totum / Amittere il Castor che si morde via / i testiculi p salvarsi

Right: il christo risusito da una banda cō il ciel aperto et serafini / dal altra sā filastro vestito da veschevo e san pietro martire / cō una meza madonina il putin in brazo / inalto cō nuovole / Va in nel lougo di Valcalepi / sol bregamascho / il patrō dil cōfalon san / nl [?nicol]

48

Zāper de saveldei de / vel lougo ene [?dove] bertolamio / rigozo fa la fatoria p il sopra (?scritto)

The handwriting seems to be that of Paolo Farinati, though the *gonfalone* referred to in the inscription does not seem to have survived.

D 1598 Fig. 348

Mithridates, King of Pontus.

418×282. Pen, brown ink and wash, heightened with white on blue paper, over black chalk. Squared in white chalk. (Laid down.) No. *107* inscribed in top margin. Inscription: *Mitridate nobilissimamēte / vestito in abito di / combattere. et era. re.*

PROV: Sir Peter Lely; David Laing; Royal Scottish Academy. Transferred 1910.

LIT: *Catalogue: National Gallery of Scotland* (1946), p. 388.

Several similar drawings of emperors are known (for example *Italian Drawings at Windsor*, 299–308). Those that have been identified have turned out to be for single figures in niches on façades. Terence Mullaly dates this sheet *c.* 1560/70.

D 749 Figs. 349 and 350

(recto) Madonna and Child; (verso) The Baptism between a standing bishop and a (?) saint; figure of a putto below.

252×194. Recto: black chalk and brown wash, heightened with white on blue paper. Verso: pen and brown ink. Inscription on verso (in W. Gibson's hand): *P. Farinato 6.*

PROV: Sir Peter Lely; W. Gibson; Jonathan Richardson, Senr (L. 2183); David Laing; Royal Scottish Academy. Transferred 1910.

The recto has been severely rubbed, and some of the contours look as if they have been gone over. The verso is unusual in style for Farinati, but Terence Mullaly has drawn attention to two other drawings executed in the same pen and ink technique: (1) at Frankfurt (477, called Perino del Vaga), first correctly attributed to Farinati by Philip Pouncey, and identified by Terence Mullaly as being a preliminary study of part of the *Massacre of the Innocents* in S. Maria in Organo, Verona, which is dated 1556; (2) a drawing in the Janos Scholz Collection, which is a preliminary idea for the *Assumption* in S. Maria del Paradiso, Verona, which according to the guide books is supposed to be undated, but on which Terence Mullaly has discovered the date 1565.

D 3089 Fig. 351

The Baptism of Christ.

436×331. Pen, brown ink and wash over black chalk, heightened with white on blue faded paper. A strip of *c.* 65 mm on the left and 23 mm at the bottom has been added. (Laid down.)

PROV: 'P. Crozat'? (L. 474); W. F. Watson. Bequeathed 1881.

An inscription in the upper left margin by the last owner ascribes the drawing to Palma Giovane. It appears to be clearly from the hand of Farinati.

D 1577 Figs. 352 and 353

(recto) Madonna and Child under a tree; (verso) Study of a male figure holding an open book; another figure cut off.

277×210. Recto: Pen, brown ink and wash heightened with white on blue paper. Verso: Brush and brown wash. Inscribed (in W. Gibson's hand): *P. Farinato 5.2.*

PROV: Sir Peter Lely; Jonathan Richardson, Senr (L. 2184); W. Gibson; David Laing; Royal Scottish Academy. Transferred 1910.

A late drawing, dating, according to Terence Mullaly, from the 1580s. The verso may be connected with a scheme of decoration for a villa.

D 706 Fig. 354

Five putti playing on the branches of a tree.

227×345. Brush and brown wash over black chalk on yellow-toned paper. (Laid down.) Inscription on the back: *Drawing by Corregio, Par.*

PROV: Sir Peter Lely; David Laing; Royal Scottish Academy. Transferred 1910.

LIT: *Catalogue: National Gallery of Scotland* (1946), p. 388.

A characteristic late drawing, which Terence Mullaly dates after 1590.

D 2983 Fig. 355

The Rest on the Flight to Egypt.

245×273. Brush and wash on yellow-toned paper. (Laid down, and cut all round.)

PROV: W. F. Watson. Bequeathed 1881.

This appears to be a late drawing.

FRANCESCO FERNANDI
See Francesco IMPERIALI.

Attributed to
GIOVANNI DOMENICO FERRETTI
(Giovanni Domenico da Imola)
Florence 1692–c. 1769 Florence

D 1937 Fig. 356

A group of three women.

179 × 154. Black chalk and wash, heightened with white, on toned paper. (Damaged and laid down.) Inscription on back: *felice Nardi*.

PROV: (? Allan Ramsay); Lady Murray. Presented 1860.

The convincing attribution is due to Anthony Clark. The drawing should be compared for style and technique, among others, with the *Bacchanalian Scene* in the Albertina (III, 912), which has a traditional attribution to Ferretti. The composition may be a study for the *Three Marys at the foot of the Cross*.

CIRO FERRI
Rome 1634–1689 Rome

Copy after CIRO FERRI

D 1770 Fig. 357

Caesar preferring his agrarian law.

238 × 307. Pen, brown ink and wash. Faintly squared with black chalk. (Laid down.) 19th century inscription of the artist's name on the mount.

PROV: Charles Rogers; William Esdaile; David Laing; Royal Scottish Academy. Transferred 1910.

LIT: C. Rogers, *A Collection of Prints in imitation of Drawings* (1778), p. 169; Weigel, 31.

Three versions of this composition are known, of which the original is in the collection of the Earl of Leicester at Holkham (Courtauld Neg. 245/48/4). D 1770 was engraved by S. Watts when it was in the Rogers collection (cf. Weigel, *op. cit.*) as an autograph Ciro Ferri. A third, more superficial, copy is at Düsseldorf (1579). The composition seems to go back to Pietro da Cortona, and the drawing is in fact so 'Cortonesque' and more carefully worked than Ferri's usual rather sketchy manner, that Philip Pouncey has suggested it might have originated in Cortona's studio.

Attributed to
GIOVANNI AMBROGIO FIGINO
Milan 1548–1608 Milan

D 1516 Fig. 358

St John the Baptist in the wilderness.

261 × 180. Black chalk and wash, heightened with white on toned paper. (Laid down. Bottom left corner torn off.) Inscribed: *Raphael*.

PROV: 'P. Crozat'? (L. 474); David Laing; Royal Scottish Academy. Transferred 1910.

Philip Pouncey suggested tentatively that this drawing, previously ascribed to Sodoma or his Circle, might possibly be by Figino. The chalk lines and the prepared paper are not unlike some of the drawings in the album of Figino drawings at Windsor (*Italian Drawings at Windsor*, pp. 222 ff.).

SEBASTIANO FLORIGIERO
Conegliano (Udine) 1500–c. 1545 Udine

Ascribed to SEBASTIANO FLORIGIERO

D 4890/46 B Fig. 359

A man, seen from the rear, looking over a parapet.

132 × 74. Black chalk and wash on blue paper. (Top left corner cut off.) Inscribed: *Bastiano flori[giero]*.

PROV: Marchese del Carpio; Paul and Edwardo Bosch, Madrid; H. M. Calmann. Purchased 1964.

The ascription to Florigiero is unlikely to be correct, as the drawing seems to be of the late 16th or early 17th century.

SEBASTIANO FOLLI
Siena 1568–1621 Siena

D 1895 Fig. 360

The Adoration of the Kings.

270 × 185 (arched top). Pen, brown ink and wash on black chalk, heightened with white. Inscribed: *mano di Follo pignori* (?)

PROV: (? Allan Ramsay); Lady Murray. Presented 1860.

Owing to a misreading of the last word of the inscription, the drawing was formerly ascribed to Simone Pignone, a pupil of Furini. This would place the drawing well within the 17th century, whereas it appears to date from a century earlier. Philip Pouncey has suggested that the name of Folli, which is apparently referred to in the inscription, should be respected. The Casolani-like features visible in the drawing would tend to support an attribution to Folli, who was a pupil of Casolani. The style accords well with what is known of Folli's drawings, particularly those published by P. A. Riedl in 'Zu einigen Toskanischen Bozzetti', *Pantheon* 1 (1963), figs. 8 and 9. The shape of the composition suggests a place above a door, perhaps with choir-stalls underneath.

DOMENICO FOSSATI
Venice 1743–1784 Venice

D 994 Fig. 361
Part of the Arch of Titus.

250 × 206. Pen, brown ink and grey wash. (Very damaged and brittle paper.)

PROV: Count Moritz von Fries (L. 2903); David Laing; Royal Scottish Academy. Transferred 1910.

D 995 Fig. 362
'Capriccio' of a ruined circular temple and an aqueduct.

246 × 373. Pen, brown ink and grey wash. Signed and dated: *D°· F¹· del 1775.*

PROV: David Laing; Royal Scottish Academy. Transferred 1910.

D 996 Fig. 363
'Capriccio' of Roman ruins.

383 × 246. Pen, brown ink and grey wash over black chalk. (Damaged and laid down.) Signed: *Domenico Fossati...* Inscribed in the artist's hand: '*15. Varie Ruine antiche fra le quali si vede urna anticha dove si conservano le ceneri, vestibollo di antico Tempio, ed in lontano un arco Trionfale.*'

PROV: David Laing; Royal Scottish Academy. Transferred 1910.

BALDASSARE FRANCESCHINI
(Il Volterrano)
Volterra 1611–1689 Florence

D 1485 Fig. 364
St Zenobius healing the boy.

175 × 120. Pen and black ink over black chalk. (The passage of the boy's face drawn on a piece of paper stuck on.) Inscribed: *del Volterran*, and on the back: *S⁰· Zanobi quando risucito un banbino.*

PROV: David Laing; Royal Scottish Academy. Transferred 1910.

D 1541 Fig. 365
Study for a portrait of Cosimo III.

153 × 104. Red chalk. Inscribed: *del Volterran.*

PROV: (?Paul Sandby); David Laing; Royal Scottish Academy. Transferred 1910.

As Matthias Winner remarked, this appears to be a rather late drawing, and it is therefore probable that the identity of the sitter is indeed Cosimo III, who succeeded in 1670.

He wears the dress of the Order of S. Stefano. What appear to be the identical features occur on a figure on the right of a drawing by Volterrano in the Albertina (III, 651) which is a design for the title page of the Statutes of the Order of S. Stefano.

D 1613 Fig. 366
The mystic marriage of St Catherine.

301 × 212. Pen, brown ink, grey wash over red chalk. 19th century inscription on mount: 'Francesco Volterrano'.

PROV: David Laing; Royal Scottish Academy. Transferred 1910.

Not a particularly good drawing, but the facial types and the rendering of the draperies betray the hand of Volterrano. A closely related drawing is in the Uffizi (3204s) [Gernsheim 12573].

RSA 178 Fig. 367
St Matthew.

183 × 243. Red chalk. Inscribed: *P. Mattys originale.*

PROV: David Laing; Royal Scottish Academy. On loan 1966.

The style of this lunette design is characteristic of Volterrano.

RSA 179 Fig. 368
A grinning face.

146 × 121. Red and black chalk. (Torn and laid down.) Inscribed on the back: *Orig! Di Baldasar Franceschini detto Il Volterrano. Ritratto di una sua Serva.*

PROV: Nathaniel Hone; David Laing; Royal Scottish Academy. On loan 1966.

MARCANTONIO FRANCESCHINI
Bologna 1648–1729 Bologna
Studio of MARCANTONIO FRANCESCHINI

D 3102 Fig. 369
St Sebastian, St Francis with Mary Magdalen and putti in clouds above.

397 × 237. Pen, brown ink, and wash, heightened with white, over black chalk, on grey paper. (Laid down.)

PROV: W. F. Watson. Bequeathed 1881.

There is a 19th century ascription to Ludovico Carracci. The present attribution to the studio of Marcantonio Franceschini, though tentative, seems reasonable. Especially the putto carrying the palm and the figure of the Magdalen are strikingly similar to Franceschini's style. As Dwight Miller has pointed out, there is not quite the crispness of

line and articulation, particularly in the drapery, which one has come to expect from this artist. Miller has suggested that this might possibly be the hand of Luigi Quaini (1643–1717), a less accomplished artist who was a pupil of Franceschini, but as his drawing style is not well known, it is difficult to corroborate this supposition. The strange iconography can only be explained by its being a design for an altarpiece which commemorated a family whose patron saints were the three figures here depicted, or one which was commissioned for a special occasion.

BATTISTA FRANCO
Venice c. 1498–1561 Venice

D 634 Fig. 370

The Resurrection.

214 × 146. Pen and brown ink. Inscribed on the mount: 'B. Franco'.

PROV: J. Pz. Zoomer; Thomas Hudson; Richard Cosway (L. 629); Sir Thomas Lawrence; David Laing; Royal Scottish Academy. Transferred 1910.

LIT: Metz, p. 36; Weigel, 2552.

This is a study for Franco's etching (B. XVI, p. 125, 18). The composition, in reverse, corresponds exactly. Metz engraved it as being 'in the Collection of Rich^d. Cosway Esq., R.A.' but before Cosway's collector's mark was added. The composition is also very close to the artist's lunette over the altar in the Grimani Chapel in S. Francesco della Vigna, Venice, but the drawing was not discussed by W. Rearick in his paper on the chapel ('Battista Franco and the Grimani Chapel', *Saggi e Memorie di Storia dell'Arte*, 2 (1959), p. 127, fig. 12).

D 2893 Fig. 371

A boy with upraised hands.

171 × 205 (largest dimensions, as paper cut to irregular shape). Black chalk. (Cut and laid down.) Inscribed on mount: 'Battista Franco' in Richardson's hand.

PROV: Sir Peter Lely (L. 2092); Jonathan Richardson, Senr (L. 2183); Sir Joshua Reynolds; W. F. Watson. Bequeathed 1881.

LIT: *Fifty Master Drawings in the National Gallery of Scotland* (1961), pl. 17.

EXH: Colnaghi, 1966 (9).

A good and characteristic example of Franco's black chalk technique. It is obviously a pose-study for one of the *Virtues* and *Angels* in the vault of the Grimani Chapel in S. Francesco della Vigna *c.* 1560 (reproduced in W. R. Rearick, 'Battista Franco and the Grimani Chapel', *Saggi e Memorie di Storia dell'Arte*, 2 (Venice, 1959), p. 124, fig. 10e).

D 1590 Fig. 372

God the Father.

292 × 241. Black and red chalk, heightened with white, on blue paper. Inscription on the back: 'In the latter part of his life (Vasari says) Battista finding his expenses at Rome too great for his Inc…that 'tis chargeable living there & he had not much employment, nor a ready Sale for those Pictures he made un…return'd to Venice his Native place, where he made in the Ch: of S. Francesco della Vigna a Picture in Oyl, of our [Lord bap]tized by S. John, above is God the Father of w^ch probably this is the Drawing. Jonathan Richardson.'

PROV: Jonathan Richardson, Senr (L. 2184); Sir Joshua Reynolds; Sir Thomas Lawrence; David Laing; Royal Scottish Academy. Transferred 1910.

This drawing shows the artist, after his return from Rome, in a strongly Venetian vein, and under the influence of Tintoretto. It is a study for the figure of God the Father at the top of the altarpiece of the *Baptism of Christ* in the Barbaro Chapel in S. Francesco della Vigna, Venice, of 1554. (Cf. also D 1591.) The drawing was not mentioned by W. R. Rearick in his discussion of the chapel ('Battista Franco and the Grimani Chapel', *Saggi e Memorie di Storia dell'Arte*, 2 (Venice, 1959)).

D 1591 Fig. 373

The Baptism of Christ.

187 × 215. Pen, brown ink and wash. (Right bottom corner of paper added.)

PROV: (W. Y. Ottley, with his mount); Sir Thomas Lawrence; David Laing; Royal Scottish Academy. Transferred 1910.

LIT: W. R. Rearick, 'Battista Franco and the Grimani Chapel', *Saggi e Memorie di Storia dell'Arte*, 2 (Venice, 1959), p. 115, fig. 5.

As Rearick remarked, this drawing—a preliminary study for the Barbaro Chapel altarpiece in S. Francesco della Vigna, Venice—shows a departure from the linear, 'engraved' style of the early sketches toward a softer chiaroscuro. This is even more noticeable in the other drawing (D 1590) connected with this altarpiece, and the difference in style between these two studies for the same work is truly dramatic.

D 666 Figs. 374 and 375

(*recto*) Drawing of a Roman female statue; also sketches of a boy running and sprawling; (*verso*) Sheet of figure studies (?for a *Rape of the Sabines*).

285 × 212. Pen and brown ink. 19th century inscription: *B. Peruzzi* on recto.

PROV: David Laing; Royal Scottish Academy. Transferred 1910.

The figure copied on the recto is that of the *Priestess of Romulus* in the Loggia dei Lanzi, Florence (cf. C. Fabriczy, *Archivio storico dell'Arte* (1893), VI, 110ff.). In spite of the 19th century inscription of Peruzzi's name, the drawing entered the collection under the convincing attribution of Battista Franco. A collection of similar drawings of copies from the antique, *Il libro di Contrafazioni*, is in the Biblioteca Reale at Turin. As Franco's earliest artistic activity seems to have been the copying of antique sculpture—almost invariably done in ink—it seems reasonable therefore to date this drawing, with the others, before 1530. See also D1592.

D 1592 Fig. 376

Sheet of studies with figures (after the antique) and animals, of which some are symbolical of the Evangelists. In the extreme left corner: part of a ?*Deposition*.

114 × 205. Pen, brown ink. (Cut and laid down.)

PROV: (W. Y. Ottley, with his mount); Sir Thomas Lawrence; sale Sotheby, 10 May 1838, lot 101; David Laing; Royal Scottish Academy. Transferred 1910.

Similar in style to D 666, and also presumably an early drawing. The figures come almost certainly from a Bacchic relief.

D 1653 Fig. 377

Sheet of studies with soldiers battling, and a single crouching figure in the lower right corner.

372 × 301. Black chalk, ? on toned paper. (Very damaged and laid down. The sheet must have been cut horizontally at one time and re-assembled.) Faint inscription on the back: *M. Angelo*.

PROV: Sir Thomas Lawrence; Woodburn sale, 4 June 1860, lot 155(6).

The attribution was first suggested by A. E. Popham, and confirmed by W. R. Rearick.

RSA 177 Fig. 378

Sheet of animal studies.

242 × 399 (irregular). Pen, brown ink and wash. (Damaged, cut and laid down.) Inscribed on the mount: 'Battista Franco'.

PROV: Lord Spencer; (J. Richardson, according to inscription and style of mount); W. Esdaile; W. Thane (according to inscription); David Laing; Royal Scottish Academy. On loan 1966.

The attribution to Franco, by Richardson, is correct.

RSA 306 Fig. 379

Study of a hooded head.

93 × 65. Pen and brown ink.

PROV: David Laing; Royal Scottish Academy. On loan 1966.

This hitherto unattributed drawing seems certainly to be by Battista Franco.

D 761 Fig. 380

Constantine offering the city of Rome to the pope (after Giulio Romano).

405 × 576. Pen, brown ink and wash. (Laid down and very damaged.) Inscription in Richardson's hand on mount: 'Battista Franco apresso Rafaelle', and the relevant section from Vasari's life of Giulio Romano on the back.

PROV: Jonathan Richardson, Senr (L. 2170); David Laing; Royal Scottish Academy. Transferred 1910.

Study by Franco for his etching (B. XVI, p. 137, 55, in reverse), after the fresco in the Sala del Costantino in the Vatican.

Ascribed to BATTISTA FRANCO

D 3140 Fig. 381

A seated soldier.

265 × 218. Pen, brown ink and light grey wash, over faint black chalk. (Top left hand corner added.) Old inscription: *Bat. Franco.*

PROV: W. F. Watson. Bequeathed 1881.

The traditional attribution appears rather strange. On the other hand, such elongated lines of the contours, interspersed with rather shorter, sketchy strokes—mainly in the drapery parts—occur on such drawings as for example *The Hunt* in the Louvre (4942), also done in pen and light wash over a rapid chalk sketch.

Attributed to
ANTONIO DOMENICO GABBIANI

Florence 1652–1726 Florence

D 2940 Fig. 382

God the Father supported by angels.

218 × 227. Red chalk. (Tear in the middle of the drawing.)

PROV: Jonathan Richardson, Jnr; W. F. Watson. Bequeathed 1881.

The attribution of this hitherto anonymous drawing is due to Philip Pouncey. Comparison should be made with a drawing by Gabbiani at Lille (1642) of *The Madonna and Child with angels*. The style of this pupil of Ciro Ferri reflects the last faint echoes of the Pietro da Cortona tradition.

RSA 145 Fig. 383

Male head.

112 × 88. Black chalk, on blue paper. Inscribed on the old backing: *Gabbiani nº 11122.*

PROV: David Laing; Royal Scottish Academy. On loan 1966.

SEBASTIANO GALEOTTI
Florence 1676–1746 Vico (Mondovì)

D 1319 Fig. 384

The triumph of Venus.

323 × 396. Pen, brown ink and grey wash, on yellowish toned paper. Inscribed on the back in pencil: *di Sebastiº· Galeotti*, and *28 Maggio 1830* (the date of acquisition by a previous owner).

PROV: David Laing; Royal Scottish Academy. Transferred 1910.

The design of this drawing is very close to the main portion of the ceiling-decoration in the Palazzo Porto-Breganze at Vicenza (N. Carboneri, *Sebastiano Galeotti* (Venice, 1955), pls. 15 and 17). Walter Vitzthum has drawn attention to a drawing in similar style at the Louvre (18.199) which has a contemporary inscription of the artist's name.

RSA 291 Fig. 385

Study of a seated male nude.

428 × 318. Black chalk, heightened with white on toned paper. Inscribed on the back: *Sebastⁿº Galeotti*, and *21.Xember 1833.*

PROV: David Laing; Royal Scottish Academy. On loan 1966.

GASPARO GALLIARI
Treviglio c. 1760–1818 Milan

D 823 Fig. 386

A Roman chariot race.

322 × 470. Pen, brown ink and wash over black chalk. (Laid down.)

PROV: David Laing; Royal Scottish Academy. Transferred 1910.

The attribution is the traditional one and seems convincing.

DOMENICO GARGIULIO
See Micco SPADARO.

GIOVANNI BATTISTA GAULLI
(Bacciccio)
Genoa 1639–1709 Rome

RSA 144 Fig. 387

Study of a head and hand. (On the verso: studies of praying hands, etc.)

265 × 234. Red chalk, heightened with white. Inscribed in pen: *Gio: Battista Gauli detto il Bacciccio.*

PROV: Sir Thomas Lawrence; David Laing; Royal Scottish Academy. On loan 1966.

GIROLAMO GENGA
Urbino 1467–1551 Urbino

D 1569 Figs. 388 and 389

(*recto*) The Risen Christ;
(*verso*) Small sketch of a horse's head, and inscription (see below).

406 × 265. Recto: red chalk. Verso: ink. (Paper torn and damaged.) Inscribed: *Raffaelle*; on verso: *Hiʳº Ginga inᵛ·.*

PROV: David Laing; Royal Scottish Academy. Transferred 1910.

LIT: BM Raphael, p. 159; A. M. Petrioli, 'La "Resurrezione" del Genga in Santa Caterina a Strada Giulia', *Paragone*, no. 177 (1964), fig. 56.

The attribution to Genga and the identification of the recto as a preliminary study for the top part of the altarpiece in the Oratory of S. Caterina da Siena in the Via Giulia, Rome, is due to Philip Pouncey, confirmed by the subsequent uncovering of the inscription on the verso. The altarpiece, commissioned by Agostino Chigi, can be dated *c*. 1519, the year in which the church was consecrated. This represents a *terminus ante quem* for the drawing, which is one of the few by Genga which can be connected with a known painting. The little sketch on the verso of a horse's head is highly characteristic of Genga, and appears in many of his drawings—for example Louvre 10469 and 10514. Interesting is the mention of Peruzzi in the last line of the inscription.

> 'Ricordo andare a doⁿ Gironimo...nioner
> Ricordo andar al messer Gironimo...
> Ricordo andar a mº Guido p̃ il Gruppo...
> pro antonio darlo portar...a casa di...
> in volti ne sciughatoio cō la scuffia
> Ricordo far̄ portare il materazzo al patrone
> Ricordo parlare a baldasare da Siena.'

GENTILE DA FABRIANO

Fabriano c. 1370–1427 Rome

D 2259 Fig. 390

Christ and St Peter. (On the verso: slight sketch of drapery.)

182 × 129. Pen and ink on vellum. Inscribed on verso: *Lorenzo Ghiberti.*

PROV: (W. Y. Ottley (cat. 602) according to Roscoe sale catalogue); William Roscoe; sale Liverpool, 23 September 1816, no. 18 as Ghiberti. Bought Ford, Manchester; W. B. Johnstone, according to pencilled initials on verso; W. F. Watson. Bequeathed 1881.

LIT: Vasari Society, 1st Series, VII, no. 7; Van Marle, VIII, 16; *Catalogue: National Gallery of Scotland* (1946), p. 392 (as Pisanello ?).

EXH: *Old Master Drawings*, Royal Academy, London, 1953 (4); Colnaghi, 1966 (1, pl. 1).

The attribution to Ghiberti was accepted by W. F. Watson, for the inscription on the back is in his hand, and is not surprising, considering the strongly sculptural quality of the figures. When the drawing entered the Gallery's collection a tentative ascription to Pisanello was also suggested. Campbell Dodgson, in his note in the Vasari Society, was the first to suggest the name of Gentile in connection with this drawing, linking it with a similar double-sided sheet—also on vellum—in Berlin (Z 5164). The recto of the Berlin drawing shows a standing *St Paul*, with book and sword held upright, and with features which come close to a Gentile face. The verso represents a seated woman, perhaps a *Madonna of the Annunciation* (repr. L. Grassi, *I Disegni Italiani del Trecento a Quattrocento* (Venice, 1961), no. 18). Both D 2259 and the Berlin sheet seem certainly to be by the same hand, particularly in the treatment of the drapery, although the strong emphasis of the folds of the cloak held by the figure of St Paul gives the Berlin drawing a more 'Gothic' look than the more restrained fall of the drapery in the Edinburgh drawing.

A strikingly similar handling of the drapery can be noted in Gentile's panel of the *Madonna and Child with St Nicholas and St Catherine* at Berlin (1130).

Whilst it is impossible to be absolutely certain that a sheet like D 2259 is in fact by the hand of Gentile himself, one might feel confident enough of his presiding genius to head the entry with his name.

FILIPPO GERMISONI

1684–1743 Rome

D 1671 Fig. 391

Portrait of Salvator Rosa.

360 × 246. Black chalk (portrait part in red chalk) heightened with white on prepared paper. Inscription: *SALVATOR*

ROSA | NEAPOLITANUS PICTOR | ET ORATOR NATUS | ANNO DOMINI MDCXV OBIIT | ANNO MDCLXXIII.

PROV: N. Pio; P. Crozat and G. Huquier (according to inscriptions in Dutch on the back of the old mount: 'door Carlo Maratti Eertijds uit Crozats Kabinet. Nu N.ʳ 105 uit Huquiers verk[oop] te Amst[erdam] in Sept. 1761.'); David Laing; Royal Scottish Academy. Transferred 1910.

LIT: A. M. Clark, 'The Portraits of Artists drawn for Nicola Pio', *Master Drawings*, V, 1 (1967), no. 194, p. 13.

The correct attribution of the drawing, formerly given to Maratta, is due to Anthony M. Clark, who recognized that this drawing must be part of the series of portraits and self-portraits commissioned by Nicola Pio to illustrate his series of artists' biographies. (See A. M. Clark, 'Imperiali', *Burlington Magazine* (May, 1964), pp. 226ff.). The Imperiali *Self-portrait* (D. 1930) also belongs to this series.

The name of Maratta had got attached to this drawing because of the inscription on the back, and the same applies to yet another drawing, obviously also for this series: the portrait of Correggio in the Albertina (III, 774). In neither case is the ascription tenable. Anthony Clark has drawn attention to other portrait drawings at Stockholm (where the bulk of the Pio drawings went) and elsewhere which are in the same medium, of the same format and by the same hand.

ALESSANDRO GHERARDINI

Florence 1655–1723 Livorno

D 2973 Figs. 392 and 393

(*recto*) The beheading of St John the Baptist; (*verso*) A kneeling figure, and a standing woman.

195 × 200. Recto: Pen, brown ink, grey wash and black chalk. Verso: Brush and grey wash over black chalk. Old label stuck to the lower margin: *Di Alessandro Ghelardini.*

PROV: PM, i.e. probably Florentine 18th century collection (L. 2099, see also Supplément); W. F. Watson. Bequeathed 1881.

The traditional attribution seems plausible. For a comparison the drawing of a *Martyrdom* in the Uffizi (15396F) might be cited.

PIER-LEONE GHEZZI

Rome 1674–1755 Rome

RSA 132 Fig. 394

Caricature portrait of a gentleman.

318 × 220. Pen and ink. Inscribed on the back: *Giovanni Bravetta. Caricatura d.ᵉˡ Sig.ʳ Cav.ˡ Ghezzi.*

Nothing seems to be known about Sig. Bravetta. Judging from the drawing, he may have been a local landlord in the Roman *colli* with an interest in viniculture.

GIACINTO GIMIGNANI

Pistoia 1611–1681 Rome

D 695 Fig. 395

Christ and the woman of Samaria.

276 × 190. Pen, brown ink and light wash over black chalk. Squared in black chalk. (Laid down.) Old inscription: *Albani*.

PROV: Charles, 15th Earl of Shrewsbury (L. 2688); David Laing; Royal Scottish Academy. Transferred 1910.

It is not clear who proposed the present attribution. A similar composition occurs in Gimignani's painting *Rebecca at the Well* (Pitti). There are faint Poussinesque echoes in this drawing, and Gimignani studied with Poussin when he first came to Rome. The handling of the drapery and the disposition of light and shade should be compared with the drawing of *Rebecca and Eliezar* in the Fogg Museum, which is also attributed to Gimignani (Mongan and Sachs, *Drawings in the Fogg Museum* (1946), no. 254, pl. 129).

LUDOVICO GIMIGNANI

Rome 1643–1697 Zagarola

D 3051 Fig. 396

Madonna and Child with St John.

162 × 233. Pen, black ink over black chalk on discoloured blue paper. Old label: *di Lodovico Gimignani*.

PROV: PM, i.e. probably Florentine 18th century collection (L. 2099); W. F. Watson. Bequeathed 1881.

ANTONIO GIONIMA

Venice 1697–1732 Bologna

D 660 Fig. 397

The Madonna and Child appearing to St Roch.

383 × 257. Pen, brown ink and wash over black chalk. Some traces of white chalk heightening. Old inscription on mount: 'Gionima'; on the back: *Ludovico Carracci 981*.

PROV: David Laing; Royal Scottish Academy. Transferred 1910.

LIT: Ashmolean Cat. no. 1005, pl. CCXIII.

A drawing at Oxford shows the same composition in a more elaborate state. It is more carefully composed and the three cherubs' heads in the upper left corner are as yet only very faintly indicated in the Edinburgh drawing. Parker

draws attention to a drawing by Gionima of the *Martyrdom of St Isias*, signed and dated 1725, which shows a similar technique (repr. Catal. *Mostra del Settecento Bolognese* (Bologna, 1935), p. 17, pl. LXV).

LUCA GIORDANO

Naples 1632–1705 Naples

D 714 Figs. 398 and 399

(*recto*) Pluto and Proserpina;
(*verso*) Sketches of putti and a garlanded bull.

243 × 302. Pen and black ink over red chalk. Inscribed in lower right corner: *Luca Giordano*, as well as across the back.

PROV: David Laing; Royal Scottish Academy. Transferred 1910.

It is possible that the two figures on the recto represent a preliminary study for a similar group in the fresco of mythological scenes which Luca Giordano executed in the Palazzo Riccardi-Medici at Florence between 1682 and 1683. The oil sketch for this fresco is in the collection of Denis Mahon (Catal. *Italian Art and Britain*, Royal Academy (London, 1960), no. 357). Walter Vitzthum has drawn attention to a drawing in a similar style at Naples, obviously dating from the same period and representing *Deianira and Nessus*.

D 1202 Fig. 400

The embarkation of the Queen of Sheba.

168 × 231. Pen and black ink, red wash, over red chalk. Some of the outlines incised. Inscribed: *Jordaens* on the old backing.

PROV: David Laing; Royal Scottish Academy. Transferred 1910.

The attribution, presumably intending to refer to Luca Giordano, may well be correct. If not from his own hand, the drawing must have originated within his immediate circle.

RSA 310 Fig. 401

Adam and Eve expelled by the angel (over sketch of a male torso). (On the verso: study of a male nude.)

192 × 197. Recto: pen and black ink, over red chalk. Verso: red chalk. Inscribed in pencil: *Jordaens*.

PROV: David Laing; Royal Scottish Academy. On loan 1966.

RSA 180 Fig. 402

Joseph and the sacks of corn.

265 × 381. Pen, brown ink and wash over black chalk. (Laid down.) Inscribed on the back: *Luca Giordano di Napoli*.

PROV: David Laing; Royal Scottish Academy. On loan 1966.

Attributed to
GIOVANNI DA SAN GIOVANNI
(Mannozzi)
S. Giovanni Valdarno 1592–1636 Florence

D 2907 Fig. 403

Head of a youth with open mouth.

229 × 165. Red chalk on buff paper. Initials *M. A.* in red chalk on the back.

PROV: W. F. Watson. Bequeathed 1881.

If not by Giovanni da San Giovanni himself, the drawing probably originated from his immediate circle.

Studio of GIOVANNI DA SAN GIOVANNI

D 3211 Fig. 404

An allegory.

380 × 570. Brush and reddish-brown wash, heightened with white. Squared in black chalk.

PROV: Sir Peter Lely; Sir Joshua Reynolds; W. Y. Ottley (from type of mount); Sir Thomas Lawrence; W. F. Watson. Bequeathed 1881.

The attribution to Giovanni da San Giovanni is in Ottley's hand on his characteristic mount. Though the drawing is not from Giovanni's own hand, the somewhat bizarre composition might well be his. However, Baldinucci, in his biography of the artist, does not appear to mention such an allegorical subject.

The iconography is unexplained, although it may have a political significance, if the crown and sceptre held by the smaller blindfolded putto refer to the Dukes or Grand Dukes of Tuscany. The two blindfolded winged figures must represent 'Ill-Fortune' and the one on the right, with ass's ears, either 'Ignorance', 'Arrogance' or 'Ignobility'. The whole may depict the rescue of 'Virtue' from the onslaught of various Vices, similar to the subject of Andrea Andreani's chiaroscuro woodcut of 1585 after Ligozzi (B. XII, p. 130, 9), which also has political undertones.

Circle of GIOVANNI DA SAN GIOVANNI

D 1913 Fig. 405

Woman with a lute and an open book.

184 × 134. Red chalk. (Laid down.) Old inscription on mount: 'Orazio Gentileschi'.

PROV: (? Allan Ramsay); Lady Murray. Presented 1860.

The old ascription to Gentileschi is not convincing. The red-chalk technique and easy charm point to an artist around Giovanni da San Giovanni, or Furini, or even to Cecco Bravo in a more substantial manner.

GIOVANNI DA UDINE
(Nanni or Recamatori)
Udine 1487–1561 (or 4) Rome

Copies after GIOVANNI DA UDINE

D 644 Fig. 406

Satyr and two nymphs.

322 × 254. Pen, brown ink over black chalk. (Laid down.) Inscribed: *Bachio Bandinelli*. Another inscription erased from the lower left margin, and a further contemporary inscription, in the top margin, begins: *porta la testa…*

PROV: David Laing: Royal Scottish Academy. Transferred 1910.

This appears to be a contemporary copy, perhaps after a drawing, of the decorations on the pilasters of the *Loggie*.

D 930

Sheet of ornaments and grotesques.

316 × 215. Pen, brown ink and wash. (Laid down. Two large tears in lower margin.) Inscription: *Polidoro*.

PROV: David Laing; Royal Scottish Academy. Transferred 1910.

These are late 16th or early 17th century copies from the decorations of the Upper *Loggie* in the Vatican.

GIULIO ROMANO
(Pippi)
Rome 1499–1546 Mantua

D 4827 Figs. 407 and 408

(*recto*) Amorini round a wine-press; (*verso*) A female figure, a female and a satyr (illegible inscription).

268 × 412. Pen, brown ink, traces of black chalk on the central figure. Inscribed on mount: 'Raffaello'.

PROV: Sir Peter Lely; Jonathan Richardson, Senr; John Barnard; William Esdaile; sale Sotheby, 11 May 1960, lot 6, as 'School of Raphael'; H. M. Calmann. Purchased 1960.

The composition has not been connected with any known work, but the theme of disporting putti and amorini was a favourite one in the circle around Raphael (cf. the tondo in the National Gallery, Washington, no. 1151) and especially with Giulio himself (cf. the drawing at Chatsworth *The Erotes of Philostratus*, no. 107, repr. F. Hartt, *Giulio Romano* (1958), fig. 354, which Hartt connects with the decorations in the Palazzo del Te, Mantua, around 1532). D 4827 appears, however, to be an earlier drawing and shows Giulio's characteristic wiry pen style.

D 4890/43 Fig. 409

Ornamental scroll-work of acanthus leaves with a putto and a bull.

100 × 160. Pen and brown ink. (Laid down.) Inscribed: *Giulio Romano*.

PROV: Marchese del Carpio; Paul and Edwardo Bosch, Madrid; H. M. Calmann. Purchased 1964.

Copies *after* GIULIO ROMANO

D 3083 Fig. 410

Battle scene.

265 × 337. Pen, brown ink and wash, heightened with white. Squared in black chalk. (Laid down.) Inscribed: *Giulio Romano*.

PROV: Charles Rogers; W. F. Watson. Bequeathed 1881.

The background figures on horseback, though not those in the foreground, are identical with one of the battle scenes which adorn the Loggia della Grotta in the Palazzo del Te (Hartt, *Giulio Romano*, fig. 279). It is possible that this copy is from a lost drawing rather than from part of the fresco.

D 2932

Battle scene.

357 × 306. Pen, brown ink and wash over black chalk. (Damaged in parts.)

PROV: W. F. Watson. Bequeathed 1881.

Possibly copied from a Giulio composition.

D 3193 Fig. 411

Christ feeding the multitude.

284 × 415. Pen, brown ink, heightened with white, on brown prepared paper. (Repaired and laid down.)

PROV: E. Peart; F. Abbott; W. F. Watson. Bequeathed 1881.

Possibly copied from a Giulio composition.

D 3075 Fig. 412

Figures entering a banqueting hall.

397 × 291. Pen, brush and wash, heightened with white on brown prepared paper. (Laid down.)

PROV: W. F. Watson. Bequeathed 1881.

No corresponding composition by Giulio has been traced, though this drawing must be a copy after him. The scene and the architecture with niches is very close to some of those occurring in the designs for the tapestries illustrating the *Triumph of Scipio* (see F. Hartt, *Giulio Romano*, figs. 478 and 482).

D 628

The hunting of the Calydonian boar.

265 × 413. Black chalk. (Laid down.) Inscribed in ink in lower right margin: *M. D. C.^{gio}* (i.e. Michelangelo da Caravaggio?) and 'Polidoro' on the mount.

PROV: Nicholas Lanier (L. 2885); David Laing; Royal Scottish Academy. Transferred 1910.

LIT: BM Raphael, pp. 64 f.

A feeble copy after the engraving by Francis Lonsing (1772).

D 3224

Two music-making fauns.

196 × 183. Pen, brown ink, over black chalk. (Laid down.) Inscribed: *N. Poussin*.

PROV: 'P. Crozat'? (L. 474); W. F. Watson. Bequeathed 1881.

Copies of the two outer figures in a drawing by Giulio Romano in the Albertina (III, 84), probably copied not from the drawing, but from Agostino Veneziano's engraving of it.

Follower *of* GIULIO ROMANO

RSA 279 Fig. 413

Warriors being offered a libation by a priest.

275 × 420. Pen, brown ink and wash. Inscription on back: *Scha...*

PROV: David Laing; Royal Scottish Academy. On loan 1966.

The influence of Giulio Romano (for example in the kneeling figure on the right) is evident, but the drawing is probably by a 17th century artist.

BENOZZO GOZZOLI

Florence 1420–1497 Pistoia

D 1249 Fig. 414

A standing bearded man leaning on a staff.

163 × 67. Pen, brown ink, heightened with white (oxidized) on pink-toned paper. (Laid down.)

PROV: David Laing; Royal Scottish Academy. Transferred 1910.

LIT: Berenson, 533A; *Catalogue: National Gallery of Scotland* (1946), p. 388; *Fifty Master Drawings in the National Gallery of Scotland* (1961), no. 2.

Berenson quoted the correct inventory number and the description of the medium, but obviously confused the subject with that of the drawing attributed to Granacci, D 680 (see following entry).

It is a study for the figure of Isaac, standing in front of the right pier of the archway, in Gozzoli's fresco depicting *The Birth of Jacob and Esau* in the Campo Santo at Pisa. The double lines at the bottom and in the lower part of the right margin are characteristic additions occurring on drawings which belonged to Vasari, and it is possible that this drawing was at one time in his collection.

Attributed to
FRANCESCO GRANACCI
Florence 1477–1543 Florence

D 680 Fig. 415

A kneeling saint.

136 × 84. Silverpoint, heightened with white on prepared paper.

PROV: Jonathan Richardson, Senr (L. 2184); David Laing; Royal Scottish Academy. Transferred 1910.

LIT: Berenson, 533A; *Catalogue: National Gallery of Scotland* (1946), p. 389, as 'Italian School, 15th Century'.

EXH: Colnaghi, 1966 (3).

For the confusing entry in Berenson, see D 1249 (previous entry). The attribution to Granacci was first tentatively suggested by A. E. Popham. If it is correct, then the drawing must be from the early Ghirlandaiesque phase of the artist, as later on Granacci's figures became much more elongated.

ERCOLE GRAZIANI, the Younger
Bologna 1688–1765 Bologna

D 1790 Fig. 416

The martyrdom of SS. George and Alexandra.

325 × 215. Black chalk and light brown wash. Inscribed on the mount: 'Ercole Graziani'.

PROV: David Laing; Royal Scottish Academy. Transferred 1910.

LIT: R. Roli, 'Ercole Graziani', *Arte Antica e Moderna*, no. 22 (April–June 1963), p. 169, fig. 68c.

The old attribution is correct. As Roli pointed out, the drawing is a preliminary study for the altarpiece in the Duomo at Ferrara (unveiled in 1735). Apart from the two protagonists, every other figure was changed in the finished painting, and the tower in the background was omitted. It is interesting to note the influence of Donato Creti, Graziani's master, in this drawing.

RSA 288 Fig. 417

Self-portrait.

436 × 302. Black and red chalk, heightened with white. (Laid down.) Inscribed: ...*Graziani suo Rit*°·

PROV: David Laing; Royal Scottish Academy. On loan 1966.

Owing to the mutilation of the inscription, it is impossible to say for certain which Graziani is represented here, and it was assumed that on stylistic grounds it must be Ercole the Younger.

GIOVANNI FRANCESCO
GRIMALDI
Bologna 1606–1680 Rome

D 625 Fig. 418

River landscape with fishermen and lute-players in a boat.

345 × 522. Pen, brown ink and wash. (Laid down.)

PROV: John Barnard; Paul Sandby; Lord Eldin (sale Edinburgh, 14–29 March 1833, no. 588); David Laing; Royal Scottish Academy. Transferred 1910.

Study for the engraving after Titian (B. XIX, p. 116, 54).

RSA 128 Fig. 419

Buildings and bridge by a river. (On verso: red chalk offprint of an *Aeneas and Anchises* group.)

204 × 238. Pen and ink. Inscribed on the back in pencil: *F. G. Bolognese*.

PROV: David Laing; Royal Scottish Academy. On loan 1966.

RSA 159 Fig. 420

Landscape with three figures under a tree.

275 × 232. Pen and ink over black chalk, with blue tinted sky (probably by a later hand). Inscribed on back: *Gio Francesco Grimaldi called 'Il Bolognese'*.

PROV: David Laing; Royal Scottish Academy. On loan 1966.

RSA 269 Fig. 421

River landscape with bathers, in the background a mill, a temple and a large villa on a hill.

366 × 489. Pen and brown ink, over black chalk. (Lower left corner torn and laid down.) Inscribed at top *514*.

PROV: David Laing; Royal Scottish Academy. On loan 1966.

The formerly unattributed drawing seems certainly to be by Grimaldi.

D 641 Figs. 422 and 423

(*recto*) Landscape with castle on a lake; (*verso*) Similar composition.

135 × 273. Pen and brown ink. Verso: *idem* with wash.

PROV: David Laing; Royal Scottish Academy. Transferred 1910.

At one time tentatively ascribed to Agostino Carracci. There can be little doubt that the present attribution is the correct one.

D 676 Fig. 424

Hilly landscape with a town near a river.

304 × 523. Brown and black ink and chalk.

PROV: David Laing; Royal Scottish Academy. Transferred 1910.

D 691 Fig. 425

Rocky river landscape with four figures on the left.

206 × 299. Pen and brown ink. Inscribed on the mount: 'Bolognese', and on the back: *1st Day. Lt 21.*

PROV: William Esdaile; David Laing; Royal Scottish Academy. Transferred 1910.

D 1001 Fig. 426

View of a walled town.

273 × 399. Pen and brown ink. (Laid down.) Inscribed on the 19th century mount: 'Annibale Carracci'.

PROV: N. Hone; John Barnard (L. 1419) on the back of the mount; David Laing; Royal Scottish Academy. Transferred 1910.

The ascription to Annibale appears to have been made by Barnard, but cannot be maintained. The broad pen strokes, the rather schematic hatching point to Grimaldi in one of his duller moments. A suggestion that the topography represents the Castello S. Angelo and part of the walls of Leo IV in Rome, which someone has written on the mount, is incorrect. It would seem that this is one of the numerous imaginary townscapes which Grimaldi executed.

D 1006 Fig. 427

View of the Torre Delle Milizie, S. Maria di Loreto and the Temple of Antoninus, Rome.

196 × 231. Pen and brown ink. Inscribed on the back: *G. F. Bolognese.*

PROV: David Laing; Royal Scottish Academy. Transferred 1910.

The old attribution to Grimaldi may well be correct.

D 1712 Fig. 428

Two intertwining tree trunks. (On the verso: indecipherable scribbles.)

180 × 178. Pen and brown ink. (Laid down, and rather damaged.) Inscribed on the backing in pencil: *Il Bolognesi.*

PROV: David Laing; Royal Scottish Academy. Transferred 1910.

The attribution of this fragment to Grimaldi seems convincing. A similar cluster of trees occurs in a drawing at Windsor (O. Kurz, *Bolognese Drawings at Windsor*, no. 307, pl. 44).

D 4885 Figs. 429 and 430

(*recto*) River landscape with figures and dogs; (*verso*) Study of a tree.

226 × 199. Pen and ink. Verso partly in black chalk.

PROV: Mrs A. G. Macqueen Ferguson. Purchased 1963.

This previously unattributed drawing seems entirely characteristic of Grimaldi's style.

FRANCESCO GUARDI
Venice 1712–1793 Venice

D 1171 Fig. 431

Lagoon 'capriccio'.

240 × 173. Pen, black ink and grey wash. (Probably cut at both sides.)

PROV: David Laing; Royal Scottish Academy. Transferred 1910.

If the traditional attribution is correct, and this is an original drawing, it must be a late work, around 1790, rather in the manner of Marco Ricci. Similar drawings are at Berlin (rep. J. Byam Shaw, *The Drawings of Francesco Guardi* (1951), pl. 74), and one formerly in the Heseltine Collection which contained an almost identical rider to the one in the Edinburgh drawing.

GUERCINO

IL GUERCINO
(Giovanni Francesco Barbieri)
Cento 1591–1666 Bologna

D 1608 Fig. 432

A boy arranging his master's dress.

181×150. Pen, brown ink and wash. (Laid down.) Inscribed on the mount: 'Michel Angelo da Caravaggio'.

PROV: Charles, 15th Earl of Shrewsbury (L. 2688); David Laing; Royal Scottish Academy. Transferred 1910.

EXH: Colnaghi, 1966 (48).

A drawing by Guercino in the Brera, Milan (33) shows the features of the same man in reverse, repr. A. Emiliani, *Mostra di Disegni del Seicento Emiliano nella Pinacoteca di Brera* (1959), no. 84.

D 2972 Fig. 433

Christ at Emmaus.

164×255. Pen, brown ink and wash. (Laid down; very damaged and ink partly corroded. Both top corners cut off.)

PROV: Jonathan Richardson, Senr (L. 2184); W. F. Watson. Bequeathed 1881.

Denis Mahon has drawn attention to the engraving after Guercino, dated 1619, by Giovanni Battista Pasqualini of this composition, which is also recorded by Malvasia (*Felsina Pittrice* (1678), I, 128; (ed. 1841), I, 104). The print, however, shows quite a number of variations: the figure of Christ is represented with eyes turned downwards and breaking the bread with both hands; the central figure, with the pilgrim's staff, is moved further to the right, has his right hand outstretched and appears as an older, bearded man, with the cockleshell fixed to his cloak which, in the drawing, is visible on the third man to the right; this figure corresponds most closely to the one shown in the drawing. It is difficult to judge a sheet in such a very damaged state. However, a drawing of the same composition, sold at Sotheby's (22 July 1965, lot 66), although also extensively damaged, appears to be of better quality, and makes it likely that D 2972 is a version, if not a copy, of an early work.

RSA 122 Fig. 434

Neptune.

196×250. Pen, ink and wash. (Laid down.) Inscribed on the back: *Guercino f.*

PROV: Bindon Blood (L. 3011); David Laing; Royal Scottish Academy. On loan 1966.

The only *Neptune* mentioned by Malvasia in his account of Guercino's work (*Felsina Pittrice*, ed. Zanotti (1841), II, 262) is the one painted for a Sig. Gio. Tartaleoni da Modena in 1632. It is hardly likely that RSA 122 has any connection

with this painting, as the drawing is obviously a much earlier work—Denis Mahon believes from before Guercino's departure for Rome in 1621.

D 1783 Fig. 435

Study of two figures, one holding a pair of scales.

312×247. Pen, brown ink on buff paper. (Laid down.) Inscribed on both sides: *Guercino*.

PROV: David Laing; Royal Scottish Academy. Transferred 1910.

The traditional attribution seems perfectly convincing. The drawing has not been connected with any known composition by Guercino. The main figure with the scales may have been intended for a representation of 'Justice' or, more likely, for the Archangel Michael.

D 2231 Fig. 436

A dragon observed by spectators behind a wall.

181×155. Pen, brown ink. (Partly damaged and laid down.)

PROV: Thomas Hudson; (Jonathan Richardson, Senr according to inscription on the backing); W. F. Watson. Bequeathed 1881.

LIT: *Catalogue: National Gallery of Scotland* (1946), p. 389.

An amusing and characteristic drawing.

D 4897 Fig. 437

Study of a man with a hat.

225×145. Pen, brown ink on faded blue paper.

PROV: Prof. Gertrud Bing. Bequeathed 1965.

EXH: Colnaghi, 1966 (45, as Mola).

The drawing was ascribed to P. F. Mola when it entered the collection, and the present attribution is due to Denis Mahon. He compares the sheet with two drawings at Windsor: 2666 (repr. in Souvenir of the 1938 Royal Academy exhibition *17th Century Art in Europe*, p. 104), and 2668 which was drawn on the back of the draft of a letter which is stuck down, but on which one can decipher through the paper 'Cento li 3 maggio 1635' (cf. *Burlington Magazine*, XCIII (1951), 56, n. 2).

Studio of GUERCINO
D 1618 Fig. 438

A putto holding up a curtain.

181×218. Red chalk. Inscribed *28* in pencil on lower left corner; and *Guercino* on the old backing.

PROV: E. Bouverie (L. 325); David Laing; Royal Scottish Academy. Transferred 1910.

Although a very good drawing, and very close to Guercino, it is most probably the work of a studio assistant.

61

D 726 Fig. 439

An evangelist.

170 × 165. Red chalk. (Very damaged and laid down on canvas.)

PROV: David Laing; Royal Scottish Academy. Transferred 1910.

The drawing is fairly near to Guercino and probably originated in his studio.

D 3107 Fig. 440

St John in the wilderness, filling a bowl with water from a rock.

319 × 441. Pen, brown ink and wash. (Laid down.)

PROV: W. F. Watson. Bequeathed 1881.

It is difficult to reach a conclusion about such a faded drawing. It has been suggested that it represents in fact Guercino's own hand, and that it is the prototype from which Bartolozzi made his etching. However, Bartolozzi's etching (no. 16 in the published volumes) varies considerably from this design. Furthermore, the drawing seems too deliberate, and such passages as the two hands far too weak, for it to be any more than a studio work.

D 753 Fig. 441

A sheet of figure-studies, and a tree.

220 × 306 (arched top). Pen and brown ink. (Laid down.) Inscribed on the mount: 'Guercino'.

PROV: Nathaniel Hone; (? Jonathan Richardson, from the appearance of the mount); David Laing; Royal Scottish Academy. Transferred 1910.

Although this drawing comes very close to Guercino's own hand, the rather mechanical treatment of the tree and the confused handling of the drapery probably point to a studio assistant.

D 1611 Fig. 442

Half-length female figure.

288 × 215. Red chalk. (Laid down, and damaged in parts.) Inscribed on the backing: *Del Guercino*.

PROV: David Laing; Royal Scottish Academy. Transferred 1910.

D 3122 Fig. 443

God the Father.

220 × 169. Red chalk. (Laid down.) Inscribed: [Gue]*rcino*.

PROV: W. F. Watson. Bequeathed 1881.

LIT. D. Mahon, *I Disegni del Guercino della Collezione Mahon* (Bologna, 1967), no. 28.

As Denis Mahon has pointed out, the figure is connected with the one in the altarpiece of the *Annunciation* painted for the church of S. Filippo Neri at Forlì and now in the Pinacoteca there, which is datable 1648. Mahon is now inclined to accept this as an original, rather than a studio work, as he at first thought.

Circle of GUERCINO

D 2934 Fig. 444

A seated man with averted head, leaning on his right arm.

245 × 232. Red chalk.

PROV: W. F. Watson. Bequeathed 1881.

The drawing of the hand hanging down is especially reminiscent of Guercino.

D 1910 Fig. 445

Half-length female portrait.

300 × 232. Red chalk on buff paper.

PROV: (? Allan Ramsay); Lady Murray. Presented 1860.

This and the two following drawings (D 1914 and 1942) are probably by the same hand as a red-chalk drawing of a bearded oriental at Dresden (C 539) which has an old inscription 'Gennari'. D 1910 may have been gone over by another hand.

D 1914 Fig. 446

The young St John the Baptist.

261 × 179. Red chalk on buff paper.

PROV: (? Allan Ramsay); Lady Murray. Presented 1860.

D 1942 Fig. 447

St John the Baptist.

305 × 223. Red chalk on buff paper.

PROV: (? Allan Ramsay); Lady Murray. Presented 1860.

D 4890/7 Fig. 448

Lot and his daughters.

166 × 111. Pen, brown ink and wash. (Torn and laid down.) Inscribed: *Matio Ballassi*.

PROV: Marchese del Carpio; Paul and Edwardo Bosch, Madrid; H. M. Calmann. Purchased 1964.

The ascription to Balassi is obviously incorrect. The inspiration behind the drawing derives clearly from Guercino.

Follower of GUERCINO

D 1817
Fig. 449

Head of a man.

101 × 146. Black chalk on blue paper. (Laid down.)

PROV: David Laing; Royal Scottish Academy. Transferred 1910.

Copies after GUERCINO

D 2963
Fig. 450

Angelica and Medoro.

172 × 221. Pen, brown ink and wash.

PROV: W. F. Watson. Bequeathed 1881.

A painting of this subject is recorded as having been executed 'All'Eminentissimo Legato di Ferrara' in 1642, but it does not seem to have been traced so far. (Malvasia, *Felsina Pittrice*, ed. Zanotti (Bologna, 1841), II, 265.)

D 3019
Fig. 451

Sheet of studies for a *Presentation of the Virgin.*

188 × 121. Pen and brown ink. (Laid down.) Inscribed on the mount: 'GUERCINO'.

PROV: W. F. Watson. Bequeathed 1881.

D 3054

Bust of a youth with fur-lined cap.

160 × 125. Pen, black ink. (Laid down.) Inscribed on mount: 'AP' (monogram) and 'F. Bartolozzi'.

PROV: W. F. Watson. Bequeathed 1881.

Probably no more than a late 18th century copy after Arthur Pond's engraving, published in Pond and Knapton, *Imitations of Drawings* (1797). Hence the monogram, which corresponds with the last of three illustrated in Nagler *Monogrammisten*, no. 1120.

D 3121

Profile head of an ecclesiastic.

341 × 241. Pen, brown ink and wash.

PROV: W. F. Watson. Bequeathed 1881.

Copied from an engraving.

D 2771

Man with feathered, fur hat and arm in a sling.

251 × 189. Pen, brown ink and wash.

PROV: W. F. Watson. Bequeathed 1881.

Copy of Bartolozzi's engraving of the drawing at Windsor (F. Bartolozzi, *Seventy-three prints from original pictures and drawings...in the Collection of His Majesty*, no. 56).

D 1559

(*recto*) Boy with cap, looking down;
(*verso*) A warrior's head.

181 × 205. Pen and black ink. Inscription: *Gennari* on the verso.

PROV: David Laing; Royal Scottish Academy. Transferred 1910.

These are copies from engravings, by Francesco Curti, after Guercino.

D 643

Diana and nymphs bathing.

210 × 303. Pen and brown ink.

PROV: David Laing; Royal Scottish Academy. Transferred 1910.

A feeble copy, possibly contemporary, of the etching by Joan. Ottaviani, published in *Raccolta di alcuni disegni del...Guercino* (Rome, 1764), when the original was in the collection of Thomas Jenkins.

Imitator of GUERCINO

D 649
Fig. 452

River landscape with herdsmen.

278 × 423. Pen and brown ink. (Laid down.)

PROV: David Laing; Royal Scottish Academy. Transferred 1910.

This, as well as the following six drawings, is from the hand of a prolific, but anonymous imitator of Guercino who seems to have worked in the late 18th century. This imitator concentrated almost solely on landscapes, but managed to capture no more than a superficial and rather mechanical resemblance of Guercino's more volatile style and mannerisms. He seems to have taken portions from the engravings after Guercino by Jean Pesne (1623–1700) and composed them, often very inaptly, into a scheme of his own. Edith Hoffmann appears to have been the first to draw attention to this imitator and to have demonstrated the sources of the various facets of his compilations (*Jahrbuch des Museums der bildenden Künste Budapest*, VI (1931), 179 ff.). Many of these drawings linger, sometimes in great numbers, in public and private collections, very often with the suggestion that they are original works by Guercino himself.

D 650

Mountainous landscape with two figures in the foreground and two herdsmen in the middle distance.

285 × 410. Pen and brown ink.

PROV: David Laing; Royal Scottish Academy. Transferred 1910.

D 2992 Fig. 453

Park-like landscape with walking and seated figures.

357 × 470. Pen and brown ink.

PROV: W. F. Watson. Bequeathed 1881.

D 3033 Fig. 454

River landscape with figures near a turreted castle.

280 × 420. Pen and brown ink. (Laid down.)

PROV: W. F. Watson. Bequeathed 1881.

D 3034

River landscape with figures, near ruins.

282 × 428. Pen and brown ink. (Laid down.)

PROV: W. F. Watson. Bequeathed 1881.

D 3035

Warriors outside a burning castle.

280 × 413. Pen and brown ink.

PROV: Unidentified mark (L. 2727).

D 3041

River landscape with figures and distant castle.

169 × 308. Pen and brown ink.

D 2929

Head of a putto.

154 × 179. Pen and brown ink.

PROV: W. F. Watson. Bequeathed 1881.

D 742

A bearded man.

257 × 713. Pen and brown ink. (Laid down.)

PROV: David Laing; Royal Scottish Academy. Transferred 1910.

FRANCESCO IMPERIALI
(Ferdinandi or Fernandi)
Milan 1679–1741 Rome

D 1930 Fig. 455

Self-portrait.

415 × 270. Red chalk. (Laid down.) Inscribed: *FRANCIS-CUS . FERNANDO | MEDIOLANESIS . PICTOR . NATUS . | ANNO . DOMINO — | MDCLXXVIIII — | VIVIT*

PROV: Nicola Pio; P. Crozat; (?Allan Ramsay); Lady Murray. Presented 1860.

LIT: *Abecedario de P. J. Mariette*, ed. Ph. de Chennevières & A. de Montaiglon (Paris, 1853–4), II, 242; E. K. Waterhouse, 'Francesco Fernandi detto d'Imperiali' in *Arte Lombarda*, Anno III, no. 1, pp. 101 ff.; A. M. Clark, 'Imperiali', *Burlington Magazine* (May 1964), p. 226; *idem*, 'The Portraits of Artists drawn for Nicola Pio', *Master Drawings* V, 1 (1967), no. 23.

The entry in the *Abecedario* (*loc. cit.*) reads: 'Il naquit en 1679, suivant l'inscription qui accompagnait son portrait dans le recueil de desseins qu'avait formé à Rome Nic. Pio, et qui a passé depuis entre les mains de M. Crozat.' No entry for this portrait has been traced in the Crozat sale catalogue (10 April–13 May 1741). It is, however, possible that it formed part of lots 329–333 which contained together 80 portraits of painters 'la plupart de l'École Romaine, faits dans l'École de Carle Maratte, & quelques-uns par les Peintres mêmes pour le dit Sieur Pio qui dans son Recueil les avoit rangés à la tête des Desseins qu'il avoit recueillis de chaque Maître'. A. M. Clark reprints the full biographical entry by Pio from Bibl. Vaticana, Cod. Capponiani 257, f. 40 and 41. It must remain hypothetical whether the drawing was in fact in the possession of Allan Ramsay, a pupil of Imperiali, who would no doubt have been eager to have it, or whether it was acquired later on by his nephew. The majority of the other portrait drawings from the Pio Collection are now at Stockholm (but see also D 1671, Germisoni). They were collected to accompany short biographies of dead and living artists.

Copy after FRANCESCO IMPERIALI

D 1943 Fig. 456

The Madonna and Child with St John.

445 × 348 (oval). Red chalk. (Laid down.)

PROV: (?Allan Ramsay); Lady Murray. Presented 1860.

Anthony Clark identified the drawing as being the subject of Imperiali's painting in Sir John's Clerk's collection at Penicuik House. It seems clear, however, that it is a copy, perhaps intended for the engraver.

GIOVANNI LANFRANCO
Parma 1582–1647 Rome

D 816 Fig. 457

Christ appearing to St Ignatius.

171 × 112. Pen, brown ink. (Top right corner cut and laid down.)

PROV: David Laing; Royal Scottish Academy. Transferred 1910.

Erich Schleier has confirmed that this is most probably a preparatory study for the painting, formerly in the Oratorio dei Nobili at Naples, but now apparently lost. Bellori describes it in his biography of the artist: 'Dipinse l'Oratorio de' Cavalieri nella Chiesa del Giesù...vi fece due quadri ad olio non molto grandi, laterali all'altare: l'Apparitione di Christo à Santo Ignatio con la croce in ispalla, additandogli la Città di Roma, San Francesco Xaverio, che languisce impiagato per amore di Giesù...' (Vite...(Rome, 1672), p. 379).

Circle of GIOVANNI LANFRANCO

D 2935 Fig. 458

Madonna and Child with SS. Carlo Borromeo, Bartholomew and two other saints.

326 × 231. Brush and brown wash, heightened with white over black and red chalk.

PROV: Indecipherable blind-stamp mark ?CM in lower right corner possibly L.605c; W. F. Watson. Bequeathed 1881.

The composition is reminiscent of Lanfranco's altarpiece at Naples of the *Madonna and Child with SS. Borromeo and Bartholomew* (*Mostra di Pittura del Seicento Emiliano* (Bologna, 1959), no. 114).

GIUSEPPE LASCARI
(Venetian 17th c.)

D 592 Fig. 459

Naval battle off the Dardanelles.

845 × 556. Pen and black ink with coloured washes heightened with gold. Several sheets stuck together. Two of the ships in the middle are drawn on separate bits of paper and then stuck on. Inscribed at the top: *La Dichiarasione della Rotta / che ebbe il Gran Turco dalla / Armata Venetiana alle Bocche / di Constantinopoli l'anno 1655 / 4: La Realle di Turco che / scapolo con altre cinque Galere / 5: Castello di Nottolia / 6: Castello di Romania / 7: Vasello di Lauro mosanige / che mando in Rotta l'armata / 8: La Capitana di Malta / 9: La Realle di Venetia / 10: La Capitana delle Nave / 11: La Capitana delle Galliare / 12: La Capitana delle Na^e Turca.* and at the bottom: *Il Mastro de detto disegno Gioseppe Lascari / sopra la Galera Magiestrale squadra / Di Malta.*

PROV: David Laing; Royal Scottish Academy. Transferred 1910.

The drawing depicts the position of the ships of the Venetian and Turkish fleets during the battle of the Dardanelles on 21 June 1655 in the defence of Crete. The Venetian 'Capitano Generale' Girolamo Foscarini had died, thus temporarily immobilizing the Venetian galleys and allowing the Turkish ships to assemble outside the Dardanelles in order to help those blockaded inside.

D 592 appears to show the positions during the final stages of the battle, with the Turkish galley-flagship retreating and their sailing-ship flagship evidently about to be taken or destroyed. Mocenigo seems to have been in command, owing to the combined Christian fleet having split, the other part being under the command of Francesco Morosini. Mocenigo's flagship is shown with the lion of St Mark on her stern. At that time the Venetians had no big sailing men-of-war of their own and were entirely dependent on hired ships, usually Dutch or English. The flagship's name is not known—the list merely states 'Capitana' (flagship). This information was kindly supplied by R. C. Anderson, in whose book *Naval Wars in the Levant 1559–1853* (Liverpool, 1952) the battle is described (Ch. v, p. 155).

Giuseppe Lascari, the author of this drawing, was most probably a scribe on one of the Maltese galleys, part of the squadron that helped the Venetian fleet. (Anderson in his book, *op. cit.* p. 152, mentions a Lascari in command of six Maltese galleys.) The Lascaris seem originally to have been a Portuguese or Provençal family, and one member was at one time Grand Master of St John in Malta.

FILIPPO LAURI
Rome 1623–1694 Rome

D 684 Fig. 460

Corisca and the satyr.

97 × 144. Red chalk. (All corners torn off. Laid down.)

PROV: Thomas Hudson; sale Langford, London, 15 March 1779, etc., no. 31?; Jonathan Richardson, Senr (L. 2183); David Laing; Royal Scottish Academy. Transferred 1910.

LIT: Charles Rogers, *A Collection of Prints in Imitation of Drawings* (1778), I, no. 31; Weigel, 4150.

This drawing was engraved by W. W. Rylands as being in the Hudson Collection, and published as thus by Rogers, *loc. cit.* The subject is taken from G. B. Guarini's *Pastor Fido* (1590), Act II, Scene 6.

FRANCESCO LAURI
Rome 1612–1636 Rome

D 983 Fig. 461

Roman ruins.

208 × 158. Pen, brown ink and wash, over pencil. Inscribed: *franchesco Lauro*.

PROV: David Laing; Royal Scottish Academy. Transferred 1910.

LEONARDO DA VINCI
Anchiano (Vinci) 1452–1519 Cloux
Copies after LEONARDO and Others

D 3142–3145

Studies of heads.

Average size 131 × 112. Red and black chalk. (Laid down.)

PROV: Unidentified mark (L. 643); Sir Joshua Reynolds; W. F. Watson. Bequeathed 1881.

Poor copies from Leonardo's caricatures, as well as an adaptation of the figure of Elymas from the Raphael tapestry.

OTTAVIO LEONI
Rome c. 1587–1630 Rome

D 1754 Fig. 462

Portrait of Signora Domitelli Archilei.

164 × 135. Black chalk on blue paper. Inscribed on the back with the name of the sitter, and dated *1617*.

PROV: David Laing; Royal Scottish Academy. Transferred 1910.

It is possible that this and the following drawings once formed part of the large collection of about 400 of Leoni's portrait drawings, which the Prince Borghese had assembled and which Mariette saw and described in his *Abecedario* as being in Paris in 1747 (see *Print Collector's Quarterly*, VI (1916), p. 329). Many of these drawings bear serial numbers and exact dates on the recto, and others are inscribed on the back with the sitter's name.

D 2260 Fig. 463

Portrait of a lady with a large collar.

206 × 145. Black chalk, heightened with white.

PROV: W. F. Watson. Bequeathed 1881.

LIT: *Catalogue: National Gallery of Scotland* (1946), p. 390.

A portrait drawing by Leoni of the same lady was with W. R. Jeudwine in 1966 (*Exhibition of Old Master Drawings*, 10–21 May, no. 13). This had the sitter's name, Angela Calzettara, inscribed on the back.

D 2994 Fig. 464

Portrait of Donna Elena, daughter of the Duke of Altemps.

227 × 166. Black and red chalk, heightened with white, on blue paper. Dated: *1621*. Inscribed on recto: *206/setembre*;

verso: *20/D. Elena fig^a del Duca Altemps* (partly erased).

PROV: W. B. Johnstone; W. F. Watson, Bequeathed 1881.

The lady depicted was a member of the famous Altemps family, who were special patrons of Leoni. Portrait drawings of G. Agnolo, Duca Altemps and of a boy Pietro Altemps—the latter dated 1617—are in the Pierpont Morgan Library (see *Drawings from New York Collections: The 17th Century in Italy* (1967), no. 26).

D 2995 Fig. 465

Portrait of Donna Madalena, daughter of the Duke of Cesi.

227 × 160. Black chalk on faded blue paper. Inscribed on recto: *114 luglio . 1618*; verso: *17 / D. Madalena f^a del Duca di Cesi*.

PROV: W. B. Johnstone; W. F. Watson. Bequeathed 1881.

D 3029 Fig. 466

Portrait of Signora Lampona.

215 × 150. Black chalk on faded blue paper. Inscribed on verso: *62 / La S^ra· Lampona*.

PROV: W. B. Johnstone; W. F. Watson. Bequeathed 1881.

D 3028 Fig. 467

Portrait of a lady with high coiffure.

212 × 160. Black chalk, heightened with white on faded blue paper. Inscribed on verso: *106*.

PROV: W. B. Johnstone; W. F. Watson. Bequeathed 1881.

The lady depicted may be the same as on the drawing in the Albertina (III, 477).

D 3024 Fig. 468

Portrait of a lady with a ruff.

213 × 162. Black chalk, heightened with white on faded blue paper.

PROV: W. B. Johnstone; W. F. Watson. Bequeathed 1881.

D 3025 Fig. 469

Portrait of a lady with a high collar.

220 × 165. Black chalk heightened with white on faded blue paper.

PROV: W. B. Johnstone; W. F. Watson. Bequeathed 1881.

D 3055 Fig. 470

Portrait of a lady with a ruff.

220 × 153. Black chalk, heightened with white on faded blue paper.

PROV: W. B. Johnstone; W. F. Watson. Bequeathed 1881.

D 2997 Fig. 471

Portrait of a cleric.

245 × 171. Black chalk, heightened with white on faded blue paper. Inscribed recto: *genral di S. Apostolo*; verso: *52 | G. Fenli di S. Apostolo*.

PROV: W. F. Watson. Bequeathed 1881.

D 3056 Fig. 472

Portrait of a man with pointed beard and a ruff.

224 × 165. Black chalk, heightened with white on faded blue paper.

PROV: W. F. Watson. Bequeathed 1881.

D 3057 Fig. 473

Portrait of a bearded man.

210 × 154. Black chalk, heightened with white on faded blue paper.

PROV: W. F. Watson. Bequeathed 1881.

D 2996 Fig. 474

Portrait of a man.

235 × 170. Black chalk, heightened with white on faded blue paper. Inscribed on verso: *58*.

PROV: W. F. Watson. Bequeathed 1881.

This appears to be a rather weaker drawing than the rest of the group, and has probably been retouched, particularly in parts of the head.

PIETRO LIBERI

Padua 1614–1687 Venice

D 1662 Fig. 475

Sketches of a lying and a crouching man, and of legs and feet.

199 × 230. Pen and brown ink over black chalk. (Laid down.) Inscribed in lower margin: *Cav. Liberi 42*.

PROV: David Laing; Royal Scottish Academy. Transferred 1910.

The old attribution seems perfectly correct. The style conforms to that of a sheet of studies in the Ashmolean, also with an inscription *Cav. Liberi*, but there attributed to Orsi (Ashmolean Cat. 421), and to an *Allegorical Composition* in the British Museum, ex Fenwick collection (A. E. Popham, *Catalogue of Drawings in the Collection ... Sir Thomas Fenwick* (1935), p. 148, no. 1).

D 4887 Fig. 476

The death of Abel.

230 × 192. Pen, brown ink over black chalk. Inscription on old backing: *Cav. Liberi 101*.

PROV: Mrs A. G. Macqueen Ferguson. Presented 1963.

PIRRO LIGORIO

Naples 1500–1583 Ferrara

Follower of PIRRO LIGORIO

RSA 182 Fig. 477

Amorini around a wine-press. (On the verso: two sleeping putti.)

415 × 275. Pen and ink, brown and blue wash, heightened with white. (Torn.) Inscribed with the letter *A* at the bottom.

PROV: David Laing; Royal Scottish Academy. On loan 1966.

The hitherto unattributed drawing appears to be by an artist influenced by Pirro Ligorio.

JACOPO LIGOZZI

Verona c. 1547–1626 Florence

Copy after JACOPO LIGOZZI

D 3115

The senate nominates Cosimo I as Duke of Florence.

354 × 266. Pen, brown ink, grey wash. (Laid down.)

PROV: (Unidentified collector's mark); W. F. Watson. Bequeathed 1881.

A copy of the fresco in the Salone dei Cinquecento, Palazzo Vecchio, above the Audience platform.

FILIPPINO LIPPI

Prato 1457–1504 Florence

Studio of FILIPPINO LIPPI

D 813 Fig. 478

Studies of a seated and a kneeling youth. (On the verso: faded, and partly overlaid drawing of a seated youth.)

151 × 170. Silverpoint and white heightening on yellowish prepared paper.

PROV: David Laing; Royal Scottish Academy. Transferred 1910.

A characteristic example of the kind of drawing which is generally connected with the Studio of Filippino. Several

of these drawings were attributed by Berenson to Davide Ghirlandaio (1452–1525), but there seems to be no convincing evidence to suggest that they are from his hand.

Attributed to
FRANCESCO LONDONIO
Milan 1723–1783 Milan

D 3222 Fig. 479

A peasant girl and a peasant boy.

280 × 397. Black chalk, heightened with white, on buff paper.

PROV: Benjamin West; W. F. Watson. Bequeathed 1881.

The drawing entered the collection under the designation 'French School'. Both style and subject matter, however, are characteristic of Londonio. A number of his drawings are in the Albertina, in the Ambrosiana and Brera, Milan, and the Fogg Museum recently acquired a sheet with two studies of an old man, in the same medium, and comparable with D 3222 (1964.83, repr. in 1964 *Report* of the Fogg Museum, p. 91).

LORENZO LOTTO
Venice 1480–1556 Loreto

D 4908 Fig. 480

Head of a bearded man.

236 × 177. Black chalk, heightened with white on faded blue paper. Contours incised.

PROV: A. Paul Oppé; H. M. Calmann. Purchased 1966.

LIT: B. Berenson, *Lorenzo Lotto* (1956), p. 107, pl. 300b; Philip Pouncey, *Lotto disegnatore* (1965), p. 14, pl. 13.

EXH: *The Paul Oppé Collection*, London, Royal Academy, 1958 (353); Colnaghi, 1966 (15).

Berenson suggested a date between 1535 and 1540 for this drawing.

AURELIO LUINI
Milan 1530–1593 Milan

D 3151 Fig. 481

Three studies of Tobias and the angel.

122 × 197. Pen, brown ink and wash. (Laid down.) Inscribed by a later hand: *B F Venetur 1537*.

PROV: W. F. Watson. Bequeathed 1881.

The ascription to Battista Franco, suggested by the inscription on the drawing, is not correct. It seems fairly clear that this is the hand of Aurelio Luini (cf. *Italian*

Drawings at Windsor, 408, pl. 148). Also the damaged drawing of the *Flight into Egypt* at Berlin (1671), with an inscription 'Luino' which, although there classified under Bernardo Luini, is typical of his son Aurelio.

BENEDETTO LUTI
Florence 1666–1724 Rome

D 1535 Fig. 482

Danaë.

105 × 172. Red chalk and red wash, heightened with white. Inscribed in pencil: *Luti*.

PROV: Nathaniel Hone; Paul Sandby; David Laing; Royal Scottish Academy. Transferred 1910.

The traditional attribution seems perfectly convincing. Drawings by Luti in the same technique are the figure of *Flora* at Düsseldorf (FP 3288, Budde 485) and the *Mystic Marriage of St Catherine* at Christ Church, Oxford (Inv. 0638).

RSA 292 Figs. 483 and 484

(recto) Seated girl and youth with a pipe; (verso) Half-length male nude.

217 × 284. Recto: pen and ink, over black chalk on blue paper. Verso: black chalk heightened with white. Inscribed: *B. Luti*.

PROV: David Laing; Royal Scottish Academy. On loan 1966.

Drawings with the same inscription (signature?) are at Düsseldorf.

Circle of BENEDETTO LUTI
D 656 Fig. 485

The penitent Magdalen.

310 × 220. Black chalk, brown wash, a few lines in pen. Inscribed on the mount: 'L. Carracci'.

PROV: David Laing; Royal Scottish Academy. Transferred 1910.

The drawing is much later than Ludovico Carracci, and appears to show affinities with the style of Luti. A drawing of the same subject, and probably by the same hand, is at Stockholm (1369), under the name of 'Cittadini' (although not specifying which member of this large family).

Copy after BENEDETTO LUTI
D 3192

Cain fleeing from the wrath of God.

503 × 347. Brush and brown wash, heightened with white, over red chalk.

PROV: W. F. Watson. Bequeathed 1881.

A copy, probably after the engraving by Giuseppe Wagner (1746), from the painting by Luti for a competition at the Academy of St Luke, Rome, in 1691, and now in the collection of Viscount Scarsdale at Kedleston Hall (cf. Moschini, *L'Arte* (1923), pp. 89 ff.). Another copy is at Turin (647).

LUZIO ROMANO

See RSA 151, *Studio of* Perino del VAGA.

GIROLAMO MACCHIETTI

Florence 1535–1592 Florence

D 683 Fig. 486

A seated nude man.

230 × 122. Red chalk on brown, toned paper. (Damaged.) Inscribed twice on the back, in an old hand: *Franciabigio*.

PROV: David Laing; Royal Scottish Academy. Transferred 1910.

A. E. Popham accepted the old ascription to Franciabigio. The present attribution seems convincing when comparison is made with similar figure drawings in the Uffizi, and especially in the Louvre, in particular 13.717 (repr. Ph. Pouncey, 'Contributo a Girolamo Macchietti', *Bolletino d'Arte*, II–III (April–September 1962), 237, fig. 1) and 8819, a study for the *Baths of Pozzuoli* in the Studiolo (repr. L. Marcucci, 'Girolamo Macchietti Disegnatore', *Mitteilungen des Kunsthist. Institutes in Florenz*, VII (1953–56), 124, fig. 5).

PIETRO MALOMBRA

Venice 1556–1618 Venice

Ascribed to PIETRO MALOMBRA

D 4890/23 Fig. 487

The Adoration of the Shepherds.

108 × 147. Pen, ink and wash, with traces of black chalk. (Laid down.) Inscribed: *Cau. Malombra*.

PROV: Marchese del Carpio; Paul and Edwardo Bosch, Madrid; H. M. Calmann. Purchased 1964.

It is highly doubtful whether this has anything to do with Malombra. It may not even be Italian, looking more like a Northern—perhaps French—Mannerist drawing. The composition with its curious half-submerged foreground figures, seems to have been derived from dell'Abbate.

GIOV. MANNOZZI

See GIOVANNI da San Giovanni.

ANDREA MANTEGNA

Isola di Carturo 1431–1506 Mantua

Circle of ANDREA MANTEGNA

D 809 Fig. 488

A standing bearded male figure, carrying a staff.

180 × 90. Brush and brown wash, heightened with white, on prepared paper. (Damaged and laid down.)

PROV: Sir Joshua Reynolds; David Laing; Royal Scottish Academy. Transferred 1910.

Although the drawing is extremely faded and damaged, the affinities with Mantegna are unmistakable. An example is the figure of Joseph (in reverse) in the engraving of the *Adoration of the Magi*, 'School of Mantegna' (B. 9; T. Borenius, *Four Early Italian Engravers* (1923), p. 37). In general appearance the style seems not far from Marco Zoppo (1433–78), cf. BM XIV–XV, 266, pl. CCXXVIII, and also the standing figure on the extreme left on the verso of the sheet of studies by Zoppo at Munich (2802), whose recto is reproduced in Halm, Degenhart, Wegner, *Hundert Meisterzeichnungen aus der Staatlichen Graphischen Sammlung München* (1958), pl. 10.

D 1529 Fig. 489

Study of the lower part of a seated draped figure, holding two tablets.

121 × 179. Pen and brown ink.

PROV: Padre Resta (Resta no. *m.8*); Paul Sandby; David Laing; Royal Scottish Academy. Transferred 1910.

LIT: *Catalogue: National Gallery of Scotland* (1946), p. 390 (as School of Mantegna).

The entry in Padre Resta's inventory simply refers to D 1529 as by Andrea Mantegna. The style of the drawing is certainly very Mantegnesque, but it is also reminiscent of some of the 'Broad Manner' Florentine engravings of Prophets and Sibyls, dating from the late 15th century, which Hind relates to the circle around the brothers Pollaiuolo (cf. A. M. Hind, *Early Italian Engraving* I (1938), pp. 153 ff., and for example pl. 248). The position of the tablets might suggest a figure of Moses rather than of a Sibyl.

Copy after ANDREA MANTEGNA

D 3197

Triumph of Caesar: the corselet bearers.

206 × 307. Pen and brown ink over red chalk. Inscribed: *Andrea Mantegna*.

PROV: W. F. Watson. Bequeathed 1881.

Copy from a section of one of the cartoons at Hampton Court.

CARLO MARATTA
Camerano 1625–1713 Rome

D 639 Figs. 490 and 491

(recto) Studies of a seated female figure, crowned by another (*Virtue Crowned by Honour*) and two other figure studies;
(verso) A larger study of the main figure.

321 × 425. Recto: two left hand figures in ink; large middle group in red chalk; right hand group pen and ink over red chalk. Verso: red chalk. Inscribed *Carlo Maratti* on both sides in pencil. The verso has also the number *410* in pencil, and '*Lot 1558*' in red ink.

PROV: Sir Joshua Reynolds; Sir Thomas Lawrence; David Laing; Royal Scottish Academy. Transferred 1910.

LIT: W. Vitzthum, 'Drawings by Carlo Maratta for the Altieri Palace in Rome', *Burlington Magazine* (August 1963), figs. 37 and 39.

Walter Vitzthum was the first to point out that this drawing, depicting *Virtue Crowned by Honour*, is a study for a spandrel for the unexecuted part of the ceiling in the Audience chamber of the Palazzo Altieri in Rome, datable between 1674 and 1677. (For these decorations see, apart from Vitzthum, *op. cit.*, *Drawings from New York Collections: The 17th Century in Italy* (1967), nos. 111–14.)

Other drawings connected by Vitzthum with this particular spandrel are in the Metropolitan Museum (61.169, 64.295.1), the Albertina (SR 1190, 1191), at Darmstadt (AE 1924) and in the Academy of San Fernando, Madrid (see *Burlington Magazine* (April 1967), fig. 96).

D 1775 Fig. 492

The Baptism of Christ.

248 × 170. Black chalk. (Laid down.) Inscribed in ink: *Albani.*

PROV: David Laing; Royal Scottish Academy. Transferred 1910.

The inscription would suggest a Bolognese provenance and there are indeed several similar compositions among Bolognese artists, for example Ludovico Carracci's painting at Munich. Anthony Clark, however, was the first to point out that this is a study for Maratta's late painting (1710) in the Certosa di S. Martino at Naples (Voss, *Barock*, p. 342). The drawing corresponds fairly closely with the composition of the altarpiece, although the pose of the Baptist and of the kneeling angel on the right, and the tree in the background, are different. Also the holy dove at the top is surrounded by three putti in the painting, which are not indicated in the drawing. What appears to be an earlier study for the Naples painting is in the Real Academia de San Fernando at Madrid (see V. M. Nieto

Alcaide, *Carlo Maratti: Cuarenta y tres Dibujos de Tema Religioso* (1965), no. 15, pl. 9), and five others at Düsseldorf, including one also of the whole composition (FP 1119).

D 1531 Fig. 493

Sketch of a female head and that of a putto.

133 × 86 (a strip of *c.* 12 mm. has been added to the paper on the left). Red chalk heightened with white on buff-toned paper. (Laid down.) Inscribed in ink: *71.*

PROV: (?Paul Sandby); David Laing; Royal Scottish Academy. Transferred 1910.

Formerly ascribed to Polidoro di Caravaggio. The present convincing attribution was first suggested by A. E. Popham.

D 1680 Fig. 494

Studies of a woman holding an ear-ring, as well as of her arms and hands.

385 × 237. Red chalk on blue paper. (Top corners cut off.) Inscribed: *Carlo Maratta.*

PROV: Nathaniel Hone; David Laing; Royal Scottish Academy. Transferred 1910.

In spite of the inscriptions, the drawing entered the collection as being 'Flemish'. The correct attribution was reaffirmed by A. E. Popham.

Circle of CARLO MARATTA
D 3116 Fig. 495

Apotheosis of Pope Clement XI.

205 × 144. Red chalk. (Laid down.)

PROV: Unidentified mark WT (L. 2468); W. F. Watson. Bequeathed 1881.

There is an ascription to 'Guido Reni' on the back of the mount. However, the drawing is close to Maratta and can conveniently be dated after 1700, when Clement XI came to the throne. One of his major deeds was the saving and reconstruction of the Colosseum, which is faintly indicated in the background of the drawing.

The inscription on the floating banner reads: *MITIS POSUIT CLEMENTIA SEDEM.*

Copy after CARLO MARATTA
D 3081

The Holy Family, with the Christ Child reading.

362 × 276. Black ink over red chalk. Squared in black chalk.

PROV: W. F. Watson. Bequeathed 1881.

A copy from the engraving by Jacob Frey (1729) after Maratta's painting then in the collection of the Abbate Albicini.

Follower of CARLO MARATTA

D 1939 Fig. 496

Female head.

115 × 113. Red chalk. (Laid down.) Inscribed in ink with a capital *A*.

PROV: (?Allan Ramsay); Lady Murray. Presented 1860.

The technique points to a pupil or follower of Maratta, rather close to Benedetto Luti.

RSA 297 Figs. 497 and 498

(*recto*) A soldier carrying a woman;
(*verso*) Academy study of a nude.

392 × 257. Black chalk heightened with white, on blue paper.

PROV: (Unidentified collector's mark); David Laing; Royal Scottish Academy. On loan 1966.

The drawing is certainly Roman, and seems to be by a follower of Maratta. The recto is obviously a study for a *Rape of the Sabines*.

MARCO MARCHETTI
(da Faenza)

Faenza ?–1588 Faenza

D 636 Fig. 499

Bacchanalian scene.

94 × 135 (cut to an oval shape). Pen, brown ink and wash. (Laid down.)

PROV: Jonathan Richardson, Senr (L. 2183); David Laing; Royal Scottish Academy. Transferred 1910.

Former ascriptions to Rosso and Perino del Vaga cannot be maintained. It seems fairly clear, however, that this is the characteristic hand of Marco Marchetti, a follower and imitator of Giovanni da Udine. Drawings like those in the Uffizi (1563E and 101 orn.), *The Conversion of St Paul* at Windsor (*Italian Drawings at Windsor*, 416, fig. 85) and the design for a ceiling decoration at Turin (Bertini, *I Disegni Italiani...di Torino* (1958), no. 241) provide convenient comparisons.

ALESSIO DE MARCHIS

Naples 1684–1752 Perugia

RSA 126 Fig. 500

River landscape with boats and figures.

276 × 452. Pen, ink and wash. (Laid down.) Inscribed, in Richardson's hand: *Alessio de' Marchesi.*

PROV: J. Richardson, Jnr (L. 2170); Charles Rogers; David Laing; Royal Scottish Academy. On loan 1966.

Attributed to
MARCO MARCOLA

Verona 1740–1793 Verona

D 1818 Fig. 501

The battle between the Greeks and the Trojans around the wooden horse.

290 × 445. Brush, black wash over black chalk, heightened with white on blue paper.

PROV: David Laing; Royal Scottish Academy. Transferred 1910.

An anonymous suggestion that this drawing is either French or Genoese is written on the mount. It appears, however, that this is the same hand as that of the drawings at Bergamo, on the *History of Alexander the Great*, which have been attributed to Marcola (L. and C. L. Ragghianti, *Disegni dell'Accademia Carrara di Bergamo* (Venice, 1962), p. 36, figs. 88–91).

VALERIO MARUCELLI

Florence fl. 1589–1620

D 1522 Fig. 502

St Roch.

143 × 102. Red chalk and brown wash, heightened with white. (Laid down and paper stained.) Inscribed on back: *Valerio Marucelli*. Pencilled inscription on mount: 'Ag. Caracci'.

PROV: Paul Sandby (according to inscription); David Laing; Royal Scottish Academy. Transferred 1910.

In the absence of a better suggestion, it seems best to accept the old inscription on the back of the drawing. Little is known of Valerio Marucelli, who was a pupil of Naldini and Santi di Tito, although none of the characteristics of either of these two artists seems to be in evidence in this drawing, and no others attributed to Valerio have been traced. It is possible that the inscription intended to refer to Giovanni Stefano Marucelli (1586–1646) in whose red chalk drawing of the *Ascension* in the Uffizi (5776) a similar angular treatment of the drapery can be observed. Another pen and wash drawing, with an old inscription 'Maruscelli', is in the Albertina (III, 353).

AGOSTINO MASUCCI

Rome 1691–1758 Rome

D 1927 Fig. 503

The Holy Family with St Anne.

424 × 298. Red chalk, heightened with white, on pink toned paper. (Laid down.)

PROV: (?Allan Ramsay); Lady Murray. Presented 1860.

LIT: A. M. Clark, 'Agostino Masucci: A Conclusion and a Reformation of the Roman Baroque', in *Essays in the History of Art presented to Rudolf Wittkower* (1967), p. 259, n. 7.

Philip Pouncey first suggested the name of Masucci for this drawing, and Anthony Clark identified it as a study for the altarpiece to the left of the Sacristy in S. Maria Maggiore in Rome, signed and dated 1743.

GIUSEPPE MAZZA
Bologna 1653–1741 Bologna

D 1477 Fig. 504

Empedocles throwing himself into Etna.

294 × 208. Pen, brown ink and wash over black and red chalk. Inscribed on the back: *Del Sig.ʳ Giuseppe Mazza Scultore.*

PROV: Paul Sandby; David Laing; Royal Scottish Academy. Transferred 1910.

G. MAZZOLA BEDOLI
See G. Mazzola BEDOLI.

GIUSEPPE MELANI
Pisa 1673–1747 Pisa

D 926 Fig. 505

Design for a tomb.

249 × 338. Pen, brown ink and grey wash over black chalk. Inscribed in pencil on the back: *Del Malini di Pisa.*

PROV: Nathaniel Hone; David Laing; Royal Scottish Academy. Transferred 1910.

The attribution must remain a tentative one. The previous owner interpreted the inscription on the back as a reference to Giuseppe Maria Milani. However, it might well have meant to suggest Giuseppe Melani, also of Pisa.

ANDREA MELDOLLA
See Andrea SCHIAVONE.

MICHELANGELO BUONARROTI
Caprese 1475–1564 Rome

Copies after MICHELANGELO BUONARROTI

D 679

Nude male figure.

222 × 122. Pen, brown ink on blue paper. (Laid down and damaged.)

PROV: Charles, 15th Earl of Shrewsbury; David Laing; Royal Scottish Academy. Transferred 1910.

Probably a late 16th century copy of the *Ignudo* at the top of *God dividing light from darkness* on the Sistine ceiling; or of the identical figure among the wall decorations by Niccolò dell'Abbate in the Palazzo Zucchini-Solimei, Bologna.

D 1643

(*recto*) Two reclining nudes;
(*verso*) The prophet Joel (from the Sistine ceiling).

385 × 266. Red chalk.

PROV: David Laing; Royal Scottish Academy. Transferred 1910.

D 1650

The prophet Daniel (from the Sistine ceiling).

329 × 243. Brush and brown wash. (Laid down. Completely faded.)

PROV: David Laing; Royal Scottish Academy. Transferred 1910.

D 3147

The prophet Elijah (from the Sistine ceiling).

276 × 208. Pen and black ink over red chalk. (Laid down.)

PROV: C. M. Cracherode (L. 606); J. Richardson, Senr; W. F. Watson. Bequeathed 1881.

A tracing, most probably from an engraving.

D 3160

Head of a faun.

252 × 198. Pen and brown ink.

PROV: Baron de Malaussena (L. 1887); W. F. Watson. Bequeathed 1881.

This is a simplified version of the drawing in the Louvre (Inv. No. 109 according to Berenson [1728, fig. 793] and Inv. No. 684 according to Dussler [*Zeichnungen des Michelangelo* (1959), 644]). The Louvre version has been variously attributed to Michelangelo himself, to Mini, or Bandinelli based on Michelangelo. D 3160 appears to be by a 17th century hand and is no more than a copy.

D 3166

Copy of the figure of 'Night' (from the Medici tomb).

299 × 233. Red chalk. (Laid down.) Inscribed on the mount (in Lely's hand?): 'Parmigiano'.

PROV: Sir Peter Lely (L. 1734 and 2092); W. F. Watson. Bequeathed 1881.

D 3205

Group of three bathers.

311 × 289. Pen, brown ink and wash. (Figures cut out and laid down.)

PROV: W. F. Watson. Bequeathed 1881.

Weak 16th century copy from an engraving of the right portion of *The Battle of Cascina*.

PIER FRANCESCO MOLA
Coldrerio (Como) 1612–1666 Rome

D 699 Fig. 506

Nymphs and satyrs near a pool.

199 × 284. Pen, brown ink and wash over red chalk. (Laid down.)

PROV: David Laing; Royal Scottish Academy. Transferred 1910.

LIT: E. Schaar in *Zeitschrift für Kunstgeschichte* (1961), Heft 2, pp. 184–8.

There is a drawing of a similar subject and in the same technique in the collection of F. Lugt, Paris (I, 6232).

D 762 Figs. 507 and 508

(*recto*) The Trinity in glory;
(*verso*) Sketches of a seated figure and a bearded head.

365 × 237. Recto: Pen, black ink, red and brown wash, over black chalk, heightened with white. Verso: Figure in black chalk, head in ink.

PROV: David Laing; Royal Scottish Academy. Transferred 1910.

LIT: *Catalogue: National Gallery of Scotland* (1946), p. 390; W. Vitzthum, review of Blunt and H. L. Cooke, 'Roman Drawings at Windsor Castle' in *Burlington Magazine* (December 1961), p. 517; J. Rowlands, 'Mola's Preparatory Drawings and some additions to his œuvre', *Master Drawings*, II, 3 (1964), 274 f., fig. 256.

Walter Vitzthum was the first to draw attention to the engraving by Cornelis Bloemaert after this composition (Hollstein, 36) which bears the inscription *P. F. Mola inv.* It appeared as an illustration in the *Missale Romanum*, published in Rome (ex typographia Reverendae Camerae Apostolicae) in 1662 for Pope Alexander VII. J. K. Rowlands has pointed to another engraving, by François de Louvement, of the same composition (Nagler, 5; plate in the Calcografia Nazionale, Rome) which at first sight appears to be a re-engraving of Bloemaert's print, but on closer scrutiny shows slight differences, especially in the composition of the wreath of surrounding angels at the top.

Both engravings vary considerably from the original drawing.

It may be of significance that in an elaborate drawing showing *Christ being carried to heaven by angels* (Berlin 1409) Bloemaert adapted closely Mola's figure of Christ for his own composition.

D 807 Fig. 509

Hagar and Ishmael.

182 × 241. Pen, black ink and brown wash over black chalk. Inscribed: *f. mola*.

PROV: Sir Thomas Lawrence; David Laing; Royal Scottish Academy. Transferred 1910.

An identical inscription of the artist's name occurs on a drawing by Mola of *Lot and his daughters* in the Albertina (VI, 274).

D 3153 Fig. 510

The Adoration of the Shepherds.

201 × 274. Brush and brown wash over red chalk. (Laid down.)

PROV: W. F. Watson. Bequeathed 1881.

The attribution is the traditional one.

Attributed to
PIER FRANCESCO MOLA

D 3267 Fig. 511

Pan, nymph and putto seated under trees.

197 × 288. Pen, brown ink and wash. (Laid down and very damaged.)

PROV: W. F. Watson. Bequeathed 1881.

The present attribution was first suggested by Sir Anthony Blunt. The former ascription was to Poussin. As far as anything definite can be stated about such a badly damaged drawing, the attribution to Mola, or a close associate, appears very convincing.

Circle of PIER FRANCESCO MOLA

D 2898 Fig. 512

Two standing figures.

135 × 100. Pen and brown ink, shaded in black chalk. (Laid down.)

PROV: R. Dumesnil (L. 2200); W. F. Watson. Bequeathed 1881.

It is doubtful whether the drawing can be by Mola himself, but it is possible that it originated in his circle.

IL MONCALVO
(Guglielmo Caccia)
Montabone (Acqui) c. 1568–1625 Moncalvo

D 1767 Fig. 513

S. Carlo Borromeo healing the plague-stricken.

253 × 312. Pen, brown ink and wash. (Laid down on canvas.) Inscribed: *Del Moncalvo*.

PROV: Count Gelozzi (L. 545); David Laing; Royal Scottish Academy. Transferred 1910.

D 3161 Figs. 514 and 515

(*recto*) The Nativity;
(*verso*) Fragments of figures in armour. Also biographical notes in French on Aliense.

254 × 192. Recto: pen and brown ink. Verso: left figure in pen and wash, the right in black and red chalk, pricked for transfer.

PROV: Marquis de Lagoy; Alliance des Arts (L. 61); W. F. Watson. Bequeathed 1881.

The biographical inscription on the back was probably the cause of the drawing being ascribed to Antonio Vassilacchi (Aliense). The hand of Moncalvo can, however, be recognized quite clearly.

Circle of MONCALVO
D 635 Fig. 516

The Adoration of the Magi.

265 × 373. Pen, brown ink over black chalk. Inscribed: *Scarcellino da Ferrara*.

PROV: David Laing; Royal Scottish Academy. Transferred 1910.

This rather unpleasant drawing has nothing to do with Scarcellino. It is either a copy or has been crudely gone over. The composition, the types and such features as the simplified legs and the tapering feet are reminiscent of Moncalvo.

D 806 Fig. 517

The Madonna and Child in glory, with the young St John the Baptist below and two attendant martyr saints.

170 × 115. Pen, brown ink and wash. (Laid down.) Inscribed on the front *139*, on the back (in Esdaile's hand) *Francesco Vanni*.

PROV: William Esdaile; David Laing; Royal Scottish Academy. Transferred 1910.

The former ascription to Vanni is not convincing for this rather tame drawing, although a case might be made for its being Sienese. However, Philip Pouncey has put forward the suggestion that the influence of Moncalvo can be discovered to some extent in the wash technique and the facial types, and that the drawing might have originated in his circle.

Imitator of MONCALVO
D 2998 Fig. 518

A swooning female figure (the Madonna?) aided by two attendants.

164 × 110. Pen, brown ink and wash.

PROV: W. F. Watson. Bequeathed 1881.

The drawing bore an ascription to Angelica Kauffmann when it entered the collection. The attribution to Moncalvo has been suggested by Walter Vitzthum, but the draughtsmanship is too superficial to be from the artist's own hand, and appears to be by a facile imitator.

See also D 756, 'Follower of Pordenone'.

Attributed to
DOMENICO MONDO
Caserta c. 1720/30–1806 Naples

D 3017 Fig. 519

Decorative design with figures, including two warriors.

130 × 186. Pen, brown ink, grey wash over black chalk.

PROV: John Auldjo (L. 48); W. F. Watson. Bequeathed 1881.

Both Anthony M. Clark and Walter Vitzthum have independently suggested an attribution to Mondo. The design, probably for a *soprapporta*, should be compared with the signed allegorical drawing in the Albertina (VI, 689).

RSA 194 Fig. 520

A queen distributing alms.

232 × 229. Pen, black ink and grey wash over black chalk. (Laid down.)

PROV: David Laing; Royal Scottish Academy. On loan 1966.

The attribution is due to Philip Pouncey.

MONOGRAMMIST AB
Worked in Rome 1723–44

D 854 Fig. 521

View near the Ponte Salario, Rome.

275 × 430. Red chalk. (Laid down.) Inscribed on the back and mount: *Veduta passato Ponte Salaro su la via Salara dell'Hosteria di Ponte Salaro.* Dated on the back *1741.*

PROV: Jonathan Richardson, Jnr; Paul Sandby; David Laing; Royal Scottish Academy. Transferred 1910.

This is one of a large series of red chalk drawings of places in the neighbourhood of Rome, many of them in the British Museum, ex Fenwick collection (A. E. Popham, *Catalogue of Drawings in the Collection...Sir Thomas Fenwick* (1935), p. 155), several bearing the monogram *AB*. Others were formerly in the collection of the late Sir Bruce Ingram. All of them have inscriptions of the locality represented on the mount, in the hand of the younger Jonathan Richardson, whose collector's mark, as well as that of Paul Sandby, appears on each of the drawings.

RSA 163 Fig. 522

View of Grottaferrata.

275 × 425. Red chalk and grey wash. Partly outlined in pen. Inscribed: *Veduta di Grotta Ferrata per fianco.*

PROV: J. Richardson, Jnr (L. 2170); Paul Sandby; David Laing; Royal Scottish Academy. On loan 1966.

RSA 318 Fig. 523

Landscape near the sea with a river and hill-town.

276 × 423. Red chalk. (Laid down.) Signed *AB. W. V* on the back.

PROV: J. Richardson, Jnr (L. 2170); David Laing; Royal Scottish Academy. On loan 1966.

Without the usual inscription of the locality depicted or with Paul Sandby's collector's mark, as in the case of all the other extant drawings by the Monogrammist AB.

GIOVANNI BATTISTA MONTANO

Milan 1534–1621 Rome

D 927 Fig. 524

Design for a tabernacle.

275 × 177. Pen, brown ink and wash, over black chalk.

PROV: David Laing; Royal Scottish Academy. Transferred 1910.

This and the following drawing show the same technique, and generally resemble those in the 'Talman' volume in the Ashmolean Museum, relating to Montano's *Cinque Libri di Architettura* (1684), and particularly to the title page (379, Fol. 1), see Ashmolean Cat. pp. 199f. However, both the Edinburgh drawings seem to be connected with

Montano's *Tabernacoli Diversi* (1684), and D 927 is very close indeed to the design engraved as plate 14 of the book.

D 928 Fig. 525

Design for a tabernacle.

224 × 183. Pen, brown ink and wash.

PROV: David Laing; Royal Scottish Academy. Transferred 1910.

FRANCESCO MONTELATICI
(Cecco Bravo)

Florence 1607–1661 Innsbruck

D 1571 Fig. 526

Study of a head in profile.

271 × 200. Red chalk, heightened with white. Inscribed on both sides, in ink: *Cecco Bravo.*

PROV: David Laing; Royal Scottish Academy. Transferred 1910.

Although this is ostensibly a female head, it appears to be a study for the second figure from the right of the five male Saints—protectors of Florence—which are recorded on a drawing in the Louvre (1347) from the Baldinucci collection (R. Bacou and J. Bean, *Disegni fiorentini del Louvre* (Paris, 1958 and Rome, 1959), no. 58; A. R. Masetti, *Cecco Bravo* (Venice, 1962), no. 15, fig. 77). The finished composition has either never been executed or appears to be lost. Masetti suggests that the Saint in question is St Cosmas, although the book which the figure holds is not the normal attribute of this Saint. Yet the identification is plausible, as St Cosmas, together with his brother St Damian (presumably represented opposite him in the Louvre drawing) were the patron Saints of the Medici family.

D 1956 Fig. 527

Standing male nude, turned right, arms at back.

397 × 253. Red chalk. (Laid down, lower left margin torn off.) Inscribed in ink: *64.*

PROV: (?Allan Ramsay); Lady Murray. Presented 1860.

The attribution to Cecco Bravo of the group D 1956–72 is due to Philip Pouncey. Drawings by the artist in the same medium, on sheets numbered in the same handwriting are, among other collections, in the Uffizi, cf. A. R. Masetti, *Cecco Bravo* (Venice, 1962), Catalogue and figs. 81–104.

Some of these drawings, for example D 1964, D 1965 and D 1970, may be connected with Cecco Bravo's chief work *The Fall of the Angels*, formerly in SS. Michele e Gaetano, Florence.

D 1957 Fig. 528

Standing male nude, turned left, holding a cross.

415 × 280. Red chalk. (Laid down, top left margin torn off.) Inscribed in ink: *31*.

PROV: (? Allan Ramsay); Lady Murray. Presented 1860.

Obviously for a St John in a *Baptism of Christ*.

D 1958 Fig. 529

Male nude, bent with left knee on a stone, hands at back.

389 × 270. Red chalk. (Laid down. Top margin, including number, cut off.)

PROV: (? Allan Ramsay); Lady Murray. Presented 1860.

Possibly for a *Flagellation of Christ*.

D 1959 Fig. 530

Standing male nude, with outstretched left arm.

415 × 267. Red chalk. (Laid down. Stained. Lower right margin torn.) Inscribed in ink: *40*.

PROV: (? Allan Ramsay); Lady Murray. Presented 1860.

D 1960 Fig. 531

Male nude, striding to left, with outstretched right arm.

406 × 267. Red chalk. (Laid down. Stained.) Inscribed in ink: *68*.

PROV: (? Allan Ramsay); Lady Murray. Presented 1860.

Two similar drawings are in the Uffizi (10573 F verso and 10692 F, repr. Masetti, *op. cit.* nos. 90 and 100).

D 1961 Fig. 532

Male nude, moving towards right, with turned head. Sketch of a right arm in the margin.

403 × 267. Red chalk. (Laid down. Stained.) Inscribed in ink: *42*.

PROV: (? Allan Ramsay); Lady Murray. Presented 1860.

D 1962 Fig. 533

Standing male nude, with drapery round his left shoulder.

408 × 261. Red chalk. (Laid down. Stained.) Inscribed in ink: *57*.

PROV: (? Allan Ramsay); Lady Murray. Presented 1860.

An interesting Michelangelesque, almost 'classical' pose.

D 1963 Fig. 534

Male nude striding towards left, with flowing light drapery, with inclined head, raised right and outstretched left hand.

419 × 275. Red chalk. (Laid down. Stained.) Inscribed in ink 65.

PROV: (? Allan Ramsay); Lady Murray. Presented 1860.

D 1964 Fig. 535

Seated male nude, holding up light flowing drapery.

417 × 282. Red chalk. (Laid down. Top left margin torn.) Inscribed in pencil: *67*.

PROV: (? Allan Ramsay); Lady Murray. Presented 1860.

Probably connected with the frescoes of *St Michael battling with Lucifer* and *The Fall of the Angels*, formerly in SS. Michele e Gaetano, Florence, but removed in 1786 and now presumed lost (cf. W. and E. Paatz, *Die Kirchen von Florenz*, IV (1952), pp. 177 and 191.

D 1965 Fig. 536

Male nude with wings, striding towards left, looking back to another figure below.

399 × 276. Red chalk. (Laid down.) Inscribed in ink: *79*.

PROV: (? Allan Ramsay); Lady Murray. Presented 1860.

See note to D 1964.

D 1970 Fig. 537

Kneeling male nude with wings, sword and scales. (St Michael.)

403 × 270. Red chalk. (Laid down.) Inscribed in ink: *28*.

PROV: (? Allan Ramsay); Lady Murray. Presented 1860.

Similar pose to D 1967. See note to D 1964.

D 1967 Fig. 538

Kneeling male nude with raised head and arms.

399 × 255. Red chalk. (Laid down. Stained. Top margin torn.) Inscribed in ink: *39*.

PROV: (? Allan Ramsay); Lady Murray. Presented 1860.

For similar pose cf. Uffizi 10662 F (Masetti, *op. cit.* no. 89).

D 1966 Fig. 539

Standing, lightly draped male nude. Sketches of legs and feet in margin.

339 × 237. Red chalk. (Laid down. Stained.) Inscribed in ink: *55*.

PROV: (? Allan Ramsay); Lady Murray. Presented 1860.

D 1969 Fig. 540

Standing male nude, with outstretched arms.

390 × 231. Red chalk. (Laid down. Stained and margins torn all round.) Inscribed in ink: *99*.

PROV: (? Allan Ramsay); Lady Murray. Presented 1860.

Obviously a copy (by a pupil?) of D 1966. Several of such copies are among the Cecco Bravo drawings in the Uffizi, revealing smoother, rather weaker contours and a general softening of the nervously excited manner of the original. It is not often that original and copy can be seen side by side.

D 1968 Fig. 541

Lightly draped male nude, striding towards left, leaning on a stick.

391 × 270. Red chalk. (Laid down. Stained. Right margin torn.) Inscribed in ink: *20*.

PROV: (? Allan Ramsay); Lady Murray. Presented 1860.

D 1971 Fig. 542

Lightly draped male nude turned towards left, with stick in his left hand and right arm outstretched.

417 × 282. Red chalk. (Laid down. Stained. Top and left margins torn.) Inscribed in ink: *23*.

PROV: (? Allan Ramsay); Lady Murray. Presented 1860.

D 1972 Fig. 543

Male nude astride, with flowing drapery.

411 × 278. Red chalk. (Laid down.) Inscribed in ink: *32*.

PROV: (? Allan Ramsay); Lady Murray. Presented 1860.

The model seems to hold a sling, and may have been intended for a figure of *David*.

RSA 188 Fig. 544

Seated female figure.

370 × 256. Red chalk with traces of white heightening. (Laid down.) Inscribed on the mount: 'Francesco Montelatici detto Cecco Bravo'.

PROV: Sir Thomas Lawrence; David Laing; Royal Scottish Academy. On loan 1966.

RSA 187 Fig. 545

Carnival scene.

277 × 414. Black chalk. (Torn and laid down.) Inscribed: ? *Gesù Eros*, and 'Cecco Bravo' on the mount.

PROV: David Laing; Royal Scottish Academy. On loan 1966.

RSA 189 Fig. 546

A dream.

384 × 252. Red and black chalk. Inscribed: *Sogno. Di mano di Francesco Montelatici Pittor Fiorentino per il suo grande spirito nel Disegnare, e per la sua bravura, chiamato Cecco Bravo*.

PROV: Nathaniel Hone; David Laing; Royal Scottish Academy. On loan 1966.

One of the famous *Dreams*, another of which, also from the Hone collection and with an almost identical inscription, is in the Ashmolean Museum (Cat. 917). The entry in the Ashmolean Catalogue refers to a number of 'large dreams...very fantastical' which formed lots 240–8 in the Knapton sale (27 May 1807) and one of which may have been RSA 189. Four further 'singular designs of dreams by Cecco Bravo, in red and black chalk' were in the sale of the Paul Sandby collection (18 March 1812, lot 112).

RSA 190 Fig. 547

A king sacrificing.

435 × 287. Black chalk heightened with white, on blue paper. No. *86* in the top left corner.

PROV: N. Hone; David Laing; Royal Scottish Academy. On loan 1966.

The former attribution, according to an inscription on the mount, was to Guercino. There can be little doubt that the drawing is by Cecco Bravo.

GIOVANNI MARIA MORANDI

Florence 1622–1717 Rome

RSA 161 Fig. 548

Half-length figure of an abbot.

261 × 206. Red chalk. Inscribed on mount: 'Morandi'.

PROV: David Laing; Royal Scottish Academy. On loan 1966.

Attributed to
ALESSANDRO MORETTO
(Bonvicino)

Brescia c. 1498–c. 1554 Brescia

D 2235 Fig. 549

The reclining Christ Child.

156 × 256. Pen, brown ink and wash, heightened with white, over black chalk, on faded blue-grey paper. (Laid down. Traces of handwriting showing through from the back.)

PROV: Ch. Jourdeuil (L. 527); sale Sotheby, 12–13 June 1868; W. F. Watson. Bequeathed 1881.

LIT: *Catalogue: National Gallery of Scotland* (1946), p. 395 (as School of Veronese).

The drawing was called 'School of Veronese' when it entered the collection. The attribution to Moretto was first put forward tentatively by Philip Pouncey. Another drawing of the identical figure, but obviously a copy, is contained on page 40 of the *Codice Bouola* in the Museum at Warsaw (*I Disegni del Codice Bouola del Museo di Varsavia*, Catalogo…a Cura di Maria Mrozinska. Exhib. Fondazione Cini no. 8 (Venice, 1959), no. 64, p. 88). The Warsaw drawing has been tentatively ascribed to Giorgione, but neither this nor a connection with a drawing in the collection of Frank Mather, attributed to the 'Circle of Titian' (Tietze, 2012, pl. LXXV, 3), seems in any way convincing. Both D 2235 and the Warsaw copy may very likely be connected with an as yet unidentified painting by Moretto.

POMPEO MORGANTI

See Pompeo da FANO.

RAFFAELLO MOTTA

See RAFFAELLINO da Reggio.

GIROLAMO MUZIANO

Acquafredda (Brescia) 1532–1592 Rome

D 4890/38 Fig. 550

A saint healing a woman from inability to give milk.

200 × 157. Black and red chalk, brown and red wash. (Cut and laid down.) Inscribed: *Mutiano.* Black chalk inscription partly erased.

PROV: Marchese del Carpio; Paul and Edwardo Bosch, Madrid; H. M. Calmann. Purchased 1964.

D 4865 Fig. 551

St Andrew.

305 × 187. Black chalk. Squared twice, in black and red chalk. (Laid down.) Inscribed faintly at the bottom: *penno*, and on the back: *Ricchiarelli.*

PROV: Herbert Bier. Purchased 1961.

The fairly recent ascription to Ricchiarelli, i.e. Daniele da Volterra, does not seem to be correct. An attribution to Siciolante da Sermoneta has been considered, but has not been found satisfactory on closer examination. John Gere has proposed, with some conviction, the attribution to Muziano which, judging by the pose, the deliberate and

rather lifeless drawing of the drapery, seems very convincing, though no identical figure in Muziano's œuvre has been traced. The handling of the drapery should be compared to that in the Louvre drawing of a seated saint (repr. H. Voss, *Zeichnungen der ital. Spätrenaissance* (1928), pl. 24) which A. E. Popham has recognized as a study for the figure of S. Romualdo in the altarpiece in S. Maria degli Angeli, Rome (Venturi, IX/7, fig. 257), and also to that of the *Seated Apostle* in the Janos Scholz Collection (repr. *Drawings from New York Collections: The Italian Renaissance* (1965), no. 124).

———

GIOVANNI BATTISTA NALDINI

Florence 1537–1591 Florence

D 992 A Figs. 552 and 553

(*recto*) View of the Colosseum, Rome; (*verso*) Copy of a relief on a Roman sarcophagus.

280 × 440. Pen and brown ink over black chalk (sketch of two boars' heads on the verso in red chalk). (Lower left corner torn away and repaired.) Inscriptions on recto: *A: Coliseo / B: meta sudans / al arco di Costatino.*

PROV: Sir Thomas Lawrence; David Laing; Royal Scottish Academy. Transferred 1910.

The drawing, formerly ascribed to Stefano della Bella, was first correctly attributed to Naldini by A. E. Popham. The verso is copied from a sarcophagus depicting the *Rape of the Leucippides*, published as being 'in a private collection in Rome' by Carl Robert, *Die antiken Sarkophag-Reliefs* (Berlin, 1904), III, 2, no. 182. The pen-work of this copy is similar to Naldini's copy of Polidoro's *Entombment* in the British Museum (BM Raphael, pl. 194). A series of 14 similar drawings of views and copies after the antique, with red chalk studies on the verso, is at Christ Church, Oxford (Inv. 0832–44 and 0846).

The *Meta Sudans* (on the left) was the remains of an ancient fountain which marked the meeting-point of four of the fourteen regions into which Augustus had divided the city. The remains were removed to widen the street and the place is now marked by a circle on the pavement. (See M. R. Scherer, *Marvels of Ancient Rome* (1956), pls. 124 and 125).

D 4890/15 A Fig. 554

A seated figure.

100 × 70. Red and black chalk and ink. (Laid down.) Inscribed: *Battista Naldi*[ni].

PROV: Marchese del Carpio; Paul and Edwardo Bosch, Madrid; H. M. Calmann. Purchased 1964.

Most probably the original drawing consisted of a rapid red chalk sketch, and the traces of black chalk and ink are later, inapt, additions. Otherwise the old attribution appears to be correct.

D 4890/19 Fig. 555

Seated figure with an open book.

115 × 168. Black chalk. (Laid down. Top right corner torn.) Inscribed: *Battista Naldini* (crossed out and *F. Zuccari* substituted).

PROV: Marchese del Carpio; Paul and Edwardo Bosch, Madrid; H. M. Calmann. Purchased 1964.

The rubbed condition of this sheet makes a considered judgement very difficult. It is, however, quite possible that the earlier of the two attributions, to Naldini, is correct.

D 4890/42 Fig. 556

The Lamentation.

142 × 110. Black chalk. (Laid down.) Inscribed: *Naldino*.

PROV: Marchese del Carpio; Paul and Edwardo Bosch, Madrid; H. M. Calmann. Purchased 1964.

A fine and typical example by the artist.

Attributed to
GIOVANNI BATTISTA NALDINI

D 4890/14 Fig. 557

Seated nude boy.

142 × 105. Black chalk. (Laid down.) Inscribed: *Jacomo da Pontormo*; and in blue pencil: *Prado 340*.

PROV: Marchese del Carpio; Paul and Edwardo Bosch, Madrid; H. M. Calmann. Purchased 1964.

The drawing, whilst Pontormesque, is certainly not by Pontormo himself. The softer modelling of the contours, and the shading, seem to point more in the direction of Naldini. The face, although perfectly consonant with Naldini's types, shows strongly the influence of Vasari.

D 4890/15 B Fig. 558

Study of a right hand holding a ?book.

87 × 126. Black and red chalk, on reddish toned paper. (Laid down.) Inscribed: *Salimbene*.

PROV: Marchese del Carpio; Paul and Edwardo Bosch, Madrid; H. M. Calmann. Purchased 1964.

The draughtsmanship, the manner of shading and modelling, even the prepared red paper, seem typical of Naldini. However, the structure of the hand recalls vividly Andrea del Sarto (cf. that of the figure on the extreme left in the fresco of *The Funeral of St Philip*, in the SS. Annunziata,

Florence, repr. Freedberg, *Andrea del Sarto* (1964), I, fig. 15; or the hands on the sheet of studies in the Louvre (1714), repr. Freedberg, *op. cit.* fig. 178). This drawing may therefore possibly be a copy by Naldini after Andrea del Sarto.

RSA 276 Fig. 559

Seated nude.

258 × 192. Red chalk. (Laid down.) Inscription erased in lower margin. Inscribed on the old mount: 'Antonio da Correggio'.

PROV: Thomas Hudson; J. Richardson, Jnr (L. 2183); Sir Joshua Reynolds; David Laing; Royal Scottish Academy. On loan 1966.

Though the drawing is very rubbed, it seems fairly certain that it is from Naldini's own hand.

FRANCESCO NARICI (NARICE)

Genoa 1719–1785 Genoa

RSA 261 Fig. 560

S. Giovanni di Dio distributing bread, and preaching.

108 × 155. Oil sketch in red on paper. Inscribed on the back: *di F^{co} Narici dipinsi nella Chiesa di S. Carlo in Strada Balli…trovati alla 2^{da} Capella a diritta.*

PROV: (Previous owner noted date of acquisition *15 Maggio 1829*); David Laing; Royal Scottish Academy. On loan 1966.

These are two sketches for wall paintings in a chapel in San Carlo at Genoa. The style shows the influence of Solimena.

GIUSEPPE NASINI

Castel del Piano (Grosseto) 1657–1736 Siena

RSA 185 Fig. 561

The Flight into Egypt.

259 × 173. Pen, brown ink and reddish-brown wash, over black chalk. Inscribed in pencil with the artist's name.

PROV: David Laing; Royal Scottish Academy. On loan 1966.

Circle of GIUSEPPE NASINI

D 1574 Fig. 562

Lot and his daughters.

278 × 238. Pen, brown ink, grey wash with traces of black chalk. (Laid down.)

PROV: J. Auldjo; David Laing; Royal Scottish Academy. Transferred 1910.

79

The former, erroneous ascription was to Baldassare Franceschini, il Volterrano. The style comes fairly close to that of Nasini, the pupil of Ciro Ferri. Two large drawings at Copenhagen (Mag. XIXª, 5 and 6), depicting respectively *Prisoners, some being thrown from a ship* and *Fisherwomen with net*, are very likely by the same hand as D 1574, and have also tentatively been attributed by Philip Pouncey to 'Gabbiani/Nasini'.

CESARE NEBBIA
Orvieto 1536–1614 Orvieto

D 4906 Fig. 563

Heraclius carrying the cross to Jerusalem.

259 × 204. Pen, brown ink and wash, over black chalk. (Tiny tear in bottom margin.) Pencilled inscription *Tintoret* in bottom left corner.

PROV: Miss G. Donati, London. Purchased 1966.

Study for the fresco in the Oratorio del Crocifisso (S. Marcello al Corso), Rome.

PARIS NOGARI
Rome c. 1536–1601 Rome

D 932 Fig. 564

The meeting between a commander and his army, and a king.

170 × 276. Pen and brown ink over black chalk. (Slightly damaged in parts. Laid down.)

PROV: Jonathan Richardson, Senr (L. 2184); David Laing; Royal Scottish Academy. Transferred 1910.

The old attribution, confirmed by Richardson on the mount, seems convincing. For a discussion of Nogari, see the article by F. Antal in OMD XIII (December 1938), p. 40. The design suggests a scheme for an elaborate decoration of a room.

NOSADELLA
See Giov. Franc. BEZZI.

PIETRO ANTONIO NOVELLI
Venice 1729–1804 Venice

D 827 Fig. 565

Caricature of a man chasing butterflies with two swords.

268 × 175. Pen, brown ink and water-colour. Inscription:

> *Si vanta esser costui Tagliacantoni*
> *e fà la guerra poi co i farfalloni.*

PROV: David Laing; Royal Scottish Academy. Transferred 1910.

The attribution of this and the four following drawings is based on the contemporary inscription of P. A. Novelli's name on one of three others, obviously also belonging to this series, at Berlin (17500–02). The pen-work is characteristic of Novelli and is also apparent in the drawing of a *Frate showing a tabernacle* in the Paul Wallraf collection (*Disegni Veneti del Settecento nella collezione Paul Wallraf*, Venice, 1959, no. 47). Some of the figures seem to be based directly or indirectly on Callot's series of twenty-one etchings *Les Gobbi, ou Bossus* (Meaume 747–67; Plan 304–24) executed in Florence in 1616, which in turn were at least partly inspired by Brueghel, and by the caricatures entitled *Les Songes drolatiques de Pantagruel* (Paris, 1565). (D 827 is Callot's no. 11 in reverse.) Apart from such French sources, Novelli could have drawn on a fairly long Italian tradition of similar caricatures: Guercino (whose influence is also reflected in the landscape backgrounds) and Mola come first to mind, and even more pertinently a drawing such as that by Johann Liss at Hamburg (23507) of a *Lotta di menestrelli*, repr. in the Catalogue by T. Pignatti, *Disegni Veneti del Seicento* (Venice, 1959), no. 29.

D 828 Fig. 566

Caricature of a man blowing a trumpet.

246 × 157. Pen, brown ink and water-colour. Inscription:

> *Mogliazzo hà nome questo Montanaro*
> *Che suona rozzamente quel Trombetto*
> *Sempre lo accorda quando fà un Balletto*
> *Co i ragli, e le coreggie d'un Somaro.*

D 829 Fig. 567

Caricature of a man piping to some mice and an owl.

246 × 157. Pen, brown ink and water-colour. Inscription:

> *Balla costui come il cervel gli frulla*
> *e fà saltar i Topi, e le Civette*
> *e mentre fà con quel Subiol corvette*
> *Brutto Porco co'l cul pettezza, e trulla.*

D 830 Fig. 568

Caricature of a man with flask and glass of wine.

256 × 180. Pen, brown ink and water-colour. Inscription:

> *E questo il gran Martano Bevitore*
> *di Bacco amico, e nemico di Marte*
> *Il suo mestiero, e di giocar le carte*
> *estar all'osteria da tutte l'ore.*
>
> *Si vanta sempre di qualche prodezza*
> *Ma poi si scopre che egli è un Berlingaccio,*
> *Fà brindisi mai sempre alzando il braccio*
> *In somma egli è un bell'Asin da cavezza.*

D 831 Fig. 569

Caricature of a man with a sword.

250 × 157. Pen, brown ink and water-colour. Inscription:

> Fà disfida Martano a tutte l'ore
> Con crudo aspetto, e furibonda faccia
> Ma se alcun rissoluto se gli affaccia
> Corre dal gran timor su'l Cacatore.

PROV: David Laing; Royal Scottish Academy. Transferred 1910.

D 1236 Fig. 570

Illustration to Metastasio's 'Giustino'.

147 × 92 (whole sheet). Pen, brown ink and grey wash. Inscribed:

> ...Ecco l'anello
> Con cui potreste suggellar la carta,
> Acciò tosto ubbidisca, e a noi ritorni.
> Atto II. Sc. 4.

PROV: David Laing; Royal Scottish Academy. Transferred 1910.

The design was engraved by G. Zuliani for the edition of Metastasio's works, published by Antonio Zatta in Venice in 1781–83. The engraving is placed in vol. XII, facing p. 23.

D 1628 Fig. 571

A female head looking upwards.

115 × 90. Pen and black ink.

PROV: David Laing; Royal Scottish Academy. Transferred 1910.

The attribution is convincing, especially when comparison is made with another female head in the Albertina (I, 403).

Attributed to
PIETRO ANTONIO NOVELLI

D 1224 Fig. 572

Venus and Cupid.

97 × 211. Pen, brown ink and grey wash.

PROV: David Laing; Royal Scottish Academy. Transferred 1910.

Style and technique point to Novelli.

RSA 281 Fig. 573

Juno with Cupid and peacock.

100 × 215. Pen, brown ink and grey wash.

PROV: David Laing; Royal Scottish Academy. On loan 1966.

A pendant to D 1224.

Ascribed to PIETRO ANTONIO NOVELLI

D 1920 Fig. 574

Female head in profile looking upwards.

71 × 84. Pen, brown ink and wash over red chalk. (Laid down.)

PROV: Lady Murray. Presented 1860.

The pen-work and the manner of shading of this fragment seem fairly characteristic of the style of P. A. Novelli, although the drawing may be of a slightly earlier date.

AVANZINO NUCCI
Città di Castello 1551–1629 Rome

D 3133 Fig. 575

The Presentation in the Temple.

256 × 178. Pen, brown ink and wash. (Tears repaired and laid down.) Inscription on an 18th century mount: 'L. Caracci'. The number 54 in the upper margin.

PROV: Count Gelozzi (L. 545); W. F. Watson. Bequeathed 1881.

This drawing belongs to a group of about fifty, whose artist Philip Pouncey gave the provisional name 'Pseudo-Bernardo Castello', owing to the resemblance of their rather frigid draughtsmanship to the style of Bernardo Castello. It seemed clear that, whatever his origin, the 'Pseudo-Bernardo Castello' worked in Rome, as late as the pontificate of Paul V, whose arms he drew on a sheet now in the British Museum. It was only recently that Philip Pouncey recognized that the real identity of the mysterious artist was Avanzino Nucci, an associate of Niccolò Pomarancio (Circignano). A drawing of a semi-nude Kneeling Man at Berlin (15505, as 'Domenichino') he was able to connect with the main figure of Nucci's altarpiece of The Baptism of Constantine in S. Silvestro al Quirinale, Rome. A squared drawing at Liverpool of the Madonna and Child with SS. Anthony Abbot and Thomas Aquinas (5083, Walker Art Gallery: Old Master Drawings and Prints (Liverpool, 1967), no. 68, pl. I), which bears a traditional attribution to Avanzino, is further evidence that the whole group, including D 3133, is correctly attributed to this artist.

LELIO ORSI
Reggio Emilia 1511–1587 Novellara

D 914 Fig. 576

Design for a house façade.

278 × 361. Pen, brown ink and wash. Squared in black chalk. Outlines incised. Inscribed: Lelio da Novellara on the tablet at the bottom.

PROV: W. Y. Ottley (with his mount); Sir Thomas Lawrence; David Laing; Royal Scottish Academy. Transferred 1910.

LIT: R. Blomfield, *Architectural Drawings and Draughtsmen* (1912), pl. 26c.

Orsi received several commissions to redecorate façades of houses in Novellara in 1563, none of which has survived (see *Italian Drawings at Windsor*, 530 and 531). D 914 is probably one of these and may have been intended for the house of a nobleman, whose arms were to appear on the two shields at either side of the central figure.

Miss F. Kossoff has drawn attention to several drawings which may be connected with D 914:

1. Witt Collection, Courtauld Institute (4527): a scene of the *Rape of the Sabines* which fits well with that in the upper storey of D 914, although it is less refined in style, and less definitely by Orsi himself.

2. Staedelsches Kunstinstitut, Frankfurt (563): a drawing similar to the smaller scene on the left in D 914. The architectural details show definite connections with those of the Witt drawing. Again it is doubtful whether this is an original drawing, and not rather a product of Orsi's studio.

3. Windsor (535): *Two Caryatids*, of which the right hand one has the same basic pose as the one on the far right in D 914.

4. Seattle Art Museum: *Three Caryatids* (repr. in *Art Quarterly* (Spring, 1959), p. 94) one of which is identical with the second from the right in D 914. The Seattle figure seems to represent a two-faced Janus, whilst in the Edinburgh drawing the shape of the second face has been changed to a mass of hair. Otherwise everything agrees: pose, foreshortening and the arrangement of the drapery. Miss Kossoff remembers another drawing, once at the Schaeffer Gallery at New York, which was very close to the Seattle sheet.

It is possible that these other studies were intended for another section of the same façade.

Attributed to
LELIO ORSI

D 3162 Fig. 577

Apollo in a horse-drawn carriage, accompanied by a train of attendants and lions.

163 × 244. Pen, brown ink and grey wash heightened with white. Inscribed in margin: *Pellegrino Tibaldi*.

PROV: W. F. Watson. Bequeathed 1881.

The former ascription to Tibaldi is incorrect. The drawing reveals almost certainly the hand of Lelio Orsi.

Imitator of LELIO ORSI

D 1622 Fig. 578

Allegorical subject: a youth and girl on the back of a prancing horse, holding a vessel which emits flames, and accompanied by a putto carrying a torch.

157 × 155 (irregular shape). Pen, brown ink and wash, heightened with white. Squared in black chalk. (Laid down.) Inscribed: *Coregio*.

PROV: David Laing; Royal Scottish Academy. Transferred 1910.

This seems to be the hand of a weak imitator of Lelio Orsi.

———————

GIOVANNI BATTISTA PAGGI
Genoa 1554–1627 Genoa

D 721 Fig. 579

A meeting between a pope and a king (or doge?) at a landing stage.

173 × 272. Pen, brown ink and wash over black chalk. Pencilled inscription on the back: *T. Zucchero*.

PROV: David Laing; Royal Scottish Academy. Transferred 1910.

The former ascription is untenable. The drawing is not only Genoese, but seems entirely characteristic of Paggi, a name first suggested by Philip Pouncey.

D 3079 Fig. 580

The return of the Holy Family from Egypt, attended by angels.

443 × 298 (arched top). Pen, brown ink over black chalk, on toned background. Squared in black chalk and incised. (Laid down.) Inscribed on the back: *No. 1276* and very faintly: *Giov. Batt. Paggi Genoese*; a partly obliterated inscription on the front of the mount: 'di Paggi'.

PROV: W. F. Watson. Bequeathed 1881.

The drawing entered the collection as 'A. Procaccini' (presumably intended to mean C. Procaccini), and although the composition is not unlike some of Camillo Procaccini's, there is a Genoese, faintly Cambiasesque element in the style, which led Philip Pouncey to point to Paggi-like features, even before the faint inscription on the back of the drawing had been uncovered. It may be argued that D 3079 is an original drawing by Paggi, but retouched, explaining the rather crude pen-work in parts.

Another version of the full composition is at Berlin (25240, anonymous, in portfolio 'Varia 1'), in pen and blue wash,

squared in red chalk, which has the symbol of the Holy Ghost instead of the flying putti at the top. This drawing certainly looks like a copy. A drawing of the three main figures, but in reverse, is in the Courtauld Institute Collection (4691). Two original studies for the *Christ Child holding the Apple*, are at Copenhagen (10542) and in the Uffizi (2152 F), both in red chalk, the Uffizi one heightened with white on prepared paper.

D 3079, and all the above, are connected with studies for the once famous altarpiece of 1598 by Paggi in S. Maria degli Angeli in Florence (see F. Baldinucci, *Notizie dei Professori del disegno* etc., ed. Ranalli, II (1846), p. 584; Bocchi-Cinelli, *Le bellezze della città di Firenze* (1677), p. 492; W. & E. Paatz, *Die Kirchen von Florenz*, III, p. 119 and note 45). The altarpiece appears to have been twice removed from its original place within the church, in *c.* 1684 and again in 1792. It is now supposed to be in the *deposito* of the Florentine Galleries (Inv. no. 3178), but has not been traced.

The fame of the picture is reflected in a number of painted versions which abound. Two have recently appeared in Christie's sales: (1) 1 June 1962, lot 36, as Salimbeni (kindly communicated by Philip Pouncey (Cooper Neg. 281487)), which agrees almost exactly with D 3079, except that it had a squared top, and the putto in the extreme upper right had his arms spread out; (2) 24 May 1963, lot 59, on panel, as Orsi (Cooper Neg. 298735), and with Colnaghi in 1964 (*Paintings by Old Masters*, No. 24), which differed in the landscape background from the previous picture and has the putto in the upper right corner missing altogether. This version had a softer, pietistic, almost Moncalvo-like air about it. The figures alone, seen against a background of Roman ruins, appear in an Italianate picture in the possession of Mr and Mrs. A. J. Mackenzie Stuart, Edinburgh.

The composition was also engraved by Cornelis Galle I (Hollstein, VII, p. 51, no. 43).

D 4912 Fig. 581

The Holy Family with St John.

183 × 215. Pen and brown ink. (Paper cut and slightly damaged.) Inscribed: *di Paggi*.

PROV: Miss A. J. Gray, Edinburgh. Purchased 1966.

Attributed to
GIOVANNI BATTISTA PAGGI

D 3085 Fig. 582

Christ driving the moneylenders from the Temple.

355 × 253. Pen, brown ink and wash, over red chalk. (Laid down.) Inscription, at bottom of old backing: *Giacomo*

Robusti detto il Tintoretto. Pel suo grande spirito, prontezza, ed ardire nell'operare. Titiano ingelosito lo scacciò dalle sue stanze mentre ancora era giovenetto; I Caracci tutti e tre lo… virono, e conobbero in Venetia in cui vineva verso l'anno 1580. Mi fu mandato da Urbino dal Pittore Bertucci l'anno 1691. Fu detto Tintoretto, perche figlio di un Tintore.

PROV: (Unidentified mark on verso: indecipherable monogram within an oval); Viscount Hampden, according to an inscription on the back; W. F. Watson. Bequeathed 1881.

Because of the reference to Tintoretto in the above inscription, the drawing entered the collection under his name. There can, however, be little doubt that it is Genoese, for the excited pen-work, and particularly the facial types, make one think of G. B. Paggi.

D 1167 Fig. 583

Venus and Cupid.

301 × 264. Pen, brown ink and wash over black chalk.

PROV: Bindon Blood (L. 3011); David Laing; Royal Scottish Academy. Transferred 1910.

Formerly ascribed to Cambiaso, the style is, however, much closer to G. B. Paggi.

Circle of GIOVANNI BATTISTA PAGGI

RSA 181 Fig. 584

Girls fleeing from a cavalry attack.

340 × 297. Pen, brown ink and wash over black chalk on blue paper. (Laid down.) Inscribed on the back: *Lionel Spada*.

PROV: David Laing; Royal Scottish Academy. On loan 1966.

The drawing is certainly Genoese, and probably from the hand of an artist influenced by Paggi.

JACOPO PALMA
(il Giovane)
Venice 1544–1628 Venice

RSA 134 Fig. 585

The Holy Family in a stable.

350 × 270. Pen and ink. Inscribed in an old hand: *Titian fec. 1.4.*; 'Dom. Campagnola' in a recent hand on the back of old mount.

PROV: Sir Peter Lely; ?W. Gibson; David Laing; Royal Scottish Academy. On loan 1966.

The two previous ascriptions are erroneous. There can be little doubt that the drawing is by Palma Giovane, but he shows himself here strongly under the influence, or even actually copying a design, of Domenico Campagnola. Yet the style seems to indicate that this is a late drawing.

RSA 175 Fig. 586

The woman taken in adultery.

294 × 209. Pen, brown ink and wash, heightened with white. Dated: *1626*.

PROV: H. C. Jennings (L. 2771), according to inscription on back; David Laing; Royal Scottish Academy. On loan 1966.

D 708 Fig. 587

Christ on the Mount of Olives.

88 × 77. Pen and brown ink. (Part of the paper cut and laid down.)

PROV: Thomas Hudson; David Laing; Royal Scottish Academy. Transferred 1910.

LIT: Tietze, 892.

The style of this drawing would suggest a date around the end of the 16th century, as the Tietzes have also remarked (*loc. cit.*). For comparison one might point to the pen drawing of flying figures in the Uffizi (7871s), for which a similar date has been suggested (see Anna Forlani, *Mostra di Disegni di Jacopo Palma il Giovane* (Florence, 1958), no. 31, fig. 15).

D 3100 Fig. 588

The Entombment of Christ.

285 × 193. Pen, brown ink and wash over black chalk. (Laid down.) Inscription on old mount: 'Squarcione'.

PROV: W. F. Watson. Bequeathed 1881.

LIT: Tietze, 897 (as Palma Giovane).

The Tietzes attributed the drawing to Palma Giovane and related it to a drawing in the Stroelin Collection, Lausanne. This attribution has been retained, although it is not absolutely convincing.

D 3156 Fig. 589

The dead Christ supported by seven angels.

216 × 191. Pen, brown ink and wash, slightly heightened with white. Inscription on mount: 'Le Tintoret'.

PROV: W. F. Watson. Bequeathed 1881.

LIT: Tietze, 898 (as Palma Giovane).

The Tietzes accepted this drawing as being 'typical of the latest period' of Palma Giovane. The composition in fact agrees closely with that of the small painting in the Pinacoteca at Cremona (A. Puerari, *La Pinacoteca di Cremona* (1951), no. 193, fig. 168) except for the pose of the angel supporting Christ on the right, as well as that of the kneeling putto. These variations might suggest that D 3156 is a preliminary study for the Cremona painting, but the draughtsmanship seems rather weak so that it is possible that the drawing is the work of a studio assistant.

D 3099 Fig. 590

Christ standing in a chalice, supported by angels.

269 × 193. Pen, brown ink with traces of black chalk. Outlines pricked for transfer. (Corners cut. Laid down.) Inscribed: *Palma*.

PROV: W. F. Watson. Bequeathed 1881.

LIT: Tietze, 896; *Fifty Master Drawings in the National Gallery of Scotland* (1961), no. 12.

The style would suggest that this is a late drawing, around 1620. As the Tietzes have pointed out, a similar drawing is in the Museo Correr, Venice (1242), but their observation that the composition resembles the frontispiece of the *Mariegola* of the Brotherhood of the Scuola del Santissimo Corpo di Cristo (Museo Correr, MS. IV, 25), although certainly correct, is of less significance than may at first appear, as the subject seems to have occurred rather frequently in the popular art of the period and similar images were used in church services. The same type of inscription occurs on a sheet of studies at Munich (6585). The pinpricks show that the design was used for transfer, perhaps for a cope.

D 697 Fig. 591

St Martin and the beggar.

390 × 259. Brush and oil-colour over black chalk on buff paper. Squared in black chalk. Inscribed on the back: *No. 44. Tintoretto bought at Hudson's Sale AD 1779*.

PROV: Thomas Hudson; David Laing; Royal Scottish Academy. Transferred 1910.

LIT: Vasari Society, 1st Series, VIII, 8 (as Jacopo Tintoretto); Detlev von Hadeln, *Die Zeichnungen des Giacomo Tintoretto* (1922), p. 16 (as Palma Giovane Circle); J. Meder, *Die Handzeichnung*, 2nd ed. (1923), fig. 55 (as Tintoretto); Detlev von Hadeln, *Venezianische Zeichnungen der Spätrenaissance* (1926), pl. 98 (as Palma Giovane); Tietze, 891 (as Palma Giovane); *Catalogue: National Gallery of Scotland* (1946), p. 395 (as Jacopo Tintoretto).

EXH: *Old Master Drawings*, Royal Academy, London, 1953 (115, as Palma Giovane).

The Tietzes suggested that this might possibly be a design for the lost altarpiece by Palma Giovane in S. Martino, Murano. The technique of chalk, heightened with oil-colour, comes very close to that favoured by Domenico Tintoretto, and an attribution to him had been considered but finally discarded. On balance, the style seems to be nearer to Palma Giovane, as, for example, a strikingly similar drawing in the Albertina (I, 177) shows, also reproduced in *Disegni veneti dell'Albertina*, etc. (Venice, 1961), no. 66.

RSA 164 Fig. 592

St Jerome.

294 × 175. Pen, ink and wash, heightened with white. Dated: *1627*. Inscribed on the back: *Palma*.

PROV: Sir Thomas Hudson (according to inscription on the mount); Sir Joshua Reynolds (mark cut out); David Laing; Royal Scottish Academy. On loan 1966.

RSA 196 Fig. 593

The torturing, by boiling, of St John the Evangelist. (On the verso: studies of three female figures.)

334 × 256. Recto: pen and brown ink over black chalk. Verso: red chalk. Inscribed: *G.P. No. 136*.

PROV: David Laing; Royal Scottish Academy. On loan 1966.

Similar inscriptions to that on the verso occur frequently on drawings by Palma (see D 1173).

RSA 223 Fig. 594

St Francis in ecstasy.

380 × 239. Pen, brown ink and wash over black chalk, on brown paper. Inscribed on the back: *Carrache* and *Vieux Palma*.

PROV: David Laing; Royal Scottish Academy. On loan 1966.

Both previous ascriptions are wrong, and there is little doubt that this is a characteristic example of Palma Giovane's draughtsmanship.

D 1616 Fig. 595

St Anthony and the centaur.

207 × 271. Pen, brown ink and wash heightened with white, on buff paper. Dated *1625* in lower right hand corner.

PROV: Nicholas Lanier (L. 2885); Richard Cosway; Jonathan Richardson, Jnr (L. 2170); William Mayor; David Laing; Royal Scottish Academy. Transferred 1910.

LIT: Tietze, 894.

The subject is taken from the *Legend of St Anthony*. As the Tietzes have remarked, the style of the drawing is characteristic of Palma's latest period.

D 723 Fig. 596

Solomon and the Queen of Sheba.

137 × 191. Pen, brown ink and wash over black chalk. Squared in black chalk. Very faint inscription: *Palma* in the bottom margin, and 'Jacopo Palma' on the mount. (Laid

down. Another drawing on the back faintly visible through the paper.)

PROV: Jonathan Richardson, Senr (judging from the mount); David Laing; Royal Scottish Academy. Transferred 1910.

LIT: Tietze, 893.

As in the case of the previous drawing, a date around the end of the 16th century is suggested.

D 1627 Fig. 597

A king, with crown and sceptre, holding a scroll.

176 × 84. Pen, brown ink and wash over black chalk. Squared in black chalk. (Laid down and three of the corners cut.) Old inscription on mount: 'di Simone Pignone'.

PROV: David Laing; Royal Scottish Academy. Transferred 1910.

The present attribution is due to A. E. Popham.

D 4890/11 Fig. 598

Seated female figure.

193 × 140. Pen and ink, over black chalk on blue paper. (Laid down.)

PROV: Marchese del Carpio; Paul and Edwardo Bosch, Madrid; H. M. Calmann. Purchased 1964.

Although there is no inscription, the drawing is undoubtedly by Palma Giovane.

RSA 149 Fig. 599

Prometheus and the eagle.

257 × 185. Pen and brown ink, with pink wash. Traces of red chalk. (Laid down, corners cut.)

PROV: David Laing; Royal Scottish Academy. On loan 1966.

The previously unattributed drawing is obviously by Palma Giovane.

D 1173 Figs. 600 and 601

(*recto*) Two allegorical figures: 'Sculpture' and 'Painting';
(*verso*) Sketch for an *Annunciation* and rough outline sketches of a reclining figure, a leg and a torso seen from the back.

360 × 243. Pen and brown ink. Inscriptions (partly cut) on recto in curious orthography, see below; also *Scultura* and *Pittura* underneath the relevant figures; on the verso: *G. P. nº: 151*.

PROV: David Laing; Royal Scottish Academy. Transferred 1910.

EXH: Colnaghi, 1966 (21).

Inscriptions: top—*A vinti quatro hori vini un vinto cusi ardenti chi | pariva fiami di focho chi molti pinsavono chi si abrugiasse | case dovi* (?) *chi a lasciare un caldo intolirabilli*; bottom—*bortolomio grandi…in lion di fa…*

Other drawings with similar inscriptions—usually not relating to the subjects depicted—are known and would suggest that they formed part of a drawing book. See note to RSA 196, above.

D 2237　　　　　　　　　　　　　　　　Fig. 602

Self-portrait. (On the verso: sketch of legs, cut.)

238 × 200. Black and red chalk on faded blue paper. Old inscription on the drawing: *Palmae effigies ab ipsomet delineata anno Dñi 1614. Die 15 Decemb:*

PROV: W. F. Watson. Bequeathed 1881.

LIT: Tietze, 895; H. Schwarz, 'Palma Giovane and his Family: Observations on some Portrait Drawings', *Master Drawings*, III, 2 (1965), p. 160, pl. 27.

EXH: Colnaghi, 1966 (27).

A self-portrait at the age of 70. It might be connected with the painted self-portrait in the Uffizi with which the pose and general appearance of the drawing corresponds, although the painting seems to show the artist at a younger age. A very close smaller version of this portrait is contained in a little sketch book in the collection of F. Lugt, Paris, where it shares the page with portraits of Palma Vecchio and Tintoretto (*Le Dessin Italien dans les Collections Hollandaises*, Paris–Rotterdam–Haarlem (1962), no. 126, pl. XCI bottom left).

Circle of JACOPO PALMA

D 4890/31 A　　　　　　　　　Figs. 603 and 604

Two heads of children.

70 × 70 and 70 × 62. Pen and brown ink on blue paper. (Laid down.)

PROV: Marchese del Carpio; Paul and Edwardo Bosch, Madrid; H. M. Calmann. Purchased 1964.

These unattributed drawings clearly reveal the influence of Palma Giovane.

D 2954

Head of a child.

94 × 127. Pen, brown ink. (Laid down.)

PROV: W. F. Watson. Bequeathed 1881.

GIUSEPPE PALMIERI

Genoa 1674–1740 Genoa

RSA 174　　　　　　　　　　　　　　　　Fig. 605

St Christopher.

251 × 195. Black chalk and grey wash (composed into an oval). Inscribed: *Giuseppe Palmieri.*

PROV: David Laing; Royal Scottish Academy. On loan 1966.

Attributed to
PIETRO GIACOMO PALMIERI, the Elder

Bologna 1737–1804 Turin

D 1721　　　　　　　　　　　　　　　　Fig. 606

Rocky river landscape with figures.

280 × 394. Pen and brown ink over black chalk. Pencilled inscription: *Gennari.*

PROV: David Laing; Royal Scottish Academy. Transferred 1910.

The inscription to Benedetto Gennari (1633–1715), the nephew and pupil of Guercino, spotlights the undoubted affinities of this drawing with Guercino's style. However, even the paper suggests that it must be a drawing of the middle of the 18th century, or later. The style is reminiscent of the 18th century imitator of Guercino (see D 649 ff.), but reveals more individuality and merit. The attribution to Palmieri was suggested by Denis Mahon. A drawing, almost certainly by the same hand, and bearing an ascription to Guercino, is at Hamburg (1915–979).

GIOVANNI PAOLO PANNINI

Piacenza 1691–1765 Rome

D 962　　　　　　　　　　　　　　　　Fig. 607

Architectural 'capriccio' with an equestrian statue on the left.

183 × 131. Pen, brown ink and wash, heightened with white. Pencilled inscription: 'Pannini' on mount.

PROV: David Laing; Royal Scottish Academy. Transferred 1910.

D 963　　　　　　　　　　　　　　　　Fig. 608

'Capriccio' of classical ruins, with figures.

245 × 346. Pen, black ink and water-colour over black chalk. Inscribed: *P. Panini.*

PROV: Sir Thomas Lawrence; David Laing; Royal Scottish Academy. Transferred 1910.

LIT: R. Blomfield, *Architectural Drawings and Draughtsmen* (1912), pl. 64b.

D 965 Fig. 609

Figures within the ruins of a classical temple.

278 × 191. Pen, black ink and grey wash.

PROV: E. V. Utterson; David Laing; Royal Scottish Academy. Transferred 1910.

D 998 Fig. 610

The Porta Santo Spirito, Rome.

355 × 251. Pen, black ink and water-colour, over black and red chalk.

PROV: David Laing; Royal Scottish Academy. Transferred 1910.

BERNARDO PARENTINO

Parenzo (Istria) c. 1437–1531 Vicenza

D 655 Fig. 611

A horseman and his attendant.

267 × 191. Pen and brown ink. (Rather damaged and spotted, laid down.)

PROV: Sir Peter Lely; David Laing; Royal Scottish Academy. Transferred 1910.

LIT: Vasari Society, 1st Series, VII, 9; J. Byam Shaw in *Old Master Drawings*, IX (June 1934), pp. 1ff. as 'Paduan School'; *Catalogue: National Gallery of Scotland* (1946), p. 390 (as 'School of Mantegna'); *Fifty Master Drawings in the National Gallery of Scotland* (1961), no. 4.

EXH: Colnaghi, 1966 (4).

The present attribution was first suggested by Tancred Borenius, and seems entirely convincing, especially the facial types, and particularly when compared with the material that J. Byam Shaw published (*op. cit.*). To this can be added another characteristic drawing at Munich (41127) of a woman carrying a basket, etc., as well as RSA 259. The symbolism of the twigs and the tree, held by the two figures in D 655, has not been explained.

Attributed to
BERNARDO PARENTINO

RSA 259 Fig. 612

A pilgrim plucking a gourd from a tree.

218 × 178. Pen and brown ink on pink toned paper. (Corners torn.) Inscribed on the back: *Mantegna*.

PROV: Nathaniel Hone; David Laing; Royal Scottish Academy. On loan 1966.

The drawing is obviously by the same hand (even in the same medium) as the one in the Janos Scholz Collection, depicting a man carrying a bundle of wood and gourds (*Italienische Meisterzeichnungen…Sammlung Janos Scholz*, Cologne, Wallraf-Richartz-Museum, December 1963–January 1964, no. 176, pl. 13). The attribution there to Marco Zoppo, based on comparison with drawings in the British Museum, among others, does not seem very convincing. The style of both drawings accords well with the group now generally agreed to be by Parentino.

FRANCESCO PARMIGIANINO
(Mazzola)

Parma 1503–1540 Casalmaggiore (Parma)

D 820 Figs. 613 and 614

(*recto*) A seated man in armour;
(*verso*) Madonna and Child ('Madonna della Umiltà').

187 × 105. Pen and black ink. Inscribed (in Richardson's hand): *Parmeggiano*.

PROV: N. Lanier (L. 2886, on verso); Sir Peter Lely; P. Lankrink; Jonathan Richardson, Senr (L. 2183); J. Barnard; David Laing; Royal Scottish Academy. Transferred 1910.

LIT: L. Frohlich-Bume, 'Some Unpublished Drawings by Parmigianino', *Apollo* (November, 1962), p. 695, figs. 7 and 8; K. Andrews, *Parmigianino* (*The Masters*, no. 25 (1966), fig. 1).

EXH: Colnaghi, 1966 (14).

Contrary to Mrs Frohlich, who believed this sheet to have been done in Bologna, where Parmigianino lived and worked before returning to Parma in 1531, it may be argued that it is in fact an early drawing of the 1520s, before the journey to Rome. The broad vigorous pen strokes accord well with such drawings as the youthful *Horseman* formerly in the Rudolf collection (Arts Council Exhibition 1962, no. 51, pl. 7; Colnaghi, *Exhibition of Old Master Drawings*, July 1963, no. 7, frontispiece) or the British Museum drawing 1948-10-9-126 (A. E. Popham, *The Drawings of Parmigianino* (1953), pl. V) for the fresco in S. Giovanni Evangelista, Parma, which was executed in 1522.

It would be tempting to connect the verso with the *Holy Family* now in the Prado (S. Freedberg, *Parmigianino*, (1950), pl. 35) which can be dated 1524. A. E. Popham has suggested that it might be connected with the early, now lost, *Madonna with St Jerome and the Beato Bernardino da Feltre* (Freedberg, figs. 6 and 7), in which a tree forms an important and significant element. The compiler has

pointed out (*op. cit.*) that a drawing like D 820 seems to reveal the influences of the more robust styles of Romanino and Pordenone.

D 646 Fig. 615

Anatomical drawing of two legs.

257 × 135. Black chalk. (Laid down.) Old inscription on mount: 'Francesco Mazzoli d° il Parmigian°·'.

PROV: David Laing; Royal Scottish Academy. Transferred 1910.

EXH: *Old Master Drawings*, Leicester, 1952 (42).

The old attribution may well be correct. The drawing is rather reminiscent of the one in the Casa Buonarroti from the 'Circle of Michelangelo' (Dussler, *Die Zeichnungen des Michelangelo* (Berlin, 1959), no. 421, pl. 222; Paola Barocchi, *Michelangelo* (Florence, 1962), no. 230, pl. 333). However, the similarity is probably quite fortuitous, and in any case the proportions, especially of the upper thighs in D 646, are completely characteristic of Parmigianino. It would appear to be a late drawing.

Attributed to
FRANCESCO PARMIGIANINO

D 3000 Fig. 616

Mars, Venus and Cupid.

196 × 142 (whole sheet). Pen and brown ink, partly gone over in black chalk. (The actual composition has been cut and laid down, and additional sketches in black ink over red chalk added—possibly by a later hand.)

PROV: W. F. Watson. Bequeathed 1881.

LIT: L. Frohlich-Bume, 'Some Unpublished Drawings by Parmigianino' in *Apollo* (November 1962), p. 696, fig. 9.

The attribution to Parmigianino appears to be of recent date. A. E. Popham, according to a note on the back of the drawing, disagreed with this and suggested Bertoia instead. Mrs Frohlich-Bume, accepting the attribution to Parmigianino, suggests moreover that it originated from the artist's mature period. It is difficult to come to any definite conclusion in the case of such a damaged drawing: it is certainly Parmigianinesque, and all one can say is that it seems to be by either Parmigianino or Bertoia.

D 3046 Fig. 617

Seated female figure with open book at table, with attendant figures.

125 × 97. Black chalk. (Laid down.) Inscribed: 'Parm...' on the old mount.

PROV: W. F. Watson. Bequeathed 1881.

The traditional attribution was first questioned but lately accepted by A. E. Popham. Although the style is not inconsistent with Parmigianino's handling of chalk, it would be difficult to know where to place it within Parmigianino's œuvre, unless one assumes that it dates from his Roman period, when chalk drawings not unlike the present one occur. The pentimenti suggest that it is an original drawing.

Ascribed to FRANCESCO PARMIGIANINO

D 2909 Fig. 618

Two seated nude figures, facing each other.

132 × 77. Pen and brown ink. Composed into an oval. (Laid down, damaged and very faded.) Inscribed in an old hand: *Parmigianino*.

PROV: Francesco II, Duke of Mantua (L. 1893); W. F. Watson. Bequeathed 1881.

From the little one can see, it seems improbable that this is even a wreck of an original drawing by Parmigianino.

Copies after FRANCESCO PARMIGIANINO
D 729 Fig. 619

A seated nude youth.

141 × 119. Pen and brown ink. The remains of an erased inscription have been cut out and are still partly visible in the lower margin. Inscription on the back of the mount: 'Lot 35.14'.

PROV: David Laing; Royal Scottish Academy. Transferred 1910.

LIT: L. Frohlich-Bume, 'Some Unpublished Drawings by Parmigianino' in *Apollo* (November 1962), p. 696, fig. 10.

Mrs Frohlich-Bume has suggested that the drawing is an original, dating from the last years of the artist, at the time when he was engaged on the frescoes in the vault of the *Steccata* church at Parma. Philip Pouncey, however, shares the compiler's conviction that this cannot be an original. It seems a confused and unintelligent drawing, rough and mechanical in a way which Parmigianino never was, and is perhaps based on a composition by him which is now lost. Proof of this seems to be the meaningless leg—probably that of a putto placed behind the figure in the original design—which appears below the outstretched arms.

D 2255

Allegorical figure of 'Astronomy'.

106 × 81. Pen and ink.

PROV: W. F. Watson. Bequeathed 1881.

As A. E. Popham pointed out, this is a copy of a drawing by Parmigianino at Chatsworth (no. 795 B verso, Courtauld list 601), of which other copies are at Windsor (*Italian Drawings at Windsor*, 611 verso and 614 recto).

D 2255 is in the same sense as the etching with the signature *FP* (B. XVI, p. 25, 20), from which it may in fact have been copied. The composition was also reproduced as a chiaroscuro (B. XII, p. 138, 16).

D 2946
A pair of legs.

126 × 86. Pen, brown ink.

PROV: Sir Peter Lely (mark cut off); W. F. Watson. Bequeathed 1881.

Close to the legs of the standing warrior on the sheet of figure studies reproduced in E. v. Schaack, *Master Drawings in Private Collections* (New York, 1962), no. 14.

D 3158
St Christopher.

215 × 159. Pen, brown ink, wash, heightened with white on prepared paper. Inscribed: *1538/F. M./P.*

PROV: W. F. Watson. Bequeathed 1881.

A copy of the Parmigianino drawing in the École des Beaux-Arts (no. 2367). A copy or tracing is in the Louvre (no. 6577). It was also engraved by Hendrik van den Borcht II (Hollstein, 8). D 3158 seems to have been copied from the original drawing, as the engraving is in the reverse sense.

DOMENICO PARODI
Genoa 1668–1740 Genoa

RSA 173 Fig. 620
A Dominican monk.

238 × 182. Pen, ink and grey wash, composed into an oval. Inscribed: *Dom. Parodi.*

PROV: David Laing; Royal Scottish Academy. On loan 1966.

LORENZO PASINELLI
Bologna 1629–1700 Bologna

Ascribed to LORENZO PASINELLI
D 903 Fig. 621
Design for a memorial tablet.

254 × 144 (arched top). Pen, brown ink and wash, over black chalk. (Laid down.) Inscribed on the old mount, in Richardson's hand?: 'Lorenzo Pasinelli', and on the back: *L. 56–10.*

PROV: 'P. Crozat'? (L. 474); Jonathan Richardson; David Laing; Royal Scottish Academy. Transferred 1910.

The drawing is so bad that it is impossible to judge whether even the composition is by Pasinelli.

BARTOLOMEO PASSAROTTI
Bologna 1529–1592 Bologna
D 1674 Fig. 622
Study of a spaniel.

253 × 321. Oil on brown prepared paper. (Laid down.) Inscribed in an old hand: *passerota in Verona feci*[t].

PROV: David Laing; Royal Scottish Academy. Transferred 1910.

LIT: *Catalogue: National Gallery of Scotland* (1946), p. 392.

D 506 Fig. 623
Head of a man.

284 × 192. Reed pen and brown ink. (Rather damaged and laid down.) Old inscription on the mount: 'Passarotti', and on the back: *Passarotti/Fiori 1570.*

PROV: N. F. Haym (L. 1530); Earl Spencer (L. 1530); George Smythe, according to a pencil inscription on the back of old mount, in Laing's hand, 'bought by him in London'; David Laing; Royal Scottish Academy. Transferred 1910.

A characteristic drawing in the artist's broad and vigorous style.

Studio of BARTOLOMEO PASSAROTTI
D 3078 Fig. 624
Profile head of a female clad in armour.

385 × 263. Pen and brown ink. (Laid down.) Inscribed: *Passarota.*

PROV: Earl of Arundel, according to inscription on the back of the mount; N. Lanier (L. 2885); J. Pz. Zoomer; W. F. Watson. Bequeathed 1881.

This rather feeble and mechanical drawing cannot be considered an original by Passarotti, but may have originated in his studio.

Circle of BARTOLOMEO PASSAROTTI
D 4890/49 Fig. 625
Head of a man.

130 × 102. Pen and black ink with traces of red wash. (Cut out and laid down.) Inscribed: *Frabaldese.*

PROV: Marchese del Carpio; Paul and Edwardo Bosch, Madrid; H. M. Calmann. Purchased 1964.

It is not clear whether the inscription is supposed to refer to Francesco Trabellesi who worked in Mantua in the last quarter of the 16th century. All that can be said is that the style of this drawing reveals the influence of Passarotti.

Follower of BARTOLOMEO PASSAROTTI

D 733 Fig. 626

The penitent Magdalen.

235 × 200. Pen, brown ink and wash. (Laid down.) Inscribed: *Scuo. di Lod. Carracci.*

PROV: Woodburn sale, 1860, lot 1180; David Laing; Royal Scottish Academy. Transferred 1910.

The drawing is clearly in the Passarotti tradition, and has been catalogued under his name rather than with the anonymous Bolognese School.

D 3117 Fig. 627

A satyr's head, in profile, with the tongue sticking out. (On the verso: a nude seated figure, playing the lute.)

230 × 164. Pen, brown ink and traces of red chalk. Inscription: *M. Angelo.*

PROV: W. F. Watson. Bequeathed 1881.

The broad and heavy hatching points to Passarotti's influence. The drawing, though weak, seems to be contemporary. The figure on the verso is very feeble indeed.

GIOVANNI BATTISTA PASSERI

Rome c. 1610–1679 Rome

D 3015 Figs. 628 and 629

(*recto*) Adoration of the Shepherds; (*verso*) Two standing robed figures.

216 × 178. Pen and brown ink. Old inscription: *Passeri.* Other inscriptions: (recto)—*si principia ad app(rovare?)*; (verso)—*riprova non ha la quadragesima (?)*.

PROV: Jonathan Richardson, Jnr (L. 2170); W. F. Watson. Bequeathed 1881.

The attribution seems convincing, especially when compared with the large collection of Passeri's drawings at Düsseldorf, although the usual white heightening is missing here.

IL PASSIGNANO

(Domenico Cresti)

Passignano (near Florence) 1558–1636 Florence

D 701 Fig. 630

The Virgin contemplating the instruments of the Passion.

216 × 161 (whole sheet). Pen, brown ink and wash, heightened with white, over black chalk. Inscribed: *Passignano*, and in the lower margin: *mr francesco se mai è bisognato adoperar la discrezione, questa | è la volta convenendovi*

cavar una buona opera da un tristo | disegno. Il vostro valore è grande, e però mi raccdo.

PROV: David Laing; Royal Scottish Academy. Transferred 1910.

The traditional attribution to Passignano seems possible. A drawing in the Uffizi (*Rape of Lucretia*, 868F recto) attributed to Passignano shows similarities of style, as does —on the other hand—a drawing in the Albertina, of *Christ with some pilgrims* (S.R. 499a), there attributed to Mario Balassi (1604–67), a pupil of Passignano. Philip Pouncey has suggested that D 701 may possibly be by Fabrizio Boschi, another pupil of Passignano.

GIOVANNI ANTONIO PELLEGRINI

Venice 1675–1741 Venice

D 1656 Fig. 631

Esther before Ahasuerus.

141 × 202. Pen, brown ink and wash; traces of black chalk. (Laid down.) Inscribed: *Titiano.*

PROV: David Laing; Royal Scottish Academy. Transferred 1910.

The drawing seems characteristic of Pellegrini's nervous yet assured pen-and-wash technique, emphasizing mass rather than detail (see for example the large collection at Düsseldorf, especially Cat. *Disegni e dipinti di G. A. Pellegrini* (Venice, 1959), nos. 15–30). The same subject, but within a more elaborate architectural setting, has been treated by Pellegrini in two other drawings, one in the Louvre (5320), the other in the Uffizi (7802s), reproduced in Venice Cat. *op. cit.* as nos. 88 and 89.

PIETRO PERUGINO

(Vannucci)

Città della Pieve c. 1445–Fontignano (Perugia) 1523

Copy after PIETRO PERUGINO

D 3009

Angel playing a harp.

201 × 83. Brush and body-colour (perhaps over silverpoint) on pink prepared paper. (Very damaged and laid down.)

PROV: W. F. Watson. Bequeathed 1881.

As A. E. Popham has pointed out, this total wreck is a copy from the drawing in the British Museum (BM XIV–XV, no. 198, pl. 177) which in turn copies a Perugino design.

BALDASSARE PERUZZI
Siena 1481–1536 Rome

D 1625 Fig. 632

St Christopher.

285 × 209. Pen, brown ink and wash over black chalk. Old inscription: *BALDASS: DI SIENA.*

PROV: Sir Peter Lely; David Laing; Royal Scottish Academy. Transferred 1910.

LIT: C. L. Frommel, 'Baldassare Peruzzi als Maler und Zeichner', *1. Beiheft des Römischen Jahrbuchs für Kunstgeschichte der Bibliotheca Hertziana*, XI/XIII (1967), cat. 120, fig. 87a.

EXH: Colnaghi, 1966 (12, pl. 7).

A fine and characteristic late drawing, which Frommel dates c. 1532 and relates to another *St Christopher* drawing in the École des Beaux-Arts, Paris (249), and the rather similar head on the right of the sheet of studies in the Albertina (VI, 126). A representation of the same Saint, not unlike D 1625, occurs in the fresco of the chapel in the Castello di Belcaro (outside Siena) which, however, may not be an autograph work (Venturi IX/5, fig. 231).

DOMENICO PERUZZINI
fl. Pesaro 1640–1661

RSA 342 Fig. 633

Landscape with seated hunters under a tree.

407 × 250. Pen and brown ink. (Slightly damaged in parts and repaired.) Faded inscription on the back: *di Dom^co Peruzzini f.*, and in a later hand: *Titiano Vecelli.*

PROV: David Laing; Royal Scottish Academy. On loan 1966.

GIOVANNI BATTISTA PIAZZETTA
Venice 1682–1754 Venice

D 1849 Fig. 634

A man and a boy with recorders.

325 × 440. Black chalk and wash, heightened with white. (Laid down.)

PROV: (? Allan Ramsay); Lady Murray. Presented 1860.

LIT: *Fifty Master Drawings in the National Gallery of Scotland* (1961), no. 43.

EXH: Colnaghi, 1966 (78).

GIORGIO PICCHI
Casteldurante (Urbania) c. 1550–1599 Rome

D 654 Fig. 635

Four studies of putti.

(a) 183 × 110; (b) 179 × 107; (c) 178 × 122; (d) 180 × 108. Pen, brown ink and wash over black chalk, except (c) which is in black chalk only. The last one signed: *1598 in Castelduranti di Giorgio Pichi.*

PROV: David Laing; Royal Scottish Academy. Transferred 1910.

These studies are obviously related to the two drawings of putti, exhibited anonymously as nos. 69 and 70 in the *Mostra di Cento Disegni inediti della Biblioteca di Urbania: Barocci e Barocceschi*, Urbino, 1959 (repr. in cat., pls. 85 and 86).

PIETRO DA CORTONA
(Berettini)
Cortona 1596–1669 Rome

D 1906 Fig. 636

David and Abigail.

270 × 389. Pen, black ink and grey wash, heightened with white over black chalk.

PROV: (? Allan Ramsay); Lady Murray. Presented 1860.

The drawing was labelled 'Follower of Pietro da Cortona' when it entered the collection, but the compiler's suggestion that it is in fact an original drawing of Pietro's early period was vindicated by Walter Vitzthum's discovery of an engraving after a now-lost painting by Cortona which depicts, with significant variations, the composition of D 1906. This engraving, by Benedetto Eredi, refers to the painting 'esiste nel Palazzo dell Ill.mo...Cav. Michele Grifoni in Via Servi in Firenze' and was published in *Bonarum Artium Splendori XII. Tabulas a praestantissimis Italiae Pictoribus expressas ac primum sub Auspiciis Ferdinandi Caroli Archid. Austr. etc. aere incisas, publicique juris factas Ben. Eredi, et Joannes Baptista Cecchi* (Florence, 1779). The style of both drawing and painting would point to a date around 1620–22, roughly contemporary with *The Oath of Semiramis* (Coll. Denis Mahon).

D 1609 Fig. 637

Head of a youth wearing a laurel wreath.

255 × 207. Black chalk, heightened with white on faded blue paper. (Several sections of the paper have been irregularly cut and then laid down.) Pricked for transfer.

PROV: David Laing; Royal Scottish Academy. Transferred 1910.

EXH: *Old Master Drawings*, Leicester, 1952 (25), as 'Head of a woman'.

This is a cartoon-fragment for the head of the youth standing in the middle distance, behind the sacrificial tripod in the central fresco in S. Bibiana, Rome, depicting *The Saint refusing to sacrifice to Idols* executed between 1624 and

1626 (repr. R. Wittkower, *Art and Architecture in Italy, 1600–1750* (1958), fig. 87; G. Briganti, *Pietro da Cortona* (1962), pl. 38).

D 1657 Fig. 638

Adam, Eve and Abel.

157 × 192. Pen and brown ink. Inscription on the old mount; 'Pietro da Cortona'.

PROV: David Laing; Royal Scottish Academy. Transferred 1910.

LIT: W. Vitzthum, 'Dessins de Pietro da Cortona pour la Chiesa Nuova à Rome', in *L'Œil* (November 1961), pp. 63 ff.

It was Walter Vitzthum who first recognized the drawing as a preparatory study for part of the decorations of the cupola in the Chiesa Nuova in Rome, executed between 1647 and 1665. It constitutes the final composition as it appears in the finished fresco. An earlier stage of this section, including part of this particular group, is recorded in a large and elaborate chalk drawing in the Albertina (III, 712), and the figure of Adam alone, also in a chalk drawing in the Louvre (535)—all reproduced by Vitzthum, *op. cit.* He has also analysed, with great perception, the striking variations in the appearance of these three drawings, due to the different techniques. The reason why the Edinburgh sheet seems so much coarser and more hesitant is due, according to Vitzthum, to Pietro's pen sketches becoming freer, broader and more impressionistic with advancing years, and also because, on the artist's own admission, his gout-ridden hand found it more congenial to draw with the more smoothly flowing chalk than with the pen.

D 869 Figs. 639 and 640

(*recto*) Study of a male torso (river god), leaning on a fountain-head;
(*verso*) River landscape with ? Apollo and Daphne.

240 × 354. Recto: red chalk. Verso: pen, black ink and grey wash. Both sides are inscribed: *Pietro da Cortona*, on the verso occur also the word *Fine* and the figure *2/–*.

PROV: David Laing; Royal Scottish Academy. Transferred 1910.

Recto: The traditional attribution seems perfectly plausible. It is probably an early drawing, resembling the style of some of the 'academies' in the Louvre (489 for example), which bear old attributions to Cortona.

Verso: The landscape on the back seems surprising, because it is quite untypical of Cortona, even if one considers this to be a hurried sketch.

D 920 Fig. 641

Design for a title page.

493 × 375. Black chalk. (Laid down.)

PROV: David Laing; Royal Scottish Academy. Transferred 1910.

EXH: Colnaghi, 1966 (41, cover plate).

The composition was most probably intended as the decorated framework for a title page—to be engraved. There are signs of heavy incision with the stylus, and the whole of the figure on the left has been cut out and laid down. The indenting of the outlines tend to give the whole a rather hard look, but the quality of the drawing, particularly the modelling of the two figures, would suggest that the drawing is from Cortona's own hand and not the work of a studio assistant, as was thought at one time. The whole sheet has obviously been trimmed all round, including what may have been an erased inscription at the bottom. The indecipherable inscription in the middle, approving the drawing for the engraver, appears to be in the same hand as occurs on a number of drawings, for example on another design for a title page by Andrea Sacchi (*Roman Drawings at Windsor* (1960), no. 769, fig. 74).

Studio of PIETRO DA CORTONA

D 1837 Fig. 642

Hilly landscape with classical buildings and a group of people gathering grapes in the foreground.

310 × 473. Brush and grey wash over chalk. (Laid down.)

PROV: David Laing; Royal Scottish Academy. Transferred 1910.

Cuttings from a sale catalogue ascribe this and the two following drawings to Locatelli, under whose name they were formerly registered. However, their style is clearly Cortonesque. This kind of drawing emerged from Pietro's studio, undoubtedly based on his own compositions and frequently copied by his assistants, in particular Ciro Ferri. Both D 1836 and RSA 118 are indeed close to Ferri, while the *Grape Harvest* (D 1837) seems nearer to Pietro himself, in particular the figures. Walter Vitzthum has drawn attention to a further very Cortonesque drawing at Bologna (1908), which also depicts a wine harvest but without the elaborate landscape surroundings.

D 1836 Fig. 643

River landscape with fishing boats and the Holy Family disembarking from a ferry boat.

328 × 461. Brush and grey wash over chalk. (Laid down.)

PROV: Count von Ross (L. 2693); David Laing; Royal Scottish Academy. Transferred 1910.

RSA 118 Fig. 644

River landscape with *Flight into Egypt.*

333 × 495. Brush and grey wash over chalk. (Laid down.)

PROV: David Laing; Royal Scottish Academy. On loan 1966.

Circle of PIETRO DA CORTONA

D 3198 Fig. 645

David slaying Goliath.

222 × 298. Pen and brown ink. (Rubbed and faded.)

PROV: W. F. Watson. Bequeathed 1881.

Obviously by the same hand as D 2923, this Cortonesque drawing is somewhat reminiscent of the composition, in reverse, by Francesco Murgia in the Sala del Trono in the Quirinale, Rome.

D 2923

David and the lion.

316 × 195. Pen, brown ink. (Badly faded.)

PROV: W. F. Watson. Bequeathed 1881.

Follower of PIETRO DA CORTONA

D 629 Fig. 646

The Massacre of the Innocents.

341 × 505. Pen, brown ink and wash, heightened with white, on double sheet. (Laid down.) Inscribed on mount: 'L. Giordano. Engraved by C. Metz'.

PROV: David Laing; Royal Scottish Academy. Transferred 1910.

The information given by the inscription is incorrect. The style reveals strong Cortonesque features and the drawing probably originated within Pietro's close circle. A drawing in the Victoria and Albert Museum (Dalton Bequest 1035–1900 as School of Pietro da Cortona) and squared in red chalk, depicts an almost identical composition, with the exception of variations in some of the background figures, though only with very slight indications of the architectural background. It is possible that a drawing depicting *The Entry of a Roman Emperor*, at Leipzig (NJ 5138), bearing an old inscription 'Lazzaro Baldi', is by the same hand.

D 2902 Fig. 647

Two figures with a goose by a rock.

168 × 185. Red chalk. Inscribed: *Ciro Ferri fecit* and *Solimene* (crossed out).

PROV: W. F. Watson. Bequeathed 1881.

While not by Ciro Ferri, the drawing reveals Cortonesque features. The presence of the goose may indicate that the subject matter is connected with the discovery of St Martin of Tours's hiding place.

RSA 272 Fig. 648

The Virgin on the crescent moon, with the Christ Child killing the serpent on the globe, with the Trinity and attending angels, including St Michael.

252 × 231. Pen, brown ink and wash over black chalk, gone over in parts. (Left margin irregularly cut.)

PROV: David Laing; Royal Scottish Academy. On loan 1966.

The Cortonesque influences are prominent in this drawing. The style comes near to that of Giov. Niccolò Nasini.

RSA 286 Fig. 649

Europa and the bull.

196 × 254. Pen, brown ink and wash, over black chalk. (Laid down.)

PROV: J. Richardson, Jnr (L. 2170); David Laing; Royal Scottish Academy. On loan 1966.

The drawing is by a follower of Cortona, and Richardson, in a note on the backing, suggested a disciple of Romanelli.

RSA 317 Fig. 650

A woman bringing a statue to a king.

208 × 155. Pen, brown ink and wash over black chalk, heightened with white, on brown paper.

PROV: David Laing; Royal Scottish Academy. On loan 1966.

Probably by an artist around Giacinto Gimignani. The scene possibly depicts Solomon being tempted by his strange women to worship foreign idols (1 Kings xi).

PIETRO ANTONIO DE PIETRI

Cremia 1663–1716 Rome

D 670 Fig. 651

The Assumption of the Virgin. (In the bottom left corner a variant of the same composition.)

412 × 274. Pen, brown ink and wash, heightened with white, on blue paper. Inscribed on both sides: *Pietro di Pietri.*

PROV: Sir Thomas Lawrence; David Laing; Royal Scottish Academy. Transferred 1910.

A drawing of a similar, but more elaborate composition, depicting also the tomb and two kneeling saints, is in the British Museum (1946-2-9-34).

BARTOLOMEO PINELLI
Rome 1781–1835 Rome

D 4835 Fig. 652

A Roman peasant family.

212 × 291. Water-colour over black chalk. Inscribed: *Pinelli fece Roma 1828 Costume Romano.*

PROV: P. and D. Colnaghi. Purchased 1960.

The drawing formed part of an album of a large number of similar drawings by Pinelli.

DOMENICO PIOLA
Genoa 1627–1703 Genoa

D 921 Fig. 653

Design for a lunette: angels with the 'Sudorium', a chalice and instruments of the Passion.

233 × 393. Pen, brown ink and wash over black chalk. Old inscription: *Domco Piola. 3.*

PROV: David Laing; Royal Scottish Academy. Transferred 1910.

D 4899 Fig. 654

The finding of Moses.

247 × 187. Pen, brown ink and wash.

PROV: J. F. Bianchi (stamp on the back); J. H. Wiegersma (L. 1552b); P. and D. Colnaghi. Purchased 1965.

RSA 205 Fig. 655

Seated female figure on clouds with angels.

524 × 360 (octagonal). Pen, brown ink and wash, over black chalk. Inscribed: *Domᵒ Piola.*

PROV: David Laing; Royal Scottish Academy. On loan 1966.

RSA 206 Fig. 656

St John the Baptist in the wilderness.

287 × 414. Pen, brown ink and wash, over black chalk. (Laid down.) Inscribed: *Dom. Piola.*

PROV: David Laing; Royal Scottish Academy. On loan 1966.

RSA 207 Fig. 657

The wise and foolish virgins.

423 × 285. Pen, brown ink and wash, over black chalk. (Laid down.) Inscribed on the old backing: *Dᵒ· Piola.*

PROV: David Laing; Royal Scottish Academy. On loan 1966.

RSA 208 Fig. 658

The Holy Family with St John.

420 × 291. Pen, brown ink and wash, over black chalk. (Laid down.) Inscribed: *Dom. Piola.*

PROV: David Laing; Royal Scottish Academy. On loan 1966.

RSA 209 Fig. 659

Pietà.

297 × 221. Pen, brown ink and wash, over black chalk. (Laid down.) Inscribed: *Dᵒ Piola.*

PROV: David Laing; Royal Scottish Academy. On loan 1966.

RSA 210 Fig. 660

A guardian angel protecting a child from the devil.

431 × 298. Pen, brown ink and wash, over black chalk. (Laid down.) Inscribed: *Dom. Piola.*

PROV: David Laing; Royal Scottish Academy. On loan 1966.

RSA 211 Fig. 661

The penitent Magdalen.

219 × 164. Brown wash over black chalk. (Laid down.)

PROV: David Laing; Royal Scottish Academy. On loan 1966.

RSA 212 Fig. 662

The Madonna and Child with SS. John and Elizabeth.

197 × 242 (composed into an oval). Brown wash over black chalk. (Laid down.)

PROV: David Laing; Royal Scottish Academy. On loan 1966.

RSA 215 Fig. 663

Death of Adonis.

248 × 315. Red chalk and brown wash. (Laid down.)

PROV: 'P. Crozat'? (L. 474); David Laing; Royal Scottish Academy. On loan 1966.

The traditional attribution seems correct.

Attributed to
DOMENICO PIOLA
RSA 213 Fig. 664
Vulcan and Cupid.
188×286. Pen, brown ink and wash, over black chalk.
(Laid down.)

PROV: David Laing; Royal Scottish Academy. On loan
1966.

This lunette design is certainly Genoese, and not far from
Piola, but perhaps not from his own hand.

RSA 214 Fig. 665
Abraham and the three angels.
273×192. Pen, brown ink and yellowish wash, over black
chalk. (Laid down.) Inscription on the mount: 'V. Castello'.

PROV: David Laing; Royal Scottish Academy. On loan 1966.

In spite of the inscription, the style seems to point more
towards Domenico Piola.

D 3136 Fig. 666
Hagar and Ishmael.
151×190. Pen, ink and brown wash. Squared in red chalk.
(Laid down.) Inscribed on the mount: 'Luca Jordano'.

PROV: W. F. Watson. Bequeathed 1881.

The drawing seems certainly to be Genoese and the style
and facial types appear close to Piola.

Follower of DOMENICO PIOLA
D 2899 Fig. 667
Venus and Cupid.
173×145. Pen, brown ink and wash, heightened with
white, over black chalk, on prepared paper.

PROV: W. F. Watson. Bequeathed 1881.

SEBASTIANO DEL PIOMBO
See SEBASTIANO del Piombo.

GIOVANNI BATTISTA PIRANESI
Mogliano (Mestre) 1720–1778 Rome
D 964 Fig. 668
An antique mausoleum.
347×243. Pen, brown ink and grey wash, over black chalk.
(The main outlines incised.)

PROV: David Laing; Royal Scottish Academy. Transferred
1910.

LIT: R. Blomfield, *Architectural Drawings and Draughtsmen*
(1912), p. 67; *Catalogue: National Gallery of Scotland* (1946),
p. 392; Hylton Thomas, *The Drawings of Giovanni Battista
Piranesi* (1954), no. 2.

EXH: *Five Centuries of Drawings*, Montreal, 1953 (78,
repr.); *G. B. Piranesi*, Turin, 1961–62 (177).

The reproduction in Blomfield (*op. cit.*) shows the drawing
with its old mount, since discarded, and with an ascription
to 'Canaletto'. It appears to have been Blomfield who first
connected the drawing with Piranesi. It is in fact the pre-
paratory drawing for the etching which appeared as
Plate 3 in *Opere Varie di Architettura prospettive grotteschi
Antichità*... (1750). The etching is in the reverse sense from
the drawing, and as they are both of the same size it can be
presumed that the incised lines on the drawing are proof of
its direct transfer on to the copper-plate. Both Blomfield
and Hylton Thomas have pointed out the pentimenti,
mainly at the top of the composition, indicated in the draw-
ing by faint and rather sketchy black chalk lines. Hylton
Thomas has also convincingly shown that, although the
etching was not published till 1750, the drawing was
intended for, but finally excluded from, *Prima Parte di
architettura*... of 1743, and must thus have originated
during Piranesi's early Roman years, 1740–43.

A drawing in similar style is a fantasy on antique archi-
tectural motifs at Berlin (8458; Turin Exh. no. 184) which
dates probably from the same period, although it resembles
the frontispiece of the *Antichità Romane* which again was
not published till 1750. (See the compiler's review of the
Turin exhibition in *Burlington Magazine* (January 1962),
p. 43.)

D 1858 Fig. 669
Interior of a prison.
217×252. Pen, brown ink and wash over black chalk.

PROV: (?Allan Ramsay); Lady Murray. Presented 1860.

LIT: A. Hind in *Burlington Magazine* (May 1911), p. 91,
pl. IVF; R. Blomfield, *Architectural Drawings and Draughts-
men* (1912), pp. 67f., pl. opp. p. 72; A. Hind, *Piranesi*
(1922), p. 22; *Catalogue: National Gallery of Scotland* (1946),
p. 392; Hylton Thomas, *The Drawings of Piranesi* (1954),
no. 8; *Fifty Master Drawings in the National Gallery of
Scotland* (1961), no. 42; P. M. Sekler, 'Giovanni Battista
Piranesi's "Carceri": etchings and related drawings' in
Art Quarterly (Winter 1962), pp. 331ff., fig. 27.

EXH: *Italian Drawings*, Royal Academy, 1930 (322, repr.);
European Masters of the 18th Century, Royal Academy,
1954–55 (574); *G. B. Piranesi*, Turin, 1961–62 (180, repr.);
Colnaghi, 1966 (75, pl. 35).

It has always been noted that this drawing was connected
with the *Carceri* cycle of etchings, but it had been as-
sumed hitherto that it was not used for the series as finally

published. However, it constitutes in fact a preliminary study for Plate XIV in its first state (see the compiler's review of the Turin exhibition in *Burlington Magazine* (January 1962), p. 43). Two similar drawings, in the same technique, are at Hamburg (1915/648–649).

ANTONIO PISANELLO
(di Puccio Pisano)
Pisa, before 22 November 1395–1455 Rome

D 722 Fig. 670

Rear view of a man with hands at his back.

267 × 185. Pen and brown ink over faint traces of lead- or silverpoint.

PROV: Marquis de Lagoy; Sir Thomas Lawrence; David Laing; Royal Scottish Academy. Transferred 1910.

LIT: A. E. Popham in OMD XI, March 1937, no. 44, pl. 64; B. Degenhart, *Pisanello* (1945), p. 35; BM XIV–XV, p. 135; B. Degenhart and A. Schmitt, 'Gentile da Fabriano in Rom und die Anfänge des Antikenstudiums' in *Münchner Jahrbuch der bildenden Kunst*, XI (1960), pp. 67, 137 n. 30, 139 n. 31; Maria Fossi Todorow, *I Disegni di Pisanello* (Florence, 1966), no. 82.

EXH: Colnaghi, 1966 (2, repr. as frontispiece).

As A. E. Popham was the first to observe, this drawing is closely connected with the group of men hanging from the gallows in the background of the fresco *St George liberating the King's daughter* in S. Anastasia, Verona. Two other related studies are known, one in the British Museum (BM XIV–XV, no. 220), the other, formerly in the Oppenheimer Collection (sale Christie, 1936, lot 145), and now in the Frick Collection, New York. These two drawings seem to have been done from actual corpses, whilst D 722 was probably drawn from the living model, perhaps a *garzone* in the studio, standing up, with his hands behind him.

As Degenhart and Schmitt have shown, this sheet once formed part of a complex of drawings, probably originating in Pisanello's studio and there used as patterns by the students and assistants. The two authors have listed a large number of such drawings, many of which were at one time in the collection of Count Moriz von Fries (L. 2903) and, like the Edinburgh sheet, in the collection of the Marquis de Lagoy, but are now distributed in various public collections. Like other drawings of this group, D 722 probably bore at one time an inscription of the artist's name and the subject matter, but this had been cut off by the time the drawing entered the collection.

GIOVANNI BATTISTA PITTONI
Venice 1687–1767 Venice

D 4853 Fig. 671

Madonna and Child with saints.

410 × 260. Red chalk. Inscribed on the back: *Paolo Veronese . 14*, and two other indecipherable inscriptions.

PROV: H. M. Calmann. Purchased 1961.

This may possibly be an idea for Pittoni's altarpiece in S. Corona, Vicenza, which however shows considerable differences in the composition. If the connection with this altarpiece is correct, the drawing would then date from about 1723.

GIACOMO DEL PÒ
Rome 1652–1726 Naples

D 4916 Fig. 672

The martyrdom of St Andrew.

216 × 110. Pen, black ink and brown wash, heightened with white on pink toned paper. (Laid down.) Inscribed at the top in pencil: *Giac° del Po.*

PROV: The Earl of Crawford and Balcarres. Presented 1967.

BERNARDINO POCCETTI
(Barbatelli)
Florence 1548–1612 Florence

D 936 Figs. 673 and 674

Double sheet of architectural studies:
(*recto*) Design for part of a wall with caryatids, and ceiling brackets with grotesque figures; (*verso*) Sketches for three panels of a ceiling, with figures of 'Temperance' and 'Fortitude'.

376 × 275. Pen, brown ink and wash over red chalk. Inscribed: *Poccetti.*

PROV: David Laing; Royal Scottish Academy. Transferred 1910.

The old attribution to Poccetti may be correct, but the drawing seems a little disappointing for otherwise so spirited a draughtsman.

D 4890/29 Fig. 675

A sibyl.

192 × 115. Red chalk. (Irregularly cut and laid down.) Inscribed: *202 Bernardino Poccetti.*

PROV: Marchese del Carpio; Paul and Edwardo Bosch, Madrid; H. M. Calmann. Purchased 1964.

Attributed to
GIOVANNI ANDREA PODESTÀ
Genoa c. 1620–before 1674

D 717 Figs. 676 and 677

(recto) Pan, satyrs and putti seated round a tree;
(verso) Studies of a child, bearded man and dog.

297 × 210. Pen and brown ink. Inscription in lower right corner: *Possino. 46.*

PROV: J. Talman (inscription on verso); Richard Cosway; David Laing; Royal Scottish Academy. Transferred 1910.

EXH: *Old Master Drawings*, Leicester, 1952 (64, as Testa).

The drawing was formerly ascribed to Pietro Testa, and exhibited as such at Leicester. Sir Anthony Blunt has proposed the present convincing attribution to Podestà, the Genoese-born artist who worked in Rome in the Circle of Testa and Cassiano del Pozzo. (See A. F. Blunt, 'Poussin dans les Musées de Province' in *La Revue des Arts*, 8me année, 1 (1958).) A sheet of studies at Rennes (repr. Blunt, *loc. cit.* fig. 16) is especially close to the verso of D 717. Furthermore, the facial types of the amorini and that of the bearded man on the reverse agree with those in Podestà's etchings of Bacchanalian scenes, particularly B. xx, p. 170, 3 and p. 171, 4.

POLIDORO DA CARAVAGGIO
(Caldara)
Caravaggio (Lombardy) 1496/1500–? 1543 Messina

D 1799 Fig. 678

St Roch.

178 × 127. Pen, brown ink and wash, slight traces of white heightening. (Rubbed and laid down.) Inscribed: *Polidoro da Caravaggio. 183.*

PROV: Sir Peter Lely; N. F. Haym (L. 1972); unidentified mark (L. 2914a); Lord Somers, from inscription on the back, in ? Richardson's hand; (? Jonathan Richardson); David Laing; Royal Scottish Academy. Transferred 1910.

This fine and characteristic drawing is probably a late work, resembling in style the drawing within a decorated frame at Windsor (*Italian Drawings at Windsor*, 690), which has been connected with Polidoro's Neapolitan or Sicilian period. D 1799 may be a study for an altarpiece, with the Saint's dog to be added in the lower left corner. If such a painting has been executed at all, it has not been traced. The theme of St Roch is also represented in two drawings by Polidoro in the Louvre (6072–6073) which,

however, show the Saint healing the sick and have no direct connection with D 1799.

D 3020 Fig. 679

A draped, forward-striding female figure.

197 × 129. Pen, brown ink and wash. (Laid down.) Inscribed in lower margin: *Polidoro.*

PROV: W. F. Watson. Bequeathed 1881.

Philip Pouncey agrees that the old attribution should be respected. He pointed out that figures with such violent movements, mainly for façade decorations, do occur among Polidoro's drawings, and the wash-technique resembles that of the drawing in the British Museum of *Two women carrying a body* (BM Raphael, 200). Rolf Kultzen, however, suggested that, in his opinion, the wash covers the underlying drawing to a greater extent than is usual with Polidoro. A drawing of a seated female figure, probably by the same hand, is at Dresden (C 170), as 'Roman School'.

D 3104 Figs. 680 and 681

(recto) Study for the lower part of a *Transfiguration*;
(verso) Part of a sketch of a man with outstretched arm, inscriptions, etc.

220 × 277. Pen, brown ink and wash over black chalk. (Certainly cut along the upper margin, if not all round.) Inscribed on the verso, in an old hand: *polidoro.*

PROV: Unidentified crest on the old backing; W. F. Watson. Bequeathed 1881.

The old attribution to Polidoro appears strange at first sight, and the hand looks perhaps more like that of a Northern Mannerist. It might be tempting to connect the composition with others by Polidoro, also treating the theme of the *Transfiguration*, such as at Berlin (21501, as 'Raphael'), in the British Museum (BM Raphael, 217 and 218), and at Frankfurt (5609, attributed to Polidoro by J. A. Gere).

Polidoro is known to have executed a painting of the *Transfiguration* for S. Maria del Carmine, Messina (see BM Raphael, p. 127) which, however, has been destroyed.

Circle of POLIDORO DA CARAVAGGIO

D 1631 Fig. 682

Studies of three male heads.

133 × 140. Black and white chalk on buff paper, part of the lower head gone over with ink. Inscribed in lower margin: *M. A. Bona Rota.*

PROV: Padre Resta, with his mark *m.10*; Richard Cosway; Sir Thomas Lawrence; Woodburn sale, 1860, lot 155 as Michelangelo; David Laing; Royal Scottish Academy. Transferred 1910.

The facial types, particularly the bearded central head, resemble closely others by Polidoro; for example those on the verso of the drawing at Berlin (20737).

Copies *after* POLIDORO DA CARAVAGGIO

D 2982

Soldiers with horses.

231 × 187. Pen, brown ink and wash, heightened with white, over black chalk. (Laid down.)

PROV: W. F. Watson. Bequeathed 1881.

D 3074

Procession of warriors.

232 × 389. Pen, brown ink and wash, heightened with white. (Laid down.)

PROV: W. F. Watson. Bequeathed 1881.

Copy from the lowest frieze on the façade of the Palazzo Ricci, Rome. Similar copies are at Turin (349) and Windsor (737).

D 3155

Scaevola being captured by Roman soldiers.

206 × 310. Pen, brown ink and wash. (Laid down.)

PROV: W. F. Watson. Bequeathed 1881.

CESARE POLLINI

Perugia c. 1560–c. 1630 Perugia

D 2895 Fig. 683

The Adoration of the Magi.

109 × 222. Pen, brown ink and wash, over red chalk. Inscribed: *Cesar Pollino*, and by a later hand in pencil: *élève de Baroche*.

PROV: V.C., unidentified (L. 2508); W. F. Watson. Bequeathed 1881.

The old inscription, like that on four drawings at Darmstadt (1585–88), confirms Philip Pouncey's attribution to Pollini of a series of drawings which are at Munich, in the same medium, with inscriptions to Bandinelli (2228–31)—see Halm, Degenhart, Wegner, *Hundert Meisterzeichnungen aus der Staatlichen Graphischen Sammlung München* (1958), p. 52, no. 54. Another drawing at Munich of the *Crucifixion* (2922) inscribed 'Cirani' should also be given to Pollini, and further drawings are in the Louvre (99, as 'Bandinelli') and in the Janos Scholz collection (*Drawings from Tuscany and Umbria*, Oakland and Berkeley, U.S.A., 1961, no. 69). It would appear that the drawing in the Albertina (III, 356) with an inscription 'Ferro Fensone' is also by Pollini, who is chiefly known for his miniatures, many of them in the Galleria Nazionale at Perugia.

POMARANCIO

See Cristofano RONCALLI.

JACOPO PONTORMO

(Carrucci)

Pontormo (Empoli) 1494–1556 Florence

D 1612 Figs. 684 and 685

(recto) A young man holding a small child; *(verso)* An old man holding a small child.

400 × 254. Black chalk. (Tears and holes repaired.) Inscribed on recto in pencil: *18679* and *N/*.

PROV: David Laing; Royal Scottish Academy. Transferred 1910.

LIT: Berenson 1959B (mentioning the recto only, with wrong inventory number and medium); K. Andrews, 'Three Pontormo Drawings in the National Gallery of Scotland', *Burlington Magazine* (December 1958), pp. 436f., figs. 36 and 37; J. Cox Rearick, *The Drawings of Pontormo* (1964), 234 and 235, pls. 228 and 227.

EXH: *Old Master Drawings*, Leicester, 1952 (45, the verso was shown); *Between Renaissance and Baroque*, Manchester, 1965 (361, recto); Colnaghi, 1966 (22, recto, pl. 3).

Recto: As suggested by the compiler in the above-mentioned article, the pose of the youth is strongly reminiscent of the figure of Simon of Cyrene in the fresco *The Way to Golgotha* at the Certosa di Galuzzo outside Florence. There the figure, instead of grasping the child, lifts the cross from the stumbling Christ. A group with a child occurs in the right hand corner of the same fresco, but no figure corresponds closely enough with the drawing. A connection with the period of the Certosa frescoes would date the drawing c. 1523–24, with which J. Cox Rearick roughly agrees. Berenson imagined it closer to the slightly later S. Felicita period.

Verso: This side of the drawing is much rubbed, and J. Cox Rearick is right in considering parts of it to have been gone over, but whether this has been done by a later hand, as she claimed, seems very doubtful. The pose of the figure, together with the presence of the child, calls to mind the group—probably a Joseph with the Christ Child —in the background of the painting of the *Madonna and Child* at Munich. Several versions of this composition exist, none of them the original, but the Munich painting appears to be the best. (See *Mostra del Pontormo*, Florence, 1956, nos. 67 and 68.)

Ascribed to JACOPO PONTORMO

D 2230 Fig. 686

Two studies of small boys.

238 × 207. Red chalk on rough, dark-brown paper. (Water-stained, cut down the middle and laid down.) Inscribed: *Coreggio*.

PROV: Small circular, but illegible, collector's mark in lower right corner of the old mount; W. F. Watson. Bequeathed 1881.

LIT: *Catalogue: National Gallery of Scotland* (1946), p. 392; K. Andrews, 'Three Pontormo Drawings in the National Gallery of Scotland', *Burlington Magazine* (December 1958), pp. 436f., fig. 34; J. Cox Rearick, *The Drawings of Pontormo* (1964), A 22.

The two halves of the drawing probably once formed one single sheet which was cut and then reunited. In spite of the old ascription to Correggio, the drawing entered the collection under the name of Pontormo, and it is not clear who first suggested the attribution. Since publishing the above-mentioned article, the compiler began to doubt the validity of an attribution to Pontormo himself, a doubt shared by J. Cox Rearick. However, whether the drawing is as late as the beginning of the 17th century, and whether it is Bolognese, as she suggests, seems doubtful.

GIOVANNI ANTONIO DA PORDENONE

Pordenone c. 1484–1539 Ferrara

Follower of PORDENONE

D 756 Fig. 687

A group of seven putti.

150 × 307 (cut to an octagonal). Brown wash, with black chalk retouches (which probably have been added later). Inscribed: [Po]*rdenone*.

PROV: David Laing; Royal Scottish Academy. Transferred 1910.

Similiar groups of putti do occur at times in compositions associated with Pordenone or his circle. However, the drawing, even without the retouches in chalk, is of a later date, although the water-mark of the paper (a hand and star, flanked by the initials M A) is near to Briquet 10689, which it is suggested was a paper from Emilia at the end of the 15th century.

The types of putti do not seem to be far from Moncalvo, as Philip Pouncey observed, if one imagines him doing a wash drawing in a more than usually robust moment.

GIUSEPPE PORTA

See Giuseppe SALVIATI.

STEFANO POZZO

Rome c. 1707–1768 Rome

D 1935 Fig. 688

Three putti: one carrying an oil-lamp and facing a cockerel, the two others holding a yoke.

348 × 217. Black chalk. Inscribed on the back: *Stephano Pozzi*.

PROV: (? Allan Ramsay); Lady Murray. Presented 1860.

This is a very characteristic drawing by the artist, and was presumably intended to form part of a ceiling decoration.

MATTIA PRETI

Taverna (Calabria) 1613–1699 Malta

D 2249 Fig. 689

A man holding a barrel.

317 × 234. Red chalk. (Laid down.)

PROV: Richard Houlditch (L. 2214); (Jonathan Richardson, according to the type of mount and the inscription on the back); Sir Joshua Reynolds; W. F. Watson. Bequeathed 1881.

LIT: *Catalogue: National Gallery of Scotland* (1946), p. 393; W. Vitzthum, 'Le dessin baroque à Naples', *L'Œil*, no. 97 (January 1963), p. 46.

EXH: *Seventeenth-Century Art in Europe*, Royal Academy, 1938 (427); *Drawings by Old Masters*, Royal Academy, 1953 (154); *Neapolitan Baroque and Rococo Painting*, Bowes Museum, Barnard Castle, 1962 (23, repr.); Colnaghi, 1966 (46, pl. 30).

A. E. Popham has pointed out that this and a drawing in the British Museum (1874-8-8-45) showing the figure slightly more from the back, are studies for the painting *The Pope inspired by the Holy Ghost receives homage from the ecclesiastical orders*, which was engraved by Giulio Traballesi. The wrong information of the inscription on Traballesi's engraving, stating that the painting is in S. Francesco, Siena, has caused a good deal of confusion. Walter Vitzthum has confirmed that the picture is in fact, and always has been, in the church of S. Domenico, Siena.

Attributed to

MATTIA PRETI

D 3118 Fig. 690

The massacre of the innocents.

217 × 182. Pen, brown ink and wash over black chalk. (Laid down.) Pencilled inscription on the mount: 'G. de Crayer', and 'Gaspar d. C.'

PROV: W. F. Watson. Bequeathed 1881.

The ascription on the back cannot be correct. The drawing is fairly certainly Italian, and, although faintly Venetian in style, is strongly suggestive, also in its composition, of Preti. It could be imagined that he executed a drawing like this during his years in Malta, but no painting has been traced which corresponds to it.

FRANCESCO PRIMATICCIO
Bologna 1504–1570 Paris
D 2247 Fig. 691

Jupiter commanding the clouds to pour water on to the earth.

213 × 427 (arched top). Pen, brown wash, heightened with white. Squared in black chalk. Inscribed in body-colour: *Bologne*.

PROV: Marquis de Lagoy; Sir Thomas Lawrence; W. F. Watson. Bequeathed 1881.

LIT: L. Dimier, *Le Primatice* (1900), p. 487, no. 9; *Catalogue: National Gallery of Scotland* (1946), p. 393 (as ?Primaticcio, *Design for Lunette*).

EXH: *Old Master Drawings*, Royal Academy, 1953 (108, as *Composition of nude figures*).

Contrary to the information given in the catalogue entry of the Royal Academy exhibition, this is not a design for the Porte Dorée at Fontainebleau, but for a lunette in the 'Appartement des Bains', which was destroyed in 1697. The composition has been engraved by Léon Davent (Thiry) *c.* 1500–1550 (B. XVI, p. 326, 54). Dimier quotes a passage from Mariette's *Abecedario*, IV, 215 'que ce morceau était dans un plafond de l'appartement des Bains, qui ne subsiste plus'. A copy of the composition is among the uncatalogued drawings at Dresden (ca 6, fol. 514).

D 1779 Fig. 692

A seated female figure seen from the back.

189 × 144. Black and red chalk, heightened with white on buff paper, outlines incised. The verso is blackened for tracing. (Tear in lower right margin.)

PROV: Nicholas Lanier; Bindon Blood (L. 3011); David Laing; Royal Scottish Academy. Transferred 1910.

The drawing is rather close to one in the Louvre of *La Muse Clio* (8555) (see L. Dimier, *Le Primatice* (1900), p. 431, no. 42).

D 663 Fig. 693

Figure of Ceres, surrounded by the signs of the zodiac.

377 × 203. Pen, brown ink and wash over black chalk. Squared in black chalk. (Damaged and laid down.) Inscribed: *No. 683* and *Gulielmo della Porta*.

PROV: David Laing; Royal Scottish Academy. Transferred 1910.

It is not clear who first proposed the attribution 'School of Primaticcio'. It is difficult to come to any final decision about such a sadly damaged drawing, and one which most probably has been retouched. A. E. Popham agrees, however, that it should be looked at as a mutilated original, rather than a studio work. Two seemingly related drawings, both in black chalk, are in the Louvre: 8628 (heightened with white) of a similar figure of *Ceres*, and 8631 representing *Music*, with an inscription: *parmésan*.

Studio of FRANCESCO PRIMATICCIO
RSA 195 Fig. 694

The Lamentation.

338 × 267. Black chalk heightened with white. All outlines heavily incised. Squared. Top corners cut. Inscribed: *F. Parmigiano*.

PROV: Richard Cosway; F. Abbot (L. 970); David Laing; Royal Scottish Academy. On loan 1966.

The artist must have been a close associate of Primaticcio (possibly working with him in France), as Philip Pouncey suggested. The composition probably records a lost design by Primaticcio himself. The tapering arms, the incisive modelling of the contours, and the daring foreshortening of the legs of the figure of Christ are typical of Primaticcio, as is the crowded composition and the pose of the standing figure behind the Madonna. A copy of this drawing, in pen and wash, with inscriptions to 'Sebastiano del Piombo' and 'B. Peruzzi', is at Dresden (C. 290).

CAMILLO PROCACCINI
Bologna c. 1551–1629 Milan
D 780 Fig. 695

Two griffins opposing each other.

96 × 256. Red chalk. (Torn and laid down.) Inscribed *203* in the upper left margin, and 'Camillo Procaccino' on the old mount.

PROV: David Laing; Royal Scottish Academy. Transferred 1910.

A very characteristic drawing.

Circle of CAMILLO PROCACCINI
D 2226 Fig. 696

The Rest on the Flight to Egypt.

297 × 205. Gouache, varnished, heightened with white. (Laid down.)

PROV: W. F. Watson. Bequeathed 1881.

LIT: *Catalogue: National Gallery of Scotland* (1946), p. 388 (as Girolamo da Treviso).

The drawing entered the collection with the ascription 'Ferrarese School, 16th century'. It is not clear who suggested, later on, Girolamo da Treviso (1497–1544). The drawing seems however to date from the late 16th, if not early 17th century. The discernible influences of both Raphael and Correggio, and especially the composition, would suggest an artist from the circle of Camillo Procaccini. Some of Camillo's etchings, for example B. XVIII, p. 19, 1, come rather close to the drawing, which, in any case, may only be a copy.

GIULIO CESARE PROCACCINI
Bologna c. 1570–1625 Milan

RSA 160 Fig. 697

Adoration of the Shepherds.

218 × 391 (composed into a semi-circle). Pen, ink and wash over black chalk. Redrawn in two places on overlaid paper. Inscribed: *Procacini*.

PROV: David Laing; Royal Scottish Academy. On loan 1966.

That the drawing is by Giulio Cesare Procaccini, and not by another member of this large family, was already realized by a previous owner, who added *Cesare*, in pencil, to the inscription.

Attributed to
GIULIO CESARE PROCACCINI

D 3124 Figs. 698 and 699

(*recto*) Studies of Roman soldiers, flying putti, fortifications, etc.;
(*verso*) Studies of seated figures and of the Madonna and Child with St Dominic.

338 × 226. Pen and brown ink. Inscribed in pencil: *22*.

PROV: W. F. Watson. Bequeathed 1881.

The present attribution was put forward with some conviction by Philip Pouncey. Rather similar sheets of pen studies are at Berlin, amongst the anonymous drawings, but obviously by Giulio Cesare Procaccini (22793), and at Budapest: studies for a *St Andrew* (57.41K; I. Fenyö, *North Italian Drawings from the Collection of the Budapest Museum of Fine Arts* (1965), p. 104, pls. 74 and 75). Further similar drawings in the Ambrosiana, Milan (see E. S. Barelli, *Disegni di Maestri Lombardi del Primo Seicento* (1959), esp. nos. 29, 30 and 31) bear old inscriptions of Giulio Cesare's name.

BIAGIO PUPINI
Bologna fl. 1511–after 1575

D 2978 Fig. 700

A group of figures, possibly from an antique relief; in the lower right margin, a sketch of a bull.

208 × 287. Pen, brown ink and brown wash, heightened with white. (Laid down, and paper damaged in parts.)

PROV: W. F. Watson. Bequeathed 1881.

The characteristic wash technique with strong white heightening on cream-coloured ground, and the rather loose and imprecise drawing of the outlines, make an attribution to Pupini convincing. It looks as if there may be a drawing on the back, but the paper—laid down at present—is too brittle to warrant the experiment of lifting the sheet.

D 3076 Fig. 701

Equestrian battle scene.

263 × 393. Black chalk and brown wash heightened with white and yellow. Inscribed: ... *Giulio*.

PROV: Alfonso III d'Este (L. 112); Francesco II, Duke of Mantua and Reggio (L. 1893); W. F. Watson. Bequeathed 1881.

The former, unsupportable, ascription to Giulio Romano was based on the faint inscription in the lower margin. The present, convincing, attribution is due to A. E. Popham.

D 4869 Fig. 702

The Presentation in the Temple.

162 × 209. Black chalk and wash, heightened with white on blue paper. (Damaged at the corners and laid down.)

PROV: Mrs J. Baillie, Edinburgh. Purchased 1962.

The drawing had a 19th century ascription to Perino del Vaga when it was acquired. The rather loose forms and the heavy white heightening, however, point rather to Pupini.

RSA 258 Fig. 703

Neptune in his chariot.

198 × 414. Pen, ink and brown wash, heightened with white on blue paper. (Laid down.) Inscribed on the mount: 'Biagio Pupini call'd Biagio Bolognese'.

PROV: Earl of Arundel, according to inscription; N. Lanier; Sir Peter Lely; R. Houlditch; Thomas Hudson, according to inscription; Earl Spencer; William Esdaile; David Laing; Royal Scottish Academy. On loan 1966.

RAFFAELLINO DA REGGIO
(Motta)
Codemondo (Reggio Emilia) 1550–1578 Rome

D 1475 Fig. 704

Design for a small chapel with an altarpiece of *The Adoration of the Magi*.

264 × 175. Pen, brown ink and wash over black chalk. (Laid down.) Inscriptions on the mount in an 18th century hand: 'Zuccaro', and pencilled on the back: 'Taddeo Zuccaro'.

PROV: David Laing; Royal Scottish Academy. Transferred 1910.

LIT: *Fifty Master Drawings in the National Gallery of Scotland* (1961), no. 16.

The present attribution is due to Philip Pouncey. It is not inconceivable that the drawing represents an idea for the second chapel on the left in S. Silvestro al Quirinale, Rome. According to Baglione (*Vite* (1731), p. 24), Raffaellino was associated with the decoration of the chapel. The frescoes of the vault are from his hand, whilst the two murals on the side walls—one in fact an *Adoration of the Magi*—had usually been attributed to Raffaellino (Venturi IX/6, fig. 392, and in the guide books) until Antal first suggested that they were in fact by Jacopo Zucchi ('Zum Problem des Niederländischen Manierismus', *Kritische Berichte zur kunstgeschichtlichen Literatur* (1928/9), Heft 3/4, p. 222). The central altarpiece in the chapel is by Venusti.

Thus it will be seen that very little in the chapel is actually from the hand of Raffaellino, and furthermore its present shape differs considerably from the design on D 1475. There is a window in the apse, the altarpiece has a rounded top and the painted niches into which the sculptural figures are designed are part of pilasters which are on the outside of the chapel, not within it as in the drawing.

Nevertheless, as some features are common to both the chapel in its present state and to the drawing, and as tradition credits Raffaellino with at least some work connected with it, it could be imagined that he was perhaps initially entrusted with the overall design, and that D 1475 represents his idea of the general appearance of this chapel.

RAMENGHI
See Bartolomeo BAGNACAVALLO.

GIUSEPPE RANUCCI
fl. 1736 in Rome

D 876 Fig. 705

Landscape with towered buildings and a church.

110 × 220. Pen, brown ink and wash. Inscribed: *Ranucci*.

PROV: Count J. von Ross (L. 2693); David Laing; Royal Scottish Academy. Transferred 1910.

Presumably the inscription refers to the painter from Fondi who worked in Rome around 1736, but about whom little appears to be known.

RAPHAEL
Urbino 1483–1520 Rome
Circle of RAPHAEL

D 4890/17 Fig. 706

Christ giving the keys to St Peter.

103 × 153. Pen, brown ink and wash heightened with white, over black chalk on blue paper. (Laid down.) Inscribed: *Marcilla da Raffaele*.

PROV: Marchese del Carpio; Paul and Edwardo Bosch, Madrid; H. M. Calmann. Purchased 1964.

The inscription no doubt refers to Guillaume Pierre de Marcillat (Verdun 1475–1537 Arezzo), the designer of the window embrasures in the *Stanze* of the Vatican, and the vault of the Cathedral at Arezzo. Whether this drawing is from his hand is impossible to say, owing to the lack of other authenticated drawings by this artist. The composition is, of course, based on Raphael's cartoon for the tapestry of the same subject. The style of the drawing, with its white heightening, is reminiscent of Pupini.

Copies after RAPHAEL

D 1578

Female head.

390 × 293. Coloured chalks. (Laid down.)

PROV: David Laing; Royal Scottish Academy. Transferred 1910.

A poor copy of the head of the crouching woman in Raphael's tapestry cartoon *The Death of Ananias*.

D 1565

Battle of nude men.

394 × 310. Pen and brown ink. (Laid down.) There is an old, almost obliterated inscription, which may have read *Peruzzi*. 17th century inscription in pencil: *Santo di Tito*.

PROV: Sir Thomas Lawrence; David Laing; Royal Scottish Academy. Transferred 1910.

Copy after the etching by J. T. Prestel, *Étude pour tableau 'Descente des Sarrasins' au port d'Ostie du Cabinet Prince Charles de Ligne de Bruxelles*. Another version is among the uncatalogued drawings in the Albertina (S.R. 226). The composition is similar, but with important differences, to the drawing at Lille (Wicar Coll. 430), which may itself be a copy.

D 2957

Figure of a seated man.

240 × 168. Red chalk. (Laid down.)

PROV: W. F. Watson. Bequeathed 1881.

Copy of the figure of Heraclitus in *The School of Athens*.

D 3184

The left hand part of *The Burning of the Borgo*.

370 × 262. Pen, brown ink, grey wash, heightened with white. (Laid down and damaged.) Inscribed: *?R. Vries*.

PROV: W. F. Watson. Bequeathed 1881.

D 751

A seated female nude and another seen half-length.

257 × 184. Red chalk. (Damaged.)

PROV: David Laing; Royal Scottish Academy. Transferred 1910.

LIT: *Le Dessin Italien dans les Collections Hollandaises* (Paris, etc. 1962), no. 70.

An inferior, but possibly contemporary copy of the drawing in the Teyler Museum, Haarlem, a study for one of the figures in the Farnesina fresco *The Nuptials of Cupid and Psyche*. Possibly D 751 was in the Antaldi Collection, referred to in *The Lawrence Collection: a series of facsimiles of original drawings by Raffaello da Urbino*, London, Woodburn (1841), no. 19.

D 3176

Mercury handing the cup.

333 × 238. Pen, brown ink and wash. (Laid down.)

PROV: W. F. Watson. Bequeathed 1881.

A weak copy of the group on the extreme left of the fresco of the *Council of the Gods* in the Farnesina.

D 3191

Venus, Ceres and Juno.

373 × 258. Pen, brown ink and wash, heightened with white, on blue paper. (Laid down.) Inscribed: *Jules Romain*.

PROV: Two unidentified collectors' marks; W. F. Watson. Bequeathed 1881.

Also copied from the fresco in the Farnesina.

D 3105

The Last Supper.

200 × 335. Brush and wash, heightened with white over black chalk, on toned paper.

PROV: W. F. Watson. Bequeathed 1881.

Copy after the composition in the *Loggie*, Vatican. The style and technique look almost as if they had been done in imitation of Polidoro.

D 2903 D 2956 D 2958 D 3108 D 3109 D 3501

The flight of Jacob.
The judgement of Solomon.
The golden calf.
The finding of Moses.
Isaac blessing Jacob.
Joseph being sold by his brothers.

130 × 182. Red chalk.

PROV: W. F. Watson. Bequeathed 1881.

All copies of engravings by Badalocchio and Lanfranco after the compositions in the *Loggie*, Vatican (B. XVIII, pp. 355 f.).

D 1645

Leda and the swan.

352 × 235. Pen, black ink on tracing-paper.

PROV: David Laing; Royal Scottish Academy. Transferred 1910.

Copy of the Raphael (after Leonardo) drawing at Windsor (cat. 789, pl. 50), probably traced from an engraving, perhaps that by F. C. Lewis (1809).

D 698

The three Graces.

172 × 173. Red chalk. (Laid down.)

PROV: David Laing; Royal Scottish Academy. Transferred 1910.

19th century copy of the painting at Chantilly.

TOMMASO REDI

Florence 1665–1726 Florence

RSA 305 Fig. 707

A striding man.

385 × 236. Black chalk heightened with white, on toned paper. Inscribed on the back: *di Tommaso Redi | L'ombra di Cesare che apparisce a Bruto, o sia il di Lui malgenio, fatto al Sr Molesworth. Nº 633.*

PROV: David Laing; Royal Scottish Academy. On loan 1966.

K. Steinbart (Thieme–Becker, XXVIII, 74) mentions various compositions commissioned from Redi by English patrons, including *Brutus pursued by Caesar's ghost*, which together with *Cincinnatus proclaimed dictator* was ordered by a Mr Molesworth through the agency of Francesco Gabburri. The inscription on the back of RSA 305, in Gabburri's hand, must refer to the former. Steinbart further states that Molesworth criticized the compositions in two letters to Gabburri dated Turin 18 October and 22 November 1724.

The Mr Molesworth was John, 2nd Baron Molesworth (1679–1726), British Envoy at the Court of Turin from 1720 to 1725 (see D. B. Horn, *British Diplomatic Representatives 1689–1789*, Camden Society, XLVI (1932), 123, a reference kindly communicated by Brinsley Ford). As he only succeeded to the title in 1725, he would have been called Mr Molesworth in 1724. Brinsley Ford also drew attention to a letter from Alessandro Galilei to Molesworth, dated Florence, 15 December 1723, which has references about payments for a picture to Redi (*Historical Manuscripts Commission, Various Collections*, VIII, 367f.).

GUIDO RENI
Bologna 1575–1642 Bologna

D 702

Figs. 708 and 709

(*recto*) The Coronation of the Virgin; (*verso*) Landscape.

325 × 263. Recto: Pen, brown ink and wash. Verso: Pen, brown ink. Inscribed on recto: *82*; on verso: *Guido Reni*.

PROV: P. Mariette; F. Basan, *Catalogue Raisonné des différents objets de curiosités…de feu M. Mariette*, Paris 1775/6 (lot 642); Sir Thomas Lawrence; David Laing; Royal Scottish Academy. Transferred 1910.

LIT: K. Andrews, 'An Early Guido Reni Drawing', *Burlington Magazine* (November 1961), pp. 461 ff.

The entry in the Mariette catalogue reads: 'Un beau Paysage en travers, fait à la plume, & au verso se trouve le Couronnement de la Vierge, à la plume & lavé.' (That recto and verso were interchanged must have been due to an error of the cataloguer, for Mariette's collector's mark invariably occurs on the recto of the drawings that were in his collection, and is here on the side of the *Coronation of the Virgin*.)

Recto: The compiler, in his article (*op. cit.*), suggested that D 702 would be an early drawing, before Reni's journey to Rome, and still showing in both style and composition the influence of Ludovico Carracci, to whom the drawing was in fact at one time tentatively ascribed. It contains elements that also occur in several of Reni's early compositions of this theme, such as the top part of the *Coronation of the Virgin* (Bologna, Pinacoteca) which seems to be Reni's

earliest surviving work, or in one of the fifteen 'Mystery' panels in the *Madonna del Rosario* (Bologna, Basilica di S. Luca) supposed to have been painted immediately after the *Coronation*, about 1595–8.

Verso: The landscape reveals the strong influence of Annibale Carracci, and without the inscription of the artist's name it might easily have been confused with Annibale's own landscape drawings or those by Domenichino. The other two landscape drawings by Reni mentioned in the Mariette Catalogue (see Andrews, *op. cit.* p. 461, n. 6) are now in the Louvre (8926 and 8927).

D 1785

Fig. 710

Study of a kneeling, praying figure.

417 × 283. Black chalk on blue paper. (Laid down.) Inscribed in lower margin: *Guido Reni*.

PROV: ?N. Lanier (L. 2908); Sir Peter Lely (L. 2092); ?N. F. Haym (L. 1973 a); Jonathan Richardson, Senr (L. 2169); David Laing; Royal Scottish Academy. Transferred 1910.

LIT: *Catalogue: National Gallery of Scotland* (1946), 393.

The study is probably for a figure of Christ praying on the Mount of Olives. It shows, to a striking degree, the influence and knowledge of Northern models, particularly in the handling of the drapery, also apparent on a drawing in the Uffizi (1580F verso). It is recorded that Reni studied carefully Dürer's engravings, and of course his first teacher was the Fleming Denys Calvaert, traces of whose style can be recognized in this drawing. Judging by what little is at present known of the development of Reni as a draughtsman, it does not seem likely that this is an early drawing, executed perhaps under the direct influence of Calvaert, but points to a later, more mature period, when however the Northern influences were still strong. For example, one might suggest a date in the middle of the first decade of the 17th century, at the time of the frescoes in the Cappella Paolina in S. Maria Maggiore, Rome, where the drapery of the figure of S. Giovanni Damasceno shows an equally Northern appearance. However, there is the altarpiece of *The Virgin enthroned with Saints* (Pinacoteca, Faenza) of the early 1630s, in which the figure of St Francis in particular recalls the Edinburgh drawing. A study for this figure exists at Windsor (*Bolognese Drawings at Windsor*, no. 354, pl. 65) which, though in reverse, is not unlike D 1785. No painting incorporating this kneeling figure has been traced.

D 711

Fig. 711

Study of a male torso, with a separate sketch of a raised hand holding a club.

252 × 359. Black and red chalk heightened with white. (Laid down.)

PROV: Marquis de Lagoy; Count M. von Fries (L. 2903); Sir Thomas Lawrence; David Laing; Royal Scottish Academy. Transferred 1910. (The information that the drawing also belonged to Sir E. Astley, given in the Royal Academy 1938 Catalogue, and repeated in the Leicester Catalogue, is incorrect and probably due to a misreading of Count von Fries's collector's mark.)

LIT: Heinrich Bodmer, 'Die Zeichnungen Guido Renis', *Die Graphischen Künste, Neue Folge*, Band VII (1942/43), pp. 41–9, fig. 4 (as Samson); *Fifty Master Drawings in the National Gallery of Scotland* (1961), no. 24.

EXH: *Seventeenth-Century Art*, Royal Academy, 1938 (406); *Old Master Drawings*, Leicester, 1952 (50); Colnaghi, 1966 (42, pl. 28).

A fine and characteristic drawing. It is a study for the painting *Hercules slaying the Hydra* in the Louvre, one of a group of four paintings depicting the 'Labours of Hercules' which were commissioned from Reni by the Duke of Mantua, and painted between 1617 and 1621. From the correspondence between the Duke and Count Andrea Barbazzi, it becomes clear that the composition of *Hercules slaying the Hydra* was executed in 1620, which provides a convenient date for the drawing. (See W. Braghirolli, 'Guido Reni e Ferdinando Gonzaga' in *Rivista Storica Mantovana*, I, 1–2 (1885), pp. 88 ff.; C. Gnudi, *Guido Reni* (1955), p. 71 (45).)

D 1604 Fig. 712

The Christ Child playing with a bird.

104 × 131. Black and red chalk. Inscribed: *guido bolognese*. Also *53* in lower right corner.

PROV: F. Renaud (L. Suppl. 1042); David Laing; Royal Scottish Academy. Transferred 1910.

This is obviously a counterproof, with the shading reinforced in red chalk, of a preliminary drawing for the painting in the collection of Mrs Suida Manning, New York (C. Gnudi, *Guido Reni* (1955), no. 65, pl. 119). The painting has been convincingly dated in the second half of the 1630s.

D 4864 Fig. 713

Studies of a male nude.

248 × 163. Pen and brown ink. Inscribed on the back: *Gui^{do} Reni*.

PROV: Marquis de Lagoy; Count M. von Fries; Sir Thomas Lawrence; H. M. Calmann. Purchased 1961.

The style points to Reni's middle period, c. 1625, showing interesting influences of Venetian pen drawings (Titian, Campagnola). The head in the top corner is reminiscent of the S. Giovanni in the painting *The Meeting of Christ and St John* (Museo dei Gerolamini, Naples), or of the Apollo in the *Apollo and Marsyas* (Munich), both of which are datable around 1622–25. The kneeling figure recalls vividly

a similar pose in the painting *Sacred and Profane Love* (Palazzo Spinola, Genoa; copy in the Gallery at Pisa) which, it is now agreed, should be dated around 1620 and not as early as Gnudi had proposed (C. Gnudi and G. C. Cavalli, *Guido Reni* (1955), p. 57, no. 12). There is a drawing for the Genoa picture, with significant variations, in the Accademia, Venice (134), published by Moschini in *Bolletino d'Arte*, XXV (1931), p. 78, fig. 12, which, although freer in style, shows the same pen-technique, as does also the drawing in the Uffizi (12446F). The figures in D 4864 may have been intended for the soldiers in a *Resurrection*.

Circle of GUIDO RENI

D 949 Fig. 714

Design for an altar with *The Annunciation*, flanked by half- and full-length figures of saints.

245 × 183 (arched top). Architecture in pen and ink, figures in red and black chalk. (Cut out and laid down.) Inscribed 'Guido' on the old backing.

PROV: David Laing; Royal Scottish Academy. Transferred 1910.

What is still visible of this exceedingly rubbed drawing shows the general influence of Guido Reni (as far as the figures are concerned). It is possible that the drawing represents a design for a new architectural setting for already existing paintings.

Copies after GUIDO RENI

D 3082

Profile head of a woman.

340 × 262. Black and red chalk on brown paper. Inscribed on back: *Guido Reni f.*

PROV: W. F. Watson. Bequeathed 1881.

D 4890/26 Fig. 715

A pair of lovers, with Amor to the right.

193 × 155. Pen, ink and wash. (Damaged and laid down.) Inscribed: *Guido Reno*.

PROV: Marchese del Carpio; Paul and Edwardo Bosch, Madrid; H. M. Calmann. Purchased 1964.

This is obviously a copy, based on an original composition by Reni. A 'School' version, in black chalk, is at Windsor (*Bolognese Drawings at Windsor Castle*, no. 422).

D 1492

Two hands joined in prayer.

171 × 124. Black chalk, heightened with white on blue paper.

PROV: David Laing; Royal Scottish Academy. Transferred 1910.

As far as one can judge from this faint and rubbed drawing, it seems to be a weak copy in reverse of the drawing in the Brera, with an old inscription to Reni, which Emiliani connects with a picture of the *Madonna adoring the Child*, only known through various copies. (See A. Emiliani, *Mostra di Disegni del Seicento Emiliano nella Pinacoteca di Brera* (1959), no. 90.)

D 2987

Venus and Cupid.

209 × 160. Pen, brown ink and wash over black chalk.

PROV: W. F. Watson. Bequeathed 1881.

No composition corresponding to this feeble copy has been traced, though the figure of Cupid is close to the painting in the Corsini Gallery, Rome.

MARCO RICCI
Belluno 1676–1729 Venice

D 626 Fig. 716

Hilly landscape with bird-catchers.

375 × 542. Pen, brown ink and wash. (Laid down.) Inscribed on back: *no. 27. A.D. 1778/Marco Ricci*.

PROV: An unidentified collector has written on the back 'Bought out of Smith's Collection. A.d. 1778'. This probably refers to N. Smith (L. 2296–98); David Laing; Royal Scottish Academy. Transferred 1910.

EXH: *Mostra di Marco Ricci*, Bassano del Grappa, 1963 (135); Colnaghi, 1966 (81).

The old inscription to Marco Ricci on the back is entirely convincing. The style and subject matter are in fact very close to Marco Ricci's etching (Mostra, no. 203).

D 675 Fig. 717

Hilly landscape near a river.

417 × 291. Pen and brown ink. Traces of black chalk. (Laid down.) Inscribed on the back in pencil: *Titiano f.ⁱ./184*.

PROV: W. B. Johnstone; David Laing; Royal Scottish Academy. Transferred 1910.

LIT: Vasari Society, 1st Series, IX, 8; K. Gerstenberg, *Die ideale Landschaftsmalerei* (1923), p. 22, pl. VI (as Titian); D. von Hadeln, *Zeichnungen des Tizian* (Berlin, 1924), p. 42; I. Haumann, *Das Oberitalienische Landschaftsbild des Settecento* (1927), p. 26 (as Marco Ricci); G. Fiocco, *La pittura veneziana del Seicento e Settecento* (1929), p. 58 (as Marco Ricci); G. Delogu, *Pittori veneti minori del Settecento* (1930), p. 97 (as Marco Ricci); *Catalogue: National Gallery of Scotland* (1946), p. 395 (as Titian); Tietze, A1893

(?Bolognese, 17th century); G. M. Pilo, 'Marco Ricci ritrovato', in *Paragone* no. 165 (as Marco Ricci).

EXH: *Mostra di Marco Ricci*, Bassano del Grappa, 1963 (109). There is very little left to see of this almost completely faded drawing. However, the former ascription to Titian cannot be maintained, and it was A. E. Popham who first suggested that it might be by Marco Ricci, possibly copying Titian.

D 879 Fig. 718

Landscape with a castle and farm buildings.

272 × 387. Pen and brown ink over black chalk. Inscribed on the mount: 'M. Ricci'.

PROV: David Laing; Royal Scottish Academy. Transferred 1910.

EXH: *Mostra di Marco Ricci*, Bassano del Grappa, 1963 (116).

The inscription on the contemporary mount is certainly correct. The style is similar to the drawings which once formed an album, of which the greater part is now in the Ashmolean Museum (1048–68). Like Ashmolean 1051, for example, this drawing appears to be an early work, very much in the Titian and Domenico Campagnola tradition.

RSA 119 Fig. 719

Landscape with cathedral town in background.

282 × 395. Pen and brown ink.

PROV: David Laing; Royal Scottish Academy. On loan 1966.

The traditional attribution is convincing.

D 881 Fig. 720

Turreted town near a river, with seated and standing figures in the foreground.

137 × 220. Pen and black ink. Inscribed: *Marco Ricci*.

PROV: David Laing; Royal Scottish Academy. Transferred 1910.

Attributed to
MARCO RICCI

D 1547 Fig. 721

An orator, with outstretched left arm, talking to a crowd.

137 × 97. Pen, brown ink and wash over black chalk.

PROV: Unidentified collector's mark (L. 2728); Paul Sandby; David Laing; Royal Scottish Academy. Transferred 1910.

Formerly ascribed to Salvator Rosa, the drawing seems to be later and the figures resemble those frequently occurring in Marco Ricci's landscapes.

SEBASTIANO RICCI
Belluno 1659–1734 Belluno

RSA 283 Fig. 722

Slaves lifting a treasure from a crypt.

253 × 176. Pen, brown ink and wash. (Laid down.) Inscribed on mount: 'Bastiano Ricci Veneziano'.

PROV: Nathaniel Hone; David Laing; Royal Scottish Academy. On loan 1966.

The traditional attribution may be correct.

DANIELE RICCIARELLI
See DANIELE da Volterra.

DOMENICO ROBUSTI
See Domenico TINTORETTO.

JACOPO ROBUSTI
See Jacopo TINTORETTO.

GIOVANNI FRANCESCO ROMANELLI
Viterbo 1610–1662 Viterbo

Circle of
GIOVANNI FRANCESCO ROMANELLI

D 1638 Fig. 723

Mercury offering the crown to Diana.

277 × 488. Pen, brown ink and blue wash, over black chalk. Squared in pen. (Laid down.) Inscribed: *Romanelli*.

PROV: John MacGowan (probably Edinburgh sale, 31 January 1804, no. 560); Sir Thomas Lawrence; David Laing; Royal Scottish Academy. Transferred 1910.

The drawing—obviously a design for a ceiling decoration—is probably by an artist close to Romanelli. The handling seems too confident and competent for it to be merely a copy.

CRISTOFANO RONCALLI
(Il Pomarancio)
Pomarance (Volterra) 1552–1626 Rome

D 3063 Fig. 724

An angel seated on clouds.

313 × 237. Red chalk. Inscribed on the back in a 19th century hand: *after Correggio, fresco in Parma*.

PROV: W. F. Watson. Bequeathed 1881.

A. E. Popham was the first to propose the attribution to Roncalli. The subject would seem to be connected with the design for the cupola at Loreto.

D 3131 Fig. 725

Sheet of studies of music-making figures, a separate sketch of the head and the two hands on the strings of a lute.

365 × 261. Red and black chalk.

PROV: W. F. Watson. Bequeathed 1881.

Initially also thought to be a copy from one of Correggio's frescoes at Parma, it was first connected by A. E. Popham with Roncalli's no longer existing cupola at Loreto. The main figure corresponds in pose with the angel in the centre of the *modello* for the cupola, in the British Museum (1895-9-15-713, repr. A. E. Popham, *Correggio's Drawings* (1957), fig. 69).

The rubbed condition of D 3131 makes it difficult to decide whether the drawing is in fact an original by Roncalli, or a product of his studio.

FRANCESCO MARIA RONDANI
Parma 1490–1548 Parma

RSA 141 Fig. 726

Study of female nude (Venus?).

262 × 174. Black chalk on brown paper. (Rubbed.) Inscribed: *francesco maria Rondani. Parmegiano. Élève du Correge. École Lombarde.*

PROV: David Laing; Royal Scottish Academy. On loan 1966.

The old attribution to Rondani is possibly correct, but the drawing could also conceivably be by Bertoia.

SALVATOR ROSA
Arenella (Naples) 1615–1673 Rome

D 667 Fig. 727

Two men on hilly ground near a group of trees.

288 × 215. Pen and brown ink. (Laid down.) Inscribed on the mount: 'Salvator Rosa'.

PROV: David Laing; Royal Scottish Academy. Transferred 1910.

D 1593 Fig. 728

Head of a bearded man.

332 × 229. Red chalk. (Slight tears repaired, and laid down.) There is a partly rubbed, and therefore illegible inscription

in black chalk across the bottom of the drawing: *Questo è il ribaldo di Alessandro...*'

PROV: David Laing; Royal Scottish Academy. Transferred 1910.

The attribution is due to Philip Pouncey.

D 770 Fig. 729

The preaching of Jonah to the people of Nineveh.

200 × 270. Pen and brown ink. (Paper foxed.) Inscribed on the back of the mount: 'For the celebrated picture the King of France has'.

PROV: Jonathan Richardson, Senr (L. 2184); David Laing; Royal Scottish Academy. Transferred 1910.

EXH: *Neapolitan Baroque and Rococo Painting*, Bowes Museum, Barnard Castle, 1962 (54).

The drawing represents a sketch for some of the figures in the painting now at Copenhagen (*Royal Museum of Fine Arts: Catalogue of Old Foreign Paintings* (Copenhagen, 1951), no. 599). A more elaborate study for the full composition is at Budapest (MFA 2384; repr. in *Master Drawings from the Collection of the Budapest Museum* (1957), no. 62) which shows similar marks of foxing. The painting was commissioned from Salvator by King Christian IV for the Royal church at Fredericksborg, and was sold to the King in 1661. The information on the back of the drawing is therefore incorrect.

D 785 Fig. 730

Sheet of figure studies with a flying angel, a falling man and another lying on the ground.

185 × 210. Pen and black ink. (Left margin irregularly cut.)

PROV: David Laing; Royal Scottish Academy. Transferred 1910.

Michael Mahoney relates these studies to the painting *The Death of Empedocles* (Coll. Lord Chandos), exhibited *Art Treasures of the Midlands*, Birmingham, 1934 (278).

D 774 Fig. 731

A little child being helped on to a bull.

130 × 123. Pen, black ink and grey wash. (Laid down, parts of the left margin torn, paper foxed.)

PROV: David Laing; Royal Scottish Academy. Transferred 1910.

The subject may be *The Youth of Hercules*.

D 1568 Fig. 732

Two falling figures.

150 × 152. Pen, black ink over red chalk. (Top right corner cut and laid down.) Inscribed on mount: 'Sal: Rosa'.

PROV: Sir Thomas Lawrence; David Laing; Royal Scottish Academy. Transferred 1910.

A study connected with Rosa's large etching *The Fall of the Giants* (B. XX, p. 276, 21), which the artist reported as already finished in the summer of 1663 (de Rinaldis, *Lettera inedite di Salvator Rosa a G. B. Ricciardi* (Rome, 1939), p. 153). Other studies for this composition are in the Metropolitan Museum, 64.197.6 (*Drawings from New York Collections: The 17th Century in Italy* (1967), no. 108), and Michael Mahoney has found others in the Print Rooms at Rome and Leipzig.

RSA 199 Fig. 733

The martyrdom of a saint. (On the verso: studies of a St Michael and other flying figures.)

191 × 204. Pen and brown ink.

PROV: David Laing; Royal Scottish Academy. On loan 1966.

The recto is possibly an early idea for the painting *Jeremiah being rescued from the pit* (Musée Condé, Chantilly) with which several of the main accents agree. (L. Salerno, *Salvator Rosa* (1963), pl. 69.)

RSA 200 Fig. 734

Study of Christ, and two other figures. (On the verso: slight figure studies.)

201 × 159. Pen and brown ink.

PROV: David Laing; Royal Scottish Academy. On loan 1966.

The group on the left may be connected with the composition depicted on RSA 199.

RSA 201 Fig. 735

A sculptor carving a figure out of a stone slab.

172 × 157. Pen and brown ink. (Damaged.)

PROV: David Laing; Royal Scottish Academy. On loan 1966.

RSA 202 Fig. 736

A sculptor carving a figure out of a stone slab, surrounded by other figures.

174 × 192. Pen and brown ink. (Badly torn and damaged.)

PROV: David Laing; Royal Scottish Academy. On loan 1966.

RSA 203 Fig. 737

The angel on the Tomb.

131 × 176 (irregular edges). Pen and brown ink. (Torn and damaged.)

PROV: David Laing; Royal Scottish Academy. On loan 1966.

RSA 204 Fig. 738

A crouching figure.

199 × 173. Pen, brown ink and wash. (Laid down.)

PROV: David Laing; Royal Scottish Academy. On loan 1966.

RSA 263 Fig. 739

A warrior defending himself.

152 × 108. Pen, brown ink and wash over black chalk. (Laid down.)

PROV: David Laing; Royal Scottish Academy. On loan 1966.

RSA 264 Fig. 740

Two men fighting.

108 × 153. Pen, brown ink and wash, slight traces of black chalk. (Laid down.)

PROV: David Laing; Royal Scottish Academy. On loan 1966.

The traditional attribution to Rosa seems correct.

RSA 265 Fig. 741

Studies of fighting men.

261 × 216. Pen, brown ink and wash. (Laid down.)

PROV: David Laing; Royal Scottish Academy. On loan 1966.

Possibly a study for the fighting group on the left in the *Heroic Battle* (Louvre), commissioned in 1652. (L. Salerno, *Salvator Rosa* (1963), p. 110, pl. XIV.)

Attributed to
SALVATOR ROSA

D 662 Fig. 742

The miraculous draught of fishes.

177 × 289. Pen, black ink over red chalk. (Damaged, stained and laid down.)

PROV: David Laing; Royal Scottish Academy. Transferred 1910.

The drawing entered the collection as 'Carracci'. The present attribution appears to have been made fairly recently and may well be correct.

D 894 Fig. 743

Wild river landscape with two horsemen in the background.

211 × 274. Pen and brown ink. (Laid down. Much of the left and upper right margins torn away.)

PROV: David Laing; Royal Scottish Academy. Transferred 1910.

Former attributions were: Annibale Carracci, 'Bolognese', Cantagallina. The fragment that remains of this damaged drawing appears to show characteristics of Salvator Rosa's style.

Imitator of SALVATOR ROSA

D 2791 A Fig. 744

A sleeping shepherd watched by two other figures.

191 × 315. Pen and brown ink. Pencilled inscriptions on the back: *A. Carracci* (crossed out), *François Millet*.

PROV: W. F. Watson. Bequeathed 1881.

The drawing seems to be Italian, not French. Both style and subject matter imitate the characteristics of Salvator Rosa.

MATTEO ROSSELLI
Florence 1578–1650 Florence

D 766 Fig. 745

Seven studies for a *Presentation of the Virgin in the Temple*.

276 × 210. Pen, brown ink with wash and white heightening, apart from one which is in red chalk. Inscribed: *Matteo Rosselli*.

PROV: David Laing; Royal Scottish Academy. Transferred 1910.

LIT: *Catalogue: National Gallery of Scotland* (1946), p. 393.

Two other drawings by Matteo Rosselli in pen and ink over red chalk, depicting the same subject, but differing in composition, are in the Uffizi (9775 F and 9812 F).

Attributed to
MATTEO ROSSELLI

D 1632 Fig. 746

Profile head of an elderly man.

210 × 169. Black and red chalk, heightened with white, on faded blue paper. (Laid down.) Inscription: 'H. Holbein' on mount.

PROV: David Laing; Royal Scottish Academy. Transferred 1910.

An attribution to Barocci has been suggested, but both style and medium point fairly clearly in the direction of Matteo Rosselli.

GIOVANNI PAOLO ROSSETTI
Volterra ?–1586 Volterra

Ascribed to GIOVANNI PAOLO ROSSETTI

D 1542 Fig. 747

Head of a bearded man. (On the verso: indecipherable red chalk sketches.)

205 × 145. Black chalk.

PROV: David Laing; Royal Scottish Academy. Transferred 1910.

The drawing appears to be of the late 16th century, but it is very doubtful if the old ascription to Giovanni Paolo Rossetti, the nephew and pupil of Daniele da Volterra, is correct. The drawing has almost a German look.

D 4890/33 B Fig. 748

Seated bearded, draped figure (St Jerome or St Matthew ?).

106 × 51. Brush and wash. (Spotted and laid down.) Inscribed: *Paolo Rossetti*.

PROV: Marchese del Carpio; Paul and Edwardo Bosch, Madrid; H. M. Calmann. Purchased 1964.

It is impossible to judge such a small and slight sketch.

PASQUALINO DE' ROSSI
Vicenza 1641–1725 Rome

D 1890 Fig. 749

A woman combing the hair of a small girl.

115 × 147 (cut irregularly to an oval). Pen, brown ink and wash over black chalk. Inscribed on old mount: 'Pasqualino. 34'.

PROV: (? Allan Ramsay); Lady Murray. Presented 1860.

ROSSO FIORENTINO
(Giovanni Battista Rosso)
Florence 1494–1540 Paris

D 4870 Fig. 750

Seated female nude with raised arms. (In the lower right corner a study of the back of a bent right hand, and on the left the outline of the right breast and raised arm of the figure.)

315 × 178. Red chalk. Old inscription: *Checino Salviati* in the lower margin.

PROV: H. M. Calmann. Purchased 1962.

LIT: Michael Hirst, 'Rosso: a Document and a Drawing', *Burlington Magazine* (March 1964), p. 122, fig. 22.

EXH: Colnaghi, 1966 (11).

The identification of the figure as being a study for Eve from *The Creation of Eve* in the right half of the very damaged fresco lunette of the Cesi chapel in S. Maria della Pace, Rome, is due to Michael Hirst, who also published the contract of 26 April 1524, between Rosso and Antonio da Sangallo, acting on behalf of Agnolo Cesi (*op. cit.*). (For the documents, see also C. L. Frommel, 'Miszellen zu Sangallo dem Jüngeren, Rosso und Montelupo in S. Maria della Pace in Rom', *Il Vasari*, XXI, 4 (December 1963), pp. 144 ff.)

Ascribed to ROSSO

D(NG) 601 Figs. 751 and 752

(*recto*) A skeleton, with one leg kneeling on a rock;
(*verso*) Male figure with upraised arms.

428 × 237. Pen, brown ink and wash. Verso: partly in red chalk. (Much rubbed and faded.) Partly obliterated inscription at the bottom, which may have read: *M! Buonarotti*.

PROV: W. Y. Ottley; Thomas Monro; Francis Abbot. Presented 1873.

LIT: Berenson, 2393 D; *Catalogue: National Gallery of Scotland* (1946), p. 390 (as Michelangelo).

A letter from Ottley dated 23 February 1813 (in the Gallery archives) addressed to the Rev. Richard Shannon, Edinburgh, who it seems acted as an intermediary for Monro, quotes among others 'the opinion of the best judges in Italy' to justify the attribution to Michelangelo.

The attribution to Rosso was apparently first put forward by Berenson, who connected the drawing with the famous *Memento Mori* design in the Uffizi (6499 F; Berenson 2428; repr. in S. Freedberg, *Painting of the High Renaissance* (1961), pl. 666).

A companion drawing to D(NG) 602, probably from the same provenance, is in the library of the Royal College of Physicians, Edinburgh, but both these drawings appear to be later than Rosso, and nearer to the time and spirit of Alessandro Allori.

Copy after ROSSO

D 826 Fig. 753

Figure of 'Charity' standing on a pedestal.

172 × 71 (arched top). Pen and brown ink. (Stained.) Inscribed at the bottom: *rosso*.

PROV: David Laing; Royal Scottish Academy. Transferred 1910.

LIT: E. A. Carroll, 'Drawings by Rosso Fiorentino in the British Museum', *Burlington Magazine* (April 1966), p. 173, n. 22.

This design corresponds (in reverse) with the topmost part of an elaborate architectural composition, comprising the Christian Virtues, which in its complete form only survives in a large engraving by Cherubino Alberti after Rosso, dated 1575 (B. XVII, p. 73, 66), ill. Carroll, *op. cit.* fig. 5. A drawing of this tabernacle is in the British Museum, as Rosso (Pp. 2–119; Carroll, fig. 4), which is cut off at the top, thus omitting the figure of 'Charity'. It cannot, however, be claimed that D 826 is the missing part of the British Museum drawing, as the latter still shows the lower half of the plinth on which the figure is placed and which is also to be seen on D 826. As Carroll rightly says, D 826, though showing Rosso-like features, cannot be more than a copy.

GIOVANNI BATTISTA DELLA ROVERE
Milan c. 1561–after 1627 Milan

D 3137 Fig. 754

The martyrdom of St Sebastian.

375 × 202. Pen, brown ink and wash, over black chalk. Inscribed and signed on the back: *1602 an 24 agosto / G.B.R.*

PROV: W. F. Watson. Bequeathed 1881.

The present attribution was first suggested by Philip Pouncey. The date and characteristic signature on the back only came to light later, when the old backing was removed.

Attributed to
GIOVANNI MAURO DELLA ROVERE
Milan c. 1575–1640 Milan

D 1567 Fig. 755

Part of a *Triumph of David*.

220 × 260. Pen and ink, grey wash, heightened with white on blue paper. (Laid down; parts of the lower right corner missing.)

PROV: W. Y. Ottley (L. 2663 and 2664); Sir Thomas Lawrence; David Laing; Royal Scottish Academy. Transferred 1910.

The drawing had been ascribed to Ligozzi when it entered the collection. Whilst the type of figures and the technique have affinities with Ligozzi, the style points rather to Lombardy, and Philip Pouncey has suggested the present attribution to Giovanni Mauro della Rovere, the brother of

Giovanni Battista. A comparison might be made with the signed drawing of *St Catherine* in the Albertina (VI, 445) and that of *Jacob and the Angel* in the Collection of the Courtauld Institute (446). The subject of *The Triumph of David* was a particularly popular one with Milanese artists.

FERDINANDO RUGGIERI
Florence c. 1691–1741 Florence

D 935 Fig. 756

Design for a title page.

401 × 345. Pen, black ink and grey wash. (Laid down.)

PROV: Nathaniel Hone; David Laing; Royal Scottish Academy. Transferred 1910. Inscribed on back: *Nº 36, Mar 21, 1815.* Also: *Disegno fatto per / Il Frontespizio dei Libri del sudº Ruggieri delle / Fabbriche di Firenze. / Lo Architettura e di Ferdinando Ruggieri Architetto, e Le Figure sono di Giovanni Casini Pittor Fiorentino / Disegno fatto per / Il Frontespizio dei Libri del sudº Ruggieri delle / Fabbriche di Firenze.*

This is the design for the frontispiece of Ruggieri's *Studio d'Architettura Civile sopra gli ornamenti di parte...dalle fabbriche più insigni di Firenze* (1722–28), dedicated to Cosimo III. It was retained for the second edition of the work, published in 1755 under the title *Scelta di Architetture antiche e moderne della città di Firenze*, with the exception of the *stemma* of the Medici supported by two wingless putti which, in the second edition, dedicated to the Austrian Archduke, was replaced by the arms of the royal house of Austria, supported by trumpet-blowing, winged putti.

————————

LORENZO SABBATINI
Bologna c. 1530–1576 Rome

D 904 Fig. 757

Two angels holding the papal crown and globe at either side of an arch.

255 × 345. Pen, brown ink and wash over black chalk. Squared in black chalk. Inscribed: *Lorenzo Sabadini*, and *il luoco dove sta la sedia del papa.*

PROV: Alliance des Arts (L. 61); David Laing; Royal Scottish Academy. Transferred 1910.

A study for the fresco in the Sala Regia, Vatican, opposite the entrance to the Cappella Paolina.

ANDREA SACCHI
Nettuno (Rome) 1599–1661 Rome

D 3080 Fig. 758

Rebecca and Eliezar at the well.

225 × 290. Red chalk and red wash, heightened with white. Squared. Partly erased old inscription on the back: *A. Sacchi.*

PROV: W. F. Watson. Bequeathed 1881.

LIT: *Fifty Master Drawings in the National Gallery of Scotland* (1961), no. 18.

This fine and characteristic drawing has not been connected with any known painting.

Studio of ANDREA SACCHI

D 1983 Fig. 759

A male nude, sitting sideways, with averted head.

394 × 265. Red chalk. (Rather damaged.)

PROV: (? Allan Ramsay); Lady Murray. Presented 1860.

Follower of ANDREA SACCHI

D 682 Fig. 760

Seated male nude seen from three-quarter back.

315 × 240. Red chalk.

PROV: David Laing; Royal Scottish Academy. Transferred 1910.

Former ascriptions were to Raphael and Furini. The drawing appears to be of the late 17th century, and the kind of academic life-study frequently made by Sacchi and his studio.

VENTURA SALIMBENI
Siena 1567/1568–1613 Siena

D 819 Fig. 761

St John the Baptist preaching.

180 × 303. Pen, brown ink and wash over black chalk. With an inscription in Richardson's hand, giving the artist's name: *Arcangelo Salimbeni.*

PROV: 'P. Crozat'? (L. 474); Jonathan Richardson, Jnr (L. 2170); Count von Ross (L. 2693); John McGowan; sale, 1 February 1804, lot 621); David Laing; Royal Scottish Academy. Transferred 1910. (There is also a pencilled note on the back that the drawing was once *in Mons. de Calones collection* which may possibly be the Calonne collection, mentioned by Lugt under no. 2460.)

Richardson's attribution must refer to Ventura di Arcangelo Salimbeni, and not to his father Arcangelo di Leonardo Salimbeni (died *c.* 1580). Hardly any authenticated drawings by the older Arcangelo exist and D 819 appears almost certainly to be a 17th century drawing and is, moreover, with its mixture of Florentine and Sienese elements, entirely characteristic of Ventura. A suitable comparison is with another lunette design, depicting a

Miracle of St Michael at Windsor (*Italian Drawings at Windsor*, 881, pl. 45). P. A. Riedl is inclined to think that it is in fact a rather late work.

D 4890/36 Fig. 762

A group of kneeling figures, adoring the crucifix on an altar.

172 × 136. Pen, ink and blue wash, over black chalk. (Top corners cut and made-up. Laid down.) Inscribed: *Salimbene.*

PROV: Marchese del Carpio; Paul and Edwardo Bosch, Madrid; H. M. Calmann. Purchased 1964.

The old attribution is possibly correct.

ENEA SALMEGGIA
See Enea TALPINO.

FRANCESCO SALVIATI
Florence 1510–1563 Rome

D 1026 Fig. 763

Classical ruins with figures and uprooted trees.

110 × 212. Pen, brown ink and wash, heightened with white, on blue paper. (Laid down.) Inscribed on the back of the old mount: 'Cecchino, o Cecco, cioe Francesco Salviati fu Nato in Firenze circa 1500—fu discepolo d'Andrea del Sarto . e poi di Baccio Bandinelli, ed Amico fidele di Vasari…'

PROV: Jonathan Richardson, Senr (L. 2183); David Laing; Royal Scottish Academy. Transferred 1910.

As pointed out by Michael Hirst, the background of the large drawing of a *Triumphal Procession* by Salviati in the Albertina (III, 235) repeats almost the same composition. A drawing in similar style and technique, *Lot escaping from Sodom* (Victoria and Albert Museum, Dyce 165), also formerly in the Richardson Collection, is obviously by the same hand.

GIUSEPPE SALVIATI
(Porta)
Castelnuovo di Garfagnana 1520–c. 1573 Venice

D 3139 Fig. 764

Cloelia fleeing from the Etruscan King Porsena.

140 × 181. Pen, brown ink and wash over black chalk, heightened with white. Faint inscription on the mount: 'Salviati 1510–1573'.

PROV: Sir Peter Lely; W. F. Watson. Bequeathed 1881.

The inscription on the mount refers presumably to Francesco Salviati, although the dates given are incorrect even for him. However, there can be little doubt that the drawing is in fact by Giuseppe Salviati, who was a pupil of Francesco, and whose surname he adopted.

ORAZIO SAMACCHINI
Bologna 1532–1577 Bologna
D 3181 Fig. 765

A circle of music-making angels, and saints.

231 × 361 (arched top). Pen, brown ink and wash. (Laid down. Very damaged and faded.)

PROV: W. F. Watson. Bequeathed 1881.

Formerly ascribed to Federico Zuccaro, the drawing however is entirely characteristic of Samacchini. It is, moreover, a variant of the lunette drawing in the Uffizi (829F, as Poccetti). Both these drawings were attributed to Samacchini by Philip Pouncey.

ANDREA DEL SARTO
Florence 1486–1530 Florence
Follower of ANDREA DEL SARTO
D 4820 D Fig. 766

Female profile head.

297 × 240 (irregularly cut along right margin). Red chalk. Squared in black chalk. (Paper stained and rather damaged.)

PROV: Richard Cooper, Senr and Jnr; Miss M. Eyre. Presented 1959.

The drawing is connected with a small painting at Budapest (no. 809, ill. in the Catalogue of Mannerist Art pub. by the Museum in 1961) and there called 'Follower of Salviati'. This painting on panel bears on the back the monogram and crown of King Charles I, as well as the inscription *Z 47 vandik*. It appears to have got to Vienna with the collection of Leopold William and from there to the Court at Budapest, whence Kossuth presented it to the Budapest Museum in 1848. Oliver Millar has suggested that it might possibly be the little picture listed in van der Doort's Catalogue as by Parmigianino ('Abraham van der Doort's Catalogue of the Collections of Charles I', ed. Oliver Millar, *The Walpole Society*, XXXVII (1960), p. 2, no. 2), although the measurements of the Budapest picture are slightly smaller than those stated by van der Doort, and it is on panel and not on cloth (*Klaht*) as van der Doort puts it.

Whether or not the painting can be identified with the Budapest panel, neither it nor the drawing has anything to do with Parmigianino. The head strikingly resembles that of the kneeling figure of Mary Magdalen in Andrea

del Sarto's *Disputa* (Pitti, no. 172; J. Shearman, *Andrea del Sarto* (1965), pl. 66b), although the face there is turned further away from the spectator. However, this resemblance may be accidental, and the drawing, although almost certainly Florentine, is later than del Sarto and rather points to one of the artists who collaborated in the decoration of the 'Studiolo' in the Palazzo Vecchio.

ANDREA SCHIAVONE
(Meldolla)
Zara (Dalmatia) c. 1522–1563 Venice
D 1764 Fig. 767

A dancing figure.

183 × 119. Black chalk, heightened with white on faded blue paper.

PROV: King Charles I (according to an inscription on the back of the mount); Nicholas Lanier; Jonathan Richardson, Senr (L. 2183); Sir Joshua Reynolds; John Barnard (L. 1419 recto; L. 1420 verso); Bindon Blood (L. 3011); David Laing; Royal Scottish Academy. Transferred 1910.

LIT: *Catalogue: National Gallery of Scotland* (1946), p. 391 (as Parmigianino).

The drawing was formerly ascribed to Parmigianino. The present, completely convincing attribution was first suggested by A. E. Popham. The figure of *Judith* in the Albertina drawing (I, 59) and the *Mythological Figure* of the National Gallery, London, painting (1883) are very close to D 1764.

BARTOLOMEO SCHIDONE
Modena 1578–1615 Parma
D 822 Fig. 768

A female martyr saint.

180 × 140. Red chalk. (Lower right corner badly damaged and laid down.)

PROV: David Laing; Royal Scottish Academy. Transferred 1910.

The facial type is typical of Schidone. The lines to the left may indicate a martyr's palm.

SEBASTIANO DEL PIOMBO
(Luciani)
Venice 1485–1547 Rome
Studio of SEBASTIANO DEL PIOMBO
D 1792 Fig. 769

A heavily draped standing male figure.

300 × 130. Red chalk. Signs of tracing along the contours. (Laid down. Top margin and corners cut, damaged in lower left margin.) Inscribed: *M. Angelo*. Monogram, intertwined *DR* on back.

PROV: Sir Thomas Lawrence; David Laing; Royal Scottish Academy. Transferred 1910.

This impressive drawing is a real puzzle. Philip Pouncey has pointed to the very Florentine look of the drawing, especially the heavy and voluminous drapery. A figure like this would indeed not look out of place in the margins of an *Adoration* by Filippo Lippi or Botticelli. Yet it is undoubtedly an early 16th-century drawing, and strikingly resembles the upward-looking figure on the extreme right in the famous *modello* of the *Assumption of the Virgin* by Sebastiano del Piombo in the Rijksmuseum which has been connected with a Roman commission (*Le Dessin Italien dans les Collections Hollandaises* (Paris–Rotterdam–Haarlem, 1962), no. 88, pl. LXVI). The face seems to be identical and so is the drapery, except that in the Amsterdam drawing the folds are more restrained and less voluminous and elaborate.

Comparison with the handling of drapery in other well-known drawings by Sebastiano (for example the *Three standing figures* in the Boymans-van Beuningen Museum at Rotterdam, *Le Dessin Italien*, etc. *op. cit.* pl. LXVII; or two in the British Museum, BM Raphael, pl. 259 and 262) make a direct attribution to him unlikely. Neither can the old ascription to Michelangelo be taken seriously, even if it is imagined that he did it in order to help his friend—according to Prof. Johannes Wilde, who saw a photograph of the drawing, 'the folds are too crowded and lack his *fattura*'.

The compiler's idea that the artist might have been Daniele (Ricciarelli) da Volterra, who regarded Sebastiano as one of his masters (a notion to which the monogram on the verso might appear to lend support), has not found a favourable response from the experts, mainly because he is usually more painstakingly academic in his drapery studies.

The artist, if not Sebastiano himself, must have had access to his *modello*, or to studies for it, and is to be looked for within his studio or immediate circle.

FRANCESCO SIMONINI
Parma 1686–1753 Venice

D 2833 Fig. 770

A cavalry skirmish.

379 × 636. Black chalk and brown wash.

PROV: W. F. Watson. Bequeathed 1881.

The traditional attribution is convincing.

D 2834 Fig. 771

A cavalry skirmish.

392 × 554. Pen, brown ink and wash, over black chalk. Signed: *F:A:S:*.

PROV: W. F. Watson. Bequeathed 1881.

D 3167 Fig. 772

A cavalry skirmish.

228 × 367. Pen, black ink and brown wash over black chalk. (Laid down.) Signed: *Franco. Ant° Simonini*.

PROV: W. F. Watson. Bequeathed 1881.

Attributed to
GIOVANNI ANTONIO SOGLIANI
Florence 1492–1544 Florence

D 4820 F Fig. 773

A kneeling draped figure, holding a book.

287 × 202. Black chalk on brown, toned paper. (Laid down.) Faint inscription in lower right corner: *Ant (?) Coregio*.

PROV: Richard Cooper (Senr and Jnr); Miss M. Eyre. Presented 1959.

The drawing is certainly by a follower of Fra Bartolomeo, and has nothing to do with Correggio, as the old inscription suggests. It is rather weak and incoherent, unable to indicate the forms underneath the drapery. The style, even the 'shorthand' of the profile, speaks strongly for Sogliani, although he is here shown in a rather facile manner. The attribution is supported by Roseline Bacou.

RSA 142 Fig. 774

Standing male figure facing right. (On the verso: standing male nude.)

285 × 100. Black chalk, heightened with white on buff paper. Inscribed: *74*.

PROV: David Laing; Royal Scottish Academy. On loan 1965.

There can be little doubt that this and the following drawing, both previously unattributed, are by Sogliani.

RSA 143 Fig. 775

Kneeling male figure with book.

276 × 140. Black chalk on buff paper. Erased inscription in lower left corner. Inscribed: *75*.

PROV: David Laing; Royal Scottish Academy. On loan 1966.

FRANCESCO SOLIMENA
Canale di Serino (Avellino) 1657–1747 Barra (Naples)

D 818 Fig. 776

The dream of St Joseph.

235 × 193 (oval). Pen, brown ink and wash over black chalk. (Laid down.)

PROV: Bindon Blood (L. 3011); David Laing; Royal Scottish Academy. Transferred 1910.

The traditional attribution seems convincing. A painting of the same subject, for which D 818 might possibly have been a preliminary idea, is in S. Maria Donnalbina, Naples (repr. in F. Bologna, *Francesco Solimena* (1958), pl. 114). However, both the shape of the drawing and its composition are different from the painting, which can be dated towards the very end of the 17th century.

Copies after FRANCESCO SOLIMENA
D 638 Fig. 777

God the Father enthroned on clouds.

237 × 357. Pen, brown ink and grey wash over black chalk. (Laid down.)

PROV: David Laing; Royal Scottish Academy. Transferred 1910.

The drawing has the appearance of a copy.

D 1581 Fig. 778

The Virgin and Child in glory, with S. Filippo Neri and angels.

332 × 198 (arched top). Pen, brown ink and grey wash over black chalk. (Laid down.) Note of a 19th century inscription: *Sebastiano Conca*.

PROV: John Auldjo (L. 48); David Laing; Royal Scottish Academy. Transferred 1910.

LIT: M. V. Brugnoli, 'Inedite del Gaulli' in *Paragone*, 81 (1956), p. 31, n. I.

The former ascription to Sebastiano Conca was rejected for an anonymous suggestion to Gaulli, whereas Maria Brugnoli proposed instead the name of Solimena. The composition does in fact correspond in all essentials with Solimena's altarpiece in S. Filippo at Turin (F. Bologna, *Solimena* (1958), pl. 203) which has been dated *c.* 1730–40. The pose of the Saint has been altered and the angel at the lower centre has been moved over to the left in the final painting. However, Walter Vitzthum has pointed to a drawing in the Louvre (9785) of the same subject, with an inscription to Solimena on the drawing, and another on the mount—in a 19th century hand—to Francesco di Mura. As both drawings differ exactly in the same details from the picture in Turin, and as the quality of either is not very high, it is probable that both are in fact copies from an as

yet unidentified original. It is difficult to say what their relationship to the three surviving *bozzetti* is (two mentioned in the Catalogue *Mostra del Barocco Piemontese*, II, (Turin, 1963), 109, as being respectively in the Sacristy of S. Domenico, Naples and in the Museo Civico, Turin (Luigi Mallé, *I Dipinti del Museo d'Arte Antica* (Turin, 1963), p. 178, pl. 199). A third, recently discovered by W. Vitzthum, is in the Museum at Lisbon.

PIETRO SORRI
Siena 1556–1621 or 1622 Siena

RSA 192 Fig. 779

A man addressing a woman in a public square.

404 × 280. Pen, brown ink and wash. Inscribed: *Camillino* (crossed out); on the mount: 'Pietro Sorri Senese'.

PROV: David Laing; Royal Scottish Academy. On loan 1966.

Philip Pouncey suggests that this may be a drawing by Sorri's pupil Astolfo Petrazzi, by whom an inscribed drawing (with a misspelling of his name) is in the Albertina (III, 500).

Attributed to
LIONELLO SPADA
Bologna 1576–1622 Parma

D 3086 Fig. 780

Judas returning the blood money (with a representation of *Christ on the Mount of Olives* on the right).

217 × 384. Pen, brown ink and wash, traces of red chalk (the representation of *Christ on the Mount of Olives* squared in red chalk). (Laid down.)

PROV: Sir Peter Lely; W. F. Watson. Bequeathed 1881.

The drawing has an old ascription to Velasquez on the back, but it entered the Gallery's collection under the name of Andrea Sacchi. Neither of these names is tenable. It seems to be Bolognese and close to a drawing sold under the name of Spada at Christie's 9 December 1949 (lot 100, *A palace interior with architects and other men studying a model for a cathedral*). The style in general, and the elaborate architectural background of the two drawings, are rather similar.

Another anonymous drawing of the *Baptism of Constantine* in the Victoria and Albert Museum (C.A.I. 265) may also possibly be by the same hand.

MICCO SPADARO
(Domenico Gargiulio)
Naples 1612–c. 1665 or 1679 Naples

D 1549 Fig. 781

Standing, partially draped, male figure.

198 × 140. Pen, brown ink over black chalk (indecipherable black chalk sketch on the back), on buff paper.

PROV: 'P. Crozat'? (L. 474); unidentified mark (L. 525); David Laing; Royal Scottish Academy. Transferred 1910.

The previously anonymous drawing is a characteristic example of Micco Spadaro's style.

BERNARDO STROZZI
Genoa 1581–1644 Venice

D 4917 Fig. 782

Seated male figure.

337 × 241. Black chalk heightened with white. Inscribed on the back: *N.º 65. Garofalo firentino* and *P. G. n.º 47*.

PROV: H. M. Calmann. Purchased 1967.

The inscription on the back is nonsensical, and Philip Pouncey recognized that the drawing is by Strozzi. It is in fact a preliminary study for the seated man on the right in Strozzi's *Supper at Emmaus* in the Museum at Grenoble (see L. Mortari, *Bernardo Strozzi* (1966), p. 137, fig. 310). Mortari lists six other versions and dates the painting convincingly within the Genoese period of the artist, before his departure for Venice in 1630.

This is one of the very few drawings by Strozzi definitely connected with a painting.

D 1659 B Fig. 783

Two seated figures.

270 × 205. Reed pen, brown ink on blue paper. (Laid down.) Inscribed on the back: *Bernardo Strozzi, detto il Prete, o il Capuccino. Genovese—1581–1644.*

PROV: Jonathan Richardson, Jnr (L. 2170); Sir Joshua Reynolds; David Laing; Royal Scottish Academy. Transferred 1910.

LIT: *Catalogue: National Gallery of Scotland* (1946), p. 394.

EXH: *Seventeenth-Century Art in Europe*, Royal Academy, 1938 (458).

The old attribution is in Richardson's hand. The drawing seems certainly to be Genoese, though the style is unlike any other authenticated drawings by Strozzi. However, there are drawings with old attributions to Paggi which come closer to D 1659 B, for instance *The Stoning of St Stephen* at Amsterdam (57:336) and *St Francis* in the Courtauld Institute Collection (3796).

PIETRO SUJA
fl. early 19th century

RSA 268 Fig. 784

An audience with King Ferdinand IV of Naples.

347 × 515 (composition only). Pen, ink and brown wash. Inscribed: *Idea di un Quadro per Mettere in composizione i ritratti di S.N. il Re (D.G.) S.A.R. il Principe D. Leopoldo e S.A.R. La Principessa D. Mª Clementina rappresentando un'Udienza particolare del Re. Pietro Suja inventò.*

PROV: David Laing; Royal Scottish Academy. On loan 1966.

Nothing seems to be known about this artist, who may have been of Spanish extraction, working in Naples. The paper is water-marked 'Whatman 1813'.

Attributed to
ENEA TALPINO
(Salmeggia)
Salmezza (Bergamo) c. 1558–1626 Bergamo

D 1944 Fig. 785

An angel handing the martyr's palm to a nun.

235 × 160. Pen, brown ink and wash, heightened with white over black chalk. Squared in red chalk. Inscribed: *F. Barotio* in lower left corner; on the back: *Daniel* and *No. 241*; on the mount: 'Vannius', in Richardson's hand.

PROV: J. Pz. Zoomer; (J. Richardson, Jnr according to his inscription on the mount); Lady Murray. Presented 1860.

LIT: U. Ruggieri, *Enea Salmeggia detto Talpino* (Bergamo, 1966), p. 68, no. 54, pl. 82.

The present attribution is due to Philip Pouncey. The same blank and rather stylized features, and the elegantly tapering hands, occur in such drawings by Talpino as the *Sposalizio* in the British Museum (1917-12-8-2), which also shows a similar treatment of the drapery.

The nun may be St Catherine of Siena or St Clara. What must be a companion drawing, also from the Richardson Collection, of practically the same size, and in the same medium with red chalk squaring and obviously illustrating another episode in the life of the Saint (an angel giving the holy wafer to the nun), was sold with the Skippe Collection (Christie, 20 November 1950, no. 80D), bearing an inscription to Francesco Curradi (1570–1661), the pupil of Naldini, which would indicate a Florentine origin. However, both drawings appear almost certainly not merely to be North Italian, but Milanese, reminiscent also of the style of Francesco Mazzuchelli (1571–1626).

AGOSTINO TASSI
(Buonamici)
Rome c. 1580–1644 Rome

D 4890/39 A Fig. 786

The Madonna and child, with SS. Paul and John the Baptist.

90 × 98. Pen and brown ink. (Laid down.) Inscribed: *Tassi*.

PROV: Marchese del Carpio. Paul and Edwardo Bosch, Madrid; H. M. Calmann. Purchased 1964.

The old attribution seems convicing.

ANTONIO TEMPESTA
Florence 1555–1630 Rome

D 1499 Fig. 787

The Nativity.

94 × 71 (oval). Pen, brown ink and wash, over black chalk. Squared. (An inscription at the top and all the margins have been cut. Laid down.)

PROV: Paul Sandby; David Laing; Royal Scottish Academy. Transferred 1910.

It might appear that this drawing was a study for the series of engravings *Divers sujets de la vie de Jésus Christ renfermés dans des ovales* (B. XVII, p. 133, 291–324). But the composition resembles far more closely the relevant one from the series *Différens sujets du nouveau testament et les quatre Evangélistes* (B. XVII, p. 131, 263) although the format of these engravings is rectangular.

D 1497 Fig. 788

The Adoration of the Magi.

94 × 71 (oval). Pen, brown ink and wash, over black chalk. Squared. (An inscription at the top, and all the margins have been cut. Laid down.)

PROV: Paul Sandby; David Laing; Royal Scottish Academy. Transferred 1910.

Like D 1499, this seems to be a study for the same series of engravings (B. XVII, p. 131, 265).

RSA 148 Fig. 789

The Immaculate Conception.

230 × 175. Pen, brown ink and wash over black chalk. (Torn and partly damaged.) Inscribed: *Antonio Tempest 108*.

PROV: David Laing; Royal Scottish Academy. On loan 1966.

D 4890/4 Fig. 790

The entry of the Archduchess Marguerite of Austria into Ferrara.

142 × 180. Pen, ink and wash over black chalk. (Laid down.) Inscribed: *A.T.* on the drawing, and 'Antonio Tempesta' on the page.

PROV: Marchese del Carpio; Paul and Edwardo Bosch, Madrid; H. M. Calmann. Purchased 1964.

The drawing corresponds exactly, in reverse, with Callot's etching which forms part of the illustrations to Giovanni Altoviti, *Essequie della sacra cattolica e real maesta di Margherita d'Austria, regina di Spagna, celebrate dal Serenissimo don Cosimo II Granduca di Toscana IIII*, Florence (Bart, Sermatelli), 1612 (B. XVII, p. 149, 633; Meaume, p. 208, no. 440). The etching is clearly inscribed *I. Callot f.*, but Tempesta did engrave six out of the 59 plates, so that Bartsch's statement that the whole was a work of collaboration is a very likely one. Probably Tempesta, whose original hand can be distinctly seen in this drawing, provided the design, which however Callot later etched. The British Museum possesses a large pen, wash and red chalk drawing of the same composition, convincingly inscribed *Passignano* (1912-2-14-1), which shows slight variations in some of the background figures, and most notably in the pose and headgear of the central figure. It is conceivable that Tempesta's drawing, and ultimately Callot's etching, are based on Passignano's design.

D 797 Fig. 791

Moses orders the Israelite army to attack the Ethiopians.

335 × 480. Pen, brown ink and wash over black chalk. Inscribed: *Tempesta*.

PROV: David Laing; Royal Scottish Academy. Transferred 1910.

This is apparently a study for the fourth of the series of twenty-four Old Testament battles, which were engraved in Rome in 1613 (B. XVII, p. 129, 239). The artist designed a very similar composition for no. VII of the series *Les principales actions de la vie d'Alexandre le Grand* (B. XVII, p. 143, 545–56).

D 788 Fig. 792

The defeat of the Amalekites by the Israelites.

270 × 419. Pen, brown ink and grey wash over black chalk. Squared in black chalk. Inscribed: *Tempesta*, and on the back: *Clades Amalecitaru / orande Moise / Tempesta*.

PROV: David Laing; Royal Scottish Academy. Transferred 1910.

This is a preliminary study for the ninth of the series of Old Testament battles (B. XVII, p. 130, 244). See also D 797.

D 796 D 799 D 790 Figs. 793, 794, 795,
D 801 D 803 D 793 A 796, 797, 798
D 792 and 799

Scenes from the life of Charles V.

318 × 450. Pen, brown ink and wash over black chalk. Some inscribed: *Tempesta*.

PROV: David Laing; Royal Scottish Academy. Transferred 1910.

These are seven of the eight compositions which were engraved by J. de Gheyn and C. Boel and published in Leiden by Peter van der Aa, and in Amsterdam by Rob. de Bandoez in 1614 under the title *La Vie de l'Empereur Charles V. en très-belles tailles-douces, gravées sur les desseins du célèbre A. Tempeste, par deux des plus habiles Maîtres J. de Gein & C. Boel.* (See Le Blanc, *Manuel de l'amateur d'estampes*, II, 289: J. de Gheyn d. J. 4–11). The drawing that is missing from this series is for no. 6 (engraved by de Gheyn).

D 786 Fig. 800

Scipio arming a bodyguard of three hundred men.

342 × 487. Pen, brown ink and wash, over black chalk. Inscribed: *Tempesta*.

PROV: David Laing; Royal Scottish Academy. Transferred 1910.

This, and the two following numbers, D 789 and D 794, are drawings for the series of eight prints, engraved by Pieter de Jode I after Tempesta, and depicting scenes of the exploits of Scipio Africanus. The series is not mentioned in Hollstein, but a complete set is among the Mariette Collection in the Albertina, as well as a set of copies, in reverse and in reduced size, engraved by M. Merian and published by Iac. ab Heyde. D 786 depicts the scene taken from Livy XXIX, I.

D 789 Fig. 801

The continence of Scipio.

345 × 483. Pen, brown ink and wash, over black chalk.

PROV: David Laing; Royal Scottish Academy. Transferred 1910.

D 794 Fig. 802

The triumph of Scipio.

345 × 490. Pen, brown ink and wash over black chalk. Squared in black chalk. Inscribed: *Tempesta*.

PROV: David Laing; Royal Scottish Academy. Transferred 1910.

The composition occurs again in the large print of *The Triumph of a Roman Emperor* (B. XVII, p. 147, 618), and is based on the 2nd century Roman relief of *Marcus Aurelius passing a Temple* in the Museo dei Conservatori, Rome.

D 787 Fig. 803

Surrender of a city.

345 × 495. Pen, brown ink and wash.

PROV: David Laing; Royal Scottish Academy. Transferred 1910.

No engraving of this composition has been traced.

Copy after ANTONIO TEMPESTA
D 2846

Henri IV on horseback.

437 × 352. Red chalk and wash, heightened with white. (Laid down.)

PROV: W. F. Watson. Bequeathed 1881.

A copy of the engraving of 1595 (B. XVII, p. 150, 636).

Attributed to

MAURO ANTONIO TESI
Montalbano (Modena) 1730–1766 Bologna

D 938 Figs. 804 and 805

(recto) Architectural and ornamental studies; (verso) Idem.

290 × 185. Pen, brown ink on faded blue paper. (Stained.) Illegible inscription.

PROV: David Laing; Royal Scottish Academy. Transferred 1910.

The drawing entered the collection anonymously, but was classified for a long time under the name of Piranesi. That it is, however, less accomplished and of a later date than Piranesi is apparent. It was Richard Wunder who, from a photograph, suggested that the drawing was certainly Bolognese and made the tentative attribution to Tesi. This seems perfectly convincing when comparison is made with other designs by this artist (see for example R. P. Wunder, *Extravagant Drawings of the Eighteenth Century from the Collection of the Cooper Union Museum* (New York, 1962), no. 31). Wunder has, on the other hand, mentioned that another possible candidate would be the Bolognese artist Carlo Bianconi (1732–92), here perhaps copying motifs from drawings or engravings by Agostino Mitelli.

PIETRO TESTA

Lucca 1611–1650 Rome

D 2251 Fig. 806

Venus bringing arms to Aeneas.

313 × 415. Pen, brown ink over black chalk. Squared in black chalk. Inscribed: *P. Testa.*

PROV: W. F. Watson. Bequeathed 1881.

The drawing corresponds almost exactly, in reverse, with Testa's etching (B. XX, p. 226, 24) and is undoubtedly the preparatory study for it. A very early idea for the composition is contained in a sketch-book by Testa at Düsseldorf (Z 6407).

Circle of PIETRO TESTA

D 2913 Fig. 807

Diana.

145 × 89. Pen and brown ink over red chalk. Inscribed *13.* (Torn in places.)

PROV: W. F. Watson. Bequeathed 1881.

ALESSANDRO TIARINI

Bologna 1577–1668 Bologna

D 2964 Fig. 808

A seated potentate holding a sceptre.

170 × 127. Brush and wash, heightened with white over black chalk. Inscribed on the back: *87* (crossed out); *85*; *Lot 44* (in red chalk). *Alessandro Tiarini* (crossed out), *Ercole Graziano.*

PROV: W. F. Watson. Bequeathed 1881.

The old attribution to Tiarini, since crossed out, seems perfectly convincing. The massive figure, the heavy fall of the sleeve and the well-thought-out arrangement of the drawing, all speak for Tiarini.

GIOVANNI BATTISTA TIEPOLO

Venice 1696–1770 Madrid

D 1225 Fig. 809

Christ presented to the people.

323 × 230. Pen, brown ink and wash, over black chalk. (Lower right corner torn.)

PROV: David Laing; Royal Scottish Academy. Transferred 1910.

LIT: Vasari Society, 1st Series, VII, 14; J. Meder, *Die Handzeichnung*, 2nd ed. (1923), fig. 15 (detail); *Catalogue: National Gallery of Scotland* (1946), p. 395; *Fifty Master Drawings in the National Gallery of Scotland* (1961), 41.

EXH: *Old Master Drawings*, Leicester, 1952 (69, as 'Christ and Judas'). Colnaghi, 1966 (72, pl. 32).

Formerly called *The Mocking of Christ*, but the present title seems more appropriate. Although no painting of this subject by Tiepolo is known, it is possible that the drawing was conceived as part of the series of Passion pictures, of which the two best known to survive are *The Agony in the Garden* and *The Crowning with Thorns*, both at Hamburg (Morassi, *G. B. Tiepolo* (1955), nos. 30–3, and also Morassi, *Catalogue of G. B. Tiepolo* (1962), p. 13). Indeed, the latter shows similarities to the composition of the drawing: the old, bearded man lurking behind the figure of Christ, and the kneeling figure, facing Christ. The Hamburg paintings have been dated *c.* 1745–50.

Copy after GIOVANNI BATTISTA TIEPOLO

D 3128

A halberdier, seen from the back.

277 × 185. Brush and brown wash over black chalk. 19th century inscription on mount: 'M. A. Caravaggio'.

PROV: W. F. Watson. Bequeathed 1881.

This is a copy of the figure on the right in the version of *The Banquet of Cleopatra*, now at Archangel Museum, near Moscow (Morassi, *Catalogue of G. B. Tiepolo* (1962), fig. 311), as pointed out by Michael Levey.

GIOVANNI DOMENICO TIEPOLO

Venice 1727–1804 Venice

D 2233 Fig. 810

Two elderly and two younger peasant women.

223 × 193. Brush and brown wash over faint traces of black chalk. Signed: *Domo. Tiepolo f.*

PROV: W. F. Watson. Bequeathed 1881.

EXH: Colnaghi, 1966 (70).

In spite of the genuine signature, the previous owner had ascribed the drawing to Giambattista. It is, however, a fine and characteristic drawing by Domenico, which owes little or nothing to his father's influence.

DOMENICO TINTORETTO

(Robusti)

Venice 1560–1635 Venice

D 1655 Fig. 811

A nude man, bending forward.

245 × 169. Black chalk on faded blue paper. (Laid down. Small piece cut from lower left margin.) Inscribed: *Domᶜᵒ Tintoretto.*

PROV: David Laing; Royal Scottish Academy. Transferred 1910.

LIT: Tietze, 1488.

The Tietzes took this drawing, with its old inscription, as a key for the attribution of several other drawings. They further support the attribution of D 1655 to Domenico, by its similarity to figure studies on the verso of a drawing formerly in the collection of Sohn-Rethel, Rome (Tietze, 1546) which were studies for a fresco in the Ducal Palace, Venice. In D 1655 Domenico approaches very closely indeed his father's style of drawing.

JACOPO TINTORETTO
(Robusti)
Venice 1518–1594 Venice

D 758 Fig. 812

A running man.

343 × 235. Black chalk on faded blue paper. Squared. (Laid down.) Inscribed: *Giacomo Tintoretto*.

PROV: Benjamin West; David Laing; Royal Scottish Academy. Transferred 1910.

LIT: Tietze, 1777 (as 'Tintoretto Shop', but with wrong provenance); *Catalogue: National Gallery of Scotland* (1946), p. 395 (as original Tintoretto).

EXH: *Old Master Drawings*, Leicester, 1952 (72); Colnaghi, 1966 (19, pl. 12).

The inscription is similar to the hand whose normally reliable attributions frequently occur on Venetian drawings. The drawing is reminiscent of another chalk study for a figure in the *Crucifixion* in the Scuola di San Rocco, formerly in the possession of G. Bellingham Smith, repr. in *Burlington Magazine*, XLVIII (March 1926), p. 117, pl. II, C.

Studio of JACOPO TINTORETTO

D 1853 Fig. 813

Profile of the head of Giuliano de' Medici, after Michelangelo. (On the verso: the same, seen from a different angle.)

340 × 240. Black chalk, heightened with white on buff paper.

PROV: (? Allan Ramsay); Lady Murray. Presented 1860.

LIT: Volume of *Illustrations*, National Gallery of Scotland (1952), p. 188; Tietze, 1778.

EXH: *Old Master Drawings*, Leicester, 1952 (71).

It is known, through authors like Borghini, Ridolfi, Boschini and Zanetti, that Tintoretto drew frequently from plaster-casts of celebrated pieces of sculpture, some of which seem to have been in his studio. Examples of such drawings abound in various Print Rooms, notably in the British Museum, the Uffizi, at Oxford and at Frankfurt. It is also clear that a great number of these drawings must have originated from students and assistants in the studio, and are not by Tintoretto himself.

D 1853 agrees in all respects with a drawing at Frankfurt (15701), showing the head from a slightly higher viewpoint, whilst another (464) is of the profile. The drawing in the British Museum (1907-7-13-30) depicts the front of the head. For this, and a listing of other versions, see K. T. Parker, OMD, June 1927, p. 6 and pl. 5, in addition to the drawing which was included in the sale of the Skippe Collection (Christie, 21 November 1958, lot 214, pl. 35).

D 1855 Fig. 814

Head of Giuliano de' Medici, after Michelangelo. (On the verso: the same from a different angle.)

352 × 250. Black chalk, heightened with white, on buff paper.

PROV: (? Allan Ramsay); Lady Murray. Presented 1860.

LIT: Tietze, 1780.

The same head as D 1853, seen from below.

D 1854 Fig. 815

Head of a Roman emperor (Julius Caesar?). (On the verso: the same, seen from a different angle.)

302 × 226. Black chalk, heightened with white on buff paper.

PROV: (? Allan Ramsay); Lady Murray. Presented 1860.

LIT: Tietze, 1779.

At least two other drawings from the same cast are known, one in the Uffizi (17237F recto; A. Forlani, *Mostra di Disegni di Jacopo Tintoretto*, etc. (Florence, 1956), 71) and in the Boymans-van Beuningen Museum, Rotterdam (*Le Dessin Italien dans les Collections Hollandaises* (Paris–Rotterdam–Haarlem, 1962), 115).

Copies after JACOPO TINTORETTO
D(NG) 1212

The martyrdom of St Agnes.

547 × 252 (arched top). Pen, brown ink and grey wash.

PROV: Miss Anne Dundas. Bequeathed 1919.

LIT: *Catalogue: National Gallery of Scotland* (1946), p. 395 (as Jacopo Tintoretto).

Probably an 18th century copy of Tintoretto's painting in S. Maria dell'Orto, Venice.

D 3126

Three men carrying the golden calf.

270 × 212. Pen, brown ink and wash heightened with white, on blue paper. (Laid down.)

PROV: W. F. Watson. Bequeathed 1881.

A late 16th century copy of the central group from *The Law and the Golden Calf* in S. Maria dell'Orto, Venice.

D 3196

The Last Judgement.

615 × 321 (arched top). Pen, black ink, grey wash, heightened with white on blue paper. (Laid down.)

PROV: W. F. Watson. Bequeathed 1881.

Copy of the painting in S. Maria dell'Orto, Venice.

D 1518

The Annunciation.

290 × 203. Black and red chalk and red wash.

PROV: David Laing; Royal Scottish Academy. Transferred 1910.

A feeble copy of the painting in the church of S. Rocco, Venice.

D 3214

The Adoration of the Shepherds.

586 × 431. Brush and grey wash on blue paper, heightened with white. (Laid down.)

PROV: Sir Joshua Reynolds; W. F. Watson. Bequeathed 1881.

Copy of the painting in the Upper Hall of the Scuola di San Rocco, Venice.

TITIAN
(Tiziano Vecellio)
active before 1511–1576 Venice

Copies after TITIAN

D 1563

The Last Supper.

495 × 410. Pen, brown ink and wash. Outlines incised. (Laid down and very damaged.) Inscribed in the lower margin: *Livio Agresti forogoliensis.*

PROV: David Laing; Royal Scottish Academy. Transferred 1910.

The inscription of the name of Livio Agresti is misleading. The drawing corresponds exactly—in reverse—with the engraving after Titian by Ferrando (or Luca) Bertelli, and, as it appears to be contemporary, may possibly be the engraver's drawing, a suggestion which the incised outlines, and the same size, seem to support. It also corresponds with Titian's painting of 1564, now in the Escorial, except that the drawing, and the engraving, have additions at the top, thus making it into an upright composition.

D 3103

The Descent of the Holy Ghost.

345 × 435. Brush and oil colours.

PROV: W. F. Watson. Bequeathed 1881.

Copy from the painting in S. Maria della Salute, showing only the group of figures in the lower half of the picture.

TOGONE
See Antonio VICENTINO.

FLAMINIO TORRE
(Torri)
Bologna 1621–1661 Modena

D 709 Fig. 816

The Holy Family. Two separate studies of Joseph with the Christ Child.

190 × 133 (centre piece, with arched top). Side pieces: 85 × 65. Pen and brown ink. The central composition over red chalk. (Laid down.) Inscribed on the mount: 'Tutti del Signor Giuglio Torri' (the Christian name crossed out and 'Flaminio' substituted in pencil). A number *72* at the top.

PROV: David Laing; Royal Scottish Academy. Transferred 1910.

The old attribution to Flaminio Torre seems perfectly convincing when comparison is made with his authenticated drawings at Windsor (see O. Kurz, *Bolognese Drawings at Windsor* (1955), pp. 139 ff.). It also confirms what one has come to expect from this artist's drawings, showing him as a *pasticheur*, often making studies from rather than for pictures. In this respect he provides a parallel to Donato Creti, whose very style, as well as that of Passeri, Torre seems to be imitating in D 709.

FRANCESCO TRABALLESI
Florence 1544–1588 Mantua

D 4890/6 Fig. 817

Nude figure astride a dolphin (?).

206 × 143. Black chalk on blue paper. (Laid down.) Inscribed: *Fr° Trabaldese.*

PROV: Marchese del Carpio; Paul and Edwardo Bosch, Madrid; H. M. Calmann. Purchased 1964.

121

FRANCESCO TREVISANI

Capodistria 1656–1746 Rome

RSA 131 Fig. 818

Youth assaulting a girl.

268 × 367. Black chalk heightened with white. Inscribed in pencil on back: *Guido Cagnacci* and *Trevisani* in pencil on the front.

PROV: W. Esdaile; David Laing; Royal Scottish Academy. On loan 1966.

The attribution to Trevisani seems to be correct, unless the drawing is a studio copy.

Attributed to
FRANCESCO TREVISANI

D 4890/24 Fig. 819

Studies for a *Birth of St John*.

92 × 161. Pen, ink and wash, heightened with white. (Laid down.)

PROV: Marchese del Carpio; Paul and Edwardo Bosch, Madrid; H. M. Calmann. Purchased 1964.

The drawing is obviously from the same hand as D 4890/39 B, also part of the del Carpio Album. In fact the two probably formed one sheet at one time. The suggestion that they might be by Trevisani was first made by Philip Pouncey, and tentatively supported by Anthony M. Clark. It might at first sight have been assumed that the drawing dates from the late 16th century (hence the ascription to Federico Zuccaro on D 4890/39 B), but as the drawing shows a *retardaire* style, very loose and somewhat careless, it must date from the mid-17th century at the earliest. The oval shape too, into which the group on the recto of D 4890/39 B has been composed, is unthinkable in the 16th century. It shows the artist still absorbing Mannerist influences, which later on were transmuted into more classicizing, Marattesque features. These are visible, for example, on the drawing at Munich of the *Assumption of the Virgin* (7193, chalk and pen, with an old inscription to Trevisani).

D 4890/39 B Figs. 820 and 821

(recto) Recumbent figure on a sarcophagus; figures for a *Birth of St John* (composed into an oval);

(verso) Figure studies, including a kneeling woman emptying a pitcher.

82 × 154. Pen, brown ink and wash, one figure on the recto heightened with white. Inscribed: *Fed. Zuccaro*.

PROV: Marchese del Carpio; Paul and Edwardo Bosch, Madrid; H. M. Calmann. Purchased 1964.

See note to D 4890/24.

NICCOLÒ TROMETTA

Pesaro c. 1540–c. 1620 Rome

D 912 Fig. 822

Design for the altar wall of a chapel with a *Pietà*; above in lunette form *The Visitation*, surrounded by *The Annunciation*: at the sides, on the right the figure of St Nicholas of Bari, on the left a warrior saint (?St Eustace). In ovals on the outer pilasters: SS. Roch and Sebastian.

409 × 265. Pen and brown wash, heightened with white on blue paper. (Laid down.) Pencilled inscription on the back: *Daniele da Volterra*.

PROV: David Laing; Royal Scottish Academy. Transferred 1910.

LIT: J. A. Gere, 'Drawings by Niccolò Martinelli, il Trometta', *Master Drawings*, 1/4 (1963), p. 11; List no. 7, pl. 10.

Inscriptions, above lunette: *ECCE ANCILLA DONI / FIAT MICHI*; above the *Pietà*: *VENITE ET VIDETE / DOLOREM MEVM*.

The present attribution is due to John Gere. Baglione (*Le Vite de' Pittori*, etc. (Naples, 1733), p. 119) mentions a similar scheme in the 'nave minore' of S. Francesco a Ripa, Rome: a *Pietà* in oil, surrounded by frescoed figures of SS. Niccolò Vescovo and Antonio Abate, but this is no longer to be found in the church.

Other drawings, possibly connected with this or a similar scheme are (1) in the Ambrosiana (F. 253 inf. 1226ᵛ) of three standing bishops, in a similar technique, and (2) a lunette design with the *Annunciation* and *Nativity* at Munich (2721) attributed by Voss to Trometta.

D 1605 Fig. 823

St Paul.

317 × 208. Pen, brown ink and wash, heightened with white over black chalk on blue paper. Outlines pricked for transfer. 19th century pencilled inscription in lower left corner: *Bandinelli*.

PROV: (Illegible inscription on the back); David Laing; Royal Scottish Academy. Transferred 1910.

LIT: J. A. Gere, 'Drawings by Niccolò Martinelli, il Trometta', *Master Drawings*, 1/4 (1963), List no. 8.

A. E. Popham had put forward an ascription to Federico Zuccaro, and although the face and the drapery are very like his, it was thought doubtful whether the drawing was really from his hand. The present, convincing attribution to Federico's pupil Trometta was made by John Gere, who compared the drawing with a similar one of *St Peter* in the British Museum (1952-1-21-64). Other drawings of apostle

figures are in the Uffizi: *St Peter* (783) and *St Paul* (784), formerly as Taddeo Zuccaro, but now identified as by Trometta by John Gere.

The prick-marks on D 1605 suggest that it may have been used as a design for a cope.

D 3069 Fig. 824

A group of monastic martyrs with SS. Francis and Clare. At the top sketches for an elaborate entablature and triglyphs, rams' heads, etc.

177 × 292. Pen, brown ink and wash, heightened with white, over red chalk on blue paper. (Laid down.) Inscribed at the top: *F. Zuchero.*

PROV: J. Pz. Zoomer; W. F. Watson. Bequeathed 1881.

LIT: J. A. Gere, 'Drawings by Niccolò Martinelli, il Trometta', *Master Drawings*, 1/4 (1963), p. 10, List no. 9; pl. 7.

The present attribution was suggested by John Gere. The facial types are very similar to those in the drawing of *The Madonna in Glory*, at Munich (repr. Voss, *Zeichnungen der Italienischen Spätrenaissance* (1928), pl. 23; Gere, *op. cit.* no. 22).

D 3204 Fig. 825

A Franciscan saint appearing to an eastern potentate.

329 × 220. Pen, brown ink with blue wash, heightened with white, on blue paper. (Laid down.) Inscribed: ?*G. O. Mazzoni.*

PROV: J. Pz. Zoomer; W. F. Watson. Bequeathed 1881.

LIT: J. A. Gere, 'Drawings by Niccolò Martinelli, il Trometta', *Master Drawings*, 1/4 (1963), List no. 10.

The old inscription makes no sense in connection with this drawing. The style shows strong Zuccaresque features, and John Gere's attribution to Trometta is perfectly convincing.

The subject has not been explained. At first sight it might appear to be *St Francis confronting the Sultan*, but this he did, not as an apparition on a cloud, but in person; also one might expect to see the *stigmata* on the Saint's hands. Another possibility might have been S. Giuseppe da Copertino, the 'flying Monk', mentioned by Norman Douglas in *Old Calabria*. Yet, although he was a Franciscan, he does not seem to have had any connections with an eastern potentate.

RSA 147 Fig. 826

Christ appearing to the Apostles.

185 × 270 (arched top). Pen, brown ink and wash over black chalk. (Laid down.) Inscribed on old backing: *T. Zuccaro.*

PROV: David Laing; Royal Scottish Academy. On loan 1966.

A comparison with the material published by J. A. Gere in *Master Drawings*, 1/4 (1963), will confirm the attribution to Trometta.

GIOVANNI BATTISTA TROTTI
(Malosso)
Cremona 1555–1619 Parma

D 3096 Fig. 827

God the Father in glory, surrounded by the symbols of the Evangelists; two ranks of saints and the virtues below.

330 × 373 (strips of *c.* 5 mm along the left margin, and of *c.* 10 mm along the bottom margin have been added). Pen and brown ink. Traces of black chalk.

PROV: W. F. Watson. Bequeathed 1881.

The convincing attribution is due to A. E. Popham. The composition is probably for a cupola or apse. It is not a very favourable example of the artist's draughtsmanship, and it is conceivable that some passages have been gone over or traced by another hand.

Ascribed to GIOVANNI BATTISTA TROTTI

D 730 Fig. 828

Copy of the left-hand portion of the *Sibyls* by Raphael.

284 × 215. Pen, brown ink and wash over black chalk. (Laid down.) Inscribed in an old hand: *Cavaliere Maloso.*

PROV: Illegible armorial device, not identifiable from Lugt; 'Principi Vidoni' on the back, in pencil; David Laing; Royal Scottish Academy. Transferred 1910.

Whether this rather bad copy of the fresco of the Cumaean and Persian sibyls in the Chigi chapel in S. Maria della Pace in Rome is really from the hand of Trotti, must remain doubtful. The severe parallel shading is not unlike Trotti's manner, and the pencilled putto in the background shows certain similarities to his style. However, the connection between the drawing, and the sheet with the inscription on which it was laid down, may be quite fortuitous, although the name of Vidoni on the back would suggest a Cremonese provenance, as a Conte Vidoni was the author of a guidebook of Cremona, *La Pittura Cremonese* (Milan, 1828).

ALESSANDRO TURCHI
Verona 1578–1649 Rome

D 3037 Fig. 829

The Resurrection.

405 × 324. Pen, brown ink and wash, over black chalk. (Damaged and laid down.) Inscribed on the front: *Scuola di Zuccari*; on the back: *Scuola R. Nº 83*.

PROV: Count von Ross; Coll. Duke of Saxony, according to inscription; W. F. Watson. Bequeathed 1881.

The present attribution is due to Philip Pouncey. The facial types and the gestures are typical of the artist.

RSA 165 Fig. 830

The victory of Cupid: Venus and Cupid, with attendant amorini, in front of a group of bound captives.

204 × 331. Pen and ink over black chalk. Inscribed: *Alessandro Turchi*.

PROV: P. Mariette (L. 2097, 2859b, with his mount); F. Basan, *Catalogue Raisonné des différents objets de curiosités ...de feu M. Mariette*, Paris, 1775/6, lot 758; Robert Udny (L. 2248); Sir Thomas Lawrence; David Laing; Royal Scottish Academy. On loan 1966.

This is a preliminary study, with considerable variations, especially in the subsidiary figures, for the painting in the Rijksmuseum, Amsterdam, as pointed out by Philip Pouncey. The subject is taken from Virgil's *Eclogues*, x, 69.

Attributed to

ALESSANDRO TURCHI

RSA 282 Fig. 831

Christ and the doctors in the Temple.

358 × 282. Pen, brown ink and wash with traces of red chalk, on brown prepared paper. Outlines incised. Inscribed on the back: *Francisco Salviati*, and *Paolo Farinati*.

PROV: J. Pz. Zoomer (L. 1511); David Laing; Royal Scottish Academy. On loan 1966.

The drawing is certainly by a Veronese artist, and Philip Pouncey has pointed out that especially the facial types reveal the hand of Turchi. A comparison with the drawing at Leningrad of the *Madonna and Child with Saints* (6320, repr. *Disegni Veneti del Museo di Leningrado* (Venice, 1964), no. 36), with an old attribution to Turchi, would confirm this. Terence Mullaly has drawn attention to a painting in the Cannon Collection as 'Unknown Veronese Painter about 1580' (J. P. Richter, *The Cannon Collection of Italian Paintings of the Renaissance* (1936), Cat. 25, repr.) which is possibly related to the drawing. Although the shape of the composition is different, there are some common features: the stance of the figure in the right foreground of the drawing and the figure to the right of the centre of the picture are similar and both wear the same curiously cut cape. The rounded steps of the plinth on which Christ is seated and the details of the chair are almost identical in both drawing

and painting. Further similarities are the standing figure of the doctor disputing with Christ, though facing in a different direction in the painting, and the seated doctor seen full face. Mullaly, however, attributes the painting to Battista del Moro, which would mean a date in the previous century.

COSIMO ULIVELLI
Florence 1625–1704 Florence

D 1796 Fig. 832

The apotheosis of a warrior saint.

298 × 545. Pen, brown ink and wash over black chalk. (Laid down.) Inscribed on the back, in Richardson's hand, with the artist's name and biographical detail.

PROV: Jonathan Richardson, Jnr (L. 2170); David Laing; Royal Scottish Academy. Transferred 1910.

The traditional attribution seems convincing and reveals something of Ulivelli's teacher il Volterrano, as well as the rather shaggy hand characteristic of a follower of Pietro da Cortona. The shield on the left appears to show the arms of the Order of St Stephen, and this may suggest that the decoration was destined for Pisa.

However, another more elaborate drawing by Ulivelli of a complete cupola design at Christ Church, Oxford (1421), incorporates the composition of D 1796 with but little alteration. The most significant change is in the kneeling figure of the warrior, who has been transformed into an ecclesiastic, and the cross on the shield into the Medici *stemma*.

No ceiling decoration corresponding to either D 1796 or the Christ Church drawing has been traced.

PERINO DEL VAGA
(Buonaccorsi)
Florence 1501–1547 Rome

D 713 Figs. 833 and 834

(*recto*) Anatomical studies and two figures; (*verso*) Sketches for a compartment of a ceiling.

251 × 168. Pen and brown ink. Inscribed: *rafael* and *1510*.

PROV: Chambers Hall (L. 551); David Laing; Royal Scottish Academy. Transferred 1910.

The style, although characteristic of Perino del Vaga, does not show him in a very good light. The sketches seem to be rather careless doodles.

Studio of PERINO DEL VAGA

RSA 169 Fig. 835

Jupiter and Alcmene.

387 × 895. Brush, brown ink and wash (partly coloured), heightened with white, on brown prepared paper. (Laid down.)

PROV: David Laing; Royal Scottish Academy. On loan 1966.

The attribution of this drawing is due to Philip Pouncey. It is, with its imitation bronze colour and frieze-like format, most probably a design for a façade and belongs to a group of related drawings, representing various mythological subjects including incidents from the lives of Jupiter, Diana and Mercury. The compositions which have so far come to the compiler's attention are:

Louvre, 10369 and 10413: as Anonymous Italian, and attributed to Perino by Philip Pouncey. The former has a large hand on the right as on RSA 169.

Munich, 2542 and 2543 (actually one drawing cut in two, depicting a scene from the life of Mercury).

Princeton University, Art Museum 48-1791 (kneeling figure of Mercury, repr. in *Italian Drawings in the Art Museum, Princeton University* (1966), no. 8).

New York art market (Jupiter and Diana).

Dresden, Kupferstichkabinett C 213 (*Diana presenting a child to two kneeling women*).

London, Courtauld Institute (Witt Collection), 4734 and 4735 (composition involving Jupiter, Alcmene and Mercury, Exh. *Newly Acquired Drawings 1965–66*, nos. 5A and B). These two drawings were engraved—each in reverse—as one composition by Nicolas Tardieu, as after a cartoon by Giulio Romano (one of five depicting various 'Loves of Jupiter') then in the Duke of Orleans Collection (*Recueil d'Estampes d'après les plus beaux Tableaux et...Dessins...dans le Cabinet du Roy, ...le Duc d'Orléans*, etc. (Paris, 1729), no. 61).

Although most of these drawings bear an attribution to Perino himself, and may in fact be based on his designs, the draughtsmanship is not subtle enough for them to be autograph works. They may be, as Jacob Bean has suggested in the Princeton Catalogue, *op. cit.*, small *modelli* worked up in Perino's studio by an assistant.

Bernice Davidson favours an attribution to Pellegrino Tibaldi of this series, possibly because of the extravagant size and manner of the designs. If this not very plausible suggestion should prove correct, it would only emphasize how very much Tibaldi owed to the powerful influence of Perino.

RSA 169 A

381 × 795. Pen, brown ink and wash, heightened with white, on prepared paper. (Laid down.)

PROV: David Laing; Royal Scottish Academy. On loan 1966.

A faithful (studio?) copy of the two figures in RSA 169.

RSA 151 Fig. 836

Two female figures (from the antique).

190 × 150. Pen and ink, over black chalk. Inscribed: *P* in right margin.

PROV: David Laing; Royal Scottish Academy. On loan 1966.

Philip Pouncey has suggested that this may possibly be the hand of the assistant of Perino del Vaga, identified as Luzio Romano (da Todi) (see BM Raphael, pp. 110ff.). The facial type of the figure on the left is indeed very close to that of the figure of 'The Church' in BM Raphael, 186, pl. 155.

Circle of PERINO DEL VAGA

D 906 Fig. 837

Design for a mural decoration.

162 × 157. Pen, brown ink and wash over black chalk. Inscribed on mount: 'Pierina'.

PROV: Sir Peter Lely; Sir Joshua Reynolds; John Barnard; David Laing; Royal Scottish Academy. Transferred 1910.

LIT: R. Blomfield, *Architectural Drawings and Draughtsmen* (1912), opp. p. 58.

This design was inspired by Perino's *bassamenti* decorations in the Sistine chapel, which were one of his last commissions, and which were mainly finished by other hands (see J. A. Gere, 'Two late fresco cycles by Perino del Vaga' in *Burlington Magazine* (January 1960)).

D 4890/20 A Fig. 838

Part of a wall- or ceiling-decoration.

92 × 72. Pen, ink and wash. (Laid down.) Inscribed: *Scola di Perino*.

PROV: Marchese del Carpio; Paul and Edwardo Bosch, Madrid; H. M. Calmann. Purchased 1964.

Copies after PERINO DEL VAGA

D 645 Fig. 839

Alexander opening the tomb of Darius.

324 × 218. Pen, brown ink and wash. Inscribed on the back: *Polidoro* and *B.d: 45:*

PROV: David Laing; Royal Scottish Academy. Transferred 1910.

The composition corresponds in all essentials with one of Perino's frescoes in the Sala Paolina, Castel S. Angelo, Rome, illustrating the life of Alexander the Great (ill. G. Briganti, *Il Manierismo e Pellegrino Tibaldi* (Rome, 1945), fig. 112). D 645, although obviously a copy, is nevertheless a vigorous one, capturing much of Perino's own style, and is an interesting document, as it most probably preserves a lost Perino drawing. It varies from the actual fresco in several details: particularly the chief figure on the left, and the ornamentation of the sarcophagus. A drawing retouched by Rubens, and much closer to the fresco, is in the British Museum (BM Raphael, 195).

D 732 Fig. 840

Study for the decoration of a wall.

339 × 274. Pen, brown ink and wash. (Laid down.)

PROV: Sir James Thornhill and Sir Thomas Lawrence, according to a pencilled inscription on the back; David Laing; Royal Scottish Academy. Transferred 1910.

The drawing is obviously a copy, repeating Perino's design for one of the *soprapporte* in the Sala Paolina, Castel S. Angelo, Rome. As there are slight differences between the drawing and the actual fresco (for example the standing male figure with outstretched arms in the top roundel looks upwards in the fresco) it may be that D 732 is based on a lost preliminary drawing by Perino.

D 1637

(*recto*) A saint with a dragon;
(*verso*) Warriors on horseback, with attendant figure.

240 × 158 (composed into an oval). Recto: Pen, brown ink and wash, heightened with white, on blue paper. Verso: Pen and ink. Pencilled inscription: *Polidor*.

PROV: Sir Peter Lely; David Laing; Royal Scottish Academy. Transferred 1910.

LIT: BM Raphael, p. 104.

As A. E. Popham was the first to point out, the recto is a copy of one of the designs for a cope for Pope Paul III. The original version of D 1637 is in the British Museum (BM Raphael, 172).

GIUSEPPE VALERIANI

Rome ?–1761 St Petersburg

D 4801 n Fig. 841

Figures within ruins of a classical domed building. (On the verso: sketches of ornamental scroll-work.)

211 × 317. Pen, brown ink and grey wash over black chalk.

PROV: Not known.

The present attribution of this drawing, previously ascribed to Pannini, was suggested by J. Byam Shaw.

FRANCESCO VANNI

Siena 1563–1610 Siena

D 4890/33 c Fig. 842

Part of an entablature with ornamental and architectural features.

65 × 204. Pen, brown ink and wash. (Laid down.) Inscribed: *Cav. frᵒ Vanni.*

PROV: Marchese del Carpio; Paul and Edwardo Bosch, Madrid; H. M. Calmann. Purchased 1964.

Copies after FRANCESCO VANNI

D 782

St Catherine being received into heaven.

254 × 351. Pen, brown ink and wash. Faint traces of red chalk. (Laid down and very damaged.)

PROV: David Laing; Royal Scottish Academy. Transferred 1910.

This is a copy in reverse of the last of the six drawings in the Albertina (III, 423), illustrating the life of St Catherine of Siena and engraved by Pieter de Jode the Elder in 1597. As far as one can judge from such a damaged drawing, it appears to be contemporary.

D 3061 Fig. 843

The Presentation in the Temple.

396 × 279. Red chalk heightened with white. (Laid down.) Inscribed: *F vaño*.

PROV: W. F. Watson. Bequeathed 1881.

As the inscription in the lower margin implies, the drawing, obviously a copy, may record a composition by Francesco Vanni, although no painted version has been traced. The figures have indeed a vague Vanniesque appearance, but the architecture is quite unlike that which normally appears in his work, as P. A. Riedl observed, and may point to a later date.

RSA 270

St Ansanus baptizing the Sienese.

424 × 286. Black and red chalk. (Rubbed and laid down.) Inscribed: *Vani di Siena*.

PROV: Fonthill, i.e. W. Beckford, according to inscription; Robert Udny; David Laing; Royal Scottish Academy. On loan 1966.

This is a copy of a drawing at Worcester, Mass., which is a study, with significant variations, for the altarpiece in Siena Cathedral (Venturi IX/7, fig. 586), repr. *Le Cabinet... P. J. Mariette*, Paris (Louvre), 1967, no. 140.

GIORGIO VASARI
Arezzo 1511–1574 Florence

D 669 Fig. 844

The Adoration of the Magi.

237 × 166. Pen, brown ink and wash.

PROV: David Laing; Royal Scottish Academy. Transferred 1910.

Preliminary drawing, with considerable variations in the details, for the altarpiece in S. Fortunato, Rimini (repr. Paola Barocchi, *Vasari Pittore* (Milan, 1964), p. 119, pl. XV). The painting can be dated 1547 (cf. Barocchi, *op. cit.*).

RSA 219 Fig. 845

Study of a man's head and separate sketches of his right arm and hand.

187 × 221. Black chalk heightened with white on blue paper. Inscribed: *G. Vasari*. Outlines incised. (Few spots of oil colour.)

PROV: David Laing; Royal Scottish Academy. On loan 1966.

Study for the figure standing behind Ahasuerus in the *Wedding of Esther and Ahasuerus* (Accademia, Arezzo), formerly in the refectory of the Badia di Santa Flora e Lucilla at Arezzo, signed and dated 1549, but begun in the previous year (Venturi, IX/6, fig. 174; P. Barocci, *Vasari Pittore* (1964), p. 120, pl. XVII).

RSA 176 Fig. 846

Coronation of the Virgin with saints.

344 × 216. Pen, brown ink and wash over red chalk. Inscribed: *Vasari*.

PROV: David Laing; Royal Scottish Academy. On loan 1966.

Preliminary study, varying especially in the flying putti at the top and the figures at the bottom, for the altarpiece in S. Francesco, Città di Castello, which can be dated *c.* 1563 (Venturi, IX/6, fig. 206; P. Barocci, *Vasari pittore* (1964), pp. 53 and 110).

Follower of GIORGIO VASARI
D 3091 Fig. 847

SS. Luke, Blaise and Dominic.

331 × 278. Pen, brown ink and wash. (Laid down.) Inscribed in an old hand: *Francesco Salviati*.

PROV: Earl of Arundel, according to an inscription on the back; Nicholas Lanier; Sir Peter Lely; W. F. Watson. Bequeathed 1881.

The style does not seem to be that of Salviati, and what Florentine influences there are appear rather to have come from Vasari. On the other hand it is not inconceivable that the artist is a Bolognese, such as, for example, the young Lorenzo Sabbatini at the time when he was a pupil of Vasari. (See, for instance, Sabbatini's altarpiece of SS. Agostino and Ambrogio in S. Giacomo Maggiore, Bologna, repr. Venturi IX/6, fig. 255.)

GIOVANNI DE' VECCHI
Borgo San Sepolcro 1536–1615 Rome

D 632 Fig. 848

'Religion' distributing the girdles of St Francis to the penitents.

337 × 197. Pen, black ink and grey-brown wash. Squared in black chalk. Inscriptions: below the seated figure: *RELIGIONE*; and on the pedestal: *TESORO DELLA CHIESA / APERTO / AI PENITENTI*. The word *INDULGENZA* on several of the sheets scattered on the steps below. Inscribed on the old backing: 'di Agostino Carracceo'.

PROV: Sir Peter Lely; David Laing; Royal Scottish Academy. Transferred 1910.

The old ascription to Agostino Carracci is understandable, as he engraved the composition in 1586 (B. XVIII, p. 98, 109). The correct attribution to Giovanni de' Vecchi is due to Philip Pouncey. The presence of the squaring tends to suggest that the composition was transferred into another medium, and Mrs Jameson in her *Legends of the Monastic Orders* (1891), p. 249, mentions a painting of the subject by Agostino in the Bologna Gallery, but this cannot now be traced.

The subject matter of the drawing most probably commemorates the inauguration of the Archconfraternity of the Chord of St Francis by Pope Sixtus V on 19 November 1585. The Pope himself is seen kneeling in front of the pedestal on the right, and the middle of the three shields at the bottom of the steps bears a faint sketch of his coat of arms. The figure of 'Religion' holds in her hand a kind of sceptre, which is topped by the badge of the Order (two crossed hands).

D 665 Fig. 849

A group of people dancing and making music.

172 × 295. Pen, brown ink and wash. (Laid down.) What appears to have been an old inscription has been obliterated and torn away from the upper right corner. Inscription on the old mount: 'Permigiano'.

PROV: David Laing; Royal Scottish Academy. Transferred 1910.

The attribution to de' Vecchi was first made by Philip Pouncey. The facial types are close to those in a drawing representing *Pentecost* in the Uffizi (7366F). The shape of the design would suggest that it was intended for the decoration of a harpsichord lid.

D 4890/5 — Fig. 850

Angels adoring the Trinity.

165×91. Pen, ink and wash over black and red chalk. (Laid down.) Inscribed: *Gio. de Vecchi.*

PROV: Marchese del Carpio; Paul and Edwardo Bosch, Madrid; H. M. Calmann. Purchased 1964.

It seems just possible that this is Giovanni de' Vecchi in a very sketchy manner, judging by the shapes of the heads and the shorthand of the faces. Philip Pouncey has suggested, however, that the style is not far from Allegrini.

DOMENICO VENEZIANO

Venice 1400–1461 Florence

Copy after DOMENICO VENEZIANO

RSA 124 — Fig. 851

St John the Baptist.

273×100. Pen, ink and wash. (Very damaged. On several joined pieces of paper.) Inscribed on back in an old, possibly 16th century, hand: *Andrea del C...*

PROV: Sir Thomas Lawrence; David Laing; Royal Scottish Academy. On loan 1966.

Copy of the figure from the panel in the Museo S. Croce, Florence, depicting SS. John the Baptist and Francis. The painting was until recently ascribed to Andrea del Castagno, and it is interesting to note that this ascription was already current in the 16th century, as reflected in the inscription on the back of the drawing, which must date from this period.

PAOLO VERONESE

(Caliari)

Verona 1528–1588 Venice

Copy after PAOLO VERONESE

D 668 — Fig. 852

Catarina Cornaro giving up her crown to the doge.

165×313. Pen, brown ink and wash, with traces of red chalk. Inscribed on the back of the mount: 'a procession by Zucchero'.

PROV: David Laing; Royal Scottish Academy. Transferred 1910.

LIT: Tietze, 2167.

This is a copy after a painting, now lost, reproduced in Emil Schaeffer, 'Bildnisse der Catarina Cornaro' in *Monatshefte für Kunstwissenschaft* IV (1911), pp. 15 ff., pl. 10, as 'School of Paolo Veronese (Paolo Caliari?)'. According to Sansovino, *Venezia*, etc., 2nd ed. (1667), pp. 374 f., the painting was then in the Palace of Nicolò Cornaro and was last traced in the sale of the Schönlank Collection (Cologne, 1896, no. 26), but has not been seen since.

D 2981

Coronation of the Virgin.

235×190. Brush with wash, over red chalk. (Laid down.)

PROV: Edinburgh Drawing Institution; W. F. Watson. Bequeathed 1881.

Very likely a copy after a detail of a composition by Veronese, but no corresponding work has been traced.

RSA 299

Standing draped female figure holding a viol.

302×157. Black chalk and wash on blue paper. (Laid down.) Inscribed: *Paul Veronese.*

PROV: David Laing; Royal Scottish Academy. On loan 1966.

This is a copy, in reverse, of one of the *Suonatrici* in the Villa Barbaro, Maser (repr. Luciano Crossato, *Gli Affreschi nelle ville Venete del cinquecento* (1962), fig. 5).

ANTONIO VICENTINO

(Tognone)

Vicenza fl. 1580

RSA 156 — Fig. 853

Apollo and Marsyas.

205 (diam.). Pen, ink and wash, heightened with white on blue paper. Inscribed on the old mount: 'Tognon di Vicenza'.

PROV: (Collector's mark cut out, probably the five-pointed star, as on the Windsor drawing, see below); Bindon Blood (L. 3011); David Laing; Royal Scottish Academy. On loan 1966.

A companion drawing to the *Flaying of Marsyas* at Windsor (*Italian Drawings at Windsor*, 965, fig. 185).

IL VOLTERRANO

See Baldassare FRANCESCHINI.

Attributed to
GIUSEPPE ZAIS
Forno di Canale (Belluno) 1709–1784 Treviso

D 3242 Fig. 854

A group of cavalrymen in a landscape.

147 × 257. Brush and brown wash over black chalk. Inscribed in the top left corner: *C. Parocel.*

PROV: W. F. Watson. Bequeathed 1881.

Because of the old inscription, the sheet was classified among the French drawings. It was J. Byam Shaw who recognized its Venetian origin and tentatively suggested Zais as the draughtsman. The subject matter, as well as the style, are also reminiscent of Francesco Casanova.

BERNARDO ZILOTTI
(or ZILIOTTI)
Borso (Bassano) c. 1730–c. 1780 Venice

D 1838 Fig. 855

River landscape with old stone bridge.

272 × 417. Pen, brown ink and wash, heightened with white over black chalk, on blue paper. Inscribed in lower right corner: *Ziliotti.*

PROV: David Laing; Royal Scottish Academy. Transferred 1910.

A very similar landscape drawing, in identical medium, and obviously by the same hand, is at Stockholm (25/1928). Its almost illegible inscription has been read as [Filippo] 'Zanimberti', but as he was a Brescian artist of the early 17th century, this is a most unlikely interpretation.

GIUSEPPE ZOLA
Brescia 1672–1743 Ferrara

RSA 323 Fig. 856

The arrival of a soldier at a peasant's hut.

189 × 258. Pen and brown ink. (Laid down.) Inscribed: *Joseph Zola.*

PROV: David Laing; Royal Scottish Academy. On loan 1966.

GAETANO ZOMPINI
Nervesa 1700–1778 Venice

D 1780 Fig. 857

Dante and Virgil meeting in the wood.

194 × 130 (size of composition). Pen, brown ink and grey wash. (Laid down.) Inscribed: *Gaetano Zompini da Nervesa* (in the reliable 18th century Venetian hand).

PROV: David Laing; Royal Scottish Academy. Transferred 1910.

EXH: *Disegni di una Collezione Veneziana del Settecento,* Fondazione Cini, Venice, 1966 (118).

This design, illustrating the famous scene from the First Canto of the *Divina Commedia,* may have been intended as an illustration for the edition of Dante's works, published by Antonio Zatti in Venice in 1757, which contains engravings after Zompini's designs. However, the plate illustrating the same scene in Zatti's edition, engraved by Giampicoli, differs radically in composition from this drawing.

FRANCESCO ZUCCARELLI
Pitigliano 1702–1788 Florence

D 1172 Fig. 858

Landscape with houses, figures and a hay-waggon near a river.

183 × 228. Pen, black ink and grey wash, over black chalk. (Laid down.) Pencilled inscription: *Zucarelli* on back.

PROV: David Laing; Royal Scottish Academy. Transferred 1910.

The attribution on the back, probably contemporary, may well be correct.

D 2236 Fig. 859

Landscape with cattle and two herdsmen, one lying under a tree.

183 × 224. Pen, brown ink and grey wash over black chalk. (Laid down.) Old inscription: 'Zuccarelli' on the back of the mount.

PROV: Paul Sandby; W. F. Watson. Bequeathed 1881.

D 3209 Fig. 860

Landscape with St Paul preaching.

350 × 516. Pen, brown ink and wash over red chalk. (Laid down.)

PROV: Thomas Monro; sale 26 June (or 3 July) 1833, no. 80, according to inscription on the back; W. Esdaile; W. F. Watson. Bequeathed 1881.

D 3201 Fig. 861

River landscape with classical buildings. In the foreground peasants and anglers.

266 × 380. Pen, brown ink and coloured washes.

PROV: W. F. Watson. Bequeathed 1881.

The attribution to Zuccarelli appears to be of fairly recent date.

RSA 120 Fig. 862

River landscape with peasants and goatherd.

292 × 456. Pen and ink and wash over red chalk, heightened with white.

PROV: Unidentified collector's mark on back; David Laing; Royal Scottish Academy. On loan 1966.

The attribution is the traditional one.

RSA 170 Fig. 863

Woodcutters.

151 × 225. Brush with grey and brown wash, over pencil. Inscribed on the back: *Zuccarelli*.

PROV: David Laing; Royal Scottish Academy. On loan 1966.

RSA 267 Fig. 864

A blind man led by a girl.

202 × 166. Grey wash over black chalk. (Laid down.) Inscribed *F. Z.*, and on the mount: 'Zucarelli'.

PROV: David Laing; Royal Scottish Academy. On loan 1966.

Ascribed to FRANCESCO ZUCCARELLI

D 3195 Fig. 865

River landscape with herdsman and classical buildings in the background.

263 × 393. Pen, ink and wash over red chalk. Inscribed in pencil on back: *Claude no. 54*.

PROV: W. F. Watson. Bequeathed 1881.

The ascription to Zuccarelli must remain very doubtful.

FEDERICO ZUCCARO
S. Angelo in Vado 1540–1609 Ancona

D 1472 Figs. 866 and 867

(*a*) The meeting of two warriors surrounded by attendants.
(*b*) A triumphal procession.

(*a*) 90 × 72; (*b*) 93 × 75. Pen, brown ink and wash over red chalk. (Laid down.) Inscribed on the mount: 'f: Zuccaro'.

PROV: Paul Sandby; David Laing; Royal Scottish Academy. Transferred 1910.

The three figures in front of the processional car, in (*b*), are inscribed respectively: *asia, europa, africa*. A. E. Popham has suggested that the two drawings might be by Cesare Pollini (see D 2895), but the traditional attribution seems convincing. The pen and wash work, the facial types, and

even the inscriptions appear to be the same as in the allegorical-satirical drawing of the *Porta Virtutis* at Frankfurt (13291; repr. Voss, *Spätrenaissance*, fig. 245), of which a replica is in the Janos Scholz Collection.

RSA 218 Fig. 868

The Virgin and Child in glory with SS. Bartholomew and George.

396 × 228 (arched top). Pen, brown ink and grey wash over black and red chalk, heightened with white on ochre prepared paper. Inscribed: *Frederico Zuccaro*.

PROV: Dr R. Mead, according to inscription on the back; J. Barnard; David Laing; Royal Scottish Academy. On loan 1966.

D 2894 Figs. 869 and 870

(*recto*) Female figure in armour ('Virtus');
(*verso*) Female figure blowing a trumpet ('Fama').

124 × 85. Red and black chalk. (Composed into ovals.) Inscribed in W. Gibson's hand: *F. Zuccaro 3.1*.

PROV: Sir Peter Lely; William Gibson; W. F. Watson. Bequeathed 1881.

Both figures occur in ovals on the ceiling of the Sala dei Fatti Farnesi at Caprarola (engraved in Giorgio Gasparo de Prenner's *Illustri Fatti Farnesiani coloriti nel real palazzo di Caprarola* (Rome, 1748)). The figure of 'Fama' is in the same direction as the fresco, whereas that of 'Virtus' is in reverse. (A squared study, which may be a studio drawing, in pen and wash, for 'Fama' is at Besançon, 2272; Gernsheim 9861).

D 1512 Fig. 871

Three men paying homage to an enthroned general.

147 (diameter). Pen, brown ink and wash. (Laid down.) Inscription in pencil on the mount: 'Zuccaro'.

PROV: N. Lanier (L. 2886); (? Paul Sandby); David Laing; Royal Scottish Academy. Transferred 1910.

LIT: J. A. Gere 'Taddeo Zuccaro as a designer for Maiolica', *Burlington Magazine* (July 1963), p. 314, fig. 40.

John Gere has recognized that several of the roundel-compositions, which are variously attributed to either of the brothers Zuccari, were designs for the decoration of maiolica. Variations of D 1512, for example, occur on two pieces of maiolica in the Victoria and Albert Museum and on five in the Bargello, Florence (Gere, *op. cit.* p. 314). In addition Federico adapted this composition for one of the roundels in the chapel at Caprarola (Venturi, XI/2, fig. 676).

D 1851 Fig. 872

Portrait of a man, holding a statuette.

261 × 188 (including a strip of about 15 mm which has been added, except to the lower margin). Black and red chalk. (Damaged and laid down.)

PROV: (?Allan Ramsay); Lady Murray. Presented 1860.

EXH: Colnaghi, 1966 (29).

The present, convincing attribution was first suggested by A. E. Popham.

D 1654 Fig. 873

Portrait of a man with a ruff.

178 × 118. Black and red chalk. (Laid down.) Pencilled inscription on the mount: 'F. Barocci' and 'Zuccaro'.

PROV: Sir Joshua Reynolds (mark effaced); Sir Thomas Lawrence; David Laing; Royal Scottish Academy. Transferred 1910.

Apart from the two names inscribed on the mount, ascriptions to the Cavaliere d'Arpino and Ottavio Leoni have also been suggested. However, an attribution to Federico Zuccaro seems to be the most plausible.

D 3070 Figs. 874 and 875

(recto) Portrait of a lady;
(verso) Portrait of a man.

105 × 77. Black and red chalk. Inscribed on the verso: F. Zuccaro.

PROV: W. F. Watson. Bequeathed 1881.

D 4895 Fig. 876

View from the terrace ('Paradisino') of the Badia at Vallombrosa, with Florence in the background.

251 × 408. Black and red chalk. Inscriptions: letter a in chalk in the bottom left corner; figures 8 in pen on the left and 125 in lower right; on the verso: Zuccharo in pencil.

PROV: (Pierre Crozat, see note below); H. M. Calmann. Purchased 1965.

LIT: D. Heikamp, 'Federico Zuccari a Firenze 1575–1579' in Paragone, 205 (March 1967), p. 56, fig. 32.

EXH: Colnaghi, 1966 (28).

According to Mariette's Catalogue of the Crozat collection, 1741 (lot 211), there were 25 drawings by Federico Zuccaro, 'devant le cours de ses voyages', possibly part of a sketchbook formerly owned by Jabach. Mariette comments: 'Les dessins de Federico Zuccaro sont fort curieux, il viennent de M. Jabach & composaient ci-devant le livre de voyage du Zuccaro.' Sixteen of these were bought (for '14 livres') by Count Tessin, and are now at Stockholm. One of them

(494), depicting the Abbot of the Badia, is dated 1576, as is a drawing of a forest scene near Vallombrosa in the Albertina (13329; repr. Heikamp, op. cit. figs. 36 and 33/34). It appears that the artist visited the place again the following summer, for another drawing at Stockholm (463/1863) is inscribed: Badia di Vallombrosa fatta ad 23 agosto 1577. Although this drawing is cut, it is likely that it, as well as the Albertina landscape and D 4895, formed part of the sketchbook, and came from the Crozat sale. A further drawing, depicting a woodland scene near the Badia, is in the Louvre (4592) and is inscribed with the date 25 agosto 1577 (Heikamp, fig. 31).

D 4814 Fig. 877

Anatomical studies.

400 × 280. Pen and brown ink, figure on left in black chalk.

PROV: John Skippe (L. 1529b); sale Christie, 20–21 November 1958, 233B; P. and D. Colnaghi. Purchased 1959.

A. E. Popham, in the Skippe sale catalogue, connects this drawing with the devils and skeletons in Federico's fresco in the cupola of the Duomo at Florence.

D 4890/41 Fig. 878

Half-length female figure with a snake (Cleopatra?).

174 × 134. Black chalk, on blue paper. Squared in red chalk. (Water-stained.) Inscribed: F. Zuccaro.

PROV: Marchese del Carpio; Paul and Edwardo Bosch, Madrid; H. M. Calmann. Purchased 1964.

The old attribution seems convincing.

D 3088 Fig. 879

Head of a lady with a hat.

339 × 231 (a strip of 7 mm has been added along the lower margin). Coloured chalks on faded blue paper. Pricked for transfer. (Rubbed and damaged.)

PROV: W. F. Watson. Bequeathed 1881.

As far as can be ascertained, this very rubbed cartoon fragment could well be by Federico. It may possibly have been connected with the preparation for the frescoes at Caprarola, where similar figures, though not exactly this head, appear.

Attributed to FEDERICO ZUCCARO

D 1550 Fig. 880

St Paul preaching at Rome.

274 × 155. Pen, brown ink and wash over black chalk. Old inscription: Ludovico Civoli on the back.

PROV: N. Hone (L. 2793); Paul Sandby; David Laing; Royal Scottish Academy. Transferred 1910.

The old ascription to Cigoli is not convincing. The composition, especially the prominent foreground figures on the left, and even the style, suggest an artist like Federico Zuccaro.

Copies after FEDERICO ZUCCARO

D 2939 Fig. 881

Two ambassadors kneeling before an emperor.

191 × 545. Pen, brown ink and wash. (Damaged.)

PROV: 'P. Crozat' ? (L. 474); W. F. Watson. Bequeathed 1881.

The composition may well be Federico's, but the actual drawing is, at best, an inferior copy.

D 3179 Fig. 882

Allegorical figure of 'Painting'.

187 × 128. Pen, brown ink and wash. (Laid down. Lower right corner cut off.) Inscribed: *pittura*.

PROV: W. F. Watson. Bequeathed 1881.

This is probably a copy after Federico. A similarly helmeted figure of Athene occurs in the fresco at Caprarola (Venturi, IX/5, fig. 522).

Circle of FEDERICO ZUCCARO

D 3067 Fig. 883

The meeting of a pope and a commander near a town.

299 × 261. Pen, brown ink and wash, with some white heightening, on blue paper. (Laid down.) Inscribed on the mount: 'Taddeo Zuccaro'.

PROV: Charles Jourdeuil; W. F. Watson. Bequeathed 1881.

Although there are strong Taddeo-like features in this drawing—for example the group in the extreme lower right corner—it seems to have originated rather in the circle around Federico. The incident depicted has not been clarified, but may represent the return of one of the early popes from Avignon to Rome—possibly Urban V, who entered Rome from Viterbo in 1367.

Follower of FEDERICO ZUCCARO

D 2900 Fig. 884

Two angels and putti.

165 × 114. Pen, brown ink and wash.

PROV: W. F. Watson. Bequeathed 1881.

The draughtsmanship suggests an influence of the early manner of the Zuccaro brothers.

D 4890/33 A Fig. 885

Madonna and Child with St John.

77 × 51. Pen, brown ink and wash, over black chalk. (Laid down.) Inscribed: *Stefano Pierio*.

PROV: Marchese del Carpio; Paul and Edwardo Bosch, Madrid; H. M. Calmann. Purchased 1964.

There is no connection with Stefano Pieri, a pupil of Naldini. All that can be said of this little sketch is that it is post-Zuccaresque.

TADDEO ZUCCARO
S. Angelo in Vado 1529–1566 Rome

D 1562 Fig. 886

A seated bearded male figure and two attendant figures behind.

291 × 236. Pen, brown ink and wash over black chalk, heightened with white. (Very damaged and laid down.) Inscribed on the mount: 'Polidoro'.

PROV: Count Moritz von Fries; David Laing; Royal Scottish Academy. Transferred 1910.

This, as well as D 1558 and D 1561, was formerly ascribed to Polidoro da Caravaggio, according to the 19th century inscription on the mount. It appears that A. E. Popham was the first to suggest a connection with Taddeo Zuccaro.

The three drawings belong obviously together, to form part of one and the same composition: D 1558 (*Christ and the Woman taken in Adultery*) in the middle; D 1561 to the right; and D 1562 to the left. This arrangement would result, as John Gere has pointed out, in a design very similar to those with which Taddeo decorated the vault of the Mattei Chapel in S. Maria della Consolazione in Rome. No work depicting *Christ and the Woman taken in Adultery* has survived, and John Gere has suggested that, as the original commission for the Mattei Chapel merely stipulated scenes from the life of Christ, this trio of drawings may in fact record an idea connected with the Mattei Chapel decorations, but one which in the end was not carried out. Two other drawings in the same technique, which may also relate to such a scheme, are in the Kunsthaus, Zürich, both amongst the anonymous drawings in Box N. 56 V, one depicting a seated male figure (perhaps a beggar), the other a bearded prophet holding an open book which is supported by an angel.

D 1558 Fig. 887

Christ and the woman taken in adultery.

275 × 270. Pen, brown ink and wash, heightened with white. (Very damaged and laid down.)

132

ZUCCARO

PROV: (Count Moritz von Fries?, see D 1561 and D 1562); David Laing; Royal Scottish Academy. Transferred 1910.

LIT: Berenson, 772k (as Davide Ghirlandaio, which is an obvious confusion with D 813: Studio of Filippino Lippi). See note to D 1562.

D 1561 Fig. 888

A seated male figure.

317 × 184. Pen, brown ink and wash, heightened with white. (Very damaged and laid down.) Inscribed: *un dei profeti in SS. Apostoli ?Bagnocavallo.*

PROV: Count Moritz von Fries; David Laing; Royal Scottish Academy. Transferred 1910.

See note to D 1562.

D 4836 Fig. 889

Charlemagne confirming the union of Ravenna and other territories of the Church in 774.

238 × 179. Pen, brown ink and wash over black chalk. (Laid down.) Old inscription in ink on the back, crossed out: *di Jacomo da Pontormo*; *Tadeo Zuccaro*, in pencil above.

PROV: A. de Clemente (L. 521b); P. & D. Colnaghi. Purchased 1960.

This is a preliminary study for the central group of the *soprapporta*-fresco in the Sala Regia in the Vatican, executed between 1561 and 1566 (repr. Voss, Spätrenaissance, fig. 170; Venturi, IX/5, fig. 513). Two drawings for the same group are at Berlin: one (15293) is also reproduced in Voss (fig. 171), the other in red chalk with an inscription *F. Zuccari*, shows the main figure in reverse (15294). Two studies of the complete composition exist: one in the British Museum (1947-7-13-108; ex Fenwick Coll., repr. in OMD VII, 1932/3, pl. 49), and the most elaborate of all, at Windsor (*Italian Drawings at Windsor*, 1070, fig. 202).

It would seem that stylistically D 4836 belongs, with the two Berlin drawings, to an early stage of the design, the main features of which have been taken over into the later, more worked out compositions, represented by the British Museum and Windsor drawings. All these surviving studies vary considerably from the final fresco.

D 1540 Fig. 890

Sheet with various figures.

152 × 224. Pen, brown ink and wash over black chalk. (Laid down.) The sheet has apparently been cut all round. In the extreme lower right corner a capital *T* can be seen, just at the point where the margin has been cut. An inscription *Baglione*, in a late hand, can be seen through the backing.

PROV: 'P. Crozat'? (L. 474); David Laing; Royal Scottish Academy. Transferred 1910.

The attribution of the hitherto anonymous drawing is due to Philip Pouncey.

Attributed to TADDEO ZUCCARO

D 3130 Fig. 891

Studies of a reclining male and female figure, and a seated female figure in profile, as well as a separate study of her left foot.

237 × 199. Pen, brown ink and wash over red chalk; traces of black chalk in the right margin. (Laid down.) Partly cut off inscription in the top margin: *del Zuccaro feder[ico].*

PROV: W. F. Watson. Bequeathed 1881.

In spite of the old inscription at the top, the style of the drawing suggests Taddeo, rather than his brother. The figures may have been intended as part of a *soprapporta*-decoration, similar to the frescoes in the Sala Regia in the Vatican (Venturi, IX/5, fig. 517).

Copy after TADDEO ZUCCARO

RSA 183 Fig. 892

Christ feeding the multitude.

296 × 239. Pen, brown ink and wash, heightened with white, on blue paper. (Laid down.)

PROV: Woodburn sale, 16 June 1854, lot 326; David Laing; Royal Scottish Academy. On loan 1966.

As John Gere pointed out, the composition is based on a design by Taddeo Zuccaro. There is an engraving of it, formerly attributed to Cornelis Cort, but according to Bierens de Haan (*L'Œuvre Gravé de Cornelis Cort* (1948), p. 79; Hollstein, 58a) by Aliprando Caprioli, inscribed *Taddeo Zuccarus inventor*. This corresponds exactly with RSA 183, except for details of the trees in the right background. Another old copy is in the Uffizi, as Muziano (7686s), and a copy of a closely related variant, in reverse, is in the collection of Ralph Holland, Newcastle.

Studio of TADDEO ZUCCARO

D 2224 Fig. 893

The marriage of Ottavio Farnese and Marguerite of Austria.

266 × 275. Pen, brown ink and wash. (Laid down.) Inscribed in W. F. Watson's hand: *Original drawing by F. Zuccaro of the Marriage of Francis II (when Dauphin) to Mary Queen of Scotland 24 April 1558.*

The composition is essentially the same as the fresco in the Sala dei Fatti Farnesi at Caprarola. It would seem at first sight to be a weak copy after it. However, John Gere has pointed out that D 2224 differs from the fresco in such details as the pose and dress of the man in the right foreground, and the position of the head of the woman in the left foreground. These differences may indicate that D 2224 was a working-drawing and seems, in fact, to be a copy of a *modello* in the Louvre (4460). John Gere has further drawn attention to a squared drawing at Chatsworth (736) for the pendant fresco of the *Marriage of Orazio Farnese and Diane de Valois*, which likewise differs in details. The Chatsworth drawing may in fact be by the same hand as D 2224.

The decorations of the room at Caprarola are traditionally attributed to Taddeo, although it is probable that Federico had a large share in their execution. The more non-committal attribution to Taddeo's studio has been preferred.

D 3129 Fig. 894

Paul III accepting the submission of Perugia in 1540.

187 × 255. Pen, brown ink and wash. Partly erased inscriptions: *titiano* and *Federigo Zuccaro*.

The composition, also engraved by Prenner (see D 2894, Federico Zuccaro) forms part of the decorations of the Sala del Concilio at Caprarola, which adjoins the Sala dei Fatti Farnesi. John Gere has drawn attention to one or two very small discrepancies between the fresco and this drawing, notably the position of the Pope's arm, and that of the legs of the front right hand bearer of the *sedia*; furthermore there is a curious pentimento: the figure in the background on the left of the Pope's outstretched hand has been drawn with a hat as well as a mitre, as if the artist was undecided whether to make him a layman or a bishop.

Some of the types—the rather skull-like faces in the background—do seem to be Zuccaresque in a general sense, but it is difficult to recognize clearly the hand of Federico in this drawing, as suggested by the inscription. That it is, on the other hand, not merely a copy has been shown, and the drawing may possibly have originated in Taddeo's studio, during the preparatory stages of the fresco.

JACOPO DEL ZUCCHI

Florence c. 1541–c. 1590 Rome or Florence

Ascribed to JACOPO DEL ZUCCHI

D 4890/37 Fig. 895

Madonna and Child.

163 × 158. Pen, brown ink and wash. (Damaged and top right corner cut. Laid down.) Inscribed: *Jacopo*.

It is doubtful if the old ascription of this weak drawing to Zucchi is correct.

CATALOGUE OF
ANONYMOUS DRAWINGS

SCHOOLS

BOLOGNESE
SEVENTEENTH CENTURY

D 633

Four figures in a hilly landscape, with rising sun.

167 × 190. Pen, brown ink and wash on brown paper. (Laid down.) Inscribed: *École Raphael.*

PROV: Nathaniel Hone; Sir Joshua Reynolds; William Sharpe (L. 2650); David Laing; Royal Scottish Academy. Transferred 1910.

Formerly called 'Titian'! A. E. Popham pointed out that the figures are copied from Parmigianino. The style of this crude drawing, probably a tracing, seems to derive from Grimaldi.

D 746 Fig. 896

St Francis receiving the Stigmata.

224 × 162. Pen and brown ink. (Laid down.) Inscribed on the mount: *campagnola.*

PROV: John Barnard; David Laing; Royal Scottish Academy. Transferred 1910.

The drawing is certainly Bolognese, showing influences of Guido Reni, and is not far from Elisabetta Sirani (1638–65).

D 748 Fig. 897

Tritons and nymphs on dolphins.

189 × 246. Red chalk (counterproof). Pencilled inscription on the back: *N. Poussin.*

PROV: Paul Sandby; David Laing; Royal Scottish Academy. Transferred 1910.

This is probably a copy from a Bolognese drawing, suggestive of Domenichino or his circle.

D 817 Fig. 898

Madonna and Child.

136 × 86. Pen, brown ink on blue paper. Inscribed: *Ludov. Carrache.*

PROV: Th. Philipe (L. 2026b); David Laing; Royal Scottish Academy. Transferred 1910.

Although not by Ludovico Carracci, as the inscription suggests, the drawing is probably Bolognese, while the inspiration may have come from Raphael.

D 888 Fig. 899

View of a distant fortified town.

97 × 301. Pen and brown ink. Inscribed: *Carazzi.*

PROV: David Laing; Royal Scottish Academy. Transferred 1910.

D 902 Fig. 900

Putti with garlands (design for a ceiling-decoration).

151 × 253. Pen, brown ink and grey wash. (Laid down.) Inscribed on mount: 'L. Caracci.' and 'N. 2'.

PROV: David Laing; Royal Scottish Academy. Transferred 1910.

D 1201 Fig. 901

The sacrifice of Isaac.

226 × 181. Pen, black ink and wash, heightened with white, over red chalk. Inscribed in the bottom margin: *L. Carracci.*

PROV: David Laing; Royal Scottish Academy. Transferred 1910.

Although the drawing is not by Ludovico, as the old inscription implies, it seems probable that it is Bolognese, rather late in the century, and showing the shaggy style favoured by an artist like Giov. Ant. Burrini for example.

D 1533 Fig. 902

A striding female figure under a tree.

217 × 137. Pen and brown ink. (Laid down.)

PROV: David Laing; Royal Scottish Academy. Transferred 1910.

The old ascription was to Ludovico Carracci. The landscape background does look faintly Bolognese, but the figure has been adapted from the well-known classical statue of Niobe and her daughter.

D 1572 Fig. 903

Head of an elderly woman.

300 × 214. Black chalk, heightened with white, on yellow toned paper. Squared with incised lines.

PROV: Unidentified 'paraphe' on the 18th century backing; David Laing; Royal Scottish Academy. Transferred 1910.

The drawing was attributed to Ludovico Carracci when it entered the collection, an ascription which cannot be maintained. The features resemble certain heads of St Anne by Bronzino (for example in *The Madonna and Child with SS. Anne and John*, Washington, National Gallery). Nevertheless the drawing seems to be Bolognese, a suggestion strengthened by the former ascription. The head is not unlike that of the figure of St Anne in the altarpiece of *The Madonna and Child with SS. Anne and John and Angels* by Giovanni Giacomo Sementi (1580–1636)—a pupil of Calvaert and Reni—in the Collegiata at Frosinone (repr. *Bolletino d'Arte*, IV (October–December, 1961), p. 356, fig. 3).

D 1597 Fig. 904

A naked youth clasping a staff above his head.

464 × 247. Red and black chalk and wash, white heightening. (Laid down. Damaged along the top margin.) Inscribed: *Carracci*.

PROV: Sir Joshua Reynolds; David Laing; Royal Scottish Academy. Transferred 1910.

The present appearance of the drawing is misleading, as the figure was drawn in black chalk before the red chalk and wash were added. It is indeed reminiscent of the Carracci, as the inscription says, but also of Guido Reni.

D 1636 Fig. 905

The Madonna of the House of Loreto.

240 × 253. Red chalk and wash. All outlines heavily incised. (Laid down and damaged in lower right corner.)

PROV: David Laing; Royal Scottish Academy. Transferred 1910.

The drawing—perhaps traced for an engraving—appears to be Bolognese, with echoes of Reni. The group of the Madonna and Child closely resembles the two figures in Sassoferato's painting repr. Voss, Barock, p. 216.

D 1742 Fig. 906

Head of a monk.

290 × 315. Black chalk and wash on brown paper. Partly incised.

PROV: ?Sir Charles Bagot (L. 493); Conte di Bardi (L. 336); David Laing; Royal Scottish Academy. Transferred 1910.

It has not been possible to identify this cartoon-fragment. It seems to be Bolognese, 17th century, and not far from Marcantonio Franceschini or Giuseppe dal Sole.

D 2941 Fig. 907

Seated nude seen from the back.

262 × 192. Red chalk. (Laid down.) Inscribed on back: *Annibale Carracci*.

PROV: W. F. Watson. Bequeathed 1881.

The drawing, though not by Annibale, seems certainly to be Bolognese, near to Schidone.

D 2977

Landscape with village and figures.

203 × 287. Pen and brown ink on brown prepared paper. (Torn and damaged.)

PROV: W. F. Watson. Bequeathed 1881.

In the manner of Grimaldi–Busiri.

D 3016

River landscape with figures and a town in the background.

185 × 252. Pen, brown ink and grey wash with traces of red chalk. (Stained and laid down.)

PROV: W. F. Watson. Bequeathed 1881.

A weak drawing, somewhat in the manner of Grimaldi.

D 3023

Landscape with a fortified town.

103 × 233. Black chalk and brown wash, heightened with white, on brown prepared paper.

PROV: Count von Ross; W. F. Watson. Bequeathed 1881.

A weak drawing in the manner of Grimaldi.

D 4890/40 Fig. 908

Adoration of the Shepherds.

100 × 165. Pen, black ink and wash. (Laid down.) Inscribed: *Scola de Caracci.*

PROV: Marchese del Carpio; Paul and Edwardo Bosch, Madrid; H. M. Calmann. Purchased 1964.

RSA 14 Fig. 909

A seated figure representing 'The Catholic Faith'.

222 × 153. Pen, brown ink and wash. Squared in black chalk. (Torn and laid down.) Inscribed 'N. Poussin' on the old mount.

PROV: Sir Peter Lely; Unidentified mark (L. 2806); Unidentified mark 'C' (not in Lugt); David Laing; Royal Scottish Academy. On loan 1966.

Contrary to the inscription on the mount, the drawing seems to be by an Italian artist, probably influenced by Ludovico Carracci. The subject has all the attributes of *Fede Cattolica* as described by C. Ripa, *Iconologia* (1611), p. 163.

RSA 309 Fig. 910

Study of a striding woman seen from the back.

292 × 161. Black chalk, heightened with white, on blue paper. (Laid down.) Inscribed on the back: *Londonio of Milan.*

PROV: David Laing; Royal Scottish Academy. On loan 1966.

As this appears to be a 17th century (probably Bolognese) drawing, the ascription to the 18th century Milanese artist Londonio is unlikely to be correct.

RSA 312 Fig. 911

Twelve draped female figures.

267 × 225. Pen, brown ink and wash, heightened with white, over black chalk, on pink prepared paper. Inscribed: *m cH*; and on the back (in Gibson's hand): *Perino 3.?*

PROV: William Gibson; Sir Thomas Lawrence; David Laing; Royal Scottish Academy. On loan 1966.

The facial types and the folds of the drapery suggest an artist strongly influenced by Ludovico Carracci.

EMILIAN
SIXTEENTH CENTURY

D 678 Fig. 912

Madonna and Child.

114 × 78. Red chalk on brown toned paper. Inscribed in pencil on the back: *Coreggio.*

PROV: David Laing; Royal Scottish Academy. Transferred 1910.

This delicate little drawing preserves something of Correggio's early manner and search into form, although it is obviously of a much later date.

D 775 Fig. 913

The left hand part of an *Adoration of the Shepherds.*

161 × 178. Pen and brown ink with traces of red wash on vellum.

PROV: David Laing; Royal Scottish Academy. Transferred 1910.

The style seems to betray influences of Parmigianino and Lelio Orsi. It might, however, equally well be by a Mantuan artist of the mid-16th century, conceivably from the circle of G. B. Bertani.

D 2906 Fig. 914

A kneeling female figure.

162 × 116. Red chalk. (A strip, 7 mm, added along the right margin.) Inscribed on the back: *An. Carache*, and *4.1* (the latter in Gibson's hand).

PROV: William Gibson; W. F. Watson. Bequeathed 1881.

The drawing—probably a study for a Madonna from an *Adoration*—seems to be derived from Parma rather than Bologna, somewhere in the ambience of Anselmi.

FLORENTINE
SIXTEENTH CENTURY

D 658 Figs. 915 and 916

(recto) The story of the brazen serpent; (verso) Figure studies.

253 × 410. Pen, brown ink and wash over black chalk. Verso: pen and ink. (Damaged.) Inscription on verso: *di Agnolo detto Bronzino…quale dipinse in fiorenza sopra la porta nella Cappela del Duc[hessa] | …buelo | volo contan*

furor sorrumano | quetado(?) el universo d'sconsuelo | consur-gienza a saber subidamano.

PROV: David Laing; Royal Scottish Academy. Transferred 1910.

This crude adaptation, on the recto, of Michelangelo's Sistine ceiling composition appears to be by a provincial follower of Vasari.

D 686

Sketch of two right legs.

258 × 163. Pen and brown ink. Inscribed on the back: *This drawing by Leonardo da Vinci was given to me by John Clerke Esq. Advocate. Feby. 23rd 1815. Alexr. Monro Junior.*

PROV: Alexander Monro, Jnr; David Laing; Royal Scottish Academy. Transferred 1910.

D 741 Fig. 917

The Birth of the Virgin.

164 × 102. Pen, brown ink and wash. (Laid down.) Inscription: 'Federigo Baroccio' on mount.

PROV: Van Puten (L. 2058); Benjamin West; Sir Thomas Lawrence; David Laing; Royal Scottish Academy. Transferred 1910.

The composition is almost identical, but in reverse, with Andrea del Sarto's fresco in the forecourt of SS. Annunziata in Florence. There are, however, differences, most markedly in the group of putti above, made necessary because of the change from a rectangular to a curved top.

D 1586 Fig. 918

The Israelites gathering manna.

439 × 344. Pen, brown ink and wash. (Laid down.) Inscribed on the mount: 'School of Raffaelle'.

PROV: David Laing; Royal Scottish Academy. Transferred 1910.

The drawing, with its strong Florentine features, seems to be from the mid-16th century. Its weaknesses suggest that it is a copy. Both the facial types and the composition reveal the influences of Vasari, and to some extent of Alessandro Allori.

D 3119 Fig. 919

The Virgin of the Immaculate Conception.

274 × 189. Pen, brown ink and wash. (Laid down.)

PROV: W. F. Watson. Bequeathed 1881.

The strong influence of Vasari, apparent in the drawing, may suggest that it originated in his studio, perhaps by a provincial assistant of the level of, but distinct from, Marco da Faenza.

D 4890/9 B Fig. 920

Standing female figure (Madonna?) with raised right arm.

110 × 62. Pen and ink. (Laid down.) Inscribed: *Massei.*

PROV: Marchese del Carpio; Paul and Edwardo Bosch, Madrid; H. M. Calmann. Purchased 1964.

The inscription presumably refers to Girolamo Massei (Lucca 1540–1614 Rome), but there seems to be no good reason for such an attribution. The drawing appears to be a copy from a figure such as occurs in early works by Fra Bartolomeo.

D 4890/10 Fig. 921

Madonna and Child.

195 × 134. Pen, ink and wash over black chalk. (Damaged and laid down.) Inscribed: *Tita d'Andrea.*

PROV: Marchese del Carpio; Paul and Edwardo Bosch, Madrid; H. M. Calmann. Purchased 1964.

The inscription probably intends to refer to Santi di Tito (although he was not a pupil of Andrea del Sarto, but of Bronzino). This battered drawing seems to be by a rather weak Florentine artist, vaguely inspired by Raphael. Similar poses of the Madonna and Child also occur in the works of Granacci.

D 4890/13 Fig. 922

Seated male figure, half-length.

154 × 134. Red chalk. (Laid down.) Inscribed: *Lattanzio scol. de Caracci.*

PROV: Marchese del Carpio; Paul and Edwardo Bosch, Madrid; H. M. Calmann. Purchased 1964.

The inscription presumably intends to refer to Lattanzio Gambara, who however was a pupil of the Campi, not of the Carracci. In any case the drawing appears to be Florentine, as is the habit of the man depicted, and may be late 16th or early 17th century, somewhere between Poccetti and Fabrizio Boschi.

RSA 274 Fig. 923

The Holy Family, flanked by SS. Jerome and John the Baptist, within an architectural framework.

197 × 184. Pen, brown ink and wash, over black chalk.

PROV: David Laing; Royal Scottish Academy. On loan 1966.

The design, probably for a tomb, seems to be by a minor Florentine. The drawing of the Saints reveals a knowledge of Federico Zuccaro, while the central group, especially the Madonna and Child, appears to have been influenced by

Pier-Francesco Foschi: see illustrations to the article by Myril Pouncey in *Burlington Magazine* (May 1957).

FLORENTINE SEVENTEENTH CENTURY

D 1520 Fig. 924

A flying female figure and two putti carrying leaves.

293 × 300. Red chalk.

PROV: David Laing; Royal Scottish Academy. Transferred 1910.

This appears to be part of a large decorative scheme, and is possibly a copy. A recent note on the mount suggested Maratta as the artist, but the style seems to point rather towards Florence, in the period of Gabbiani.

D 1588 Fig. 925

A seated nude man, with outstretched arms.

267 × 350. Red and black chalk. (Laid down.) Inscribed: *P. V^nei*.

PROV: David Laing; Royal Scottish Academy. Transferred 1910.

Style and medium of this drawing speak for a Florentine origin. The broken touch goes back in origin to Poccetti, but the artist of D 1885 seems to stand closer to Confortini (see D 3336).

D 1614 Fig. 926

A seated man with hat and cloak.

336 × 233. Black and red chalk. (Laid down.) Inscribed: *Santi di Tito*. Another inscription in ink has been torn away from the lower left margin.

PROV: David Laing; Royal Scottish Academy. Transferred 1910.

Although the drawing appears to be Florentine, the old ascription to Santi di Tito is certainly incorrect. It seems likely that the artist of this drawing had contact with Giovanni da San Giovanni, and the drawing may possibly have originated in his circle. The face and the manner of shading on the jacket and sleeve are reminiscent of Andrea Boscoli; the whole not far from Confortini.

D 1886 Fig. 927

A standing ecclesiastic.

191 × 123. Red chalk, red and brown wash on buff paper.

PROV: (?Allan Ramsay); Lady Murray. Presented 1860.

Very likely to be Florentine, around Balassi, Boschi or Passignano.

D 1891 A Fig. 928

Flying putto carrying a wreath.

116 × 156. Pen, brown ink, grey and blue wash.

PROV: (?Allan Ramsay); Lady Murray. Presented 1860.

Possibly Florentine, a generation after Cigoli.

D 1916 Fig. 929

Profile of a bearded man.

211 × 167. Black chalk on prepared paper. (Laid down.) Inscribed on the old backing: 'Michelang? Buonaroti, 15'.

PROV: (?Allan Ramsay); Lady Murray. Presented 1860.

A type which derives ultimately from Andrea del Sarto.

D 1936 Fig. 930

A flying putto.

218 × 184. Black chalk. (Laid down.)

PROV: (?Allan Ramsay); Lady Murray. Presented 1860.

This counterproof is very near to the style of Baldassare Franceschini, il Volterrano.

RSA 287 Fig. 931

Christ and the Apostles. (On the verso: a slight sketch of an *Adoration of the Virgin*.)

276 × 210. Pen, brown ink with blue wash, over black chalk. (Partly torn by corrosion of ink.)

PROV: David Laing; Royal Scottish Academy. On loan 1966.

The drawing appears to be Florentine, with faint echoes of Cigoli.

GENOESE SIXTEENTH CENTURY

D 735 Figs. 932 and 933

(*recto*) Madonna and Child adored by saints (including S. Carlo Borromeo) and a donor; (*verso*) Sketches for a ceiling-decoration.

112 × 191. Pen and ink, with traces of red and black chalk. Inscribed on the back: *Cerano (Crespi) Mil 3 Ep.*

PROV: David Laing; Royal Scottish Academy. Transferred 1910.

The ascription to Cerano is untenable. The drawing, which shows a certain skill in decoration and foreshortening, appears to be of Genoese origin, and not far from Bernardo Castello.

D 2925 Fig. 934

A sea battle by a shore.

235 × 300. Pen, brown ink and wash. Partly obliterated inscription at the bottom: *La Batag[lia] contra sotu ponp... Const[antinapoli?]*.

PROV: W. F. Watson. Bequeathed 1881.

The drawing seems to be Genoese and is in parts reminiscent of the style of Bernardo Castello.

D 3065 Fig. 935

A boat with soldiers being hauled towards a galley.

86 × 143 (cut to an octagonal shape). Pen, brown ink and wash over black chalk. (Laid down.) Inscribed on the mount: 'Ecole florentine Buonaccorsi (Pierre) dit Perino del Vaga 1500–1547'.

PROV: W. F. Watson. Bequeathed 1881.

This and the following drawing are probably designs for ceiling-decorations. They seem certainly to be Genoese, with features reminiscent of both Bernardo Castello and Paggi.

D 3066 Fig. 936

Slaves in a boat pleading with a helmeted commander in a galley.

90 × 140. Pen, brown ink and wash over black chalk. (Laid down.) Same inscription as on previous drawing.

PROV: W. F. Watson. Bequeathed 1881.

See note to previous drawing.

RSA 293 Fig. 937

Mercury bringing instructions from Jupiter to Neptune ('Quos Ego').

208 × 312. Pen, ink and grey wash. (Laid down.)

PROV: William Sharp (L. 2650); David Laing; Royal Scottish Academy. On loan 1966.

The subject of Neptune quelling the winds that had destroyed the Trojan fleet, occurs in the *Aeneid* (Book I, 132–5). The drawing is probably by an artist (possibly even a Northerner) working in Genoa, and influenced by Perino del Vaga.

GENOESE
SEVENTEENTH CENTURY

D 720 Fig. 938

Battle scene before a besieged tower.

160 × 437. Pen, brown ink and wash. (Laid down.) Pencilled inscription on the back: *Valerio Castello*.

PROV: 'P. Crozat?' (L. 474); David Laing; Royal Scottish Academy. Transferred 1910.

The drawing is without much doubt Genoese, but the apparently fairly recent ascription to Valerio Castello is not convincing. The style is more 'old-fashioned' than Valerio Castello would have adopted, even if it were assumed that this was an early drawing.

D 922 Fig. 939

A lady with attendant figures kneeling before an altar in a church.

335 × 225. Pen, brown ink and wash over black chalk. Squared in chalk. Pencilled inscription on back: *Zucchero*.

PROV: Thomas Hudson; Sir Joshua Reynolds; William Mayor (L. 2799); Barry Delany (L. 350); David Laing; Royal Scottish Academy. Transferred 1910.

Contrary to the inscription on the back, the drawing seems to be Genoese.

D 3106 Fig. 940

The Adoration of the Magi.

455 × 328. Pen, brown ink and wash over black chalk.

PROV: Baron D. Vivant-Denon (L. 779); W. F. Watson. Bequeathed 1881.

Formerly tentatively attributed to Cambiaso. While individual figures make one think of him, the composition as a whole is a little too developed, and is probably by the hand of a gifted follower of Cambiaso.

D 4886 Fig. 941

The family of Darius before Alexander.

180 × 247. Pen, ink, grey wash over red chalk. (Three of the corners torn and repaired.)

PROV: Mrs Macqueen Ferguson. Purchased 1963.

This anonymous drawing is obviously Genoese, and by some incoherent artist following in the wake of Cambiaso.

NEAPOLITAN SEVENTEENTH CENTURY

D 760 Fig. 942

The finding of Moses.

188 × 259. Pen, brown ink and wash over black chalk. (Laid down.) Inscription on the back of the mount: 'Lot 35 H'.

PROV: David Laing; Royal Scottish Academy. Transferred 1910.

The traditional attribution is to Luca Giordano, but it is certainly not from his own hand, though probably by an artist influenced by him.

D 1768 Fig. 943

A warrior in reclining position on a volute.

262 × 233. Pen, brown ink and wash on blue paper. (Laid down.)

PROV: David Laing; Royal Scottish Academy. Transferred 1910.

A design probably intended as part of an architectural decoration. The broad and vigorous style is reminiscent of Salvator Rosa.

RSA 193 Fig. 944

The Rest on the Flight to Egypt.

150 × 198. Pen, brown ink and wash over black chalk. Traces of red chalk. (Laid down.)

PROV: David Laing; Royal Scottish Academy. On loan 1966.

The influence of Luca Giordano is evident, particularly in the figure of the angel attending the ass in the background.

NEAPOLITAN EIGHTEENTH CENTURY

D 3154 Fig. 945

The beheading of a saint.

247 × 386. Pen, brown ink and wash, over faint black chalk. (Laid down.) Scale diagram at the bottom.

PROV: W. F. Watson. Bequeathed 1881.

The drawing was formerly ascribed to Pietro da Cortona. It is, however, presumably Neapolitan, by an indifferent and rather coarse follower of Luca Giordano.

RSA 300 Fig. 946

The Assumption of the Virgin.

432 × 285. Pen, brown ink over black chalk. Inscribed: *?Jesué Cesai*.

PROV: David Laing; Royal Scottish Academy. On loan 1966.

RSA 301 Fig. 947

The baptism of a bishop, with a pope above in the clouds.

491 × 316. Pen, brown ink and grey wash, over black chalk.

PROV: David Laing; Royal Scottish Academy. On loan 1966.

By a weak follower of Solimena, near to Domenico Mondo.

ROMAN SIXTEENTH CENTURY

D 705 Fig. 948

The triumph of Cupid.

146 × 212. Pen, ink and wash, over red chalk heightened with white. (Laid down.)

PROV: Charles Rogers; (W. Esdaile?); David Laing; Royal Scottish Academy. Transferred 1910.

The drawing is probably by a Roman draughtsman towards the end of the century. Its weakness may be explained by its possibly being a copy, perhaps from an engraving.

D 815 Fig. 949

The meeting between SS. Dominic and Francis.

194 × 414 (arched top). Pen, brown ink and wash, over black chalk. Late pencilled inscription on the back: *Boscolo*.

PROV: David Laing; Royal Scottish Academy. Transferred 1910.

The drawing, probably a design for a lunette, has nothing to do with Boscoli. It seems to be by an artist working in Rome at the end of the century, but is so weak that it might well be a copy. The facial types are vaguely reminiscent of Baldassare Croce, or Lombardelli.

D 898 Fig. 950

Design for an apse with sculptured figures, and *The Coronation of the Virgin* in the vault.

418 × 278. Pen, brown ink and wash, heightened with white. (Laid down.) Inscriptions above the three niches: *storie | storie di s. martiri | ec. storie*. Inscribed on the mount: 'Boscoli'.

PROV: David Laing; Royal Scottish Academy. Transferred 1910.

The drawing seems to be Roman, of the end of the century, and has nothing to do with Boscoli. It appears to be by a provincial follower of the Zuccari.

D 950 Fig. 951

Two obelisks.

298 × 168. Pen, brown ink. Dated *1587* on the left-hand obelisk, below the medallion.

PROV: David Laing; Royal Scottish Academy. Transferred 1910.

The date inscribed on the drawing is the year after the re-erection of the big obelisk in front of St Peter's, under the supervision of Domenico Fontana, and the beginning of the period when numerous obelisks were put up in Rome (see S. B. Platner and T. Ashby, *A Topographical Dictionary of Ancient Rome* (1929), pp. 366 ff.).

D 1501 Fig. 952

Studies of a right arm and a right hand. (On the verso: Study of a foot.)

170 × 144 (top corners cut). Black chalk, heightened with white on blue paper. (Water-stained and torn.)

PROV: David Laing; Royal Scottish Academy. Transferred 1910.

The drawing appears to be Roman, and not far from Sicciolante da Sermoneta.

D 4890/20 B Fig. 953

The Trinity.

105 × 136. Pen, pink-brown wash over black chalk. Squared in red chalk. (Laid down.) Inscribed: *Avanzino da Bologna.*

PROV: Marchese del Carpio; Paul and Edwardo Bosch, Madrid; H. M. Calmann. Purchased 1964.

The old ascription is nonsensical. The only Avanzi (or Avanzino) from Bologna was Jacopo, an artist born towards the end of the 14th century; the only other candidate could be Avanzino Nucci (1551–1629) who worked in Rome as an assistant to Niccolò Circignano, il Pomarancio. Although the drawing is not by Nucci, the wispy figures suggest an artist in the entourage of Circignano and the Cavaliere d'Arpino. The facial types are comparable with those in a drawing in the Louvre (Grand Format 1980) pointed out by Philip Pouncey, which is a design for the cupola of St Peter's Rome, which was eventually executed by d'Arpino, although the Louvre drawing is not by him.

ROMAN SEVENTEENTH CENTURY

D 743 Fig. 954

Three kneeling cloaked figures in front of a pope and his entourage.

149 × 216. Red chalk and red wash.

PROV: David Laing; Royal Scottish Academy. Transferred 1910.

The drawing entered the collection under the name of Carlo Maratta. Whilst this is incorrect, the drawing appears to be Roman, and of his period.

D 1050 Fig. 955

Copy of Jacopo Torriti's mosaic in the apse of S. Maria Maggiore.

309 × 427. Red chalk. (Laid down.) Inscribed: *fec. Nicola 4 dal 1288 al 1294. No. 10.*

PROV: Padre Resta; Lord Somers; William Roscoe; sale Liverpool, 23 September 1816, lot 5; David Laing; Royal Scottish Academy. Transferred 1910.

LIT: A. E. Popham, 'Sebastiano Resta and his Collections', OMD XI (1936), p. 5.

As A. E. Popham observed, this series of 11 drawings D 1050–1059 A (or 9, as D 1059 and 1059 A may not belong) almost certainly formed part of a series of 24, which belonged to Padre Sebastiano Resta, later to be acquired by Lord Somers. They were described in the letter written by John Talman in 1709 or 1710 to Dean Aldrich of Christ Church, Oxford (reprinted by Popham, *op. cit.* pp. 4–6): 'Vol. VI. This contains the ancient Greek paintings in the Mosaicks at Rome, and elsewhere, all by one hand, number 24, bound in parchment, gilt back and sides.' This volume was subsequently in the collection of William Roscoe of Liverpool. The remaining 13 (or 15) drawings must have been separated since then, and have not been traced. The writing on the drawings, that which generally occurs at the lower left, is certainly Resta's.

D 1051 Fig. 956

Copy of the mosaics on the façade of S. Maria Maggiore.

305 × 430. Red chalk. (Laid down.) Inscribed: *facciata di S. Mᵃ Maggiore. No. 46.*

PROV: Padre Resta; Lord Somers; William Roscoe; sale Liverpool, 23 September 1816, lot 5; David Laing; Royal Scottish Academy. Transferred 1910.

See note to D 1050.

D 1052 Fig. 957

Copy of the mosaic in the vault of the apse in S. Clemente.

304 × 425. Red chalk. (Laid down.) Inscribed: *S. Clemente. No. 5.* Indecipherable inscription on the right.

PROV: Padre Resta; Lord Somers; William Roscoe; sale Liverpool, 23 September 1816, lot 6?; David Laing; Royal Scottish Academy. Transferred 1910.

See note to D 1050. Another copy of this mosaic is at Windsor (8980), illustrated in Stephan Waetzoldt, *Die Kopien des 17. Jahrhunderts nach Mosaiken und Wandmalereien in Rom* (1964), no. 70, fig. 36.

D 1053 Fig. 958

Copy of mosaic on the wall of the apse in S. Clemente.

305 × 425. Red chalk. (Laid down.) Inscribed: *S. Clem^te No. 7.* Indecipherable inscription in the lower margin.

PROV: Padre Resta; Lord Somers; William Roscoe; sale Liverpool, 23 September 1816, lot 6?; David Laing; Royal Scottish Academy. Transferred 1910.

See note to D 1050. Another copy is at Windsor (9057), illustrated in S. Waetzoldt, *op. cit.* no. 74, fig. 37.

D 1054 Fig. 959

Copy of the mosaic on the wall of the apse in S. Maria in Trastevere.

305 × 427. Red chalk. (Laid down.) Inscribed: *S^a M^a in Trastevere No. 24.*

PROV: Padre Resta; Lord Somers; William Roscoe; sale Liverpool, 23 September 1816, lots 3 or 4; David Laing; Royal Scottish Academy. Transferred 1910.

See note to D 1050. Other copies are illustrated in S. Waetzoldt, *op. cit.* nos. 533 and 534, figs. 297 and 298.

D 1055 Fig. 960

Copies of two mosaics by Pietro Cavallini in the apse of S. Maria in Trastevere.

281 × 215. Red chalk. (Laid down.) Inscribed on the front in red chalk nos. *3 and 4*, and in ink on the back: *Mosaici fra Cavallini S. M. Tras[tevere].*

PROV: Padre Resta; Lord Somers; William Roscoe; sale Liverpool, 23 September 1816, lot 3 or 4; David Laing; Royal Scottish Academy. Transferred 1910.

See note to D 1050. Other copies are illustrated in S. Waetzoldt, *op. cit.* nos. 543 and 542, figs. 302 and 301.

D 1056 Fig. 961

Copy of mosaic in the vault of the apse in S. Maria in Trastevere.

283 × 426. Red chalk. (Laid down.) Inscriptions: *S. M^a. in Trastevere.*

PROV: Padre Resta; Lord Somers; William Roscoe; sale Liverpool, 23 September 1816, lots 3 or 4; David Laing; Royal Scottish Academy. Transferred 1910.

See note to D 1050. Another copy is illustrated in S. Waetzoldt, *op. cit.* no. 526, fig. 296.

D 1057 Fig. 962

Copy of mosaic by Pietro Cavallini on the façade of the Basilica di S. Paolo Fuori le Mura.

304 × 424. Red chalk. (Laid down.) Inscribed: *noto che i disegni di Giotto e di Pietro Cavallini sono migliore che loro mosaici. No. 21.* Illegible inscription at the top.

PROV: Padre Resta; Lord Somers; William Roscoe; sale Liverpool, 23 September 1816, lot 6?; David Laing; Royal Scottish Academy. Transferred 1910.

See note to D 1050. A later drawing of the same façade after restoration is illustrated in Joseph Wilpert, *Die Römischen Mosaiken und Malereien der kirchlichen Bauten vom III.–XII. Jahrhundert* (1924), II, pp. 627–8, fig. 292.

D 1058 Fig. 963

Copy of mosaic in the crypt-chapel of St Helen in S. Croce in Gerusalemme.

428 × 304. Red chalk. (Laid down.) Inscribed: *Soffitto ò sia la volta della capella di S. Elena sotterranea in S^a. Croce in Gerusaleme. No. 6.*

PROV: Padre Resta; Lord Somers; William Roscoe; sale Liverpool, 23 September 1816, lot 6?; David Laing; Royal Scottish Academy. Transferred 1910.

D 1059 Fig. 964

Copy of the mosaics below the vault of the apse in S. Giovanni in Laterano.

130 × 412. Black and red chalk, details in brown wash. (Repaired.) Inscribed: *54.*

PROV: David Laing; Royal Scotish Academy. Transferred 1910.

It is not certain that this and the following drawing (D 1059 A) belonged to the Padre Resta series (see note to D 1050), as stylistically they are somewhat different from the rest.

D 1059 A Fig. 965

Copy of four details from the mosaics in the apse of S. Giovanni in Laterano.

98 × 336. Red and black chalk. (Torn.) Inscribed: *55*.

PROV: David Laing; Royal Scottish Academy. Transferred 1910.

See note to D 1059. The two outer figures (the architect and the mason) are details from D 1059.

D 1525 Fig. 966

A kneeling female saint, surrounded by angels.

145 × 109. Black chalk on buff paper.

PROV: David Laing; Royal Scottish Academy. Transferred 1910.

The style of the drawing suggests an artist working in Rome during the first half of the 17th century, not far from Pietro Testa. The kneeling figure appears to be a Saint, holding in her right hand what looks like a crucifix.

D 1602 Fig. 967

Christ's charge to Peter.

56 (diameter). Pen, brown ink and wash.

PROV: David Laing; Royal Scottish Academy. Transferred 1910.

The original, nonsensical, ascription was to Parmigianino. The drawing appears to be of the early 17th century, probably Roman and not far from Francesco Vanni, who after all worked in Rome at the beginning of the century. The small design may have been intended for a papal cope or medal.

D 1623 Figs. 968 and 969

(*recto*) Studies of two heads;
(*verso*) Head of a man.

295 × 200. Red chalk.

PROV: David Laing; Royal Scottish Academy. Transferred 1910.

The drawing seems to be Roman, not far from Guillaume Courtois (called Cortese or Borgognone).

D 1646 Fig. 970

The penitent Magdalen.

204 × 171. Red chalk.

PROV: David Laing; Royal Scottish Academy. Transferred 1910.

The drawing seems to be Roman and of the post-Maratta period.

D 1663 Fig. 971

The discovery of Romulus and Remus.

178 × 257. Pen and brown ink. (Laid down.) Inscribed: *282* and *N. Poussin 162*.

PROV: David Laing; Royal Scottish Academy. Transferred 1910.

In spite of the inscription, the drawing seems to be Italian, probably Roman, and by an artist influenced by the Carracci and Grimaldi.

D 2905 Fig. 972

A flying angel.

231 × 210. Red chalk on buff paper. (Laid down.)

PROV: W. F. Watson. Bequeathed 1881.

The drawing appears to be Roman, in the neighbourhood of Guglielmo Cortese, and foreshadowing Gaulli's style.

D 3012 Fig. 973

Bust of a Roman emperor.

100 × 90. Pen, brown ink and wash, heightened with white on blue paper. Inscribed: *di Giuseppe del Sole*.

PROV: W. F. Watson. Bequeathed 1881.

The attribution to dal Sole is probably misleading as the drawing seems to be Roman, and not Bolognese.

D 3068 Fig. 974

The crucifixion of St Andrew.

317 × 199. Pen and brown ink over black chalk. (Laid down.) Inscribed on the back: *Testa (Pietro)*.

PROV: ? John, Viscount Hampden (L. 2837); Charles Jourdeuil (L. 527); W. F. Watson. Bequeathed 1881.

The drawing entered the collection with an ascription to Testa, but seems to have nothing to do with him. It is evidently a copy, and very coarse and bad at that. The composition has some features in common with the painting by Giov. Batt. Lenardi (1656–1704) behind the altar in S. Andrea delle Fratte in Rome, although not enough to be connected directly with the painting.

D 3177 Fig. 975

Standing female figure holding large keys, with a dog at her side ('Fidelity').

284 × 182. Red chalk. (Laid down.) Inscribed: *Carlo Maratti*.

PROV: W. F. Watson. Bequeathed 1881.

Although this drawing may date from the 17th century, it has nothing to do with Maratta but is a copy of G. B. Lombardelli's fresco in the Sala Vecchia degli Svizzeri in the Vatican, which dates from the end of the 16th century.

D 3188 Fig. 976

Two male nudes.

370 × 492. Red chalk.

PROV: W. F. Watson. Bequeathed 1881.

Probably Roman, faintly in the manner of Sacchi's academies.

D 3220 Fig. 977

Mars, Venus and Cupid.

245 × 338. Red chalk. (Laid down.) Inscribed on drawing and old mount: *N. Poussin.*

PROV: W. F. Watson. Bequeathed 1881.

The drawing (obviously a counterproof) appears to be by a Roman artist, working in the Cortona–Romanelli tradition.

RSA 295 Fig. 978

A Roman triumphal procession.

313 × 995. Pen, brown ink and wash over black chalk, on brown paper.

PROV: David Laing; Royal Scottish Academy. On loan 1966.

ROMAN
EIGHTEENTH CENTURY

D 961

Soldiers near Roman ruins.

211 × 130. Pen, brown ink and wash, over black chalk. (Torn and damaged.) Inscribed on the mount: 'Panini'.

PROV: David Laing; Royal Scottish Academy. Transferred 1910.

This damaged and rather feeble drawing may have originated in the circles of Panini or Locatelli.

D 1607 Fig. 979

The Virgin appearing to St Anthony Abbot.

290 × 168. Black chalk, heightened with white on green toned paper. (Laid down.) Pencilled inscription on old mount: 'Franceschini'.

PROV: David Laing; Royal Scottish Academy. Transferred 1910.

It is not clear whether the ascription 'Franceschini' on the mount is supposed to refer to Volterrano or Marcantonio Franceschini. Either suggestion, however, would be wrong. The drawing is certainly 18th century Roman, and shows the influence of Maratta. The type of the Madonna and the fall of the drapery are reminiscent of Stefano Pozzo, whose manner of drawing, however, is less free and more deliberate.

D 1912 Fig. 980

Autumn.

312 × 220. Red chalk. (Laid down.)

PROV: (?Allan Ramsay); Lady Murray. Presented 1860.

The drawing is undoubtedly by an 18th century Roman artist (*c.* 1720, as Anthony Clark suggested). Together with its companion (D 1911), it probably forms a pair from a series illustrating *The Four Seasons,* of which the remaining two have not been traced. The careful draughtsmanship of both drawings would suggest that they might have been intended for an engraver.

D 2944

Autumn.

This is a counterproof of D 1912.

D 1911 Fig. 981

Winter.

314 × 223. Red chalk. (Laid down.)

PROV: (?Allan Ramsay); Lady Murray. Presented 1860.

See note to D 1912.

RSA 158 Fig. 982

A seated prophet, holding a lamp.

315 × 215. Black chalk, heightened with white, on blue paper. Inscribed: *43,* and on the mount: 'Galeotti'.

PROV: David Laing; Royal Scottish Academy. On loan 1966.

The ascription to Galeotti (Sebastiano or Giuseppe?) is in a recent hand. The drawing seems, however, to be Roman, rather than North Italian, and may have originated from an artist of the circle of Stefano Pozzo.

RSA 285 Fig. 983

St John the Baptist preaching.

198 × 268. Black chalk, some details in pen and ink. Inscribed on mount: 'Fuseli'.

PROV: David Laing; Royal Scottish Academy. On loan 1966.

The drawing is probably by a follower of Maratta.

RSA 319 Fig. 984

St Luke painting the Virgin. (Slight sketches of a chair and putti on the back.)

248 × 173. Pen and ink with grey and brown wash. Inscribed on the back: *Con l'occasione de son tornato in Roma.*

PROV: David Laing; Royal Scottish Academy. On loan 1966.

This drawing, though very Italianate, may not after all be by an Italian artist. A name which has been considered is the Spanish painter Mariano Salvador Maella (1739–1819) who worked in Rome, and under Mengs in Madrid. A drawing by Maella in the Biblioteca Nacional, Madrid (B. 1354) of *St Ignatius of Loyola adoring the Trinity* (ill. *Spanische Zeichnungen von El Greco bis Goya* (Hamburg, 1966), 150, pl. 80) comes very close indeed to RSA 319.

RSA 320 Fig. 985

Adoration of the Shepherds.

232 × 149. Pen, brown ink and wash over black chalk. Squared in black chalk. Inscribed on the back: *Alla Sant di . . . / PP Clemete XI / La Compagnia di S. Caterina / della nazione Senese in Roma.*

PROV: David Laing; Royal Scottish Academy. On loan 1966.

Probably by a Maratta follower.

RSA 435 Fig. 986

Three studies for *Lot and his daughters*.

232 × 164. Black chalk, the middle sketch squared.

PROV: David Laing; Royal Scottish Academy. On loan 1966.

No painted version of this composition has been traced. The style seems to be Roman, and suggests an artist from the Luti–Trevisani–Batoni circle.

SIENESE
SIXTEENTH CENTURY

D 3004 Fig. 987

Standing figure.

264 × 159. Brush and oil colour on paper. (Repaired and laid down. Cut to an octagonal.)

PROV: W. F. Watson. Bequeathed 1881.

Very close in style to Francesco Vanni, for example his oil sketch of the *Virgin and Child with Saints* in the Uffizi (4773 s).

SIENESE
SEVENTEENTH CENTURY

D 1690 Fig. 988

Profile head of a nun.

165 × 165. Black and red chalk, heightened with white, on blue paper.

PROV: David Laing; Royal Scottish Academy. Transferred 1910.

D 3039 Fig. 989

A male and female saint adoring the Eucharist, with angels above.

222 × 149. Pen, brown ink and coloured washes, over red chalk. (Laid down.)

PROV: W. F. Watson. Bequeathed 1881.

RSA 284 Fig. 990

The Madonna blessing a kneeling male figure.

208 × 160. Red chalk and wash. (Laid down.)

PROV: David Laing; Royal Scottish Academy. On loan 1966.

The drawing may be Sienese, but there are also strong affinities (especially in the kneeling figure) with Biliverti.

VENETIAN
SIXTEENTH CENTURY

D 716 Fig. 991

A religious procession.

170 × 225. Pen, brown ink and wash. (Laid down. Lower left margin damaged.) Pencil note on mount: '5th Day Lt. 66'.

PROV: Nathaniel Hone; David Laing; Royal Scottish Academy. Transferred 1910.

Formerly ascribed to Pietro da Cortona, this drawing seems to be Venetian, to some degree influenced by Palma Giovane.

D 832–844 Figs. 992–1000

A series of emblematic illustrations.

Various sizes, the majority being either 145 × 130, or 202 × 137. Pen, brown ink and coloured washes.

PROV: David Laing; Royal Scottish Academy. Transferred 1910.

This series of drawings comprises illustrations for the prophecies of the popes by the Abbot Joachim, whose *Vaticinia sive Prophetiae* was published in numerous editions in Italy, embellished with emblematic engravings. The comparative crudeness of these drawings may point to the fact that they were intended for some popular edition, or on the other hand that they are mere copies. None of them corresponds directly with any of the illustrations in the published editions, although some come fairly close to those printed at Ferrara in 1591 and at Venice in 1600 and 1605. Prof. Lamberto Donati has drawn attention to two fine 15th century illuminated manuscripts in the Vatican

(Chig. A. VII. 220, and Reg. Lat. 580) in which some of the illustrations have affinities with the present drawings. Those that correspond with either the manuscripts or the printed editions are listed below.

D 832: variant of Chig. 2a; Reg. 1a (Nicolaus III); Ferrara, 1591 and Venice, 1600. Vaticinum XI 'Stolam suam in sanguine Agni dealbabit'.

D 833 recto: Venice 1605. 'Rota Beati Iodochi Palmerij de XVI. Futuris Pontificiis' (Marcellus II, 1555).

D 834: Chig. 7b; Reg. 6b (in reverse) (Innocentius VI); Venice, 1600. Vaticinium XII, 'Lupus habitabit cum Agno, paterque cibabit'.

D 836 recto (top): variant of Chig. 9a (Urbanus VI).

D 837 recto: Chig. 3b; Reg. 2b (Nicolaus IV); Ferrara, 1591 and Venice, 1600. Variant of Vaticinium V 'Onorius bibet de Calice irae Dei'.

D 837 verso: Chig. 3a; Reg. 2a (Onorius IV); Ferrara, 1591 and Venice, 1600. Variant of Vaticinium III 'Duros corporis sustinebit labores'.

D 838: Chig. 7a; Reg. 6a (Clemens VI).

D 839 recto: Chig. 2a; Reg. 1a (Nicolaus III); Ferrara, 1591 and Venice 1600, Fol. A₁ verso Vaticinium Primum 'Stellas congregabit ut luceant in firmamento coeli'.

D 839 verso: Chig. 2b; Reg. 1b (Martinus IV); Ferrara, 1591 and Venice, 1600, Fol. A₂ verso Vaticinium II 'Clauibus claudet, & non aperiet'.

D 1169

The Holy Family with St John.

251 × 227. Red chalk. (Laid down.) Inscribed in pencil on the back: *Titian*.

PROV: Count von Ross (L. 2693); David Laing; Royal Scottish Academy. Transferred 1910.

A counterproof, and obviously a copy. The composition, which may be Venetian, has not been identified.

D 1486

A left foot.

153 × 122. Black chalk, heightened with white on blue paper.

PROV: David Laing; Royal Scottish Academy. Transferred 1910.

A study with reminiscences of Bassano as well as Barocci.

D 1543

Fig. 1001

Three heads.

310 × 208. Red chalk on buff paper. (Torn and laid down.) Inscription in ink: *Giorgione*.

PROV: David Laing; Royal Scottish Academy. Transferred 1910.

RSA 20

Fig. 1002

Wooded bluffs with houses in the background.

248 × 267. Pen and brown ink (faded).

PROV: J. van Rijmsdijk (L. 2167); another collector's mark cut out; David Laing; Royal Scottish Academy. On loan 1966.

In the manner of Titian and Campagnola.

RSA 125

Fig. 1003

River landscape with fortified town.

227 × 350. Pen and brown ink over black chalk. Inscribed on the back, in an old hand: *40 | ?simonneau Cetna facie-[bat]*, and 'Campagnola' on the mount in Richardson's hand.

PROV: J. Richardson, Jnr (L. 2170); David Laing; Royal Scottish Academy. On loan 1966.

This drawing cannot be from Campagnola's own hand, but it does seem to be Venetian, and of his period.

RSA 222

Fig. 1004

St Francis kneeling.

287 × 206. Black chalk heightened with white on blue paper. Inscribed: *Titiano*, in Richardson's hand.

PROV: J. Richardson, Senr (L. 2183); J. Barnard; Horace Walpole, according to inscription on the back: *Bought at Strawberry Hill Sale 1842*; David Laing; Royal Scottish Academy. On loan 1966.

The ascription to Titian is wrong, and the drawing, though probably Venetian, appears to be by a later hand.

RSA 262

Fig. 1005

Seated bishop with Tobias and the angel and a female martyr (? St Dorothea).

210 × 204. Pen, brown ink and wash. (Laid down.) Pencilled inscriptions: *Albano* and *Campagnola*.

PROV: David Laing; Royal Scottish Academy. On loan 1966.

The stylistic influences seem to be derived from Palma Giovane.

VENETIAN SEVENTEENTH CENTURY

D 692 Fig. 1006

The supper at Emmaus.

218 × 293. Pen, brown ink and wash over black chalk. Squared in red chalk. (Laid down.) Inscribed on the mount: 'Tintoretto'.

PROV: Benjamin West; David Laing; Royal Scottish Academy. Transferred 1910.

The old ascription to Tintoretto is incorrect. However, the drawing seems to be Venetian, although the figure of the man pouring wine out of the pitcher appears to show an influence of Luca Giordano.

D 715 Fig. 1007

The Entombment.

220 × 211. Black chalk with grey wash. Inscribed No. *10* in bottom right corner, and *No. 454* in pencil on the back.

PROV: David Laing; Royal Scottish Academy. Transferred 1910.

This drawing is probably a copy.

D 2896 Fig. 1008

St Cecilia and Valerian visited by an angel.

221 × 126. Pen, brown ink and wash heightened with white. Squared in black chalk. 19th century inscription: *Jacopo da Empoli* on drawing and mount.

PROV: Robert Udny; W. F. Watson. Bequeathed 1881.

This very feeble drawing has nothing to do with Empoli, but seems rather 'Venetic'. There are vague resemblances to the style of Palma Giovane. In fact the figure of St Cecilia, although very crudely drawn, is similar to the St Catherine of Alexandria in the drawing at the Courtauld Institute (2549) depicting the Saint adoring the crucified Christ, with St Magdalen at the foot of the Cross, which has an inscription to Pietro Damini (in the 'reliable Venetian hand'), who was a pupil of Palma.

D 2917 Figs. 1009 and 1010

(*recto*) The Annunciation;
(*verso*) Studies for a *Presentation in the Temple*.

174 × 245. Pen, brown ink and wash (verso pen and ink only). Inscribed on recto (in pencil) *21*, and (in ink) *Keer om* (i.e. turn over).

PROV: J. Pz. Zoomer; W. F. Watson. Bequeathed 1881.

A date around 1600 may be suggested for this drawing. The verso reveals echoes of early Palma Giovane.

D 3127 Fig. 1011

Group of five saints including St Roch, St Anthony of Padua and St Sebastian.

229 × 198. Pen, brown ink and wash. (Laid down.) Inscribed on the mount: 'S. Ricci'.

PROV: W. F. Watson. Bequeathed 1881.

The ascription to Sebastiano Ricci cannot be accepted, although the drawing appears to be 17th century and Venetian. It is probably by a minor artist from the Veneto. The composition represents very likely the lower part of a *Coronation* or *Assumption of the Virgin*.

VENETIAN EIGHTEENTH CENTURY

D 589 Fig. 1012

The flagship 'Aurora'.

378 × 530. Pen, ink and water-colour on vellum.

PROV: David Laing; Royal Scottish Academy. Transferred 1910.

The inscription on the cartouche reads: NAVE AVRORA / CAPITANIA / 1697 N. II / PIERO DVODO.

R. C. Anderson gave the information that the 'Aurora' of 80 guns was built in Venice in 1696 and lasted till 1709. It was Duodo's flagship when he was Commander in Chief of the fleet in 1697. (See R. C. Anderson, *Naval Wars in the Levant* (1952), p. 230.) Anderson suggested a date around 1710 for this drawing.

D 590 Fig. 1013

The flagship 'Venere (Armata)'.

373 × 534. Pen, ink and water-colour on vellum.

PROV: David Laing; Royal Scottish Academy. Transferred 1910.

The inscription on the cartouche reads: NAVE VENET / PATRONA / N II / ALVISE CONT/ARINI.

R. C. Anderson identified the ship as the 'Venere (Armata)' built in 1684, struck off in 1702. It was in the fleet of 1697. From the inscription it should have been the flagship of the 2nd in command, but Anderson cannot find any occasion when she was, nor any mention of Alvise Contarini. He suggests a dating of around 1710.

D 591 Fig. 1014

An English merchant ship.

377 × 517. Pen, ink and water-colour on vellum.

PROV: David Laing; Royal Scottish Academy. Transferred 1910.

R. C. Anderson says that the drawing could not be before 1710. The presence of jibs and jib-booms would be most unlikely before c. 1705, unless the Venetians were ahead of the English in the matter of such improvements. Anderson suggests that it might be the 'Smyrna Factor', a merchantman hired by Venice in 1695. The 'Fattore di Smirna' appears in a list of ships hired in that year and 'Smyrna Factor' is a name which turns up now and then.

D 1551 Fig. 1015

Caricature of two priests.

257 × 176. Black chalk. (No. *76* in ink on the back.)

PROV: 'P. Crozat'? (L. 474); (? Paul Sandby); David Laing; Royal Scottish Academy. Transferred 1910.

D 2969 Figs. 1016 and 1017

(*recto*) Susannah and the elders;
(*verso*) Group of figures.

184 × 135. Pen, brown ink and wash; traces of black chalk on the recto.

PROV: W. F. Watson. Bequeathed 1881.

The recto is possibly a copy after Sebastiano Ricci.

D 3097 Fig. 1018

A water-carrier.

265 × 173. Brush, grey wash, heightened with white on grey prepared paper.

PROV: W. F. Watson. Bequeathed 1881.

Probably by a late Venetian artist, with very faint echoes from Bassano.

D 3175 Fig. 1019

A woman pursued by a king and his attendants in a burning building.

244 × 315. Pen, brown ink and wash over black chalk.

PROV: E. Peart; W. F. Watson. Bequeathed 1881.

RSA 117 Fig. 1020

Bridge and mill near fortified building.

280 × 420. Brush and brown wash over red chalk, on buff paper.

PROV: David Laing; Royal Scottish Academy. On loan 1966.

A drawing showing the influence of Marco Ricci, and near to Zais.

SCHOOL OF VERONA
SIXTEENTH CENTURY

RSA 221 Fig. 1021

A bishop healing the sick, with subsidiary scene in the background showing the bishop and attendant figures appealing to an emperor. Above: The Madonna interceding with the Trinity on behalf of the bishop.

385 × 206 (arched top). Pen, brown ink and wash, heightened with white on blue paper. Inscribed on the old mount: 'Paulo Farinati'.

PROV: Sir Peter Lely; David Laing; Royal Scottish Academy. On loan 1966.

Although the old ascription to Paolo Farinati is incorrect, the drawing appears certainly to be by a Veronese artist of his period.

RSA 266 Fig. 1022

Two men killing a slave; in the background, two men weighing gold.

408 × 275. Pen, brown ink and wash over black chalk, heightened with white on blue paper. (Laid down.) Inscribed: *Paulo Veronese*.

PROV: N. Lanier (L. 6888); David Laing; Royal Scottish Academy. On loan 1966.

Probably by a minor Veronese artist, or a copy. Terence Mullaly has suggested that the drawing is by Francesco Montemezzano, comparing it with the drawing at Darmstadt (AE 1393), signed and dated 1584 (Tietze, 805).

D 3077 Fig. 1023

The Circumcision.

327 × 251. Pen, black ink and brown wash, heightened with white on prepared paper. (Laid down.) Inscribed (on the steps) with the date: *1547*; on the back, in pencil: *Francesco Salveato*.

PROV: W. F. Watson. Bequeathed 1881.

The ascription to Francesco Salviati is wrong, nor could an attribution to his pupil Giuseppe Salviati (Porta) be maintained. The drawing is almost certainly Veronese, showing faint resemblances to Farinati, and in some of the background figures to Schiavone.

D 3163 Fig. 1024

Christ rising from the Tomb.

330 × 254. Pen, brown ink and wash on faded blue paper. (Laid down.) Inscribed in a 19th century hand: *Cavedone*.

PROV: Ch. Jourdeuil (L. 527); W. F. Watson. Bequeathed 1881.

The ascription to Cavedone is certainly incorrect. The drawing appears to be by a fairly late 16th century, or early 17th century, highly Mannerist artist, most probably Veronese, but in contact with Central-Italian Mannerism. Particularly the soldiers reveal faint Zuccaresque features. The style is not far from that of the Veronese artist Pasquale Ottini (c. 1580–1630).

SCHOOL OF VERONA SEVENTEENTH CENTURY

D 3110 Fig. 1025

The Holy Family attended by angels.

252 × 196. Pen, brown ink and wash, traces of black chalk. (Laid down.)

PROV: R. Cosway (L. 629); W. F. Watson. Bequeathed 1881.

Possibly by a Venetian artist from the circle of Palma Giovane, but more likely to be by a Veronese draughtsman.

NORTH ITALIAN SIXTEENTH CENTURY

D 704 Figs. 1026 and 1027

(recto) A seated bearded old man with hat and cloak;
(verso) A boy kneeling before a seated woman.

200 × 187. Pen and brown ink. Inscribed on the verso: *Titiano 17.*

PROV: Jonathan Richardson, Senr; Barry Delany (L. 350); David Laing; Royal Scottish Academy. Transferred 1910.

The drawing is possibly by a follower of Romanino.

D 747 Fig. 1028

Putti playing with a boar.

122 × 230. Pen, brown ink and wash. Inscribed in lower left corner: *3*; on the back: *Giulio Campi Cremonese nacque 1546. Scolario del Salviati e di Giulio Romano.*

PROV: John McGowan (L. 1496); sale Philipe, 26 January 1804, lot 116; David Laing; Royal Scottish Academy. Transferred 1910.

The old ascription to Giulio Campi cannot be maintained. The drawing, however, seems to be North Italian, 16th century, and not very far from Romanino.

D 1505 Fig. 1029

Head of a child.

160 × 126. Black chalk on faded blue paper (water-stained).

PROV: David Laing; Royal Scottish Academy. Transferred 1910.

D 1584 Fig. 1030

The Annunciation.

530 × 405 (arched top). Pen, brown ink with grey and brown washes. (Laid down.)

PROV: Sir Thomas Lawrence; David Laing; Royal Scottish Academy. Transferred 1910.

A 19th century ascription refers to Francesco Albani, a name frequently, and irresponsibly, called upon where representations of the *Annunciation* are concerned, with whom this feeble drawing, however, cannot be connected. Not even the composition appears to be his, but it might well be Bolognese.

D 1762 Fig. 1031

St Nicholas rescuing the three boys from the tub, with donor kneeling on the left.

274 × 200. Pen, brown ink and wash. (Laid down and very damaged.) Inscribed on the mount in a 19th century hand: 'Paul Veronese', and 'Lanfranco' on the back.

PROV: David Laing; Royal Scottish Academy. Transferred 1910.

Although the sheet is almost a total wreck, it seems clear that it is a drawing from the first half of the 16th century, perhaps by a Mantuan artist, and a follower of Giulio Romano.

D 1896 Fig. 1032

St James the Great.

263 × 122. Red chalk and red wash on buff paper, squared in black chalk. (Laid down.)

PROV: (?Allan Ramsay); Lady Murray. Presented 1860.

No attribution has been found for this impressive drawing. The pose and the voluminous drapery suggest a North Italian artist who has been remotely influenced by Titian.

D 2888 Fig. 1033

Christ holding the keys.

374 × 223. Brush and wash, heightened with white, over black chalk, on faded blue paper.

PROV: W. F. Watson. Bequeathed 1881.

The drawing may be Milanese. The modelling and colour of the drapery are very close to Morazzone.

D 2931 Fig. 1034

Head of a bearded man.

181 × 138. Black chalk with touches of red chalk on buff paper. (Laid down.)

PROV: W. F. Watson. Bequeathed 1881.

The decorative quality of the beard and the style in general are not far from Camillo Procaccini.

D 2947 Fig. 1035

Cupid shooting arrows.

134 × 120. Pen, brown ink over black chalk. Inscribed in pencil: *Domenichino*.

PROV: W. F. Watson. Bequeathed 1881.

D 3030–3032 Figs. 1036–1038

Three sections of a triumphal procession.

234 × 358. Pen, brown ink and wash on discoloured blue paper. (Laid down.)

PROV: W. F. Watson. Bequeathed 1881.

It is almost impossible to pass judgement on these three faded drawings. Some remote echoes from Domenico Campagnola are still discernible in the figures, and the designs may be by a weak provincial follower of his from the next generation, perhaps working in Verona or Padua.

D 3052 Fig. 1039

Madonna and Child.

180 × 122. Black chalk on blue paper. (Laid down.)

PROV: W. F. Watson. Bequeathed 1881.

The drawing, like D 3111, is possibly Cremonese, fairly close to Camillo Boccaccini, but also showing the influence of the Campi, as well as revealing remote echoes from Parmigianino.

D 3090 Fig. 1040

The Flagellation of Christ.

325 × 452. Black chalk on blue paper, squared. (Parts of both side margins added.) Inscribed in lower margin by a late hand: *Gius^{e.} D'Arpino*.

PROV: F. Renaud (L. 1042 Suppl.); W. F. Watson. Bequeathed 1881.

The name of the Cav. d'Arpino may have got attached to this drawing because of the superficial resemblance of the composition to his ceiling decoration in the Sala del Capitolo in the Certosa di S. Martino, Naples. However, the style of the drawing suggests a North Italian, possibly a Lombard artist, not far from Girolamo Muziano.

D 3111 Fig. 1041

Studies for a St Paul and a St Matthew.

101 × 113. Black chalk on blue paper. Inscribed on the old backing: 'Poccetti'.

PROV: W. F. Watson. Bequeathed 1881.

This interesting drawing is likely to be by a Cremonese artist close to Camillo Boccaccini.

D 4820 E Fig. 1042

St Jerome as Cardinal holding the Church. (On verso: study of hands.)

209 × 155. Pen, brown ink and wash over black chalk. Inscribed on the back: [Ge]*ronimo Cardinali*.

PROV: Taken from an album, once in the possession of Richard Cooper Senr and Jnr—the engravers and landscape painters. Presented by Miss M. Eyre, 1959.

Probably by an artist close to Denys Calvaert.

D 4890/16 Figs. 1043 and 1044

(*recto*) A group of figures within a classical building, watching a youth being robed (or disrobed); (*verso*) Classical buildings and ruins.

225 × 155 (arched top). Pen and brown ink. (Stained.) Illegible inscription along the right margin.

PROV: Marchese del Carpio; Paul and Edwardo Bosch, Madrid; H. M. Calmann. Purchased 1964.

The style of this drawing would suggest a North Italian artist of the mid-16th century, probably working in Bergamo or Brescia, possibly from the circle of the Campi.

D 4890/28 Fig. 1045

St Matthew. (On the verso: another, very faint, sketch of a similar figure.)

163 × 109. Recto: pen, ink and wash. Verso: black chalk (much rubbed). Inscriptions: (recto) *F. Zuccaro*; (verso) *del furore?*

PROV: Marchese del Carpio; Paul and Edwardo Bosch, Madrid; H. M. Calmann. Purchased 1964.

The style of the drawing seems to suggest a North Italian, perhaps Lombard, artist who has absorbed Parmigianinesque influences.

RSA 426 Fig. 1046

Design for a church façade.

468 × 362. Pen, brown ink and wash. (Torn and damaged.)

PROV: David Laing; Royal Scottish Academy. On loan 1966.

The watermark of the paper is close to Briquet 7111 (Perugia 1544). The architecture appears to be North Italian, possibly Milanese.

RSA 427 Fig. 1047

Design for a domed cathedral.

442 × 418. Pen, brown ink and wash. (Badly torn.)

PROV: David Laing; Royal Scottish Academy. On loan 1966.

The watermark of the paper is close to Briquet 4835 (Lucca 1565/6; Rome 1567/8). The architecture, and especially the 'fish-scale' dome, suggests a North Italian provenance, possibly Milanese or Piedmontese.

NORTH ITALIAN
SEVENTEENTH CENTURY

D 2942 Fig. 1048

St John in the wilderness.

155 × 199. Pen, brown ink and wash over red chalk. Inscribed on back: *Wonigetti*.

PROV: W. F. Watson. Bequeathed 1881.

D 2951 Fig. 1049

Reclining winged male figure.

224 × 352. Black chalk. (Torn in parts.)

PROV: W. F. Watson. Bequeathed 1881.

Probably a copy from a composition possibly by or in the manner of Camillo Procaccini.

D 2959 Fig. 1050

Fleeing warriors.

113 × 132. Brush and oil colour on yellow prepared paper.

PROV: N. Hone; W. F. Watson. Bequeathed 1881.

D 2965 Fig. 1051

Bacchanalian scene.

136 × 195. Pen, brown ink and wash. (Laid down.)

PROV: W. F. Watson. Bequeathed 1881.

Somewhere in the neighbourhood of Giulio Carpioni.

D 2968 Fig. 1052

Putto holding up curtain, revealing angels with whip and sword.

167 × 193. Brush and brown wash, heightened with white, over red chalk. Inscribed on the back: *Cavallino*.

PROV: J. Auldjo; W. F. Watson. Bequeathed 1881.

Possibly Bolognese.

D 2991

Heads of three men conversing.

200 × 284. Red and black chalk. (Stained.)

PROV: W. F. Watson. Bequeathed 1881.

D 3123 Fig. 1053

River landscape with trees.

184 × 288. Pen and brown ink over black chalk. Inscribed: *Campagnola*.

PROV: W. F. Watson. Bequeathed 1881.

D 3189 Fig. 1054

River landscape with shepherd.

254 × 378. Brush and brown wash.

PROV: W. F. Watson. Bequeathed 1881.

NORTH ITALIAN
EIGHTEENTH CENTURY

D 1000 Fig. 1055

River landscape with tower, other buildings and figures.

183 × 224. Pen, brown ink and grey wash. Inscribed on the old backing: 'Panini'.

PROV: David Laing; Royal Scottish Academy. Transferred 1910.

The drawing seems to be North Italian, possibly Venetian.

D 1933 Fig. 1056

Figures for a bacchanalia.

75 × 244. Red chalk. (Laid down.)

PROV: (?Allan Ramsay); Lady Murray. Presented 1860.

The drawing, although probably 18th century, appears to have been influenced by similar compositions of Giulio Carpioni, the Venetian–Veronese painter and engraver.

CENTURIES

SIXTEENTH CENTURY

D 825
Fig. 1057

Two figures embracing.

177 × 125. Red chalk.

PROV: Sir Thomas Lawrence; David Laing; Royal Scottish Academy. Transferred 1910.

The style of this drawing is in the Michelangelo–Sebastiano del Piombo tradition. It probably is a copy of part of a larger composition by an artist of the period between Michelangelo and Bronzino.

D 916
Fig. 1058

Design for a tabernacle.

502 × 283. Pen and brown ink. (Laid down.) Old inscription: *Baldassare da Siena*.

PROV: David Laing; Royal Scottish Academy. Transferred 1910.

The drawing has nothing to do with Peruzzi, as the inscription suggests.

D 917
Fig. 1059

Design for an altar, with an uncompleted escutcheon above.

389 × 231. Pen, brown ink, with brown and coloured washes.

PROV: David Laing; Royal Scottish Academy. Transferred 1910.

The architecture may be Tuscan.

D 918
Fig. 1060

Design for an altar, with an uncompleted escutcheon above.

375 × 266. Pen, brown ink, with brown and coloured washes. Inscribed at the bottom: *Canne. 3*.

PROV: David Laing; Royal Scottish Academy. Transferred 1910.

See note for D 917.

D 919
Fig. 1061

Part of a palace façade with giant orders.

270 × 290. Pen, brown ink and wash. (Damaged and cut all round.)

PROV: David Laing; Royal Scottish Academy. Transferred 1910.

D 1228
Fig. 1062

Design for a ceiling.

190 × 127. Pen, brown ink and grey wash. Outlines incised. Inscriptions on the back are illegible, apart from: *AVE MARIS STELLA*. (Remains of strong horizontal and vertical folds visible.)

PROV: David Laing; Royal Scottish Academy. Transferred 1910.

The elaborate 'programme' of this decoration contains at the bottom female figures of 'Virtues', including Wisdom, Temperance, Truth and Fortitude. The all-embracing tree, encircling the composition, features a drum, a ducal coronet and books; and putti are seen carrying a mitre, a papal tiara and a bishop's hat.

The tree, possibly a pear-tree, may allude to Pope Sixtus V (Peretti), as C. L. Frommel has suggested, which would explain the papal crown, and date the drawing at the end of the 16th century.

D 1482

The lower part of a left foot.

84 × 235. Red chalk.

PROV: Paul Sandby; David Laing; Royal Scottish Academy. Transferred 1910.

Probably copied from an antique statue.

D 1552
Fig. 1063

The symbols of the four Evangelists.

206 × 148 (overall size, irregularly cut). Pen and brown ink. (Laid down.) Pencilled inscription on the mount: 'Giulio Romano'.

PROV: Paul Sandby; David Laing; Royal Scottish Academy. Transferred 1910.

The shape of the design suggests perhaps a decoration for a cope.

D 1556
Fig. 1064

A male torso seen from the front and from the back.

270 × 330. Red chalk. (Laid down.)

PROV: Paul Sandby; David Laing; Royal Scottish Academy. Transferred 1910.

Most probably copies from an antique sculpture, such as a 'discobolos'.

D 1769 Fig. 1065

Male figure seen from the back.

408 × 218. Pen, brown ink and wash, over black chalk. (Damaged.) Inscribed at the bottom: *A. Carracci*.

PROV: David Laing; Royal Scottish Academy. Transferred 1910.

The figure might possibly have been copied from, or inspired by, Francesco Salviati.

D 1878 Fig. 1066

Standing female figure.

216 × 136 (a strip of 10 mm added at the top). Red chalk on buff paper.

PROV: (?Allan Ramsay); Lady Murray. Presented 1860.

A drawing of the late 16th century, probably copying an antique statue. The facial type is close to Baglione.

D 2756 B Fig. 1067

The Resurrection.

210 × 184. Tempera and gold-leaf on vellum.

PROV: W. F. Watson. Bequeathed 1881.

D 2961 Fig. 1068

Isaac blessing Jacob.

106 × 115. Pen, brown ink and wash on toned paper.

PROV: W. F. Watson. Bequeathed 1881.

The composition is vaguely reminiscent of the same scene by Raphael in the Vatican *Loggie*.

D 2966 Figs. 1069 and 1070

(*recto*) Design for two sides of a table ornament;
(*verso*) Design for a lunette showing a river-god, a lion and a tiara.

144 × 92. Pen, brown ink and wash; trace of black chalk on the recto.

PROV: W. F. Watson. Bequeathed 1881.

D 2984

Reclining male figure seen from the back.

234 × 292. Pen, brown ink and wash, heightened with white, over black chalk, and traces of red chalk. (Laid down.)

PROV: W. F. Watson. Bequeathed 1881.

A feeble drawing, somewhat in the manner of figures occurring in *chiaroscuro* prints after Beccafumi.

D 3022

Solomon and the Queen of Sheba.

212 × 327. Pen, brown ink over red chalk.

PROV: W. F. Watson. Bequeathed 1881.

The previous attribution to Peruzzi is nonsensical. As far as anything can be made out at all from this wreck of a drawing, there are remote resemblances in the figures to types occurring in Botticelli and Filippino Lippi (for example the man with the sack of gold kneeling on the right).

D 3094 Fig. 1071

Studies of a kneeling saint adoring the Madonna and Child.

289 × 426. Brush and ink on prepared paper. Traces of black chalk. (Laid down.)

PROV: Robert Udny; W. B. Johnstone; W. F. Watson. Bequeathed 1881.

D 3113 Fig. 1072

Group around a seated female figure.

281 × 250. Pen, brown ink, heightened with white, on brown paper.

PROV: W. F. Watson. Bequeathed 1881.

By a draughtsman vaguely influenced by Rosso and Beccafumi.

D 3199

The barbarians' submission to Marcus Aurelius.

234 × 212. Brush and wash, heightened with white, on blue paper. (Laid down.)

PROV: W. F. Watson. Bequeathed 1881.

Copy of the relief in the Palazzo dei Conservatori, Rome, from the lost Arch of Marcus Aurelius.

D 4890/8 Fig. 1073

St John the Baptist.

162 × 75. Pen, black ink and wash, over black chalk. (Laid down.) Inscribed: *Bastianino*.

PROV: Marchese del Carpio; Paul and Edwardo Bosch, Madrid; H. M. Calmann. Purchased 1964.

The inscription presumably intends to refer to the Ferrarese painter Sebastiano Filippi (1532–1602), called Bastianino, but he would have shown a stronger, more Michelangelesque style than is evident in this drawing.

D 4890/9 A Fig. 1074

Profile of a bearded man.

100 × 85. Red chalk. (Laid down.)

PROV: Marchese del Carpio; Paul and Edwardo Bosch, Madrid; H. M. Calmann. Purchased 1964.

D 4890/27 Fig. 1075

A dragon.

152 × 215. Black and red chalk, partly outlined in ink, and wash. (Laid down.)

PROV: Marchese del Carpio; Paul and Edwardo Bosch, Madrid; H. M. Calmann. Purchased 1964.

D 4890/35 Fig. 1076

Christ in the Tomb, attended by two angels, with a group of saints below.

195 × 110. Pen and brown ink. Squared in black chalk. (Laid down.)

PROV: Marchese del Carpio; Paul and Edwardo Bosch, Madrid; H. M. Calmann. Purchased 1964.

This drawing, as well as D 4890/44 which is by the same hand, are possibly Sienese, although the facial types seem to reflect some influence of Giovanni de' Vecchi.

D 4890/44 Fig. 1077

The Baptism of Christ, with two male saints below.

195 × 110. Pen and brown ink. Squared in black chalk. (Laid down.) Inscribed: *Zucchero.*

PROV: Marchese del Carpio; Paul and Edwardo Bosch, Madrid; H. M. Calmann. Purchased 1964.

See note to D 4890/35.

RSA 135 Fig. 1078

Two fighting equestrian warriors, and two studies of armour.

260 × 185. Black chalk. (Rubbed and laid down.) Dated in upper right corner: *1536.* Inscribed in a later hand in lower right margin: *Raphael* and (erased) *Giulio Romano.*

PROV: N. Lanier (L. 2885); David Laing; Royal Scottish Academy. On loan 1966.

The influences discernible in this sheet derive, at the bottom, from Parmigianino and, in the pair of equestrian warriors, from Lelio Orsi.

RSA 273 Fig. 1079

The parting of Abraham and Lot.

371 × 292. Black chalk heightened with white, on faded blue paper. (Laid down.) Inscribed: *Paolo Veronese.*

PROV: William Roscoe; sale Liverpool, 24 September 1816, lot 267; David Laing; Royal Scottish Academy. On loan 1966.

Although the ascription to Veronese is incorrect, the composition and the types certainly show his influence.

RSA 275 Fig. 1080

The Madonna and Child.

125 × 113 (maximum height). Pen and ink. (Laid down, lower left corner cut.) Inscribed on the mount: 'F. Bartolomeo'.

PROV: Sir Thomas Lawrence; David Laing; Royal Scottish Academy. On loan 1966.

Possibly a copy. Philip Pouncey suggested that it might derive from a composition by Battista Franco.

SEVENTEENTH CENTURY

D 672 Fig. 1081

Hercules wrestling with Achelous in the form of a bull.

308 × 233. Brush and brown wash, heightened with white, over black chalk on darkly toned paper. (Laid down.)

PROV: David Laing; Royal Scottish Academy. Transferred 1910.

Ascriptions to Polidoro da Caravaggio and Pellegrino Tibaldi have been suggested in the past. Philip Pouncey has drawn attention to the curious affinity with certain figures by Beccafumi, such as the series of standing *Apostles* (Berlin 420–23; Louvre 252), drawn on brown paper in black chalk with pen and thick blobs of white heightening. However, in spite of 16th century echoes, the drawing appears to be about a century later.

D 765 Fig. 1082

Two putti.

134 × 127. Brush and oil colour on prepared paper. Inscribed in upper margin: *N°27.*

PROV: David Laing; Royal Scottish Academy. Transferred 1910.

Not unlike the kind of putti which occur in compositions by Carl Loth (1632–98).

D 808 Fig. 1083

Tarquinius and Lucretia.

141 × 115 (size of the composition). Pen, brown ink and light grey wash.

PROV: David Laing; Royal Scottish Academy. Transferred 1910.

The composition seems to suggest a Bolognese origin, whilst the style betrays vague post-Cortonesque influences (Romanelli, Nasini).

D 892 Figs. 1084 and 1085

(*recto*) Two goatherds, one milking a goat; (*verso*) River landscape with herdsmen.

186 × 258. Pen and brown ink.

PROV: David Laing; Royal Scottish Academy. Transferred 1910.

The figures on the recto are vaguely reminiscent of Salvator Rosa.

D 931 Fig. 1086

Four putti, holding bound palm leaves.

177 × 275. Pen, brown ink and wash, over black chalk. (Laid down.) Inscribed: *Putti che vanno sopra la Porta alla sinistra* (resp. *alla destra*) *dell'Altare*.

PROV: David Laing; Royal Scottish Academy. Transferred 1910.

As indicated by the inscriptions, each vertical pair of figures was intended for either side of an altar.

D 951 Figs. 1087 and 1088

(*recto*) Sketch of a three-headed bust on a pedestal, and two other studies; (*verso*) Two figure studies.

75 × 195. Pen and brown ink. Inscribed in pencil on recto: *621*.

PROV: David Laing; Royal Scottish Academy. Transferred 1910.

A date around 1600 is suggested for this drawing. The type of faces recalls Roncalli. The main sketch on the recto superficially resembles the allegorical representation of 'Prudence', of which the best-known example is Titian's painting now in the National Gallery, London, but the faces here are almost caricatures and in any case do not depict three different ages.

D 1016 Fig. 1089

The Arch of Constantine, Rome.

223 × 278. Pen, brown ink and wash, heightened with white.

PROV: David Laing; Royal Scottish Academy. Transferred 1910.

The drawing may possibly be by a Northern artist.

D 1254 Fig. 1090

Romulus and Remus suckled by a she-wolf, watched by three draped figures.

88 × 133. Pen, brown ink and wash. (Damaged and laid down.)

PROV: David Laing; Royal Scottish Academy. Transferred 1910.

The drawing seems to be of the second half of the 17th century. It appears to illustrate the story of the founding of Rome: the suckling of the twins, and the flight of birds which decided that Romulus should be King.

D 1473 Fig. 1091

Three virtues ('Charity', 'Faith' and 'Fortitude') attending a new-born child.

298 × 283. Black chalk, with some traces of white heightening. (Laid down.)

PROV: David Laing; Royal Scottish Academy. Transferred 1910.

The drawing dates probably from the early part of the 17th century, and may be Roman. Drawings by Gaspare Celio are not very far removed from D 1473 (Bergamo 11800F: a seated angel, and Uffizi 11849F: two flying figures).

D 1487 Fig. 1092

Reclining male figure.

181 × 234. Red chalk, on coarse buff paper.

PROV: David Laing; Royal Scottish Academy. Transferred 1910.

The drawing may be Venetian, or Neapolitan, reminiscent of the style of Micco Spadaro.

D 1488 Fig. 1093

A kneeling, bearded man, in an attitude of adoration.

176 × 134 (irregularly cut). Black chalk.

PROV: David Laing; Royal Scottish Academy. Transferred 1910.

The drawing appears to be from the first half of the 17th century. The pose suggests a knowledge of Cigoli, and the figure is somewhat reminiscent of the types which occur in drawings by Filippo Bellini—for example the *St Roch* composition, D 707.

D 1498 Fig. 1094

St Michael doing battle with a demon.

97 × 120. Pen, brown ink over black chalk.

PROV: David Laing; Royal Scottish Academy. Transferred 1910.

The drawing seems to be of the late 17th century or even 18th century.

D 1502

A right arm.

102 × 225. Red chalk.

PROV: David Laing; Royal Scottish Academy. Transferred 1910.

A poor copy of an academy.

D 1504 Fig. 1095

Head of a bearded man.

159 × 131 (corners cut). Black chalk, heightened with white on faded blue paper.

PROV: David Laing; Royal Scottish Academy. Transferred 1910.

D 1513 Fig. 1096

Flying putto holding a torch.

115 × 176 (lower right margin cut). Pen and brown ink.

PROV: David Laing; Royal Scottish Academy. Transferred 1910.

D 1524 Figs. 1097 and 1098

(*recto*) Monk kneeling before a bishop;
(*verso*) Figure of the ascending Christ.

153 × 207 (overall size). Red chalk. (Cut in two and reunited.)

PROV: David Laing; Royal Scottish Academy. Transferred 1910.

The style seems that of a draughtsman of the 17th century, possibly from Florence or Siena.

D 1534 Fig. 1099

Judith and Holofernes.

119 × 120. Pen, brown ink, slight traces of white heightening. (Laid down.)

PROV: David Laing; Royal Scottish Academy. Transferred 1910.

It is impossible to decipher much from this very faded drawing. It appears certainly to be 17th century, and possibly Genoese.

D 1544 Fig. 1100

A woman carrying a child in her arms.

251 × 133. Pen, brown ink and red wash.

PROV: Paul Sandby; David Laing; Royal Scottish Academy. Transferred 1910.

D 1546 Fig. 1101

Studies of three female figures and one male figure.

121 × 77. Brush and red wash over red chalk. (Laid down.) Partly cut-off inscription in ink includes the names: *il vigniola*; *il serlio*.

PROV: Paul Sandby; David Laing; Royal Scottish Academy. Transferred 1910.

The sketches probably date from the early 17th century, and may be Florentine or Sienese.

D 1576 Fig. 1102

St Matthew.

204 × 114. Pen, brown ink and wash. Inscribed on the back: *P. Veccio.*

PROV: J. Pz. Zoomer; David Laing; Royal Scottish Academy. Transferred 1910.

The drawing appears to be of the early 17th century, perhaps around 1600, and probably North Italian.

D 1580 Fig. 1103

Head of a bearded man.

424 × 296. Black chalk on buff paper, slight traces of white heightening. Inscribed: *A°· 680 il 12 Marty.*

PROV: David Laing; Royal Scottish Academy. Transferred 1910.

The drawing, carefully dated 12 March 1680, calls to mind some of the large heads by Lanfranco. It may be a copy from a Roman bust.

D 1600 Fig. 1104

A child's head.

138 × 123. Black chalk.

PROV: David Laing; Royal Scottish Academy. Transferred 1910.

D 1624 Fig. 1105

A reclining male nude.

370 × 258. Red chalk and wash, heightened with white.

PROV: David Laing; Royal Scottish Academy. Transferred 1910.

The former ascription was to Furini, which is incorrect. The drawing may, however, be 17th century Florentine and is somewhat reminiscent of similar academies by Benedetto Luti.

D 1630 Fig. 1106

Head of a woman.

116 × 95. Pen, brush and brown ink. Inscription *Giorgione* on the back.

PROV: David Laing; Royal Scottish Academy. Transferred 1910.

The head and neck, the modelling of the mouth and the closed eyes are reminiscent of heads that occur in the work of Ferraù Fenzoni, but the style of his drawings (Uffizi) is rather different.

D 1633 Fig. 1107

Two nude male figures.

135 × 124. Brush and brown wash.

PROV: David Laing; Royal Scottish Academy. Transferred 1910.

D 1641 Fig. 1108

A kneeling pilgrim in ecstasy, with attendant putti.

303 × 428. Red chalk and wash. (Cut along the top margin.) Inscribed: *F. Barozzi*.

PROV: David Laing; Royal Scottish Academy. Transferred 1910.

Probably a copy from a Bolognese or Roman composition.

D 1649 Fig. 1109

Neptune and other river-gods paying homage to a queen.

206 × 334. Pen, brown ink and wash. Squared in black chalk. Inscribed on the back of the old mount: 'Scuola Bolognese buon dissegno originale'. Also the numbers '745' and '160' (in red ink).

PROV: David Laing; Royal Scottish Academy. Transferred 1910.

Neither the artist, nor the subject of the drawing has been identified. The female figure might possibly be Amphitrite, although normally she is not represented wearing a crown. Although the old inscription 'Scuola Bolognese' seems justified to the extent of a debt to the Carracci being discernible, the artist may in fact be Roman, somewhere in the circle of Giacinto Gimignani, or his son Ludovico.

D 1653 A Fig. 1110

Head of a man.

294 × 244. Black chalk, heightened with white on buff paper.

PROV: David Laing; Royal Scottish Academy. Transferred 1910.

D 1694 Fig. 1111

Head of an angel.

104 × 86. Black chalk. (Laid down.) Inscribed in ink: *Domini*.

PROV: David Laing; Royal Scottish Academy. Transferred 1910.

The drawing may be Bolognese.

D 1731 Fig. 1112

Landscape with riders and peasants.

252 × 404. Pen, brown ink and wash. (Much rubbed and faded.) Inscribed on the back: *Annibale Carracci*.

PROV: David Laing; Royal Scottish Academy. Transferred 1910.

As far as one can discern, the drawing seems to be of the late 17th century. There are faint echoes of Grimaldi in the architecture, and thus the origin may possibly be Bolognese.

D 1776 Figs. 1113 and 1114

(*recto*) Study of a man with upraised arms; (*verso*) Sketch of a right hand.

298 × 200. Black chalk, heightened with white on blue paper. Inscribed *29* in lower margin.

PROV: David Laing; Royal Scottish Academy. Transferred 1910.

The former ascription was to Baldassare Franceschini, il Volterrano, with whom the drawing has nothing to do. It might possibly be Venetian, though an influence of Barocci can also perhaps be discerned.

D 1778 Figs. 1115 and 1116

(*recto*) A man and a woman dancing, with another man playing the lute; (*verso*) Sketches of heads and figures.

190 × 252. Red chalk (recto squared). Faintly inscribed in pencil: *School of Caravaggio*, and *passari* (centre left).

PROV: David Laing; Royal Scottish Academy. Transferred 1910.

The drawing entered the collection under the name of 'Passeri'. It could conceivably be either Venetian or Roman.

D 2229 Fig. 1117

Seated woman with a dead child.

196 × 216. Red chalk. (Laid down.) Inscribed on the back, in Richardson's hand: *This came to me with this name, but I believe tis of Lanfranco.*

PROV: J. Richardson, Senr (L. 2813); W. F. Watson. Bequeathed 1881.

'This name' of Richardson's inscription has been cut off and can no longer be ascertained. The drawing was ascribed to G. L. Bernini when it entered the collection. Obviously a study for a *Massacre of the Innocents*, it appears to be either Bolognese or Roman.

D 2889 Fig. 1118

Christ and putto, seated on a cloud.

275 × 170. Pen, brown ink and brown and grey wash on blue paper. (Laid down.)

PROV: W. F. Watson. Bequeathed 1881.

D 2897 Fig. 1119

Three putti piercing a wineskin with arrows.

259 × 189. Pen, brown ink and wash over black chalk. Inscribed: *Palma.*

PROV: Count J. von Ross; W. F. Watson. Bequeathed 1881.

The ascription to Palma (Giovane) is incorrect. The drawing has all the marks of a pastiche, perhaps based on 16th century motifs.

D 2904

A youth holding a dove.

130 × 95 (cut to an oval). Red chalk and wash. (Paper cracked at the folds and laid down.)

PROV: W. F. Watson. Bequeathed 1881.

D 2910 Fig. 1120

Female saint, holding cross and chalice, vanquishing the devil (St Margaret?).

124 × 82. Brush and red wash over red chalk.

PROV: W. F. Watson. Bequeathed 1881.

D 2914 Fig. 1121

Head of a child.

103 × 99. Red chalk. (Laid down.) Inscribed: *A. Carracci.*

PROV: W. F. Watson. Bequeathed 1881.

Same hand as D 2920.

D 2920 Fig. 1122

Head of a child.

95 × 94. Red chalk. Inscribed on mount: 'A. Carracci'.

PROV: W. F. Watson. Bequeathed 1881.

Same hand as D 2914.

D 2919 Fig. 1123

The blinding of Samson.

145 × 215. Pen, brown ink and wash over red chalk. Squared in red chalk.

PROV: W. F. Watson. Bequeathed 1881.

D 2927

Head of a Lucretia.

222 × 188. Red and black chalk.

PROV: W. F. Watson. Bequeathed 1881.

A crude copy, somewhat in the manner of Guido Reni's *Lucretia* heads.

D 2960 Fig. 1124

Monks witnessing the abduction of a girl.

197 × 142. Pen and brown ink and reddish wash, over black chalk.

PROV: W. F. Watson. Bequeathed 1881.

A copy, possibly after an Emilian artist.

D 2971 Fig. 1125

The massacre of the innocents.

213 × 278. Brush and red wash, heightened with white, traces of black chalk. (Laid down.)

PROV: W. F. Watson. Bequeathed 1881.

The drawing may be by a Florentine artist, for echoes from il Volterrano can be discerned.

D 2974

Madonna and Child.

193 × 116. Pen and brown ink over red chalk. (Torn and damaged.)

PROV: W. F. Watson. Bequeathed 1881.

D 2975 Fig. 1126

Male figure seen from below, on clouds.

149 × 139. Pen, brown ink and wash over red and black chalk. (Laid down.)

PROV: W. F. Watson. Bequeathed 1881.

A drawing somewhat reminiscent of an artist like Canuti, revealing both Bolognese and Roman characteristics.

D 2980 Fig. 1127

Hagar and Ishmael. (On the verso: slight figure studies in chalk.)

195 × 257. Pen, brown ink and wash over black chalk.

PROV: W. F. Watson. Bequeathed 1881.

Vaguely reminiscent of Domenico Piola.

D 3008 Fig. 1128

The annunciation to the shepherds.

90 × 73 (arched top). Pen and brown ink. (Laid down.)

PROV: W. F. Watson. Bequeathed 1881.

Somewhat in the manner of Domenichino.

D 3048 Fig. 1129

Studies for a *Resurrection*.

240 × 162. Pen and brown ink. (Stained and torn in parts and laid down.)

PROV: W. F. Watson. Bequeathed 1771.

Faintly reminiscent of the styles of Baglione and Fenzoni.

D 3050

Draped male figure seen from the back. (On verso: sketch of a leg.)

201 × 105. Pen and brown ink on blue paper. (Repaired along right margin.)

PROV: W. F. Watson. Bequeathed 1881.

Possibly a copy after a 16th century original.

D 3120 Fig. 1130

Dominican saint being carried to heaven.

253 × 189. Pen, brown ink and red wash over black chalk. (Laid down.)

PROV: W. F. Watson. Bequeathed 1881.

D 3164

Seated male nude.

149 × 81. Pen, brown ink over black chalk. (Laid down.)

PROV: W. F. Watson. Bequeathed 1881.

D 3165

?Portrait of Salvator Rosa.

175 × 132. Pen and brown ink. (Laid down.) Inscribed on the back: *Ritratto di Salvator Rosa fatto da...dessin.*

PROV: J. Richardson, Jnr; W. F. Watson. Bequeathed 1881.

Probably a copy from an engraving.

D 3173 Fig. 1131

Diogenes and Alexander the Great.

241 × 357. Pen, brown ink and wash, over black chalk, heightened with white. (Laid down.)

PROV: W. F. Watson. Bequeathed 1881.

The drawing reveals both Genoese and Roman stylistic characteristics.

D 3178

Two putti with basket and fruit.

220 × 333. Pen and brown ink. (Laid down.) Inscribed: *Augustin Carats.*

PROV: W. F. Watson. Bequeathed 1881.

D 3180 Fig. 1132

The Resurrection.

252 × 181. Pen, brown ink and wash, heightened with white. (Laid down.) Inscribed on back: *Alessandro Albini.*

PROV: W. F. Watson. Bequeathed 1881.

Obviously a copy.

D 3265 Fig. 1133

A bacchanal.

170 × 246. Red chalk. (Laid down.)

PROV: W. F. Watson. Bequeathed 1881.

D 4890/1 Fig. 1134

Title page of an album of drawings.

221 × 163. Pen, brown ink and grey wash. Inscribed: *PARTE OTTAVA, | De Disegni de Scelti Autori Raccolti | In Roma | Dal Ecc^mo. Signore Don Gasparo d'Haro e'Guz^n· | Marchese del Carpio e'Helicce; del | Conseglio di Stato della Maesta Catholica | Di Carlo Secondo | Suo Ambasciatore Ordinario et Extraordinario | Alla Santità di N.S. Papa Innocenso XI | E nel 1682 | Eletto Vice Re E Capitan Generale del | REGNO DI NAPOLI.*

PROV: Marchese del Carpio; Paul and Edwardo Bosch, Madrid; H. M. Calmann. Purchased 1964.

As stated in the inscription, this is the title page for the eighth volume of the collection of drawings which Don Gasparo de Haro y Guzman, Marchese del Carpio assembled in 1682. The Marchese del Carpio, who was appointed Spanish Ambassador in Italy in 1677, was one of the most distinguished patrons of the arts of the 17th century (see F. Haskell, *Patrons and Painters* (1963), pp. 191–2). It appears that del Carpio collected his drawings into thirty albums of which only two others survive intact, as far as is known: one in the Biblioteca Nacional at Madrid, containing

chiefly 17th century Neapolitan drawings, in particular by Aniello Falcone (see A. M. Barcia, *Catalogo de la Coleccion de Dibujos originales de la Biblioteca Nacional Madrid* (1906), p. 588); the other, in folio format and also dated 1682, with 107 copies of antique statues, etc. is in the library of the Society of Antiquaries in London. The title page of Volume Eleven, apparently by the same hand as that for Volume Eight, is in the Collection of F. Lugt, Paris. The designer of these title-drawings may have been Roman, perhaps a follower of Maratta, but it is also possible that he was a Neapolitan artist.

D 4890/31 B Fig. 1135

An open loggia, filled with people. (On the verso: two draped figures.)

102 × 140. Pen, brown ink and wash over red chalk. (Laid down.) Inscribed: *38* and *N. N. Scol° de Baldassaro* (?).

PROV: Marchese del Carpio; Paul and Edwardo Bosch, Madrid; H. M. Calmann. Purchased 1964.

RSA 278 Fig. 1136

Noah and the dove.

194 × 158. Pen, brown ink, heightened with white over black chalk, on blue prepared paper. (Laid down.)

PROV: David Laing; Royal Scottish Academy. On loan 1966.

Probably Roman.

RSA 280 Fig. 1137

St Catherine of Alexandria.

203 × 138. Red chalk. (Laid down.) Inscribed on back of the drawing: *Ant. Correggio*, and on the mount: 'Guido Rheni'. Inscription at the bottom cut off.

PROV: Collector's mark cut out; David Laing; Royal Scottish Academy. On loan 1966.

The drawing may be Bolognese, as the ascription to Reni suggests. However, the style and the facial type also come close to Casolani.

RSA 294 Fig. 1138

The Madonna and Child adored by SS. George and ?Canute of Denmark.

302 × 211. Pen, brown ink and grey wash, heightened with white, over black chalk.

PROV: David Laing; Royal Scottish Academy. On loan 1966.

By a provincial artist, revealing faint echoes from Pietro da Cortona. It is presumed that the Saint on the left is King Canute of Denmark, showing his crown and mail shirt.

RSA 307 Fig. 1139

An allegorical seated female figure (?'Fortitude'), with two putti and a lion.

150 × 237 (semicircular). Pen, brown ink and wash over black chalk. (Laid down.) Inscribed: *Ricci*.

PROV: David Laing; Royal Scottish Academy. On loan 1966.

RSA 308 Fig. 1140

River landscape with millstones and ruined arch.

188 × 259. Pen, ink and brown wash. Inscribed at the top: *di 14 di gennaro 1642*.

PROV: Sir Thomas Lawrence; David Laing; Royal Scottish Academy. On loan 1966.

Possibly a drawing by a Northern artist.

RSA 436 Fig. 1141

Hagar and the angel.

371 × 150. Red chalk on bluish prepared paper. Squared in black. (Laid down.) Inscribed in a recent hand: *Bernardino Barbatelli Poccetti*.

PROV: David Laing; Royal Scottish Academy. On loan 1966.

The ascription to Poccetti does not seem right, and the drawing, though possibly of the 17th century, appears to be by a later hand.

———————

EIGHTEENTH CENTURY

D 891 Fig. 1142

Landscape with a town bordering the sea.

176 × 255. Pen, brown ink and wash, over black chalk. (Laid down.)

PROV: David Laing; Royal Scottish Academy. Transferred 1910.

The drawing is certainly by an 18th century artist. Anthony Clark has stated that certain mannerisms suggest to him the possibility that the artist is Alessio de Marchis (*c.* 1710–52), the Neapolitan painter of landscapes and architecture, who worked in Certino, Rome and Perugia (cf. RSA 126).

D 1002 Fig. 1143

The Temple of Vesta and the 'Bocca della Verità' in the Forum Boarium, Rome. (On the verso: slight sketch of a profile.)

245 × 300. Water-colour, heightened with white.

PROV: David Laing; Royal Scottish Academy. Transferred 1910.

D 1029 Fig. 1144

Part of the Ponte Molle.

213 × 310. Brush with red and brown wash.

PROV: David Laing; Royal Scottish Academy. Transferred 1910.

The drawing, which seems to be of the middle of the 18th century, shows the first two arches, with their fortifications, of the Ponte Molle, just north of Rome.

D 1030

The tomb of Cecilia Metella.

261 × 210. Pen and black ink.

PROV: David Laing; Royal Scottish Academy. Transferred 1910.

Probably a copy from an engraving.

D 1036 Fig. 1145

View of the Temple of Saturn (or Temple of Concord) in the Forum, Rome.

230 × 232. Water-colour.

PROV: David Laing; Royal Scottish Academy. Transferred 1910.

Of the late 18th or early 19th century.

D 1037 Fig. 1146

The 'Sepolcro dei Plautii', by the Ponte Lucano near Tivoli.

234 × 243. Water-colour.

PROV: David Laing; Royal Scottish Academy. Transferred 1910.

Obviously by the same hand as D 1036.

D 1040–1042

Three views of the temples at Paestum.

157 × 223; 137 × 220; and 188 × 226. Gouache, except the last, which is water-colour.

PROV: David Laing; Royal Scottish Academy. Transferred 1910.

Drawings of the late 18th, if not early 19th century.

D 1049

Buildings and watermill by a river.

239 × 348. Pen and brown ink. Inscribed: *Fran:co Dall'Occa Copiò*.

PROV: David Laing; Royal Scottish Academy. Transferred 1910.

This seems to be a copy from an engraving, possibly a pastiche of Marco Ricci.

D 1212 Fig. 1147

Mary Magdalen at the foot of the Cross.

205 × 160. Black chalk, partly gone over in ink.

PROV: David Laing; Royal Scottish Academy. Transferred 1910.

There are very faint echoes of Guido Reni discernible in this drawing.

D 1921 Fig. 1148

Landscape with farmhouses.

129 × 177. Red chalk. (Laid down.)

PROV: (?Allan Ramsay); Lady Murray. Presented 1860.

D 1922 Fig. 1149

Profile head of a bearded man.

148 × 108. Red chalk. (Laid down.)

PROV: (?Allan Ramsay); Lady Murray. Presented 1860.

D 3011 Fig. 1150

Pietà.

134 × 93. Pen, black ink and grey wash.

PROV: W. F. Watson. Bequeathed 1881.

D 3044 Figs. 1151 and 1152

(*recto*) View of the Piazzetta S. Marco, Venice; (*verso*) Sketches of a corner of a palace, and of the pedestal of the Fountain of Neptune at Bologna.

112 × 194. Pen, brown ink and wash.

PROV: W. F. Watson. Bequeathed 1881.

D 3058–3060 Figs. 1153–1155

Three designs for a frieze with river-gods and nymphs.

103 × 355. Pen, brown ink and wash, over black chalk.

PROV: W. F. Watson. Bequeathed 1881.

D 3149 Fig. 1156

Standing warrior with plumed helmet. (On the verso: studies of putti and other figures.)

252 × 148. Pen, brown ink and coloured washes over black chalk. (Cut and laid down.) Inscribed: *Festione*, and *Salvator Rosa*.

PROV: W. F. Watson. Bequeathed 1881.

RSA 296 Fig. 1157

Presentation of the Virgin.

283 × 205 (octagonal). Pen, brown ink and grey wash. (Laid down.)

PROV: J. Auldjo; David Laing; Royal Scottish Academy. On loan 1966.

An inscription 'della Marca' on the old backing is probably intended to refer to Giovanni Battista della Marca, called Lombardelli, who was, however, a 16th century artist, while the drawing is clearly of the late 17th or early 18th century, possibly by a late follower of Palma Giovane.

NINETEENTH CENTURY

RSA 4 Fig. 1158

Venetian 'capriccio'.

223 × 209 (corners rounded). Water-colour over black chalk. Inscribed on mount: 'Bart. Santi'.

PROV: David Laing; Royal Scottish Academy. On loan 1966.

This is obviously a 19th century drawing, probably dating from *c.* 1820/1830. Therefore the ascription to Bartolomeo Santi (who was a painter and theatrical designer from Lucca who lived from 1700 to 1756) must be erroneous.

ADDENDA AND CORRIGENDA

ALBANI (D 696A and B): Konrad Oberhuber suggests that these two fan designs may be French, around 1700.

BERNARDI (D 3038): Maddalena Brognara ('Pietro Bernardi, il più antico caravaggesco veronese', *Arte Antica e Moderna*, 34–6 (1966), pp. 135 ff., fig. 55c) has since published the drawing, and also suggested a relationship between D 3038 and the painting in S. Anastasia (her figs. 53a and b). However, she tentatively proposed an attribution to *Pietro* Bernardi for the painting.

BISON (D 860): John Dick and Larissa Salmina-Haskell have recently, independently, recognized that this drawing is by Giacomo Quarenghi (1744–1817).

Circle of CESARI (D 1494): John Shearman and Konrad Oberhuber have pointed out that this is a copy after the detached fresco from the Palazzo Baldassini, Rome, by Perino del Vaga, now in the Uffizi.

CESI (D 2945): Konrad Oberhuber suggests an attribution to Perino del Vaga.

PARENTINO (RSA 259): The comparable drawing in the Janos Scholz Collection is also published (as Zoppo) by E. Ruhmer, *Marco Zoppo* (1966), Cat. 4.

SACCHI (D 3080): Anne Sutherland Harris disagrees with the old attribution (Harris and Schaar, *Die Hand-zeichnungen von Andrea Sacchi und Carlo Maratta* [at Düsseldorf] (Düsseldorf, 1967), p. 23, n. 2). She tentatively proposes instead an attribution to Ludovico Gimignani.

G. SALVIATI (D 3139): LIT: Alessandro Ballarin, 'Jacopo Bassano e lo studio di Raffaello e dei Salviati', *Arte Veneta*, XXI (1967), fig. 107.

GENOESE SEVENTEENTH CENTURY (D 3106): The compiler had contemplated an attribution to Valerio Castello, and it is interesting to note that the same name had also been suggested for the drawing in the Koenig-Fachsenfeld Collection depicting the *Martyrdom of St Lawrence*, which appears to be by the same hand (EXH: *Unbekannte Handzeichnungen alter Meister...Sammlung Freiherr Koenig-Fachsenfeld*, Stuttgart and Basle, 1967 (102)).

VENETIAN SIXTEENTH CENTURY (RSA 20): This drawing merits further study. Its style appears close to the drawing of *A Group of Trees* in the Metropolitan Museum, New York, long since accepted as by Titian (*Drawings from New York Collections: The Italian Renaissance* (1965), No. 58).

CONCORDANCE TO VOLUME OF
DRAWINGS FORMERLY BELONGING TO
THE MARCHESE DEL CARPIO (D 4890)

Fol. 1 17th century
2 (MS)
3 Giovanni Paolo dal Borgo
4 Antonio Tempesta
5 Giovanni de' Vecchi
6 Francesco Traballesi
7 Circle of Guercino
8 16th century
9 A 16th century
9 B Florentine, 16th century
10 Florentine, 16th century
11 Palma Giovane
12 attrib. to Gir. Mazzola Bedoli
13 Florentine, 16th century
14 attrib. to G. B. Naldini
15 A G. B. Naldini
15 B attrib. to G. B. Naldini
16 North Italian, 16th century
17 Circle of Raphael
18 attrib. to Agostino Carracci
19 G. B. Naldini
20 A Circle of Perino del Vaga
20 B Roman, 16th century
21 Circle of Annibale Carracci
22 (missing)
23 ascribed to Pietro Malombra
24 attrib. to Francesco Trevisani
25 (missing)
26 copy after Guido Reni

Fol. 27 16th century
28 North Italian, 16th century
29 Bernardino Poccetti
30 (missing)
31 A Circle of Palma Giovane
31 B 17th century
32 ascribed to Giuseppe Cesari
33 A Follower of Federico Zuccaro
33 B ascribed to Giov. Paolo Rossetti
33 C Francesco Vanni
34 (missing)
35 16th century
36 Ventura Salimbeni
37 ascribed to Jacopo del Zucchi
38 Girolamo Muziano
39 A Agostino Tassi
39 B attrib. to Francesco Trevisani
40 Bolognese, 17th century
41 Federico Zuccaro
42 G. B. Naldini
43 Giulio Romano
44 16th century
45 attrib. to Gir. Mazzola Bedoli
46 A Biagio Betti
46 B ascribed to Sebastiano Florigiero
47 Agostino Carracci
48 copy after Federico Barocci
49 Circle of Bartolomeo Passarotti

165

LIST OF THE MORE IMPORTANT
CHANGED ATTRIBUTIONS

Former ascription	New attribution	Inventory number
Fra Bartolomeo	attr. Cesari	D 1610
J. Bassano	Leandro Bassano	D 2232
Bernini	Algardi	D 901
Ag. Carracci	Giov. de' Vecchi	D 632
Cambiaso	Paggi	D 1167
Cesari	North Ital. 16th c.	D 3090
Conca	copy after Solimena	D 1581
Correggio	Fabrizio Boschi	D 688
Franciabigio	Macchietti	D 683
Girolamo da Treviso	Circle of Camillo Procaccini	D 2226
Lanfranco	Benaschi	D 1791
Lanfranco	Follower of Lud. Carracci	D 1197
School of Mantegna	Parentino	D 655
Maratta	F. Germisoni	D 1671
Michelangelo	Alessandro Allori	D 1635
Michelangelo	ascr. to Rosso	D(NG) 601
Mola	Guercino	D 4897
Parmigianino	Anselmi	D 1766
Parmigianino	Schiavone	D 1764
Pietro da Cortona	L. Baldi	D 1585
Pignone	Folli	D 1895
Piranesi	Tesi	D 938
? Pisanello	Gentile da Fabriano	D 2259
Polidoro	Taddeo Zuccaro	D 1558, 1561, 1562
Pontormo	Naldini	D 4890/14
Pontormo	ascr. to Pontormo	D 2230
A. Ramsay	P. Batoni	D 2122, 2145, 2146, 2148
Raphael	Gir. da Carpi	D 3146
Seb. Ricci	Carlone	D 4689, 4690
F. Salviati	Follower of Vasari	D 3091
F. Salviati	School of Verona, 16th c.	D 3077
Andrea del Sarto	Balassi	D 3098
C. Schut	J. Confortini	D 1619
Testa	Podestà	D 717
J. Tintoretto	Palma Giovane	D 697
Titian	M. Ricci	D 675
Perino del Vaga	C. Alberti	D 905
Veronese	Circle of Cavedone	D(NG) 637
School of Veronese	attr. Moretto	D 2235
School of Verrocchio	L. di Credi	D 642
F. Zuccaro	Samacchini	D 3181
T. Zuccaro	Raffaellino da Reggio	D 1475

INDEX OF THE MORE IMPORTANT
FORMER OWNERS

(with the exception of Lady Murray [including possibly Allan Ramsay]; David Laing and William Watson)

INDEX OF THE MORE IMPORTANT FORMER OWNERS

Ross, Count von: dell'Abbate D 3073; B. Caliari D 2225; Cavallucci D 516; P. Farinati RSA 155; Pietro da Cortona (studio) D 1836; Ranucci D 876; V. Salimbeni D 819; Turchi D 3037
Bolognese 17th c. D 3023; Venetian 16th c. D 1169; 17th c. D 2897

Sandby, Paul: Boscoli D 1515; Busiri RSA 3; Ann. Carracci (copy) D 3132, D 3186; Cesari (circle) D 1494; ? B. Franceschini D 1541; Grimaldi D 625; Luti D 1535; Mantegna (circle) D 1529; ? Maratta D 1531; Marucelli D 1522; Mazza D 1477; Monogrammist AB D 854, RSA 163; Marco Ricci D 1547; Tempesta D 1499, D 1497; Zuccarelli D 2236; F. Zuccaro D 1472, D 1512, D 1550
Bolognese 17th c. D 748; Venetian 18th c. D 1551; 16th c. D 1482; D 1552, D 1556; 17th c. D 1544, D 1546

Shrewsbury, Charles, 15th Earl of: G. Gimignani D 695; Guercino D 1608; Michelangelo (copy) D 679

Skippe, John: Ann. Carracci D 4813

Somers, Lord: Carracci (circle) D 812; Polidoro D 1799

Spencer, Earl: Creti D 2930; B. Franco RSA 177; Passarotti D 506; Pupini RSA 258

Talman, J.: Podestà D 717

Udny, Robert: Bigari D 731; Biscaino D 1621; Ag. Carracci D 1729; Confortini D 1156; Turchi RSA 165; F. Vanni RSA 270;
Verona 16th or 17th c. D 2896; 16th c. D 3094

Vivant-Denon, D.: Genoese 17th c. D 3106

West, Benjamin: Londonio D 3222; J. Tintoretto D 758
Florentine 16th c. D 741; Venetian 17th c. D 692

Woodburn, Samuel: Algardi (copy) D 909; Cavedone (circle) D(NG) 637; Passarotti (follower) D 733; Polidoro (circle) D 1631; T. Zuccaro (copy) RSA 183

Zoomer, J. Pz.: Cambiaso D 810; B. Franco D 634; Passarotti (studio) D 3078; Talpino D 1944; Trometta D 3069, D 3204; Turchi RSA 282
Venetian 17th c. D 2917; 17th c. D 1576

INDEX OF IDENTIFIED DRAWINGS
ACCORDING TO CENTURIES

INDEX OF IDENTIFIED DRAWINGS ACCORDING TO CENTURIES

NUMERICAL INDEX ACCORDING TO
INVENTORY NUMBERS

NUMERICAL INDEX ACCORDING TO INVENTORY NUMBERS

D 3121 Guercino (copy)
3122 Guercino (studio)
3123 North Italian, 17th c.
3124 G. C. Procaccini (attr.)
3126 J. Tintoretto (copy)
3127 Venetian, 17th c.
3128 G. B. Tiepolo (copy)
3129 T. Zuccaro (studio)
3130 T. Zuccaro (attr.)
3131 Roncalli
3132 Annibale Carracci (copy)
3133 A. Nucci
3135 Calandrucci
3136 D. Piola (attr.)
3137 G. B. della Rovere
3138 Cigoli
3139 G. Salviati
3140 B. Franco (ascr.)
3141 Cambiaso
3142–5 Leonardo and Others (copy)
3146 G. da Carpi
3147 Michelangelo (copy)
3148 Daniele da Volterra (copy)
3149 18th c.
3150 Calandrucci
3151 A. Luini
3152 G. Campi (attr.)
3153 Mola
3154 Neapolitan, 18th c.
3155 Polidoro da Caravaggio (copy)
3156 Palma Giovane
3157 Boscoli
3158 Parmigianino (copy)
3159 Agostino Carracci (copy)
3160 Michelangelo (copy)
3161 Moncalvo
3162 Orsi (attr.)
3163 School of Verona, late 16th or early 17th c.
3164–5 17th c.
3166 Michelangelo (copy)
3167 Simonini
3171 V. Castello (attr.)
3173 17th c.
3175 Venetian, 18th c.
3176 Raphael (copy)
3177 Roman, 17th c.
3178 17th c.
3179 F. Zuccaro (copy)
3180 17th c.
3181 Samacchini
3184 Raphael (copy)
3186 Annibale Carracci (copy)
3188 Roman, 17th c.
3189 North Italian, 17th c.
3191 Raphael (copy)

D 3192 B. Luti (copy)
3193 Giulio Romano (copy)
3195 Zuccarelli (ascr.)
3196 J. Tintoretto (copy)
3197 Mantegna (copy)
3198 Pietro da Cortona (circle)
3199 16th c.
3201 Zuccarelli
3202–3 P. S. Bartoli
3204 Trometta
3205 Michelangelo (copy)
3207–8 G. L. Bernini (studio)
3209 Zuccarelli
3211 Giov. da San Giovanni (studio)
3214 J. Tintoretto (copy)
3220 Roman, 17th c.
3222 Londonio (attr.)
3224 Giulio Romano (copy)
3242 Zais (attr.)
3258 Cipriani
3265 17th c.
3267 Mola (attr.)
3336 Confortini
3420 Cipriani
3501 Raphael (copy)
4689–90 Carlone
4801n G. Valeriani
4812 Beccafumi
4813 Annibale Carracci
4814 F. Zuccaro
4820B Baglione
4820C Dolci
4820D del Sarto (follower)
4820E North Italian, 16th c.
4820F Sogliani (attr.)
4827 Giulio Romano
4835 Pinelli
4836 T. Zuccaro
4842 Allegrini
4853 Pittoni
4864 Reni
4865 Muziano
4869 Pupini
4870 Rosso
4873 Ludovico Carracci
4883–4 Allegrini
4885 Grimaldi
4886 Genoese, 17th c.
4887 P. Liberi
4888 Bigari
4890/1 17th c.
4890/2 MS (del Carpio Volume)
4890/3 G. P. dal Borgo
4890/4 Tempesta
4890/5 de' Vecchi

D 4890/6	Traballesi		D 4897	Guercino
4890/7	Guercino (circle)		4898	G. B. Crespi
4890/8	16th c.		4899	D. Piola
4890/9A	16th c.		4905	A. Campi
4890/9B	Florentine, 16th c.		4906	Nebbia
4890/10	Florentine, 16th c.		4908	Lotto
4890/11	Palma Giovane		4911	D. Campagnola
4890/12	Bedoli (attr.)		4912	Paggi
4890/13	Florentine, 16th c.		4916	G. del Pò
4890/14	Naldini (attr.)		4917	Strozzi
4890/15A	Naldini			
4890/15B	Naldini (attr.)		RSA 2	Della Bella
4890/16	North Italian, 16th c.		3	Busiri
4890/17	Raphael (circle)		4	19th c.
4890/18	Agostino Carracci (attr.)		8	Domenichino
4890/19	Naldini		14	Bolognese, 17th c.
4890/20A	del Vaga (circle)		20	Venetian, 16th c.
4890/20B	Roman, 16th c.		116	V. Belloni
4890/21	Annibale Carracci (circle)		117	Venetian, 18th c.
4890/22	Missing (del Carpio Volume)		118	Pietro da Cortona (studio)
4890/23	P. Malombra (ascr.)		119	Marco Ricci
4890/24	Trevisani (attr.)		120	Zuccarelli
4890/25	Missing (del Carpio Volume)		121	F. Bellini
4890/26	Reni (copy)		122	Guercino
4890/27	16th c.		123	dell'Abbate
4890/28	North Italian, 16th c.		124	D. Veneziano (copy)
4890/29	Poccetti		125	Venetian, 16th c.
4890/30	Missing (del Carpio Volume)		126	A. de Marchis
4890/31A	Palma Giovane (circle)		128	Grimaldi
4890/31B	17th c.		129	Cantagallina
4890/32	G. Cesari (ascr.)		130	Della Bella
4890/33A	F. Zuccaro (follower)		131	Trevisani
4890/33B	Rossetti (ascr.)		132	P. L. Ghezzi
4890/33C	F. Vanni		133	Brizio
4890/34	Missing (del Carpio Volume)		134	Palma Giovane
4890/35	16th c.		135	16th c.
4890/36	V. Salimbeni		138	Cantagallina (attr.)
4890/37	Zucchi		139	G. Balducci (attr.)
4890/38	Muziano		140	B. Dossi
4890/39A	Tassi		141	Rondani
4890/39B	Trevisani (attr.)		142-3	Sogliani (attr.)
4890/40	Bolognese, 17th c.		144	G. B. Gaulli
4890/41	F. Zuccaro		145	A. D. Gabbiani (attr.)
4890/42	Naldini		146	Benaschi
4890/43	Giulio Romano		147	Trometta
4890/44	16th c.		148	Tempesta
4890/45	Bedoli (attr.)		149	Palma Giovane
4890/46A	Betti		150	Allegrini
4890/46B	Florigiero (ascr.)		151	del Vaga (studio)
4890/47	Agostino Carracci		152	Agostino Carracci (attr.)
4890/48	Barocci (copy)		153-5	P. Farinati
4890/49	Passarotti (circle)		156	A. Vicentino
4892	Bertoia		157	Cambiaso
4895	F. Zuccaro		158	Roman, 18th c.
4896	Annibale Carracci		159	Grimaldi

NUMERICAL INDEX ACCORDING TO INVENTORY NUMBERS